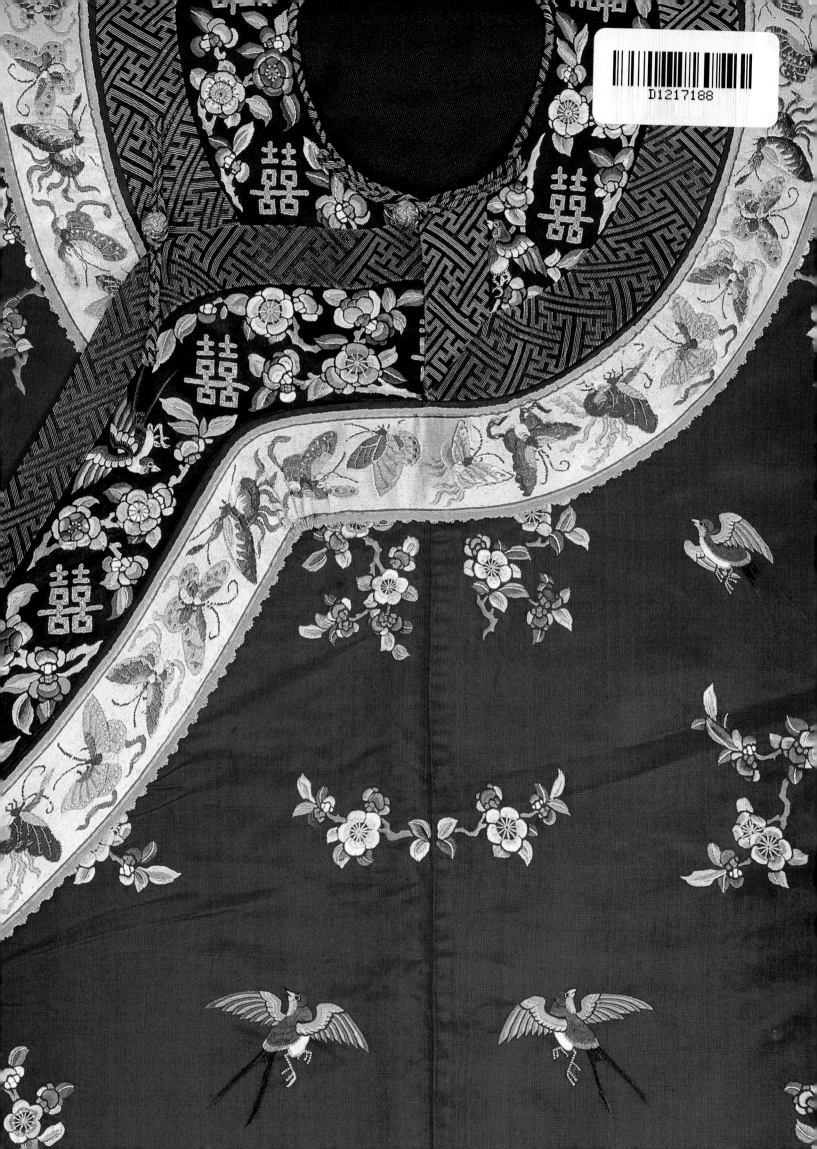

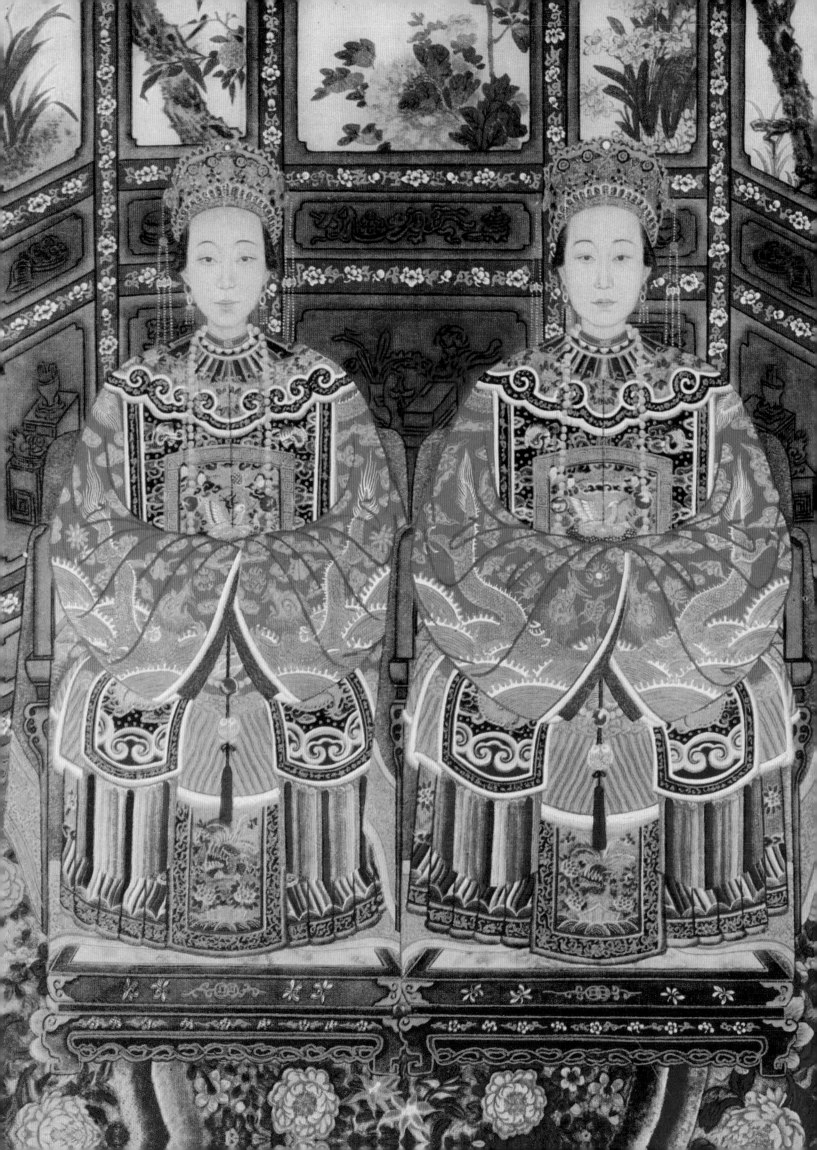

CHINESE DRESS

From the Qing Dynasty to the Present Day

Valery Garrett

TUTTLE Publishing
Tokyo | Rutland, Vermont | Singapore

Published by Tuttle Publishing, an imprint of Periplus Editions (HK) Ltd.

www.tuttlepublishing.com

Copyright © 2019 Valery Garrett

Library of Congress Control Number 2007921612 (for Hc edition)
Hc Isbn: 978 0 8048 3633 0
Pb Isbn: 978-0-8048-5256-2

Distributed by:

North America, Latin America & Europe
Tuttle Publishing, 364 Innovation Drive,
North Clarendon, Vermont 05759, USA.
Tel: 1 (802) 773 8930
Fax: 1 (802) 773 6993
info@tuttlepublishing.com
www.tuttlepublishing.com

Asia Pacific
Berkeley Books Pte. Ltd.
3 Kallang Sector, #04-01
Singapore 349278
Tel: (65) 67412178
Fax: (65) 67412179
inquiries@periplus.com.sg
www.tuttlepublishing.com

Printed in Hong Kong 1911EP
Hc 21 20 07 5 4 3 2 1
Pb 26 25 24 23 22 21 5 4 3 2 1

TUTTLE PUBLISHING® is a registered trademark of Tuttle Publishing, a division of Periplus Editions (HK) Ltd.

Page 1 Close-up of the neckline of a Manchu lady's blue embroidered robe with flowers and birds, with butterflies and double happiness characters on the borders.

Page 2 Painting of two wives of a mandarin, the bird on the rank badges on their stoles artfully concealed by the sleeves of their jackets to imply a higher rank, 19th c.

This page Detail of a poster advertising soap and cold cream showing two girls wearing the long cheongsam, Shanghai, ca. 1935.

ABOUT TUTTLE
"Books to Span the East and West"
Our core mission at Tuttle Publishing is to create books which bring people together one page at a time. Tuttle was founded in 1832 in the small New England town of Rutland, Vermont (USA). Our fundamental values remain as strong today as they were then—to publish best-in-class books informing the English-speaking world about the countries and peoples of Asia. The world has become a smaller place today and Asia's economic, cultural and political influence has expanded, yet the need for meaningful dialogue and information about this diverse region has never been greater. Since 1948, Tuttle has been a leader in publishing books on the cultures, arts, cuisines, languages and literatures of Asia. Our authors and photographers have won numerous awards and Tuttle has published thousands of books on subjects ranging from martial arts to paper crafts. We welcome you to explore the wealth of information available on Asia at www.tuttlepublishing.com.

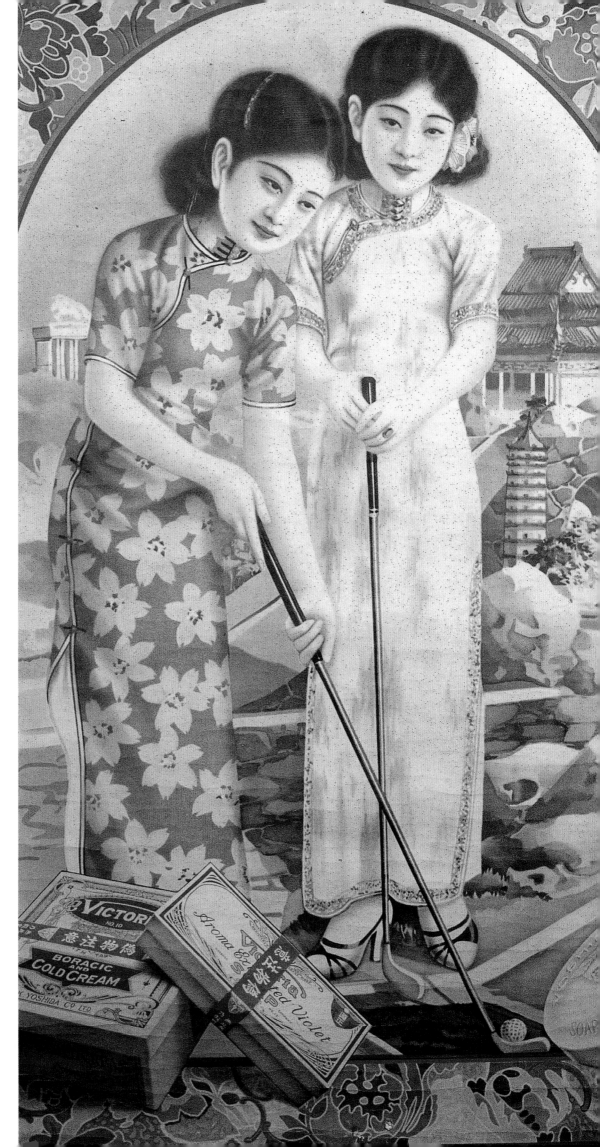

CONTENTS

6 Chapter One
THE DRESS OF THE QING
MANCHU RULERS 1644–1911
The Imperial Court 8
Manchu Dress Regulations 10
Court Attire 12
Dragon Robes 16
Imperial Surcoats and Rank Badges 23
Informal Robes 25
Military Uniforms 26

32 Chapter Two
THE DRESS OF THE MANCHU
CONSORTS 1644–1911
Life in the Forbidden City 34
Court Robes 34
Accessories 38
Semiformal and Informal Attire 40
Non-official Dress 49
Manchu Children's Clothing 55

62 Chapter Three
THE ATTIRE OF MANDARINS
AND MERCHANTS
Becoming a Mandarin 64
Court Dress 68
Dragon Robes and Informal Dress 70
Accessories 70
Surcoats and Civil Rank Badges 75
Military Officials and Rank Badges 78
Clothing for Children of Mandarins 82
The Chinese Merchant Class 84
Purses and Their Contents 88

92 Chapter Four
THE ATTIRE OF CHINESE WOMEN
At Home 94
The Mandarin's Wife 98
Formal Wear 102
Semiformal and Informal Dress 106
Accessories 113
Bound Feet 116
Wedding Attire for Men and Women 120
Funeral Attire for Men and Women 123

126 Chapter Five
REPUBLICAN DRESS 1912–1949
The New Republic 128
Formal Dress for Men 130
The Sun Yatsen Suit 132
Women's Dress 1912–1925 134
The Rise of Department Stores 142
The Cheongsam 147
Western Dress and Wedding Attire 152

156 Chapter Six
CLOTHING OF THE LOWER CLASSES
Life of the Common People 158
Working Clothes 160
Farming Communities 163
Fishing Folk 168
Wedding Clothes and Customs 172
Funeral Attire 174

178 Chapter Seven
CLOTHING FOR CHILDREN
Life in the Qing Dynasty 180
Birth to One Year 181
First Birthday Celebrations 186
Young Children's Clothing 188
Older Boys' Clothing 192
Older Girls' Clothing 195
Dress in the Twentieth Century 199
Baby Carriers 203
Charms 205
Dress for Special Occasions 207

210 Chapter Eight
DRESS IN NEW CHINA 1950–2006
The First Fifteen Years 212
Clothing Styles 213
The Mao Suit 218
The Cultural Revolution 1966–1976 220
Slogans on Clothing 225
The People's Liberation Army 227
China Opens Its Doors 229
West Meets East Meets West 231

236 BIBLIOGRAPHY
237 INDEX
240 ACKNOWLEDGMENTS

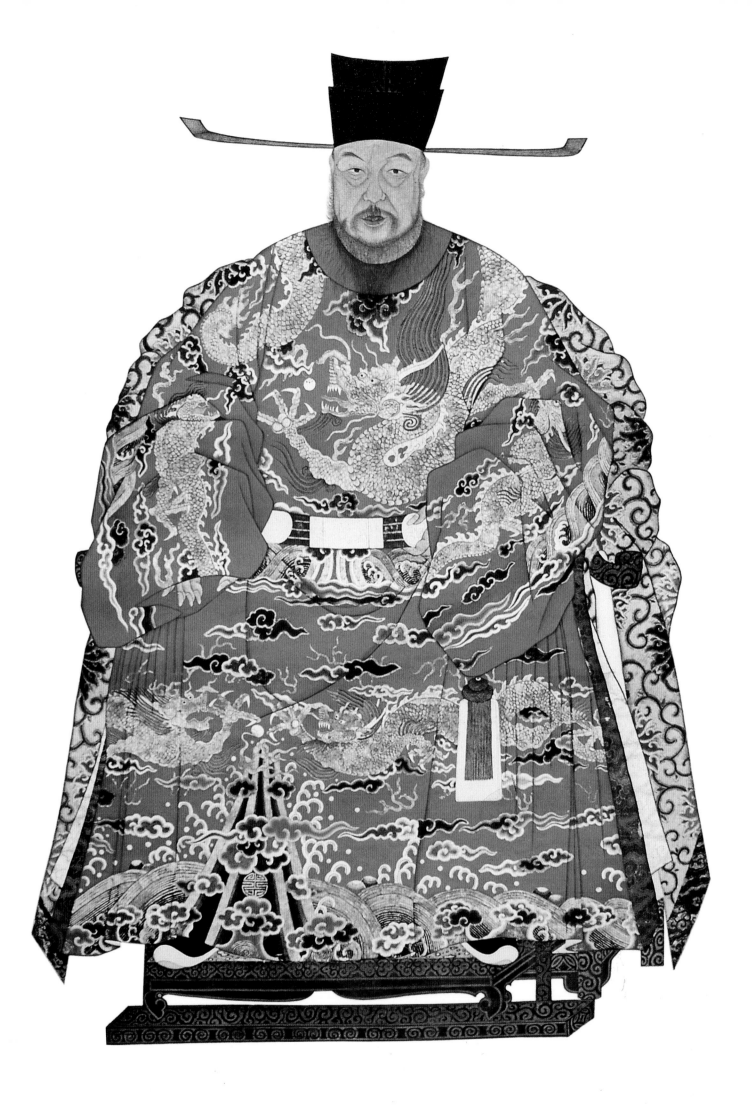

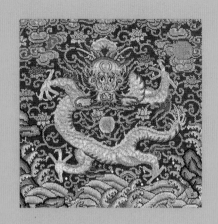

Chapter One

THE DRESS OF THE QING MANCHU RULERS 1644–1911

The Imperial Court

For almost 300 years, the Chinese emperors of the Ming dynasty (CE 1368–1644), cloistered inside the Forbidden City in Beijing, enjoyed a leisurely and scholarly lifestyle. After the overthrow of the Mongol-ruled Yuan dynasty, the court re-established the culture and traditions of their ancient and great civilization. Art and literature flourished, reaching a height seldom attained before or since.

But in 1644 all this would change. Despite the presence of the Great Wall, constructed in the Qin dynasty (221–206 BCE) to protect the fertile regions of central China from barbaric nomads who lived outside the wall's perimeters, invasion from the north was a constant fear during the Ming era. The greatest threat was from the Manchu, a group of settled tribesmen of Tungusic descent, as well as some Eastern Mongolian herdsmen from the region now called Manchuria. The Manchu raised reindeer, hunted, and traded sable furs and ginseng with the Ming army along the Liaodong peninsula. As a means of control, the Ming bribed the Manchu with dragon robes and silks as well as titles and favors (Fig. 1).

The supreme chieftain of all the Tungusic tribes in Manchuria was Nurhachi, who came from the Aisin Gioro clan. The first Manchurian chieftain of his time strong enough to be a great military leader, he was able to forge a new nation from people of differing origins and capabilities. By 1601 Nurhachi had organized the tribes into companies of 300 soldiers, with five companies forming a battalion, and had established a military organization known as the Eight Banners. The tribes moved around in battalions while hunting, and the system served both as a defense and a means of organizing taxes and land distribution for the whole Manchu population. On Nurhachi's death in 1626, his successor Abahai formally adopted the name Manchu for the collective tribes, and recruited Chinese border troops for the Manchu army.

By 1644 a Chinese rebel army had captured Beijing, an event that resulted in the Chongzhen Emperor (r. 1628–43) committing suicide in the palace gardens on Coal Hill behind the Forbidden City in Beijing. Ming border troops stationed on the Great Wall rushed back to defend the city. Abahai's younger brother Dorgon, who was appointed leader after Abahai's death in 1643, bribed the defending general Wu Sangui with a princely title and the promise of punishment for the rebels. General Wu allowed the Manchu through the Great Wall, and Dorgon and his army entered Beijing in June l644, appointing his nephew, Abahai's seven-year-old son, as the first Manchu emperor, Shunzhi.

The Manchu renamed their new empire Qing, meaning "pure." Their intention was to remove the threat of invasion by taking control of the northern and western borders and to improve the quality of life by injecting better standards into an inefficient and corrupt government. During this dynasty, which would last for the next 267 years, China reached its greatest size with the inclusion of Tibet, Inner and Outer Mongolia, and Taiwan.

Once settled in the capital, the Manchu rulers divided Beijing into two cities (Fig. 3). The Chinese population was moved to the southern part or Chinese City, separated by a dividing wall, which then became the commercial hub of the capital. The larger

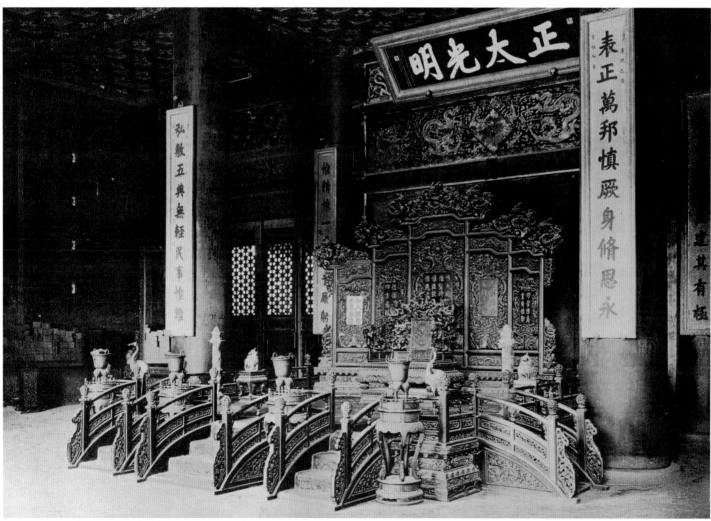

Fig. 2

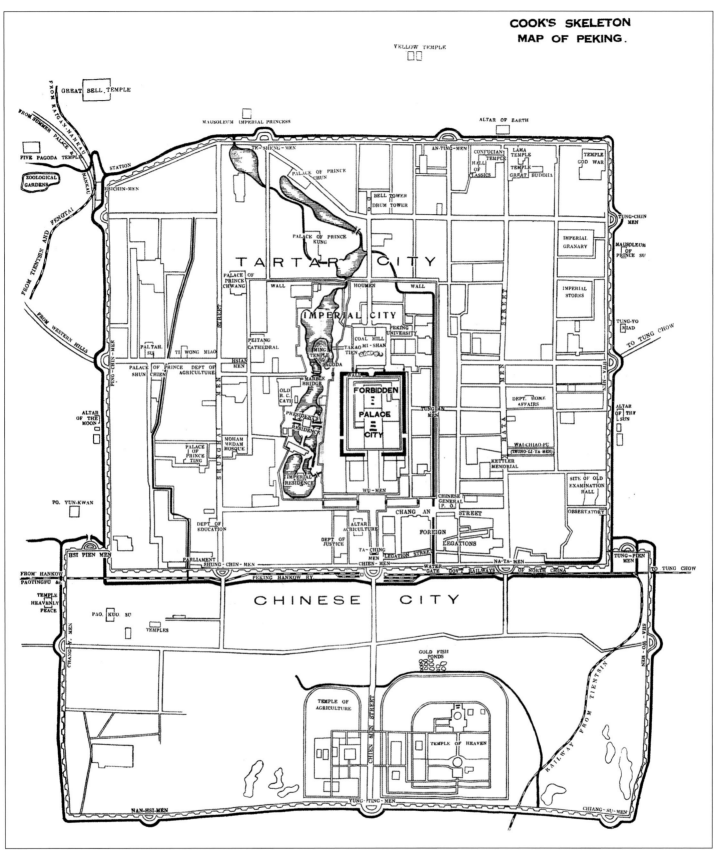

Fig. 3

(Page 6) Fig. 1 Portrait of Wang Ao (1450–1524), a high-ranking Ming official, wearing a presentation robe with four-clawed dragons on the chest, back, down the sleeves, and around the skirt.

Fig. 2 Imperial throne in the Palace of Heavenly Purity (Qianqinggong), one of the main palaces used by the emperors during the Qing dynasty, ca. 1910.

Fig. 3 Map of Beijing showing the Tartar City and the Forbidden City in the center, and the Chinese City to the south of it, 1917.

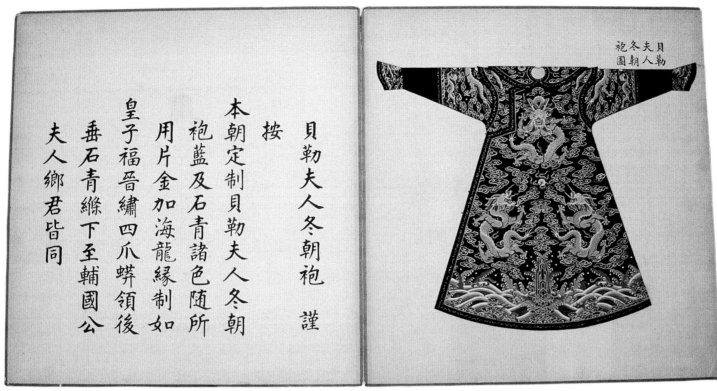

按
貝勒夫人冬朝袍 謹

本朝定制貝勒夫人冬朝
袍藍及石青諸色隨所
用片金加海龍緣制如
皇子福晉繡四爪蟒領後
垂石青縧下至輔國公
夫人鄉君皆同

袍冬夫貝
圖朝人勒

Fig. 4

northern section, known as the Tartar City, became the quarters of the banner troops, the princes' palaces, government buildings, foreign legations, temples and libraries. In the middle of the Tartar City was the walled Imperial City, with its great lakes, and at the heart of this was the Forbidden City (the "Great Within"), home to the Qing emperors.

The Forbidden City had been built during the Ming dynasty and was completed by 1420. Measuring some 3000 feet (900 meters) from north to south, and over 2300 feet (700 meters) from east to west, the high crimson-painted walls were surrounded by a moat. Entry was limited to four gates. Three of the gates led into the southern section where the main official buildings were sited. The fourth gate was situated in the rear to the north where the residential section consisted of many palaces separated by courtyards. Here were the private quarters of the emperor, his consorts, concubines, eunuchs, and children.

The southern section of the Forbidden City was the center of Qing government where matters of court and state were handled. Here were the government departments, the offices of the Imperial Household, the storehouses, workshops and stables, and the huge public halls and courtyards where government officials assembled for an audience with the emperor.

Within this section were three great ceremonial halls, set one behind the other. The largest and most notable was the Hall of the Supreme Harmony (Taihedian). This was the setting for important state events, such as the festivities at the Lunar New Year, the emperor's birthday, and most momentous of all, the emperor's enthronement, an occasion so sacred that his ascent of the throne was veiled from the gaze of such mere mortals as the nobles and officials waiting outside.

Many of the day-to-day affairs of state were dealt with in the halls and palaces to the rear of the ceremonial halls (Fig. 2). Within this compound was the emperor's office where he attended to routine matters and gave daily audience to officials. Here, too, were the emperor's private quarters, including his bedchamber. The emperor was the only male to spend the night in the Forbidden City, attended by female servants and eunuchs chosen for their inability to sire children and thus ensure the purity of the progenitor. Recruited from poor Chinese families, the 3000 eunuchs came to hold great power: they were the emperor's immediate attendants and were responsible for controlling household affairs.

Manchu Dress Regulations

By 1759, the Qianlong Emperor (r. 1736–95), concerned that Manchu customs were being subsumed and diluted by Chinese ways, commissioned a massive work entitled *Huangchao liqi tushi* (Illustrated Precedents for the Ritual Paraphernalia of the Imperial Court), which was published and enforced by 1766. Its eighteen chapters laid out regulations covering such subjects as ritual vessels, astronomical instruments, and the regalia used in governing and on state occasions. In particular, there was a long section on the dress of the emperors, princes, noblemen and their consorts, as well as Manchu officials and their wives and daughters (Fig. 4). It also included dress codes for those Han Chinese men who had attained the rank of mandarin and were employed in the service of the Manchu government, and their wives, as well as those waiting for an appointment.

Clothing was divided into official and non-official wear, and then subdivided into formal, semiformal, and informal. Official formal and semiformal clothing would be worn at court, while official informal dress was intended when traveling on official business, when attending some court entertainment, and during important domestic events. Non-official formal dress was worn for family occasions.

There were also rules indicating what to wear in each season, and when to change clothing for the next season. Changes were made from fine silks in summer through to padded or fur-lined

satin for winter, and from one season to another on a set day, the timing being dictated by the Official Gazette from Beijing. This stated the month, day, and hour that the emperor would change his clothing from winter to summer and vice versa. At this time, all those wearing official dress had to follow suit and penalties were imposed on those who failed to comply.

Ritual worship was one of the most important obligations of the emperor and his governing officials. A strict dress code was observed in elaborate ceremonial sacrifices performed by emperors to Heaven and Earth and to the ancestors of the dynasty, as well as those rituals carried out by local government officials and senior family members. The emperor's responsibilities for ensuring the well-being of his people were tied to the performance of these ceremonies. If an emperor ruled well, Heaven, which cared about the welfare of the people, would smile on Earth, and send good weather and abundant crops. If he were incompetent or corrupt, drought, famines, and floods would devastate the land. This gave the people the right to rebel and overthrow the emperor, with the "mandate of Heaven" passing to his successor.

Robes decorated with dragons were first recorded in the Tang dynasty (618–906) and again in the Song (960–1279). Because the Mongols who ruled China during the Yuan dynasty (1279–1368) had formally sanctioned the use of dragon robes, the Ming deliberately did not adopt the robe officially. Despite this, dragon robes were worn, especially as informal wear. Dragon robes became very fashionable in the early years of the sixteenth century with many officials ordering them freely, and ignoring the laws of 1459 which forbade anyone from having dragon robes made for himself, and regulations were eventually codified for lower-ranking noblemen and officials.

The Manchu were already familiar with robes decorated with dragons, as these had been presented to them both as gifts and bribes by the Ming court. Thus, despite their determination to impose their own culture and customs on the conquered Chinese, they did adopt the decorative patterns of the dragon robe, if not its shape. The Manchu, having been hunters, had developed their own style of clothing from the skins of the animals they caught. The sedentary lifestyle dictated by the ample Ming robes was abhorrent to the Manchu, and they reworked the cumbersome and impractical robe into a slimmer Manchu style to suit their more active way of life.

The symbolic properties of the five colors favored by the Ming continued to have much the same significance for the Manchu. Yellow denoted center and the earth. Blue represented spring and the east, and the Manchu adopted this as their dynastic color. White represented autumn and the west, but this was considered an unlucky color to wear, as it was associated with death. Black stood for winter and the north. Red symbolized summer and the south, but this color was generally avoided as it had been the dynastic color of the Ming, and so was only worn occasionally by the

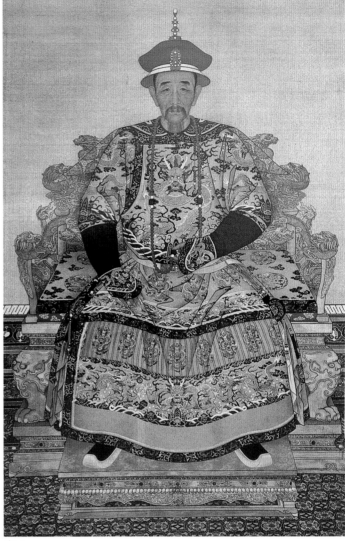

Fig. 5

emperor for the annual sacrifice at the Altar of the Sun. However, the Han Chinese considered it a lucky color because of its connections with the Ming rulers, and it was used extensively at weddings and other celebrations.

The colors of the robes were carefully controlled and certain ones were restricted for use by the emperor and his immediate family (Fig. 5). Bright yellow, representing central authority, was reserved for the emperor, although he could wear other colors if he wished or as occasion demanded, such as when worshipping at the ceremony at the Altar of Heaven when he wore blue robes. The heir apparent wore "apricot yellow," while sons of the emperor wore "golden yellow", *jin huang*, which was, in fact, more of an orange. First to fourth degree princes and imperial dukes wore blue, brown, or any colour unless "golden yellow" was conferred by the emperor. Lower-ranking princes, noblemen, and high-ranking officials wore blue-black.

Fig. 4 Painting on silk from the Regulations showing the second style of summer court robe and flared collar for the wife of an imperial duke.

Fig. 5 Portrait of the Kangxi Emperor (r. 1662–1722) in full summer court attire, his yellow satin robe (with matching collar) edged with brocade and decorated with dragons over the

chest and back, and with a row of roundels above the band on the skirt. A yellow silk girdle, from which hang purses and kerchiefs, is tied around the waist. A court necklace and a conical-

shaped hat with thick red floss fringing and a tall gold finial studded with sixteen Manchurian pearls, completes his outfit.

Court Attire

The *chao pao* or court robe was the most important of all robes and was worn for momentous ceremonies and rituals at court. Its use was restricted to the highest in the land: members of the imperial family, princes, nobles, dukes, and high-ranking mandarins at court. Together with the collar, hat, girdle, necklace, and boots, the *chao pao* formed the *chao fu*, literally "court dress," and was designated official formal attire.

Ming robes were already familiar to the Manchu as gifts in exchange for tribute to the Ming court. Despite their determination to establish their own culture and customs, they did adopt the pattern of the Han Chinese dragon robes, if not the style of them. To form the *chao pao*, the Manchu, for example, imposed some of their nomadic features on the Ming robes, reducing their bulk. The garment was cut across the middle just below the waist. The upper part was made narrower below the arms and became a short side-fastening jacket with a curved overlapping right front, which could have derived from animal skins added for extra covering and protection. It was fastened with loops and buttons, another nomadic practice. The lower skirt was reduced in width to fit the upper part by folding it into a pair of pleated aprons joined to a narrow waistband which attached to the jacket. This modified form continued to give the necessary impression of bulk traditionally associated with festival dress, but resulted in a less cumbersome garment. At the side of the waistband was a small square flap called a *ren*, whose original function, it is thought, was to disguise the fastening.

Like Ming court robes, early Qing robes were decorated with a large dragon on the front curling over one shoulder, with another on the back curling over the opposite shoulder. A band of dragons above mountain and wave motifs encircled the pleated skirt. According to the Regulations, court robes for the emperor and crown prince should have a row of nine or seven roundels, respectively, containing coiled dragons above the band of dragons on the front and back of the skirt. No one else was allowed to wear roundels on the skirt, although they did make an appearance on robes belonging to the lower ranks towards the end of the dynasty.

The Twelve Symbols of Imperial Authority, explained in more detail below, were avoided at first by the Manchu as being associated with the Ming and preceding Chinese dynasties. The Qianlong Emperor reintroduced them in 1759, when they first appeared on court robes and were later extended to the less formal dragon robes.

Another standard feature of Manchu robes was the alteration made to the long, wide sleeves of the Ming robes. The sleeves were cut above the elbow and the lower portion replaced with plain or ribbed silk, thought to have evolved so that the wearer could bend his arms more easily when hunting. The ribbed silk indicated the folds that occurred when the sleeves were pushed up the arms. Cuffs resembling horses' hooves, originally made to protect the hands when riding in bad weather, continued to cover the hands on formal occasions during the Qing dynasty, when it was considered impolite to expose them.

There were three styles of men's court robe: two for winter wear and one for summer. The first style of winter *chao pao* was lined and

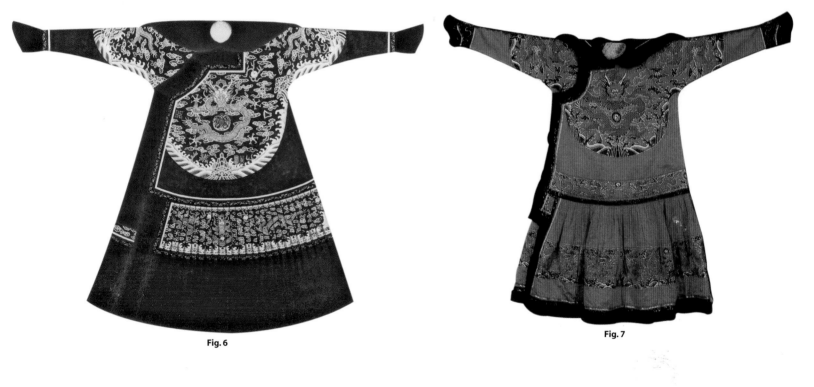

Fig. 6

Fig. 7

Fig. 6 Painting on silk from the Regulations showing the emperor's first style of winter court robe, with the Twelve Symbols of Imperial Authority on the upper part. The robe is faced with sable on the cuffs, collar, and side opening and forms a deep band of the fur on the hem.

Fig. 7 Second style of winter court robe, in red satin trimmed with otter, worn for the sacrifice at the Altar of the Sun, early 18th c.

Fig. 8 Woodblock printed page from the Regulations showing the emperor's summer court robe and flared collar.

Fig. 9 Summer court hat of a prince, with a gold and pearl finial.

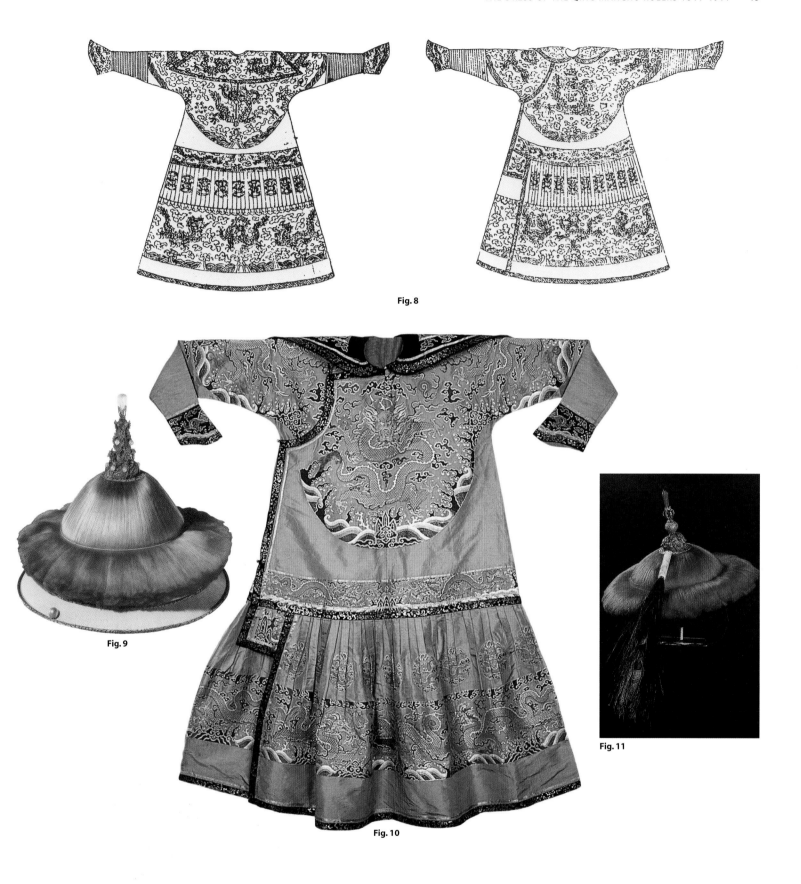

Fig. 8

Fig. 9

Fig. 10

Fig. 11

Fig. 10 Emperor's summer court robe in yellow silk brocade with a front-facing dragon on the chest grasping the pearl of wisdom, nine small roundels on the front and back of the skirt above the panel of two profile dragons and one front-facing dragon, and a flared collar attached to the robe, early Qianlong, mid-18th c. The Twelve Symbols, missing on this robe, did not make an appearance until after 1759 when they were prescribed for use on the emperor's court robes.

Fig. 11 Winter court hat of a high-ranking official, with a finial and "double-eyed" peacock feather plume, the latter awarded on merit by the emperor, 19th c.

lavishly faced with sable on the cuffs, side-fastening edge, and collar, and was trimmed with a deep band of fur round the hem (Fig. 6). Because of the amount of fur required – and its scarcity – this style was restricted to use by the imperial family, the first three ranks of civil mandarins, and the first two ranks of military mandarins. The second style of winter *chao pao* and the summer one were the same in design, the only difference being in the fabrics used. The winter style was trimmed with otter fur, whilst the summer robe was made of satin or gauze and edged with brocade (Figs. 7, 8, 10).

A flared collar known as a *pi ling* was worn around the neck. This feature may have developed from a hood, opened out along the top of the crown to extend beyond the shoulders. The *pi ling* matched the robe in style and fabric, being embroidered or woven in brocade or *kesi* (literally "cut silk," a fine tapestry weave). Dragons were dispersed across the main field, with one facing the front and four in profile above a sea wave base with a border around the edge corresponding to the edging on the court robe. It was attached to the neck of the court robe or fastened independently.

A hat was the most significant and visible part of official dress and as such was worn on every public occasion. Indeed, the codes for hats precede each set of Regulations for court dress, indicating the importance of headwear for both men and women. Official hats were subdivided according to season and worn with the requisite official robes. Summer hats were worn from the third month of the lunar calendar until the eighth month when they were replaced by winter ones. The emperor, princes, noblemen, and high officials wore a court hat (*chao guan*) with formal court attire. For winter, this had a turned-up brim of sable or fox fur and a padded crown covered in red floss silk teased at the edges to make it stand out (Fig. 11). For summer, the hat was conical in shape to shield the face from the sun. It was made of finely woven split bamboo covered with silk gauze edged with a narrow band of brocade, with a circle of brocade at the apex for the hat finial to rest upon. A fringe of red floss silk covered the crown from apex to edge (Fig. 9).

The insignia on top of the hat was its most notable accessory. Dating back to 1636, before the conquest of the Ming, Manchu laws recognized the advantages of a readily visible means of identification for the different ranks of officials (Fig. 12). For the imperial family, the insignia was in the form of a tall, gold finial intricately adorned with dragons, images of the Buddha, and tiers of pearls, the number of tiers depending on the importance of the wearer.

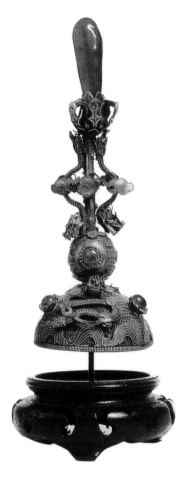

Fig. 12

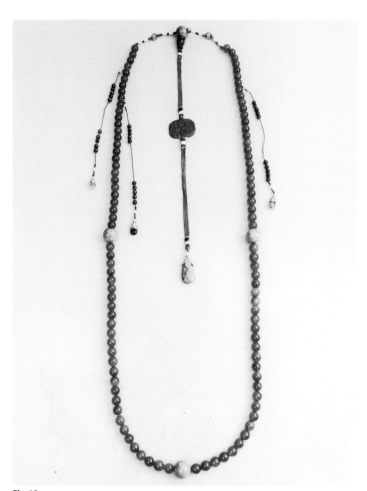

Fig. 13

Fig. 12 Gilt silver filigree hat finial for a prince or nobleman with red clear glass stones *en cabochon* to simulate polished ruby gemstones, and an additional collar of clouds and vertically facing dragons, ca. 1800.

Fig. 13 Court necklace of amber beads interspersed with four jade beads, the counting strings and counterweight made of lapis lazuli.

Fig. 14 Emperor's formal court *chao dai* with wide blue silk streamers for wearing with the *chao fu*. Suspended from side rings on the yellow woven silk girdle is a pair of drawstring purses, a knife purse, and a toothpick case.

Fig. 15 Emperor's yellow felt boots decorated with pearls and coral beads, the tops embroidered and edged with brocade.

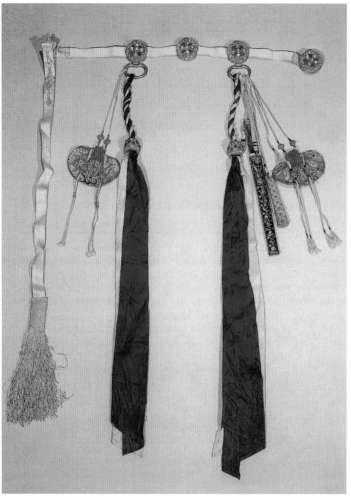

Fig. 14

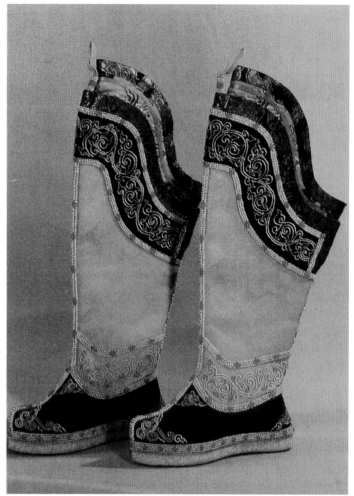

Fig. 15

The *chao zhu* or court necklace developed from a Buddhist rosary sent in 1643 by the Dalai Lama to Shunzhi, who became the first Qing emperor. The necklace comprised 108 small beads with four large beads of contrasting stone representing the four seasons, placed between groups of 27 beads (Fig. 13). These necklaces had a practical purpose too: for rapid – and private – calculations if no abacus were to hand. A long drop extension, down the back, served as a counterweight as well as an ornament. The Manchu also added three counting strings – two on the left and one on the right. The court necklace worn by the emperor was made of Manchurian pearls, coral, and jade, while necklaces worn by other members of the imperial family were made with any semiprecious stones other than pearls.

Another form of rank identification for both the Ming and Manchu was the *chao dai* or girdle, and the ornamental plaques embellishing it. While the Ming court favored a stiff, hooped leather belt ornamented with jeweled plaques, the Manchu girdle was made of tightly woven silk. Since there were no pockets in the robes, girdles were worn tightly belted over the robe around the waist to carry the articles which were frequently needed. These girdles were also a symbol of status and thus were mentioned in the Regulations, the colors being appropriate to the color of the robe and to the status of the wearer.

The Manchu girdle was also adorned with two ribbons or ceremonial kerchiefs, a pair of drawstring purses, a knife case, and other items hanging from it (Fig. 14). When worn with the *chao fu*, the kerchiefs were wide and pointed at the end. Because the Manchu had been a nomadic race, it is thought that the girdle and kerchiefs

were originally made of a stronger material, such as woven hemp, and could have replaced a broken bridle if necessary. The girdle was covered with four ornamental plaques made of gold or silver set with semiprecious stones or other materials, plus center ones forming an interlocking belt buckle.

The drawstring purses of the Manchu harked back to their nomadic origins, since such purses had developed from a circle of leather gathered up to contain pieces of flint needed to strike a flame for a fire. Once settled in China, the Manchu emperors stored areca (betel) nuts in them. The purses also held scented cotton or aromatic herbs to sweeten the sometimes putrid air.

Later, as the Manchu became more established, items suggesting a more leisurely and scholarly existence replaced the knife case and compass. These included a fan case, *da lian* purse (used to carry valuables), spectacle case, and kerchief holder, although the original drawstring purses were retained.

To match his yellow silk court robes, the emperor wore knee-high yellow silk brocade or felt boots decorated at the cuff and on the vamp with black brocade trimmed with rows of seed pearls and coral beads (Fig. 15). The thick soles were made of layers of felted paper with a final layer of leather, and whitened round the edges. A loop at the top of the boot allowed a garter to be passed through to prevent the boot from slipping down the leg. The inflexible soles originally allowed the Manchu wearer to stand up in the stirrups when on horseback, but the soles were made shorter than the uppers at the toe for ease of walking. For informal wear, the emperor wore plain black satin knee-high boots, which were also worn for general use by princes and noblemen.

Dragon Robes

Despite the early reluctance of the Manchu to wear the same kind of robes as their Ming predecessors, by the reign of the Kangxi Emperor (r. 1662–1722) the use of richly ornamented dragon robes for semiformal court occasions and official business was widespread in China. Because dragon robes were also worn by lower-ranking officials as well as members of the imperial family, they are the most common type of official robe to survive from the Qing dynasty, particularly as the high status of court robes meant they were used as burial wear. Dragon robes were known as *ji fu* or festive dress, a term of great antiquity, which suggested their considerable importance.

The Qing dragon robe was a full-length coat with sleeves and a curved overlapping right front, much like the top half of the *chao pao*. Its shape is believed to have derived from the use of animal skins, two at the front and one at the back. To make it easier to ride in, the Manchu added slits at the center seams, at the front and back hem, to those already at the sides. Like the court robe, the dragon robe was worn belted, but with the streamers narrower and straighter, and with purses containing daily necessities hanging from the girdle.

Circular roundels depicted imperial status and were a continuation of the Ming tradition. For the higher ranks, early robes displayed eight roundels containing front-facing *long* (five-clawed dragons), while side profiles of either *long* or *mang* (four-clawed dragons) were depicted on robes of the lower ranks. The original Ming arrangement, whereby the roundels were positioned in the center of the skirt, did not suit the Qing robe with its slits at the front and back seams of the skirt (Fig. 16).

Prior to the 1759 Regulations, the court was free to decide for itself the pattern of these less formal robes, as long as they were cut in the Manchu style and complied with the laws regarding color and the number of dragon claws. The distribution of dragon motifs was not regulated and early robes continued the Ming tradition of having large curling dragons over the chest and back.

The most common robes, however, were those with dragons dispersed over the entire surface of the garment. For the emperor and princes, nine embroidered dragons were *de rigueur*: one on the chest, back, and each of the shoulders, and two above the front hem and back hem. The dragons on the upper part of the robe were usually facing the front, while those on the lower skirt were in profile. By the mid-eighteenth century, the size of the upper dragons became smaller and the lower dragons bigger, until on most robes they were the same size (Figs. 18, 19). The symbolic ninth dragon was placed on the inside flap of the robe. The number nine, and the fact that the ninth was hidden, had important symbolic connotations that drew on knowledge of the relationship between tenant and landlord, known as the "well-field system." The Chinese character for "well" is written as two vertical lines crossing two horizontal lines, creating nine equal compartments. Eight farmers worked each of the eight fields around the perimeter, while all helped to farm the central ninth field (Vollmer, 1980: 22).

Robes with five-clawed dragons, known as *long pao*, continued to be the prerogative of the emperor, heir apparent, and high-ranking princes, although the emperor could bestow this honor on lesser officials if he wished. *Mang pao* or four-clawed dragon robes were worn by third-ranking princes and below. Towards the end of the Qing dynasty, when many laws were disregarded, most

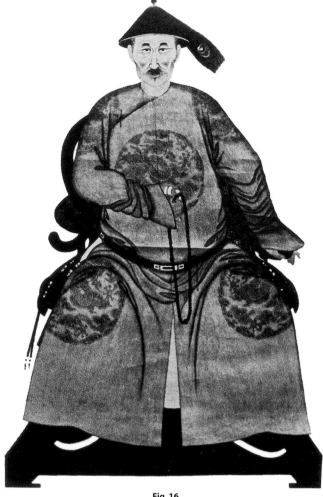

Fig. 16

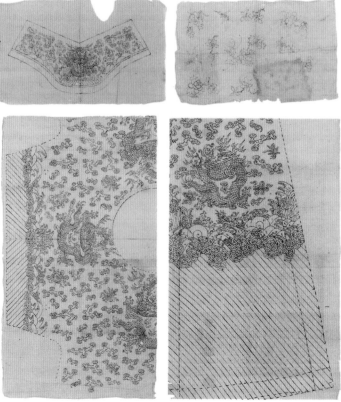

Fig. 17

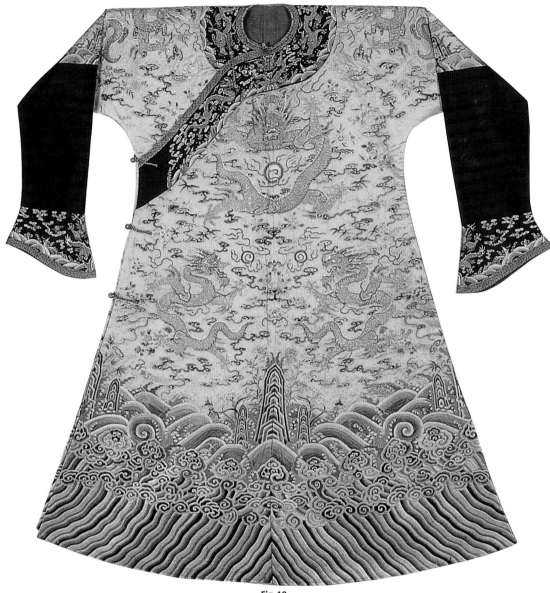

Fig. 18

robes were of the five-clawed variety, along with the hidden ninth dragon, and worn by all the ranks, as it was unthinkable to be seen wearing the four-clawed dragon. Colors for the *long pao* and *mang pao* were in accordance with those for the *chao pao*. The emperor wore yellow, the heir apparent and the emperor's sons wore shades of yellow, and lower-ranking princes and noblemen wore brown, blue, or blue-black (Fig. 20).

Scattered around the dragons on the robe were cloud patterns, and at the hem, waves, stylized mountains, and *li shui*, the diagonal stripes of the five colors representing deep, standing water. In the early part of the dynasty, the mountains were towering and bold, but later became stunted and unnatural, while the *li shui* became much longer and the waves more dominant. By the end of the nineteenth century, the background of the robe was cluttered with a multitude of symbols and lucky charms, especially the Eight Buddhist and the Eight Daoist emblems: "The *ch'i-fu* [*ji fu*] is a schematic diagram of the universe…. The lower border of diagonal bands and rounded billows represents water; at the four axis of the coat, the cardinal points, rise prism-shaped rocks symbolizing the earth mountain. Above is the cloud-filled firmament against which dragons, the symbols of imperial authority, coil and twist. The symbolism is complete only when the coat is worn. The human body becomes the world axis; the neck opening, the gate of heaven or apex of the universe, separates the material world of the coat from the realm of the spiritual represented by the wearer's head" (Vollmer, 1977: 50).

Fig. 16 Manchu nobleman wearing a robe with eight roundels and dragons in profile, mid-18th c.

Fig. 17 Cartoon for a dragon robe. One piece contains the drawing for the skirt up to the base of the front-facing dragon on the chest and back. The upper piece shows the chest and back dragons, shoulder front-facing dragons, *li shui* at the sleeve edges, and a line drawn across to indicate the shoulder fold. The overall finished measurement of the robe would have been 60 inches (154 cm) long and 24 inches (61 cm) from center front/back to sleeve edge. The cuff was drawn on paper 12 inches (30 cm) high and 20 inches (52 cm) wide; only the neckband is missing.

Fig. 18 Yellow satin dragon robe embroidered with nine five-clawed dragons in a natural setting of flowers above wavy *li shui* and the halberd, a rebus for "rise up three grades," first half 18th c.

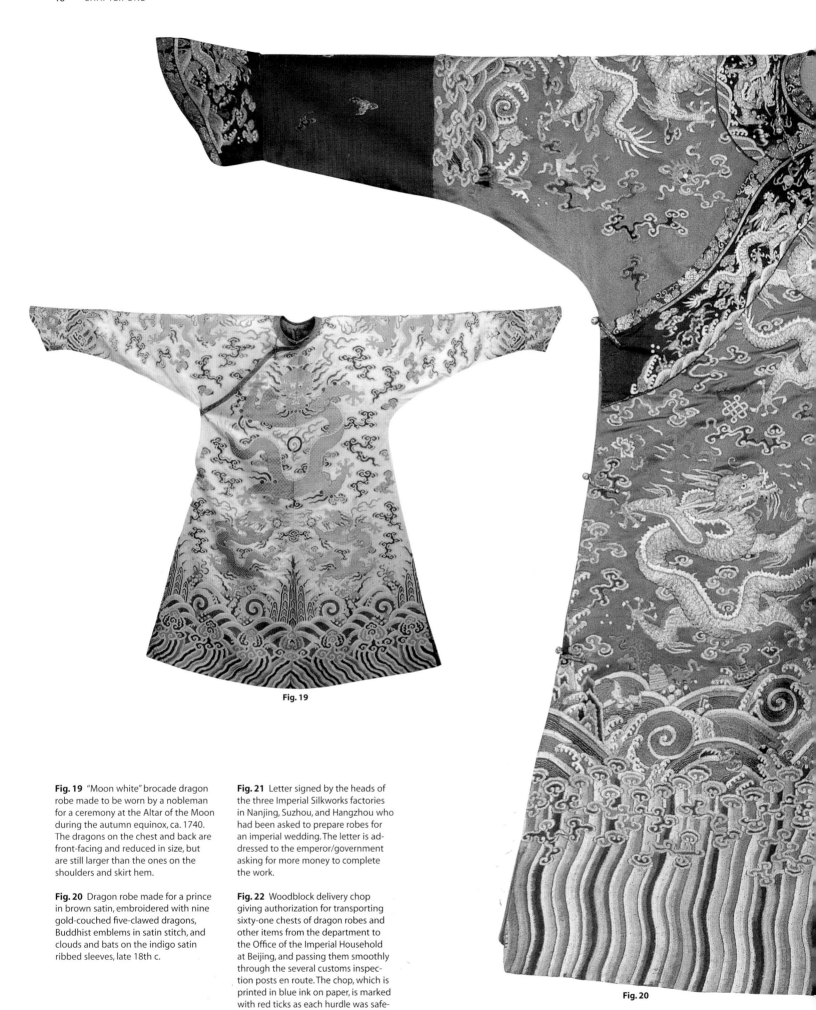

Fig. 19

Fig. 20

Fig. 19 "Moon white" brocade dragon robe made to be worn by a nobleman for a ceremony at the Altar of the Moon during the autumn equinox, ca. 1740. The dragons on the chest and back are front-facing and reduced in size, but are still larger than the ones on the shoulders and skirt hem.

Fig. 20 Dragon robe made for a prince in brown satin, embroidered with nine gold-couched five-clawed dragons, Buddhist emblems in satin stitch, and clouds and bats on the indigo satin ribbed sleeves, late 18th c.

Fig. 21 Letter signed by the heads of the three Imperial Silkworks factories in Nanjing, Suzhou, and Hangzhou who had been asked to prepare robes for an imperial wedding. The letter is addressed to the emperor/government asking for more money to complete the work.

Fig. 22 Woodblock delivery chop giving authorization for transporting sixty-one chests of dragon robes and other items from the department to the Office of the Imperial Household at Beijing, and passing them smoothly through the several customs inspection posts en route. The chop, which is printed in blue ink on paper, is marked with red ticks as each hurdle was safely passed.

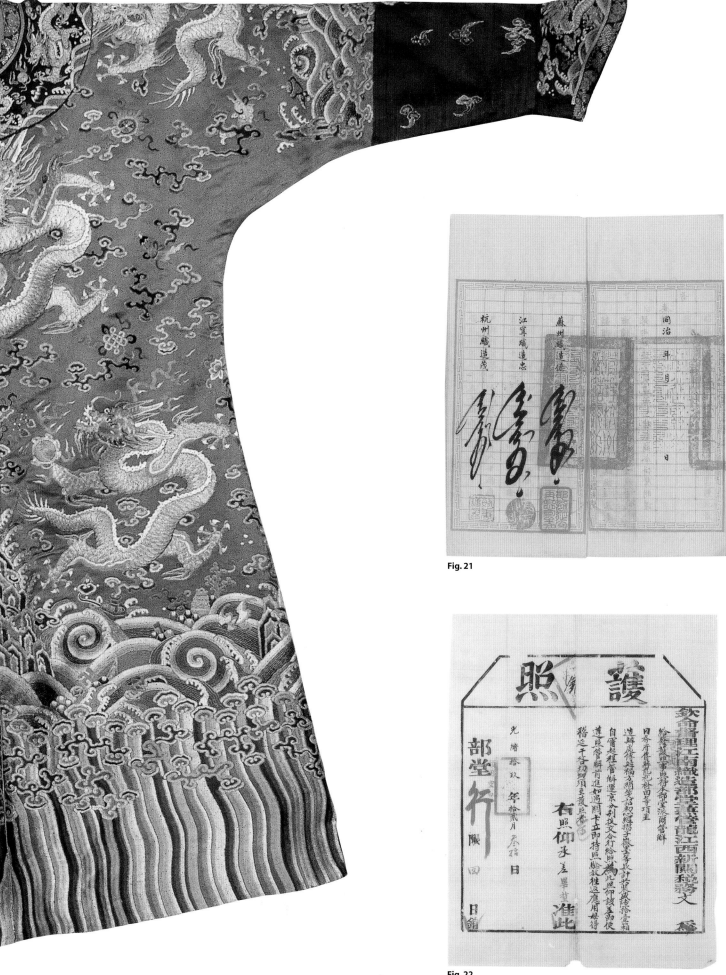

Fig. 21

Fig. 22

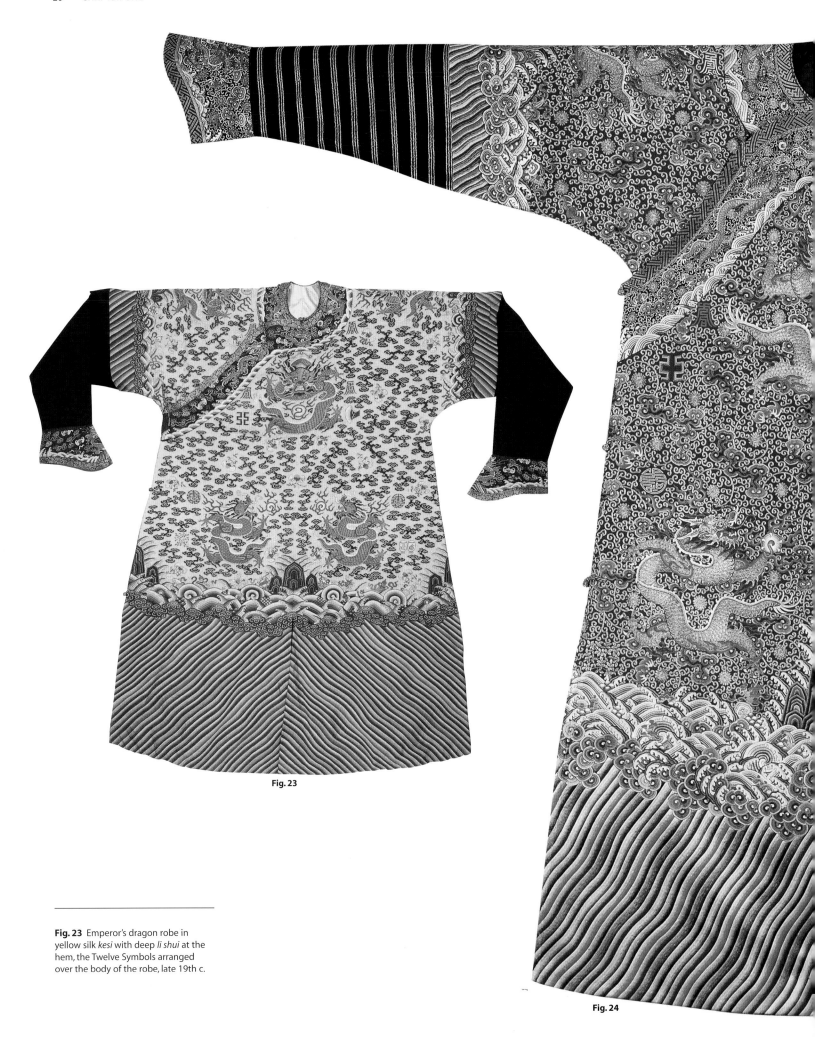

Fig. 23

Fig. 24

Fig. 23 Emperor's dragon robe in
yellow silk *kesi* with deep *li shui* at the
hem, the Twelve Symbols arranged
over the body of the robe, late 19th c.

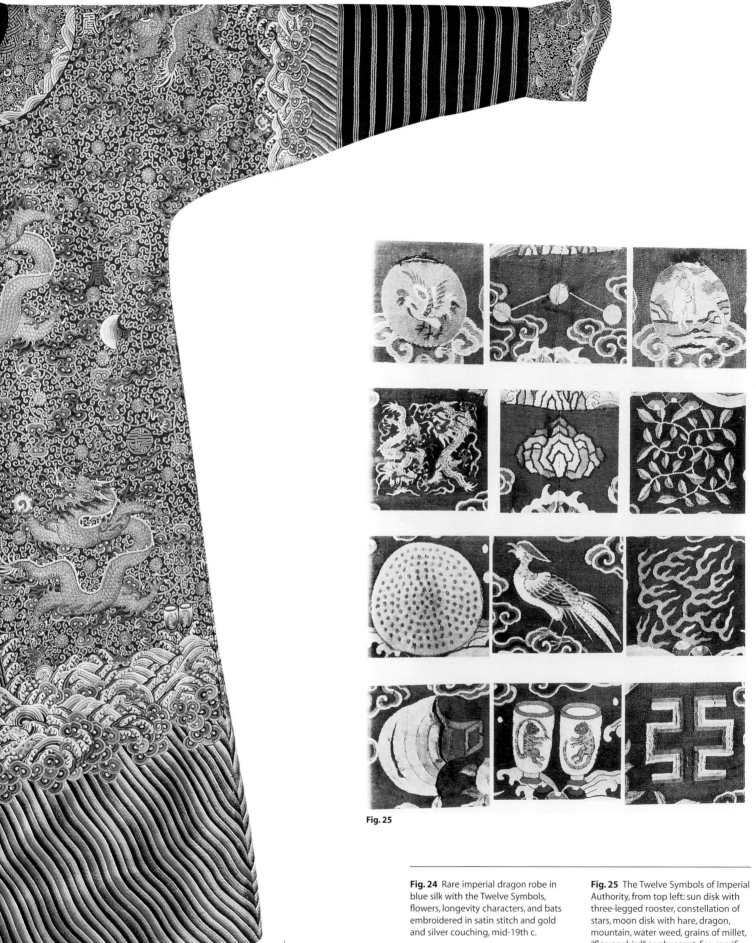

Fig. 25

Fig. 24 Rare imperial dragon robe in blue silk with the Twelve Symbols, flowers, longevity characters, and bats embroidered in satin stitch and gold and silver couching, mid-19th c.

Fig. 25 The Twelve Symbols of Imperial Authority, from top left: sun disk with three-legged rooster, constellation of stars, moon disk with hare, dragon, mountain, water weed, grains of millet, "flowery bird" or pheasant, fire, sacrificial axe, sacrificial cups, and *fu* symbol or Symbol of Discrimination.

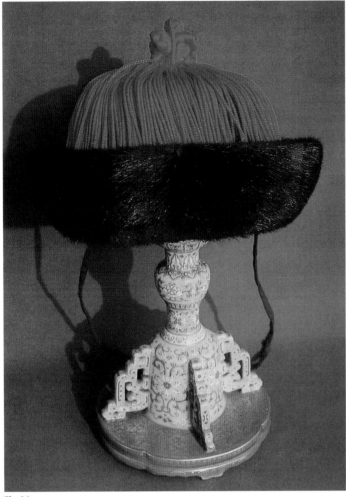

Fig. 26

The Twelve Symbols of Imperial Authority were the most important of all the motifs on the background of court and dragon robes, and their use was strictly confined to the emperor (Fig. 25). The full twelve symbols had first appeared in the Zhou dynasty (ca. 1050–256 BCE) on sacrificial robes, and then again in the Han dynasty (206 BC–AD 220). Placed on the outer jacket and skirt of these early robes, they assumed cosmic significance when worn, with the emperor representing the Ruler of the Universe. Six symbols were depicted on the jacket: the sun and moon disk on the left and right shoulders, the constellation of seven stars of the Big Dipper above the mountain on the back, and dragons and pheasants on each sleeve. A further six symbols were placed on the skirt, each appearing in a pair and together forming four columns: the sacrificial cup, water weed, grains of millet, flames, sacrificial axe, and *fu* symbol representing the forces of Good and Evil. The first three symbols of sun disk, moon disk, and constellation of stars, which were now reduced from seven to three, could only be worn by the emperor (Figs. 23, 24). However, he could, if he desired, confer the right to use the Twelve Symbols on others.

Whenever the court required new dragon robes, a request was sent by the eunuchs to the Imperial Weaving and Dyeing Office, a department within the Imperial Household (Neiwufu). Set up during the reign of the Kangxi Emperor, the office supplied the patterns for the robes as well as the dyes. Some weaving was done on site, but most was carried out in studios in Suzhou, Hangzhou, and Nanjing. Branches of the Imperial Silkworks were established in these three southern cities in the Ming dynasty, although silk weaving had been carried out there for many centuries. The

Silkworks were supervised by the Office of the Imperial Household from 1652 until they went out of production in 1894.

Before an important robe was embroidered, the main design would be drawn in black ink on heavy rice paper, with one half colored in as appropriate. The panels of the robe were joined down the center seams, then the designs were transferred to the silk either by tracing them with a fine line in black ink, or by pricking the cartoon and pouncing a white powder, which was then fixed onto the cloth with an adhesive. Roller frames were not used for large, important pieces of embroidery, as the areas rolled up would be flattened and spoilt. Instead, the marked silk was stretched over a large rectangular frame and several embroiderers would sit around it to work on the design together. The important center motifs, such as the main dragons, were worked over the central seam, thereby disguising it.

For a less important robe, the outline would be drawn, but the colors simply jotted down on the appropriate areas rather than colored in (Fig. 17). The design for the late nineteenth-century dragon robe shown here has been drawn on two pieces of rice paper in ink. Not included are the lower sleeve parts, which would have been left plain. The design includes five-clawed dragons surrounded by clouds, bats, coins, the *wan* emblem (a desire to live for ten thousand years), and some of the Eight Buddhist emblems, including a pair of fish.

Regulations governed procedures at the Imperial Silkworks factories. By the laws of 1652, the Silkworks "were ordered to send annually to Peking [Beijing] two robes of silk tapestry (*k'o-ssu*) [*kesi*] with five-clawed dragons, one of yellow with blue collar and cuffs, and one of blue with dark blue collar and cuffs. These were to be sent alternately in the Spring and Fall of each year to the Palace Storehouse in Peking. At the same time, other weaving in *k'o-ssu* was forbidden" (Cammann, 1952: 117). Once the Silkworks had fulfilled their annual quota of fabrics for the imperial court, they

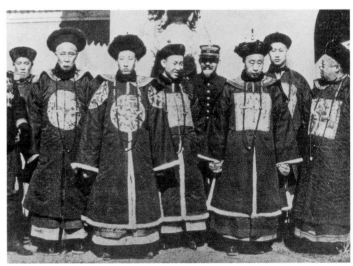

Fig. 27

Fig. 26 Emperor's winter hat with a red silk knob, worn on semiformal occasions with the dragon robe. Red silk fringing or dyed red horse or yak hair was used instead of the floss silk used on the court hat.

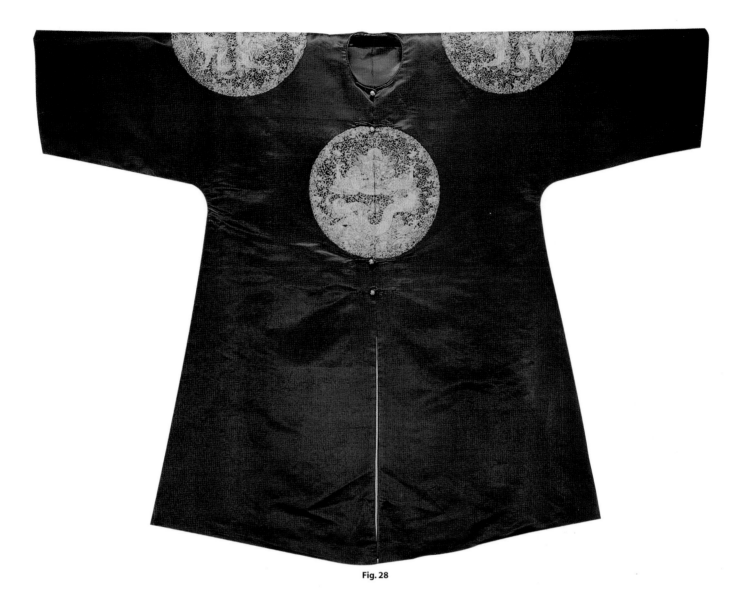

Fig. 28

were then free to take on other orders from wealthy families.

When the robes were completed, they were sent to the capital (Fig. 21). A delivery chop accompanied any consignment, such as the one shown here for dragon robes made in Nanjing and dispatched to Beijing in the late nineteenth century (Fig. 22). This chop was issued to a subordinate by the chief superintendent of the Imperial Silk Manufactory in Nanjing, who was concurrently a senior customs commissioner in Jiangxi province to the south. The woodblock chop gave authorization for the transportation of sixty-one chests of dragon robes and other items from the department to the Office of the Imperial Household at Beijing, and their smooth passage through the several customs inspection posts en route.

On semiformal occasions in winter, the emperor wore a winter hat (*ji guan*) topped with a red silk knob, with his dragon robe. Red silk fringing or dyed red horse or yak hair was used instead of the floss silk on his court hat (Fig. 26).

Imperial Surcoats and Rank Badges

The circular embroidered roundel reserved for the imperial family was extended to the *gun fu* or imperial surcoat, which became official court dress after 1759 and was worn over court or dragon robes. It was a plain satin calf-length, center-fastening coat made in a color denoting rank – as with the other robes – and was mandatory wear for all who appeared at court (Fig. 27). The plain background was specially designed to show off the badges of rank displayed on it. Four circular roundels – placed at the chest, back and shoulders – were the prerogative of members of the imperial family as an indication of their status (Figs. 28–30).

These roundels on surcoats were filled with five-clawed dragons depicted facing the front for higher ranks or in profile for lower ranks. The Qianlong Emperor, who loved pomp and pageantry, added the first two of the Twelve Symbols of Imperial Authority, the

Fig. 27 The Guangxu Emperor (r. 1875–1908, third from left in front) and members of the imperial family wearing surcoats with dragon roundels, the lower-ranking members wearing square insignia badges, ca. 1900.

Fig. 28 Imperial surcoat with four roundels with front-facing five-clawed dragons embroidered in gold thread, with three of the Twelve Symbols: the moon on the right shoulder, the sun on the left shoulder, and the *shou* symbols on the front and back roundels, early 19th c.

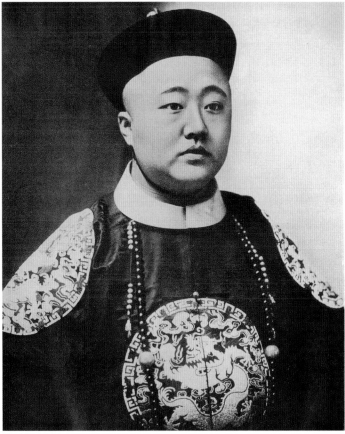

Fig. 29

Fig. 30

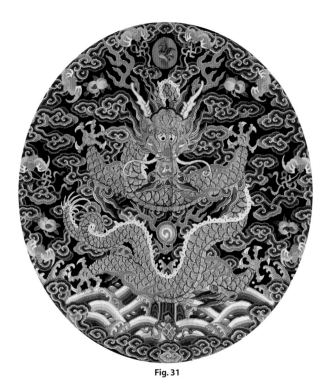

Fig. 31

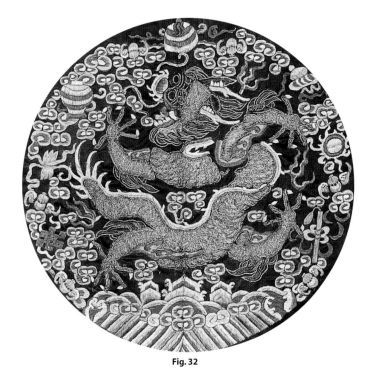

Fig. 32

Fig. 29 Prince Zaixun, brother of the Guangxu Emperor, in a surcoat with four roundels containing dragons in profile, ca. 1908.

Fig. 30 Prince Su wearing an imperial surcoat embellished with four roundels, 1905.

Fig. 31 Roundel in *kesi* from an emperor's surcoat, featuring the sun, a cockerel, and front-facing five-clawed dragons surrounded by eight bats for happiness, the *wan* emblem, and peaches for longevity, early 19th c.

Fig. 32 Roundel embroidered on a surcoat, bearing a five-clawed dragon in profile surrounded by bats and the Eight Buddhist emblems.

sun and moon, to the shoulder roundels on his *gun fu*, while the roundels at the chest and back contained the *shou* symbol for longevity. Beginning in the middle of the nineteenth century, the constellation of three stars was added to the front roundel and the mountain to the back one (Figs. 31, 32).

Imperial dukes and noblemen wore square insignia badges depicting the *long* or *mang* on the chest and back of the surcoat (Fig. 33). Later, towards the end of the nineteenth century, squares with hoofed dragons appeared, possibly for low-ranking noblemen not entitled to wear the clawed dragons (Fig. 34).

Informal Robes

Official informal clothing was worn for events not connected with major ceremonies or government matters. Ordinary dress, *chang fu*, consisted of a *nei tao* or plain long gown of silk, usually reddish brown, gray or blue, cut in the same style as the dragon robe. Originally a Manchu garment designed for use on horseback, the *nei tao* had long sleeves and narrow horse-hoof cuffs to protect the hands, and center splits at the front, back and sides for ease of movement when mounting or dismounting horses. On some there was a section at the lower right side above the hem, which could be detached when riding. On more formal occasions, the cuffs would be worn down to cover the hands as it was considered impolite to expose them, but for informal occasions the cuffs could be turned back and the sleeves pushed up (Fig. 35).

During the second half of the nineteenth century, it became fashionable to wear a small, plain, stiffened collar called a *ling tou*, which fitted over the neck of the surcoat or jacket when worn with the dragon robe or informal robe. The collar was made of dark or light blue silk, velvet, or fur, according to the season, mounted onto a narrow shaped neckband (Figs. 36, 37). When the *ling tou* was made of silk or velvet, it had an extended piece, which buttoned at the front and hung down at the back and was worn inside the robe.

In 1727, the Yongzheng Emperor (r. 1723–35) issued an edict introducing a secondary kind of hat insignia to that of the hat finials, for use on less formal occasions in order to avoid confusion over ranks when insignia squares were not worn or when belt plaques, which were also an indicator of rank, were covered by the surcoat. On semiformal and informal occasions, the emperor himself wore a hat embellished with a knot of red silk (Fig. 38), while noblemen and officials wore a simpler form of round hat jewel, later known as a mandarin button (see page 70). Later, the Regulations stipulated a large pearl in a gold collar could be worn by the emperor and heir apparent on the semiformal hat, and the knot of red silk cord reserved for the informal hat. The ranks of the imperial kinsmen were expanded into a hierarchy of eighteen. Only those in the first six ranks could wear either a red-knotted button on the hat, a three-eyed peacock feather, or a circular rank badge embroidered with a dragon.

Fig. 33

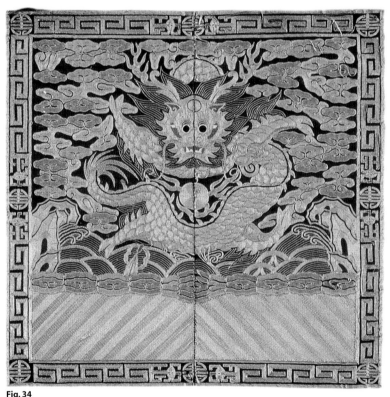

Fig. 34

Fig. 33 Square insignia badge from an imperial duke's surcoat, showing a front-facing four-clawed dragon made with counted stitches on silk gauze, ca. 1800.

Fig. 34 Square insignia badge embroidered in couched gold and silver thread for a nobleman's surcoat, showing an unusual front-facing hoofed dragon, mid-19th c.

Military Uniforms

China's rulers often attempted to pacify potential aggressors with titles and sumptuous robes, but incursions and warfare followed when such tactics failed. In times of peace, emperors and high officials wore ceremonial armor on occasion as a display of might and magnificence.

The Manchu, with their history of successful conquests, placed great emphasis on military training. During their rule they established two main armies, the Manchu Ba Qi or Eight Banners, and the Chinese Lu Ying or Green Standard Army. The Eight Banners was originally an exclusively Manchu army, instrumental in the overthrow of the Ming empire. Although the Manchu system of military organization continued to be collectively called the Eight Banners, from the start of the Qing it comprised twenty-four banners made up of eight banners of Manchu soldiers, eight of Chinese soldiers, and eight of Mongolian soldiers who were direct descendants of those who had assisted in the conquest of China.

The kinsmen of Nurhachi were imperial princes descending from the first to eighth rank. Beneath them were the banner noblemen whose high status was a result of military success, followed by the rest of the bannermen. Every adult Manchu was entitled to belong to the Eight Banners and share in the benefits thereof. At the bottom of the scale were the bondservants who had often been prisoners of war, and who worked as household servants. Initially the male descendants were subsidized by the state, but as time went on and the lineage grew, these payments were reduced. Descendants of the conquest heroes were favored, resulting in a few wealthy and privileged princes with many impoverished descendants. With succeeding generations, titles were downgraded and those entitled to perpetual inheritance reduced to a very small group.

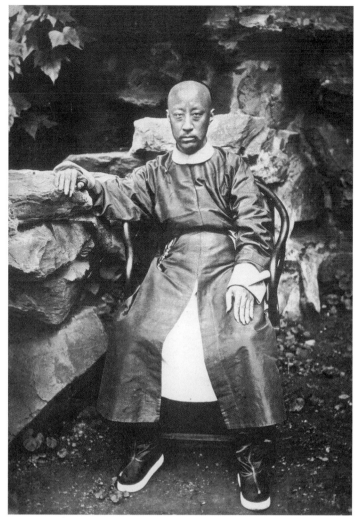

Fig. 35

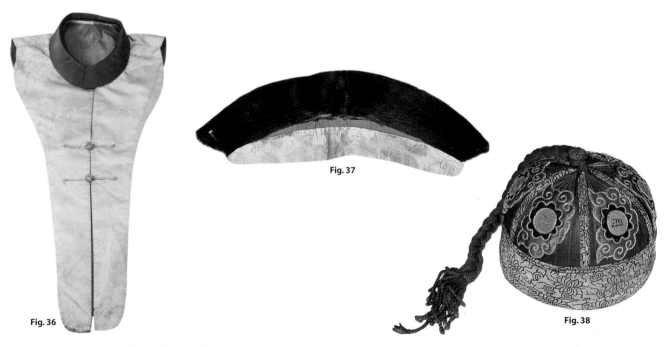

Fig. 36

Fig. 37

Fig. 38

Fig. 35 Prince Gong Yixin, brother of the Xianfeng Emperor (r. 1851–61), wearing a plain long gown with the cuffs turned back informally over a plain inner gown, a *ling tou* collar and black boots, ca. 1870.

Fig. 36 Blue silk collar worn with a surcoat, with an extended piece in cream silk worn inside the coat.

Fig. 37 Fur collar lined in blue cotton with a blue silk neckband.

Fig. 38 Informal skullcap in dark blue satin, appliquéd with *shou* characters and topped with a red silk knot and tassel.

Fig. 39 The emperor, transported in a sedan chair in a procession during a grand tour of the provinces, being greeted by his subjects. The Manchu on horseback are wearing yellow *ma gua*.

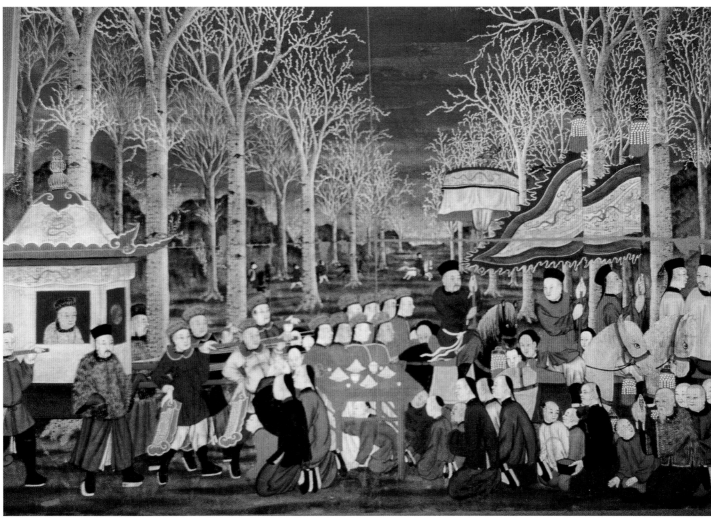

Fig. 39

Each of the Manchu battalions followed a *qi* or banner of yellow, white (actually a buff shade), blue, and red. These colors were based on "a mystic system whereby the yellow is made to represent the center; the red the south; and the white, the west; the north should have been black, but for this, as of bad omen, was substituted the blue; and to the east ... was assigned ... the green, which the native troops were directed to assume as their standard" (Wade, 1851: 252–3) (Fig. 40). In 1615, when most of northern China came under Nurhachi's rule and the army was reformed, four more banners were added by trimming the first three with red, and the red one with white.

All banner garrisons were commanded by Manchu generals, of which more than half were stationed in Beijing, the rest in walled sections of major cities throughout the empire, theoretically to control the local Chinese. These bannermen were forbidden to marry into the conquered Chinese population. Within the metropolitan areas were eight ranks of commissioned officers, both principal and subordinate, and in the provinces six ranks plus the lower-ranking non-commissioned officers and soldiers.

During the first half of the Qing dynasty, the emperors, dressed in suits of ceremonial armor, held triennial reviews of troops during which they inspected the armies to assess their strength and witnessed demonstrations of cavalry, archery, and combat techniques. Whilst these inspections did not take place on a regular basis after the reign of the Qianlong Emperor, ceremonial suits of armor remained a part of the imperial wardrobe and continued to be made, if never worn.

The armor was made of bands of copper gilt plates alternating with brocade and copper studs. The jacket and skirt were made up of loose sections held together with loops and buttons, while shoulder flaps and a center flap at the lower edge of the jacket were covered in studs. Each section was heavily padded and lined with blue silk.

Earlier suits of armor were even more elaborate, such as that worn by the Qianlong Emperor when reviewing his troops (Fig. 41). Here, the upper garment was made of yellow silk embroidered with dragons and studded all over, with more dragons around the borders at the bottom of the skirt. The emperor wore a helmet made of iron with a silver gilt inlay design of tassels and dragons topped by a tall spike with silk fringing finishing with a large pearl.

Ceremonial armor for noblemen and high-ranking officials was similar in style to that worn by the emperor, but was made of satin padded with cotton, trimmed and lined with blue silk, and covered with gilt studs. The separate sections of bodice, skirt, sleeves, shoulder capes, armpit gussets, and groin apron were fastened together with loops and buttons. The helmet, worn over a black silk padded under-hat, was made of lacquered animal hide decorated with copper gilt and topped with a silk plume. Thousands of sets were made in the imperial workshops in Hangzhou and when not worn were stored at the Western Gate of the Forbidden City.

Ceremonial armor for bannermen was made in plain silk in the color of their banner. Imperial guardsmen, whose duty it was to guard the Forbidden City, wore white satin tunics (Fig. 42), while

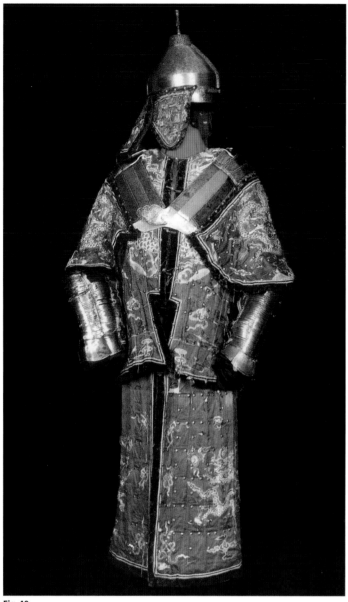

Fig. 40

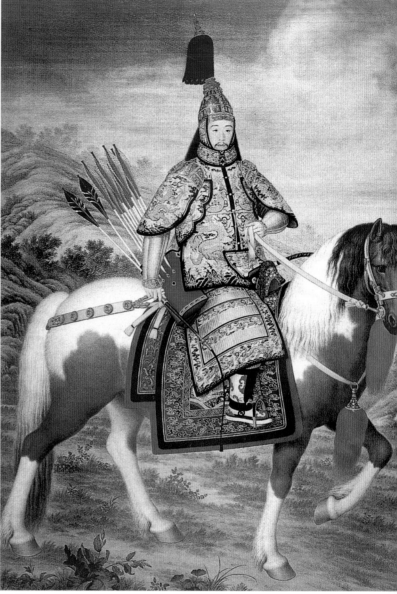

Fig. 41

cavalry brigade troops wore dark blue satin. A *ma gua* or riding jacket in the color of the banner to which a man belonged was a distinction highly coveted, and worn when accompanying the emperor on his travels. However, the highest honor bestowed by the emperor as a reward for military services was the riding jacket in imperial yellow, *huang ma gua* (Fig. 39). This was also exceptionally awarded to two foreigners: M. Giquel for military services and the establishment of the arsenal at Fuzhou, and in 1863 to General Gordon for his role in ending the Taiping Rebellion.

The uniform for a lower-ranking Manchu officer was made in the color of the banner to which he belonged. A short, loose, sleeveless jacket was worn in either the plain or bordered color of the banner over a white tunic, with stockings of the same color as the

jacket, and black cloth boots. Large banners were carried indicating the division, while smaller flags were placed in flag holders strapped to the soldiers' backs.

Dressed for battle, a soldier wore a long coat of quilted nankeen cotton or a thickly wadded jacket made of "thirty to sixty layers of tough bark-pulp paper" (Williams, 1931: 94), covered with thin plates of metal surrounded by brass studs. A girdle round the waist held a knife and chopsticks in an attached case, and a purse for tobacco. A box carried in front held arrowheads and bowstrings. A conical helmet made of leather and iron was topped with a spear and a tassel of dyed horsehair. Weapons comprised bows and arrows, pikes, sabers, matchlocks, and muskets, while rattan shields provided some protection (Fig. 43).

Fig. 40 Armor of an officer of the Chinese Green Standard Army dating from the Kangxi period. The sleeveless jacket and skirt of dark green satin are embroidered with four-clawed dragons in gold thread. The arm defenses comprise lamella iron arm pieces and iron shoulder guards linked with embroidered satin flaps over the upper arms. The iron helmet also has embroidered ear and neck flaps. All the satin elements are lined with blue cotton and inside the layers of cloth are small overlapping iron plates held with metal rivets that are visible on the outside. This form of armor using overlapping iron plates was popular in Europe from the end of the 14th century to 1600, and jackets made of it are called Brigandines.

Fig. 41 Painting by Castiglione of the Qianlong Emperor in ceremonial armor riding to the Grand Review.

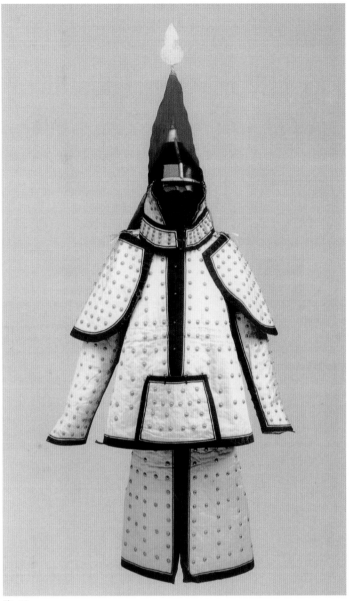

Fig. 42

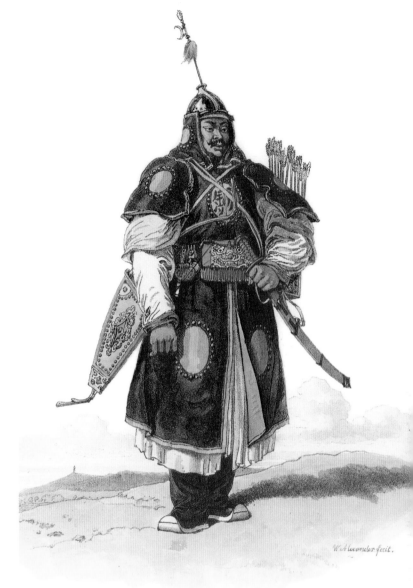

Fig. 43

Soldiers on active service wore the *diao wei* or sable tail, originally part of the uniform worn on imperial hunting expeditions. Two fur tails were arranged in a V shape and fixed to the crown of the winter hat, standing out at the back. They were subsequently worn by all military ranks, from general to private (Figs. 44, 46).

Away from the battlefield, an ordinary soldier wore a short nankeen cotton jacket in black, blue, red, brown, or yellow trimmed with cloth of another color (Figs. 45, 48). Circular plaques at front and back with black characters denoted his company and corps. Jackets were worn over the civilian long blue gown and loose blue trousers pushed into black cloth boots with thick paper soles for the higher ranks, or stockings of quilted cotton and shoes for the lower ranks. Paired aprons were worn, plus a rattan helmet or a turban.

Any formation of archers, musketeers, pikemen, cavalry, and artillerymen on the battlefield was led by shield-bearers known as *ten nai* or "tiger men." With their brightly colored and ferocious-looking dress, they were assigned to break up enemy cavalry charges with their sabers and grappling hooks.

The uniform of these shield-bearers comprised a long-sleeved jacket with yellow and black stripes imitating the skin of a tiger, worn with matching leggings and boots. The cloth helmet with ears was made to resemble a tiger's face. They carried woven rattan shields on which were painted a monster in grotesque style with large eyes, with the character for "king" (the tiger being considered the king of beasts) at the top, placed there to further instill fear into the enemy (Fig. 47).

Fig. 42 Manchu military ceremonial uniform worn by members of the Imperial Guards. Made of cream satin edged with dark blue, wadded and lined, and covered with brass studs, the jacket's separate sections are held together with loops and brass buttons. The helmet is of black lacquer with brass armatures, topped with a red horsehair plume. Qianlong reign mark on inside, 18th c.

Fig. 43 Soldier in full uniform: "The dress of the troops is clumsy, inconvenient, and inimical to the performance of military exercises, yet a battalion thus equipped has, at some distance, a splendid and even warlike appearance; but on closer inspection these coats of mail are found to be nothing more than quilted nankeen, enriched with thin plates of metal, surrounded with studs, which give the *tout-ensemble* very much the appearance of armour…. From the crown of the helmet (which is the only part that is iron) issues a spear, inclosed with a tassel of dyed horse-hair. The characters on the breast-plate, denote the corps to which he belongs" (Alexander, 1805).

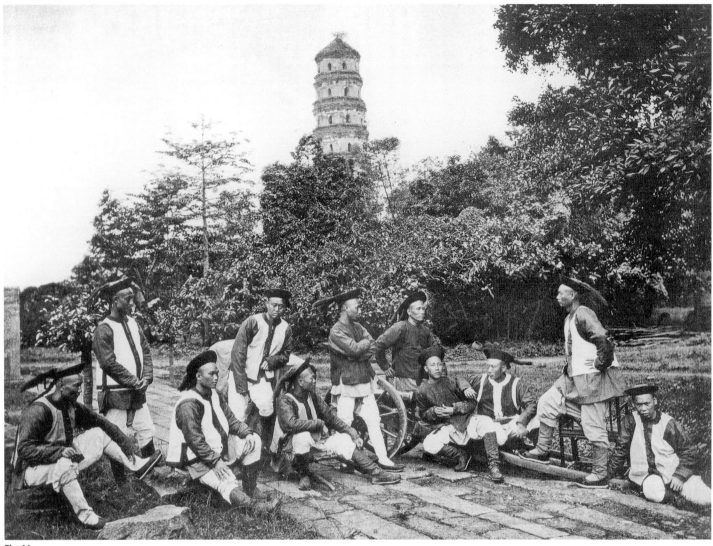

Fig. 44

Fig. 45

Fig. 44 Manchu bannermen wearing sable tails and jackets in the colors of the banner to which they belonged, stationed in Guangzhou where they formed the guard for the British Consul, ca. 1870.

Fig. 45 Infantry soldiers wearing bamboo helmets and holding rattan shields, the character for *ting* or "patrol" on their tunics, late 19th c.

Fig. 46 Manchu bannermen at a parade ground in the northern part of the walled city in Guangzhou, mid-19th c.

Fig. 47 A "Tiger of War" by William Alexander, the artist officially attached to the 1792 embassy led by Lord Macartney to the Qianlong Emperor, 1797.

Fig. 48 Part of the bodyguard for the governor of Shanxi province, late 19th c.

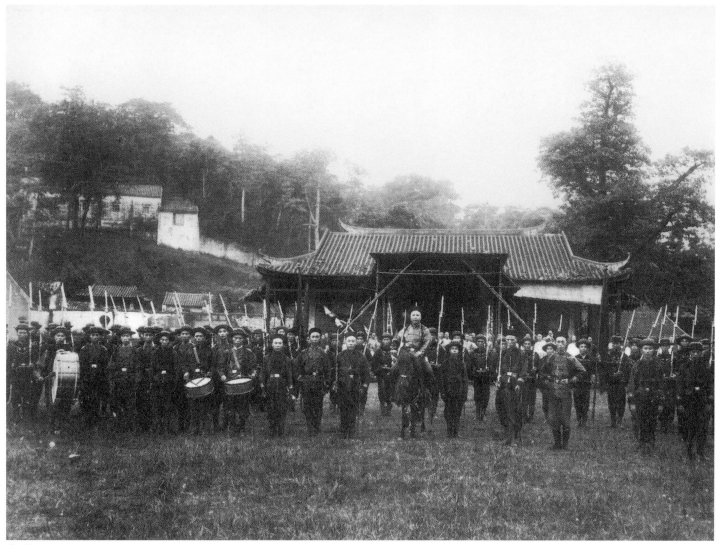

Fig. 46

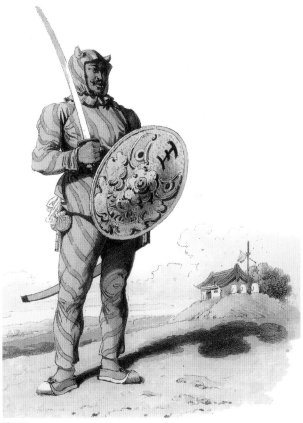

Fig. 47

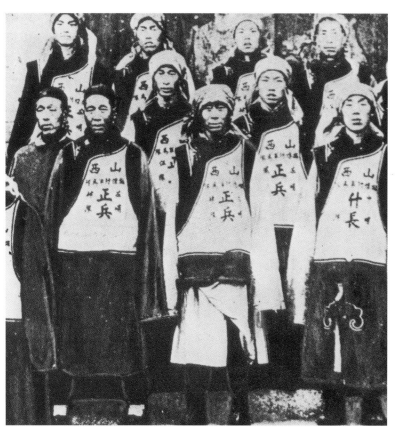

Fig. 48

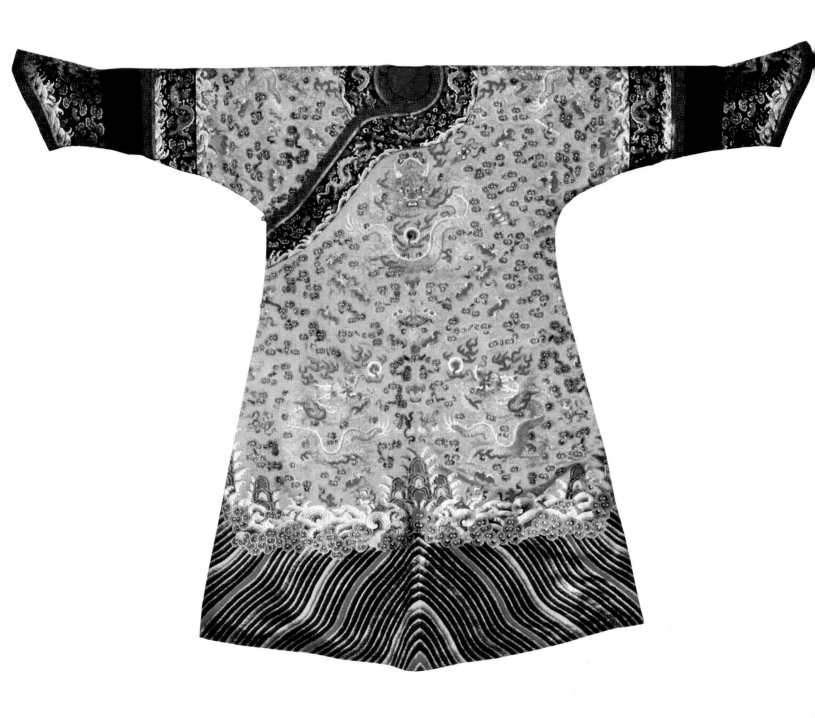

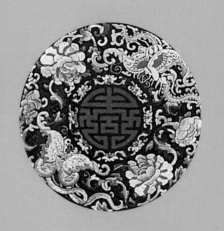

Chapter Two

THE DRESS OF THE MANCHU CONSORTS 1644–1911

Life in the Forbidden City

In order to maintain the "purity" of the Qing dynasty line, emperors chose their wives from among daughters of eminent Manchu families. For reasons of political alliance, they were sometimes selected from important Mongol families, but were never from among the Chinese. Qing emperors continued the Ming system of polygamy to produce many offspring, thus ensuring the succession.

In addition to wives, the emperors had many consorts, recruited every three years from among the important military families of the Eight Banners to become Excellent Women (*xiu nu*). Parents could be punished if they did not register their daughters' names for selection. If chosen, the girls, aged between twelve and fifteen, would live inside the Forbidden City until they were twenty-five when they were "retired" and were free to leave if they so wished.

Another group of women in the palace were the daughters of the imperial bondservants who took care of the personal duties of the emperor and his family. At whim, the emperor could also select a girl from this group to be his concubine or even his next wife (Fig. 50). Marriage between bannermen and bondservants was forbidden, but sometimes bondservant's daughters were brought into the palace as maidservants, and could be promoted into the imperial harem. For instance, Empress Xiaogong was the daughter of a bondservant, who became a maidservant, and went on to gain the favor of the Kangxi Emperor as a third-rank imperial consort.

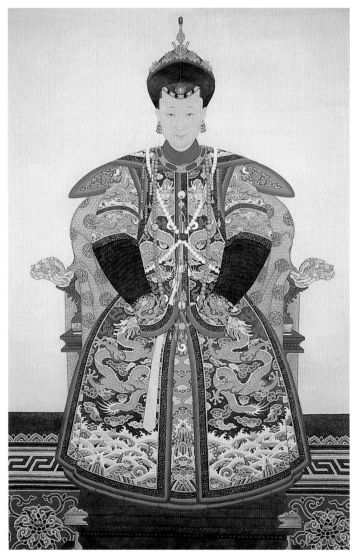

Fig. 50

She bore him three sons and three daughters, and eventually became Empress Dowager once her son ascended the throne as the Yongzheng Emperor.

The emperor's consorts fell into eight ranks: the empress was pre-eminent, followed by the *huang guifei* or first-rank imperial consort, and on down to the seventh rank. Manchu women held no official role in the government, but an empress dowager could act as regent during a ruler's minority, and held even more power than the reigning emperor himself on occasion, due to the importance attached to filial piety. For example, the Empress Dowager Cixi (1835–1908), co-regent for her son and then for her nephew, virtually controlled the government of China between 1860 and 1908. Other women's appearances in public were limited to occasions when they accompanied their husband, though there were some ceremonial events when women from the imperial family would officiate in their own right.

Court Robes

Little is known about early imperial female robes before 1759 when court and official dress became standardized. Following standardization, women's clothing, like that for men, was separated into official and non-official, and subdivided further according to degree of formality. Rules for clothing also followed the seasons, and changes were made from silk gauze in summer, through to silk and satin, to padded or fur-lined for winter.

Official formal dress worn by women at court comprised a full-length garment called a *chao pao*, with a square-cut lapel opening and projecting shoulder epaulettes, the latter thought to be a pre-Qing costume feature for protecting the wearer's arms from bad weather. As with men's robes, the ground color and arrangement of dragons indicated rank. Over the top of the *chao pao* women wore a full-length sleeveless vest called a *chao gua*, which opened down the center; its antecedent was a sleeveless vest of trapezoidal shape worn by the Ming empresses, although the deeply cut armholes and sloping shoulder seams appear to be derived from an animal skin construction. Under the *chao pao*, a skirt made from a single length of silk with eighteen pleats fell from a plain waistband. The skirt was embroidered with small roundels along the hem, filled with the *shou* character, flowers, and dragons. A hat and a large flaring collar (*pi ling*) completed the outfit. Whereas the colors of the women's robes matched those of their husbands, the daughters of the emperor and lower-ranking consorts wore a greenish yellow (*xiang se*) robe.

The various types of seasonal *chao pao* ranged from thick, heavy winter costumes to light summery ones. The first type of winter *chao pao* comprised a long gown with projecting epaulets, embellished all over with front-facing and profile dragons, with wave motifs at the hem, but without the *li shui* diagonal stripes until almost the end of the dynasty. Bands of coiling dragons decorated the upper part of the long sleeves above the plain dark lower sleeves, which ended in horse-hoof cuffs. The robe was lined with white fur and edged with sable. The second style of winter court robe was very similar to the men's *chao pao*, being made in two sections with a pleated skirt attached to a jacket similar in construction to the first style. A four-lobed yoke pattern of dragons extended over the chest, back, and shoulders, with a band of dragons above the seam of the top and skirt. Another band of dragons was placed on the lower part of the skirt. The third style was similar to the first, but with a split in the center of the skirt at the back, which was

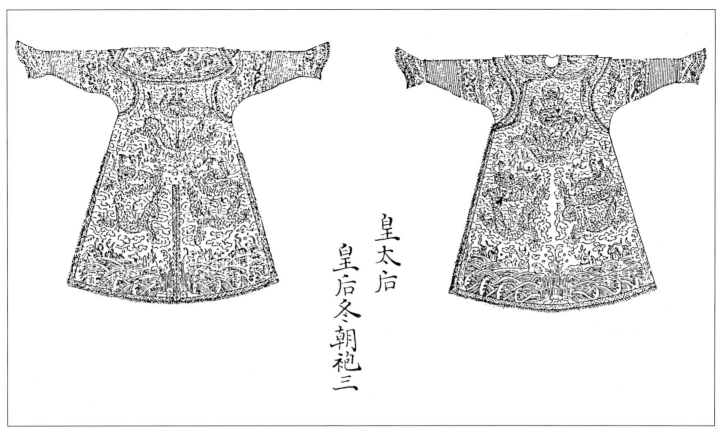

皇太后
皇后冬朝袍三

Fig. 51

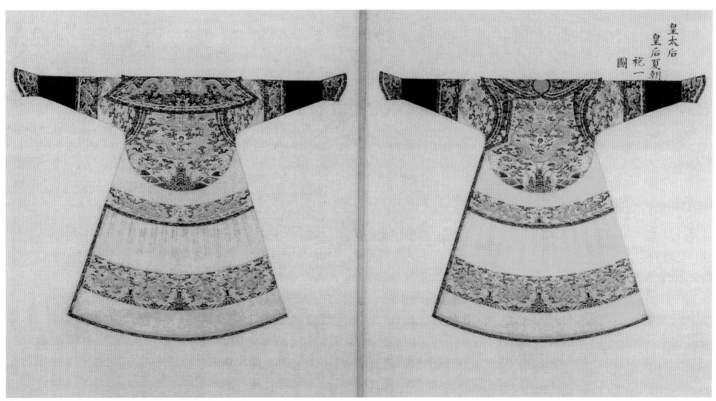

皇太后
皇后夏朝
袍一
圖

Fig. 52

(Page 32) Fig. 49 First semiformal style five-clawed dragon robe in orange silk, embroidered in satin stitch with nine dragons couched in gold thread. Orange was regarded as an off-shade of imperial yellow and restricted to use by the emperor's consorts of the second and third degree and the wives of the emperor's sons. The fact that the lower dragons have not clasped the pearl suggests that the robe was made for an imperial daughter-in-law or consort, mid-19th c.

Fig. 50 Imperial princess wearing a court vest over a court robe, both edged in fur, with a flared collar, winter court hat, diadem, torque, three neck-laces, and pointed kerchief.

Fig. 51 Woodblock printed page from the Regulations showing the back and front views of the third style winter court robe.

Fig. 52 Painting on silk from the Regu-lations showing the first style summer court robe in yellow, belonging to an empress or empress dowager.

trimmed with black fox fur. Unlike the first two styles, this style was permissible for Manchu women other than those belonging to the imperial family (Fig. 51).

Summer court robes were of two types. The first was made of two sections, like the second type of winter robe (Fig. 52). The second summer style was identical to the third kind of winter robe, but made of gauze or satin and edged with brocade (Fig. 55).

Three different styles of full-length, sleeveless *chao gua* court vests made of dark blue silk edged with brocade were worn over the *chao pao*. The first style was made in three sections: an upper part, a section from waist to knee, and a section from knee to hem (Fig. 53). Five horizontal bands embroidered with four- or five-clawed dragons and lucky symbols, depending on rank, encircled the vest. The second type of *chao gua* was similar to the second style

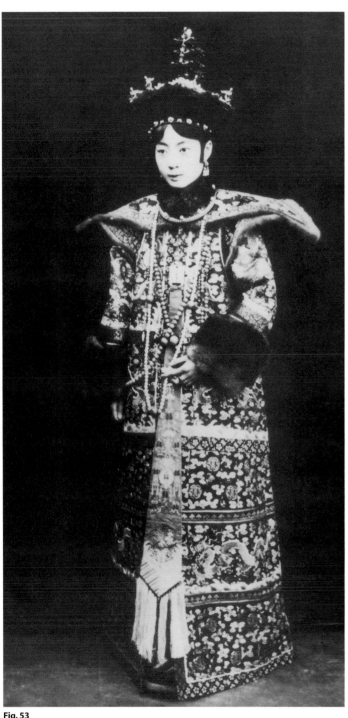

Fig. 53

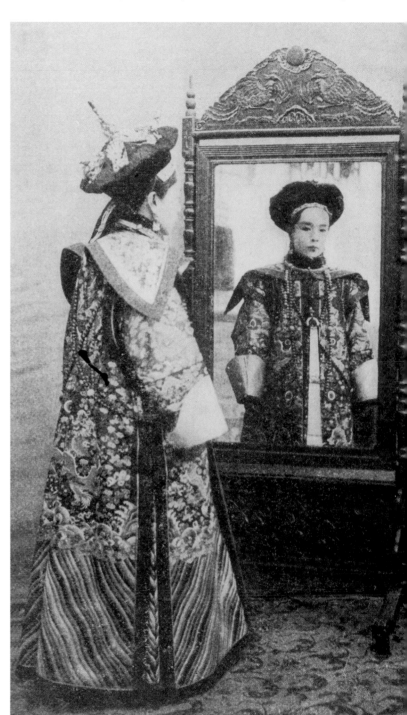

Fig. 54

Fig. 53 Wanrong, wife of the Xuantong Emperor (r. 1909–12), taken at the time of their marriage in 1922, wearing the first style court vest, court hat, flared collar, three court necklaces, together with the pointed kerchief attached to the button on her court vest, a diadem, torque, earrings, and hat finial with three phoenixes.

Fig. 54 Princess Su, whose husband gave his palace to the Christians during the Boxer siege, in the third style court vest, ca. 1900.

Fig. 55 Second style summer court robe with flared collar, 18th c.

Fig. 56 Painting on silk from the Regulations of the second style summer court vest for an imperial consort.

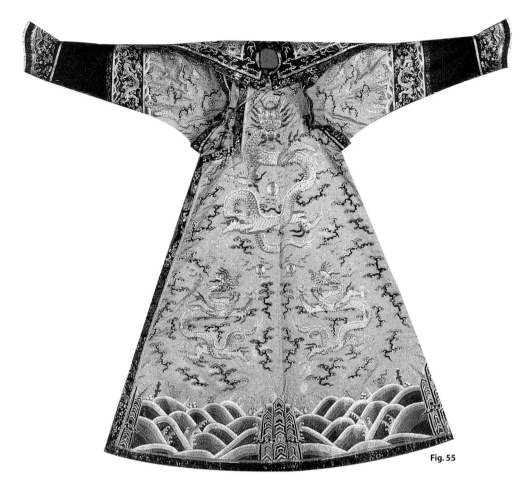

Fig. 55

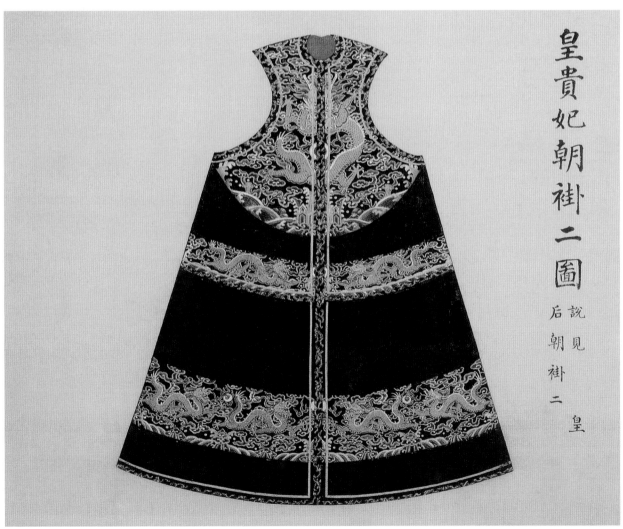

皇貴妃朝褂二圖
說見
皇后朝褂二

Fig. 56

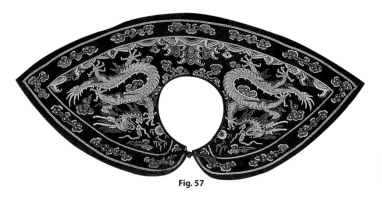

Fig. 57

Fig. 58

of *chao pao*, with a sleeveless body part joined to a pleated skirt (Fig. 56). This is very rare and, like the first, was worn only by members of the imperial family. The third style, decorated with ascending dragons presented in profile as well as wave motifs and, later, *li shui*, was acceptable wear for women of all ranks (Fig. 54). Lower-ranking noblewomen and officials' wives wore either the third style of winter *chao pao* or the second style of summer *chao pao*. This was worn with the third style of *chao gua* and the *pi ling* collar (Fig. 57).

Accessories

An important accouterment of court dress worn by female members of the Imperial Household was the *chao guan* or court hat. At the beginning of the dynasty, different hats were worn in summer and winter, but by the reign of the Kangxi Emperor the winter style had been adopted for use throughout the year. The *chao guan* was similar in shape to the men's winter hat, with a fur brim and a crown covered with red floss silk tassels, but it had an additional back flap shaped like an inverted gourd, made of fur. In summer, the hat brim and back flap were faced with black satin or velvet.

Seven elaborately ornamented gold phoenixes graced the crown of a first-rank imperial consort's summer *chao guan*, while lesser imperial concubines wore five. At the back of the hat, a golden pheasant supporting three strings of pearls anchored by a lapis lazuli ornament hung down over the flap (Figs. 58, 59). The crowns of hats worn by princesses were covered with red floss silk and decorated with golden pheasants, while the hats of lower-ranking noblewomen had small jeweled plaques secured to the base of the crown just above the brim.

As ordained by the Regulations, the hat finials of the empress, empress dowager, and first rank imperial consort were composed of three tiers of golden phoenixes and pearls (see Fig. 59). Lesser-ranking imperial concubines were allowed to wear finials comprising two tiers of phoenixes and pearls. Lower-ranking noblewomen wore a simpler, smaller version of the man's hat finial (Fig. 60).

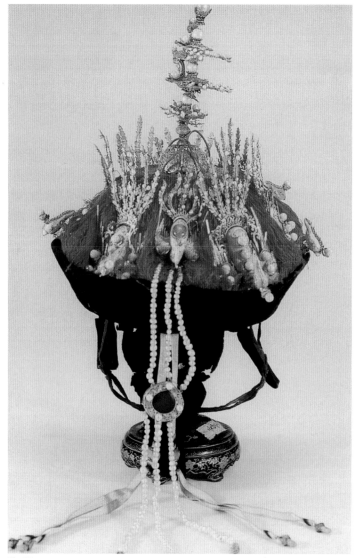

Fig. 59

Fig. 57 Woman's large flaring collar worn on top of a court robe, with two dragons in profile on either side of a mountain, the background filled with clouds and lucky emblems. Men's collars usually had five dragons.

Fig. 58 Painting on silk from the Regulations of a winter court hat belonging to an imperial noblewoman.

Fig. 59 Summer court hat of a first-rank imperial consort. The brim and back flap are in black velvet, with red floss silk fringing covering the crown, seven gold phoenix ornaments set with pearls placed around the crown, and three phoenixes on the finial.

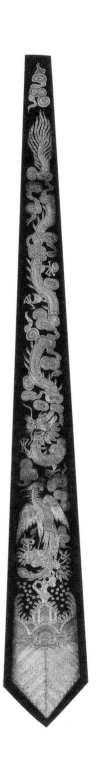

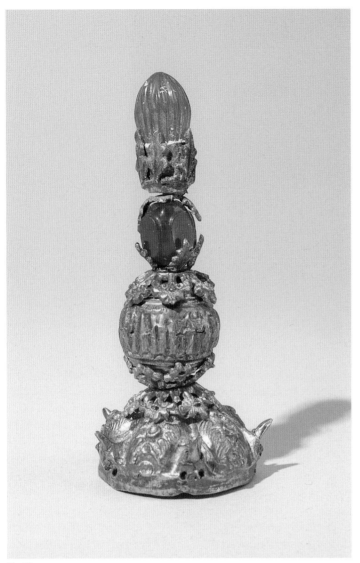

Fig. 60

Fig. 61

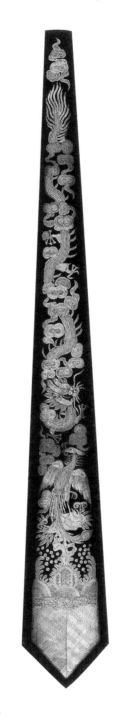

Fig. 62

Fig. 60 Noblewoman's hat finial of brass with amber jewels. This would have been sewn to the hat through the tiny holes around the base, instead of being fixed with a long screw through the crown.

Fig. 61 Diadem of gold inlaid with lapis lazuli and pearls.

Fig. 62 Black satin headband for a Manchu nobleman's wife decorated with four-clawed profile dragons couched in gold and silver thread, one on each side of a flaming pearl.

On each of the pendants, which hung down the back, there is a long coiling dragon and a phoenix of a similar design.

Fig. 63

The court hat rested on a diadem or coronet (*jin yue*), which encircled the forehead (Fig. 61). Diadems were also an indicator of rank and appear in the Regulations after the section on hats. The diadems of women in the imperial family were made of several sections of gold joined together and inlaid with precious stones such as lapis lazuli and pearls. Although not shown here, either five or three strings of pearls, depending on rank, hung down the back, anchored at the top and just above midway by two oval plaques.

On official occasions, lower-ranking women, ranging from the wives of dukes down to the wives of seventh-rank mandarins, wore a silk headband on the forehead in place of a diadem or coronet (Fig. 62). Composed of a band of black satin, it was decorated with semiprecious stones in the form of a dragon and phoenix chasing a flaming pearl. Two pendants embroidered in similar fashion hung down the back. Tiny loops at the top enabled the band to be hooked over a jeweled hairpin, which was pushed into the hair just under the back fastening of the headband.

Women from the imperial family and Manchu noblewomen had their ears pierced to accommodate three pairs of drop earrings (*erh-shih*) in each ear when wearing court dress.

A jeweled collar or torque was listed in the Regulations as an essential part of court dress for members of the imperial family and noblewomen (Fig. 63). Called a *ling yue*, it was made of gold or silver gilt inlaid with semiprecious stones such as pearls, coral, rubies, and lapis lazuli, the number of stones determining rank. Silk braids, the colors corresponding to those of the robes, hung down from the back opening, ending in drop pendants of matching semiprecious stones.

Another essential item of court dress for the ladies of the imperial family, noblewomen, and wives of high officials was the court necklace (*chao zhu*), which was similar in style to the one worn by their husbands but with the addition of two necklaces crossing from left shoulder to right underarm, and vice versa. When wearing the dragon robe on semiformal occasions, a single necklace was appropriate. Only the empress or empress dowager could wear a main necklace formed of Manchurian pearls, the other two being made of coral. Amber and coral necklaces were worn by lower-ranking consorts and princesses, while other members of the family were permitted to wear any type of semiprecious stone not restricted to the empress and empress dowager.

Another symbol of rank listed for women in the Regulations was the *zai shui*, a long pointed kerchief made of yellow, red, or blue silk and embroidered with auspicious emblems like the dragon and phoenix (Fig. 64). Suspended from a jeweled ring, it fastened to a center button on the court vest or to the side top button on the dragon robe. Silk cords with charms made from jade or other semiprecious stones hung from the jewel, with a jeweled bar approximately one-third the way down from the top.

Semiformal and Informal Attire

For semiformal official occasions and during festivals, the women within the imperial family wore the *long pao*, a side-fastening robe embroidered with nine five-clawed dragons, its long sleeves ending in horse-hoof cuffs, and in colors corresponding to rank. Unlike those worn by men, women's dragon robes had no splits at the cen-

Fig. 63 Torque made of gilt-bronze finely worked with a pair of dragon heads confronting a lapis lazuli "flaming pearl" forming the clasp, each set with a *ruyi* hook inset with turquoise, lapis lazuli, and coral plaques incised with scales, floral motifs, and butterflies, late Qing.

Fig. 64 Woodblock printed page from the Regulations showing the pointed kerchief designed for the empress, to be embroidered in green and other colors with the Abundant Harvest of the Five Grains pattern on a bright yellow ground. The same design was permitted to imperial consorts and

ter back and front hem since women did not sit astride horses. Additional bands of dragons at the seams linking the upper and lower sleeves were, in theory, restricted to the empress and highest-ranking princesses, although in practice were adopted by all Manchu women.

As with the formal court robe, there were three types of semi-formal dragon robes. The first, worn by all women, was completely covered with dragon motifs with a wave border along the hem, with the color and number of dragons indicating rank (Fig. 66; see also Fig. 49). Lower-ranking noblewomen and officials' wives wore the *mang pao*, the four-clawed dragon robe in the same style. Later, in the nineteenth century, the sleeves of these robes degenerated, ending in wide horse-hoof cuffs. Although the use of the Twelve Imperial Symbols was, in theory, restricted to the emperor, he sometimes conferred the right to use them on others (Fig. 66).

The second style of *long pao*, decorated with nine dragon-filled roundels and a wave pattern hem, was officially the preserve of the empress (Fig. 67). However, some robes made later in the dynasty, with the degenerated sleeves and wide horse-hoof cuffs popular by this time, have this same roundel pattern and were worn by noblewomen. The third type, officially worn only by the empress, was embellished with roundels but no wave pattern (Fig. 68).

The semiformal dress of the empresses and imperial consorts was not complete without a *ji guan* or festive hat. The *ji guan* resembled the emperor's winter hat, having red silk tassels and a fur brim, while for summer the brim was faced with black satin. The hats of empresses, or those women at court given the right, were topped with a pearl. The hat was worn over a silk band with a jewel at the center, which replaced the gold diadem.

Lower-ranking noblewomen wore more elaborate hats, the crowns of which were covered with red or blue satin decorated with embroidery or semiprecious stones and topped with a red silk knot (Fig. 65). Two wide streamers, embroidered with dragons chasing the flaming pearl, were inserted through a horizontal slit in the brim and hung down the back to below the waist. Other designs on the streamers include the Eight Buddhist emblems. Two small bouquets of flowers were often tucked in the hat just above the ears.

For official informal occasions, dragon robes were made of plain-colored silk damask edged with bands of embroidered dragons at the *tou jin* or curved opening at the neck, and on the sleeves, although they were cut in the usual dragon style with horse-hoof cuffs (Fig. 69). Being relatively plain, these robes are quite scarce.

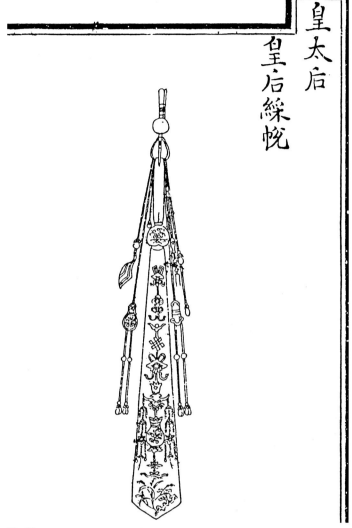

Fig. 64

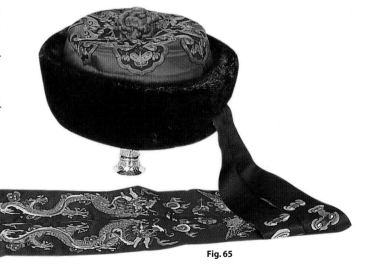

Fig. 65

consorts of princes, while the ones worn by princesses and noblewomen were plainer.

Fig. 65 Semiformal winter hat of a noblewoman, with a black sable fur brim (for summer, the brim would be made of black satin), the crown cov-ered with red satin and embroidered in a design of bats and butterflies, a red silk cord knob at the apex, and two streamers decorated with couched gold dragons on blue satin chasing the flaming pearl and phoenixes.

Fig. 66

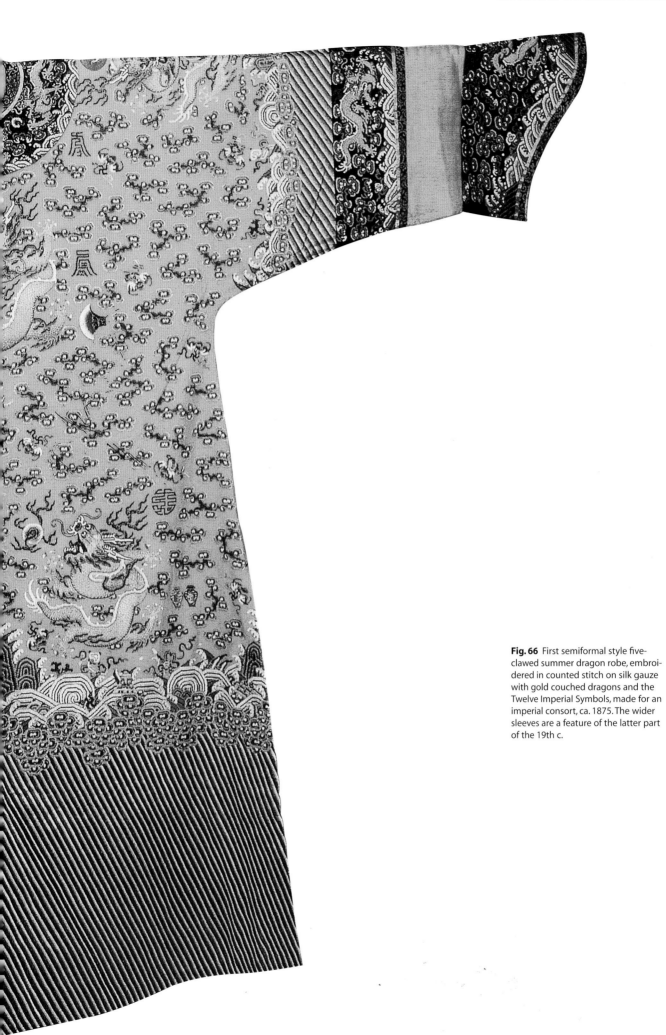

Fig. 66 First semiformal style five-clawed summer dragon robe, embroidered in counted stitch on silk gauze with gold couched dragons and the Twelve Imperial Symbols, made for an imperial consort, ca. 1875. The wider sleeves are a feature of the latter part of the 19th c.

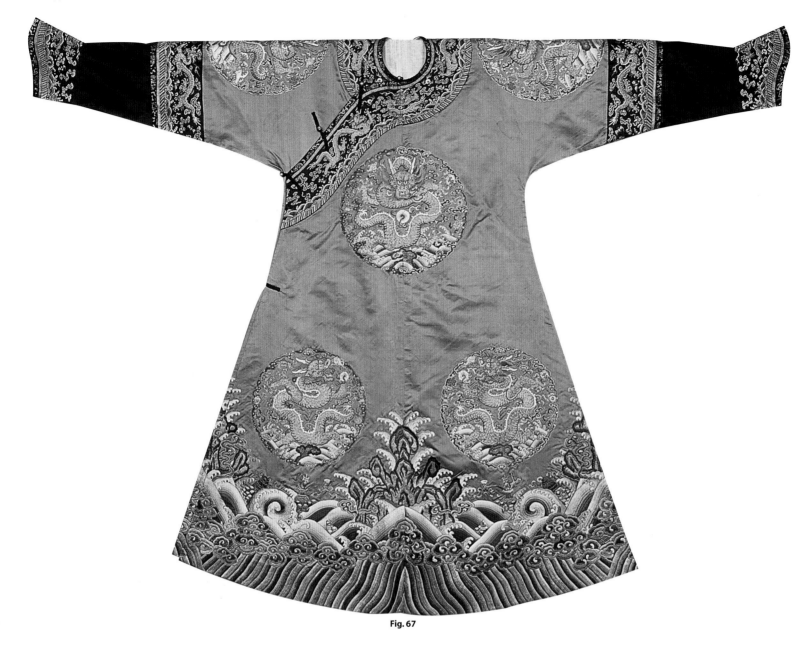

Fig. 67

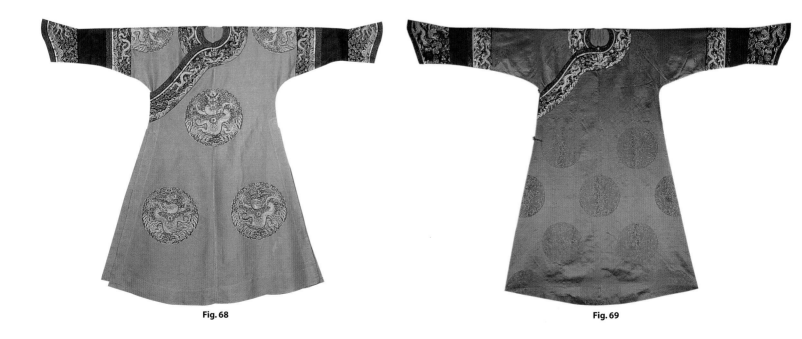

Fig. 68 **Fig. 69**

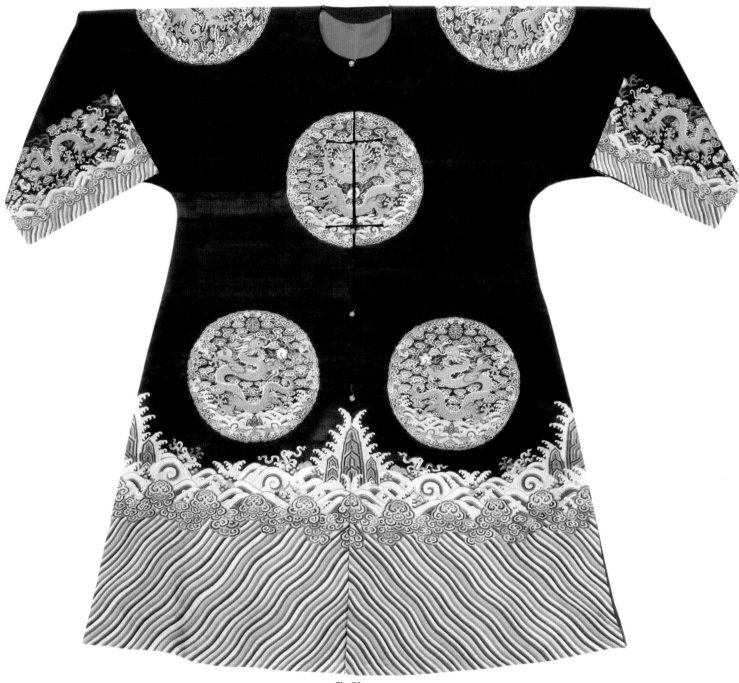

Fig. 70

Fig. 67 Second semiformal style five-clawed dragon robe in turquoise satin and lined in yellow silk, with *li shui* at hem, made for a low-ranking imperial consort or imperial daughter-in-law, ca. 1800. Of the nine dragon roundels embroidered on the robe, the upper four contain front-facing dragons, the lower four, plus the one hidden on the inside flap, have dragons in profile.

Fig. 68 Third semiformal style five-clawed dragon robe, no *li shui* at hem, in apricot silk gauze with eight dragon roundels, the four upper ones with front-facing dragons, the four on the skirt with dragons in profile (none on the inside flap), mid-19th c. The robe's color indicates it was probably made for the consort of the crown prince.

Fig. 69 Official informal robe for an imperial consort in turquoise, with embroidered facings and damask weave roundels.

Fig. 70 High-ranking ladies surcoat in *kesi*, with four facing dragon roundels on the upper body, and four profile dragon roundels on skirt, early 19th c.

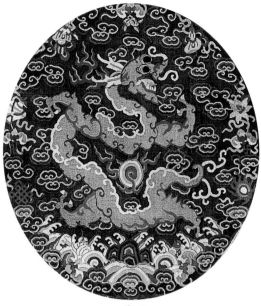

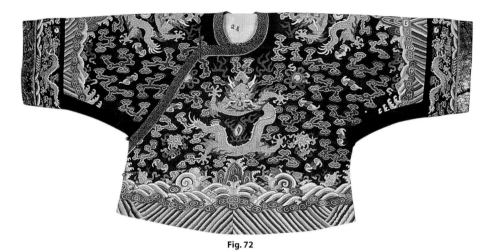

Fig. 72

Fig. 71

In public, empresses, high-ranking consorts, and noblewomen were required to wear a *long gua* – a full-length, center-opening, wide-sleeved surcoat in blue-black satin or gauze with dragon roundels arranged over it – over their *long pao* or five-clawed dragon robe (Figs. 70, 71). They were of two types: the first had eight roundels of dragons displayed on the chest, back, shoulders, and front and back hem of the coat, together with the *li shui* pattern, similar to that on the second style of *long pao* (Fig. 73). The other style had eight roundels without the wave border, as in the third style of *long pao*. Several empresses in the nineteenth century added the first four of the Twelve Imperial Symbols to the upper four roundels.

Imperial princesses were expected to wear the upper four or two roundels on a plain surcoat or *pu fu* to match their husbands' rank, although it seems they preferred to wear the *long gua* with *li shui*. Lower-ranking noblewomen were required to wear the surcoat with eight roundels of flower motifs surrounding the *shou* character, with or without *li shui*, as with dragon robes (Fig. 74).

Dragon jackets are not common (Fig. 72). They do not appear in the Regulations, but because of their similarity to dragon robes, with the dragons and *li shui*, they are clearly intended for formal use at important events within the family, such as weddings. It is likely Manchu women wore them, as the proportions of the jacket indicate they were worn over a long gown. Personal preference would dictate their use, and the fact they were cheaper to produce than a full-length robe may have added to their attraction.

Manchu women wore a *dianzi* headdress on informal festive occasions. The one shown here (Fig. 75) is made of wire lattice woven with black silk ribbon and decorated with kingfisher feather inlay and gold filigree in the style of the "endless knot," with butterflies and the *shou* character.

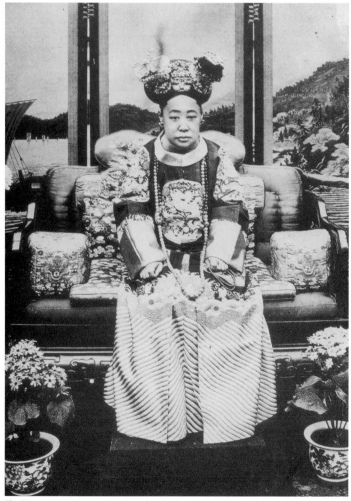

Fig. 73

Fig. 71 Roundel with a two-toed profile dragon in *kesi*, from a Manchu ladies surcoat, mid-19th c.

Fig. 72 Manchu lady's dragon jacket in *kesi*, with four five-claw front-facing dragons surrounded by Buddhist emblems, ca. 1825–50.

Fig. 73 The Guangxu Emperor's consort, Dowager Duan Kang, wearing the first style surcoat over a matching five-clawed dragon robe, its wide cuffs turned back over the surcoat, ca. 1913.

Fig. 74 Lower-ranking noblewoman's official surcoat with eight roundels, each containing the *shou* character surrounded by bats and peonies, a wish for happiness and long life, the *li shui* at the hem embroidered with Buddhist emblems, early 19th c.

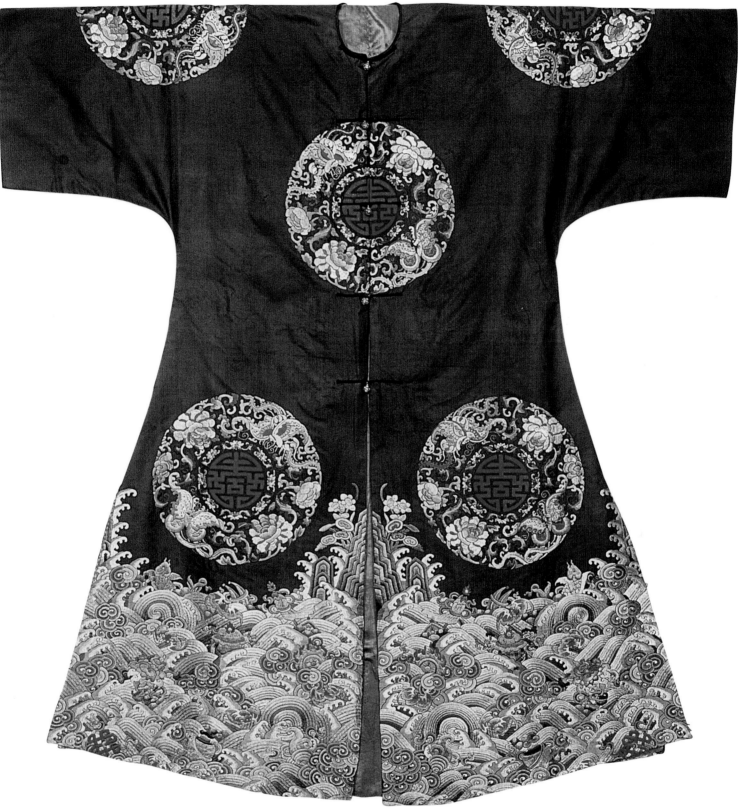

Fig. 74

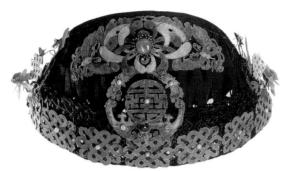

Fig. 75

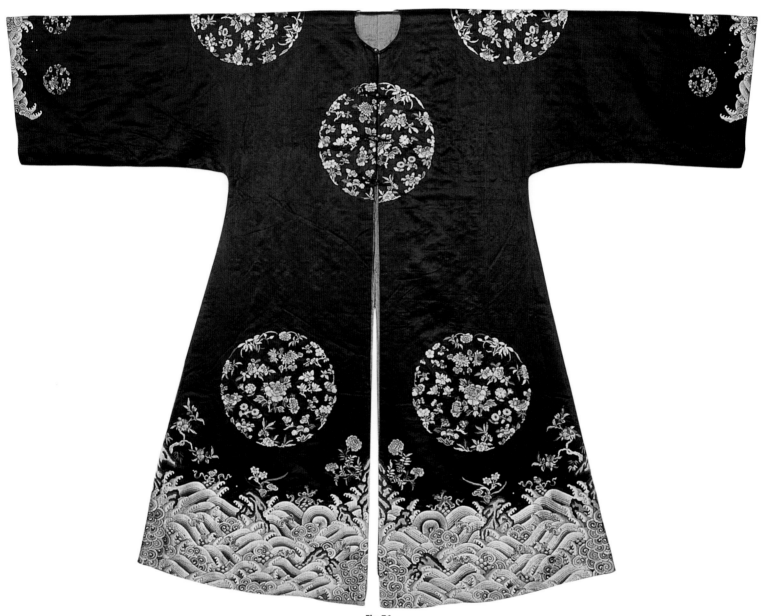

Fig. 76

Fig. 75 Manchu headdress called a *dianzi* for informal festive occasions such as birthdays, ceremonies, and New Year celebrations, made of wire lattice woven with black silk ribbon and decorated with kingfisher feather inlay and gold filigree in the style of the Endless Knot, with butterflies and the *shou* character.

Fig. 76 Non-official formal surcoat for a lower-ranking noblewoman, with eight floral roundels and *li shui* hem, early 19th c.

Fig. 77 Non-official formal robe with eight floral roundels, Qianlong period.

Fig. 78 Manchu bride, with her maid, wearing a surcoat with eight roundels, with no *li shui*, ca. 1870.

Non-official Dress

Non-official formal robes were worn for weddings and other important family occasions not connected with the court. Towards the end of the nineteenth century, formal robes, like the dragon robes of this period, had wide sleeves with horse-hoof cuffs, and a plain band rather than a ribbed one between the cuff and upper sleeve (Fig. 77). In practice, these robes were the same as those worn for official formal occasions by noblewomen and wives of officials. Eight roundels with *shou* or, later, other motifs were dispersed over the robe, which had either a *li shui* or plain hem. Worn with a surcoat having eight roundels with *shou* or floral patterns, some had the *li shui* pattern at the hem and cuffs, while others did not (Fig. 76).

A Manchu bride of an official wore a non-official formal robe with horse-hoof cuffs and eight roundels on the gown. Later in the dynasty, these garments were predominantly made in red, reflecting the Han influence of this auspicious "Chinese" color (Fig. 79). A dark blue surcoat was worn over this robe, and an elaborate headdress completed the outfit (Fig. 78).

Non-official semiformal robes were very lavishly embroidered, particularly those worn by the Empress Dowager Cixi, who favored pastel shades of blue, lilac, and pink as she felt the yellow dragon robes were unflattering to her ageing skin tone (Figs. 80, 81). The contrasting borders on clothing after the middle of the nineteenth century were based on Han styling, and indicated assimilation into Chinese culture.

In addition to the rules governing the types of fabric for certain times of the year, each season was identified with a particular flower and these appeared as motifs on semiformal robes. The flower for spring was the peony (since 1994 the peony has been the national flower of China, symbolizing love of peace and the pursuit of happiness), for summer the lotus flower, for autumn the chrysanthemum, and for winter the plum blossom. For ladies at court in the late nineteenth century, to wear the wrong flower was to disobey the imperial decree and risk incurring the wrath of the Empress Dowager (Figs. 82, 83).

Non-official robes of this period often had three very wide bands running around the edges of the robe: the outer made of brocade, the middle a wide border of embroidery, and the inner a multicolored woven ribbon (Fig. 84). Semiformal robes had wide sleeves with turned-back cuffs, which were then lavishly embroidered on the underside. In place of the *zai shui* pointed kerchief, women of the imperial family in informal dress wore a narrow band of silk embroidered with auspicious symbols and decorated with jewels. It looped around the neck, with one end tucked into the top of the gown.

Informal robes were plainer than semiformal ones, and comprised a silk damask body with a less elaborate border on the straight cuffs, around the neck, and down the side, and sometimes around the hem, although this was more common on the more formal robes (Fig. 85). They were worn with a long or short sleeveless waistcoat fastening down the center or at the side, with a wide decorated border, or a short jacket (Figs. 86–88).

The clothing of servants in the palace reflected their lowly status, as recalled by a palace maid: "We had to be completely unobtrusive. Our clothes were provided by the Palace. Come the spring, we would be measured for four sets of vest, blouse, robe and waistcoat. Except in October (the month of the empress dowager's

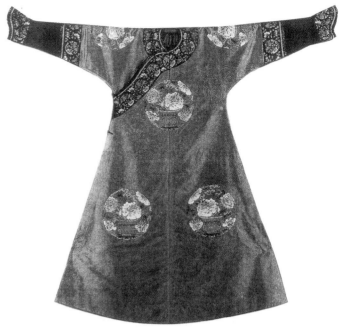

Fig. 77

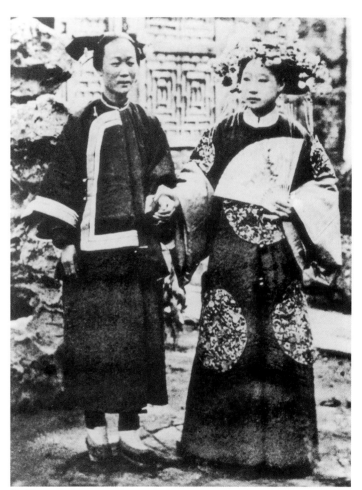

Fig. 78

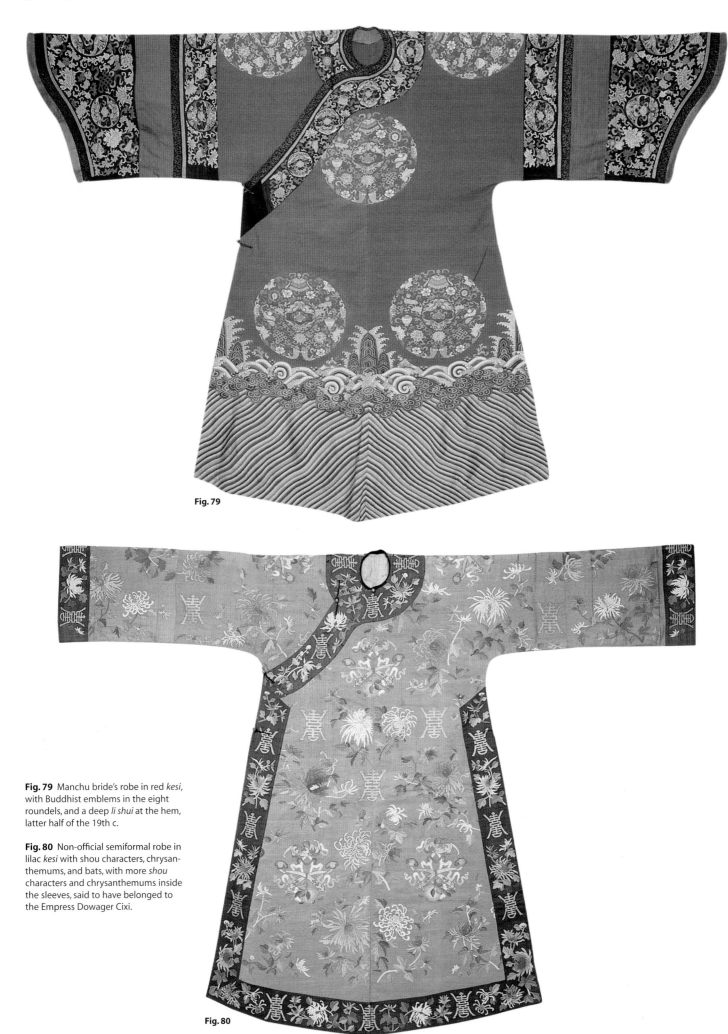

Fig. 79 Manchu bride's robe in red *kesi*, with Buddhist emblems in the eight roundels, and a deep *li shui* at the hem, latter half of the 19th c.

Fig. 80 Non-official semiformal robe in lilac *kesi* with shou characters, chrysanthemums, and bats, with more *shou* characters and chrysanthemums inside the sleeves, said to have belonged to the Empress Dowager Cixi.

Fig. 79

Fig. 80

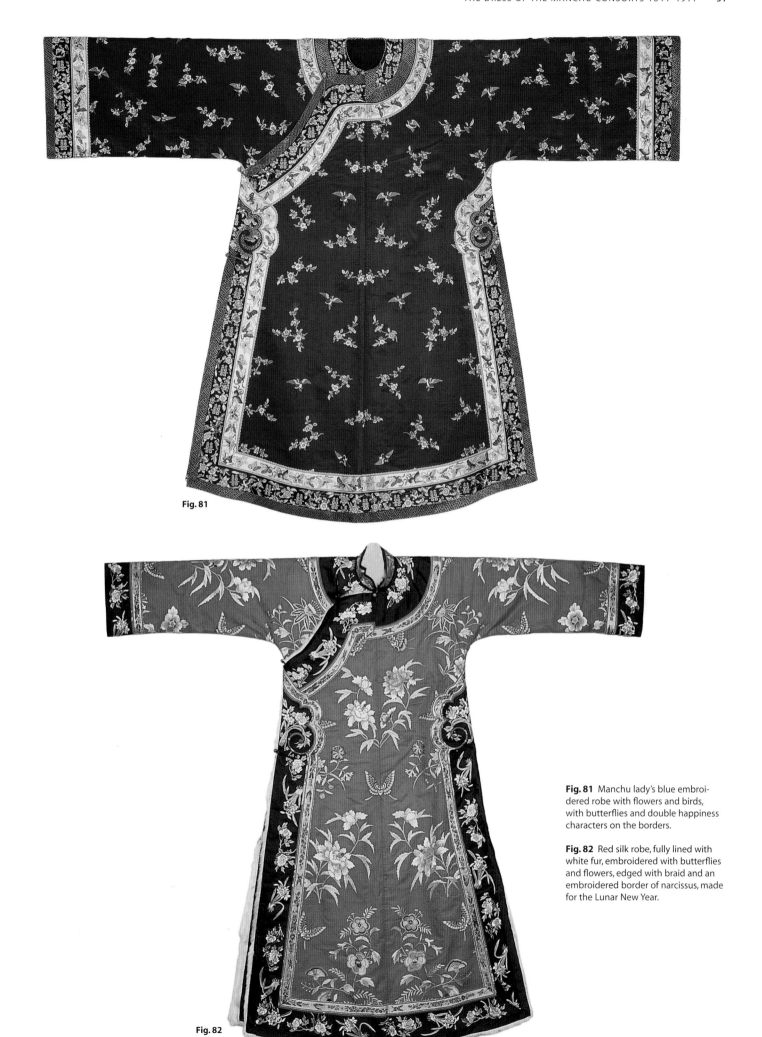

Fig. 81

Fig. 82

Fig. 81 Manchu lady's blue embroidered robe with flowers and birds, with butterflies and double happiness characters on the borders.

Fig. 82 Red silk robe, fully lined with white fur, embroidered with butterflies and flowers, edged with braid and an embroidered border of narcissus, made for the Lunar New Year.

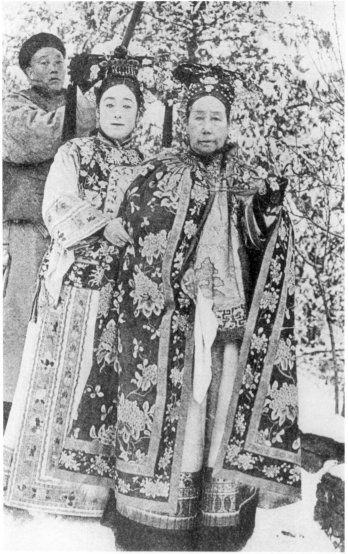

Fig. 83

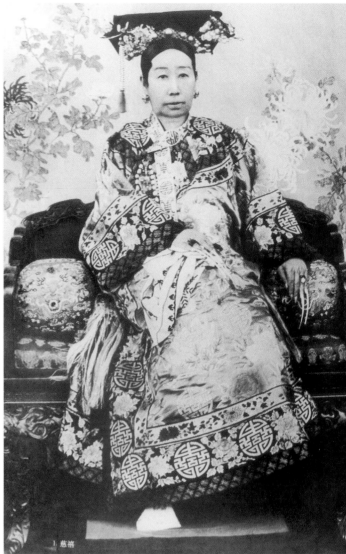

Fig. 84

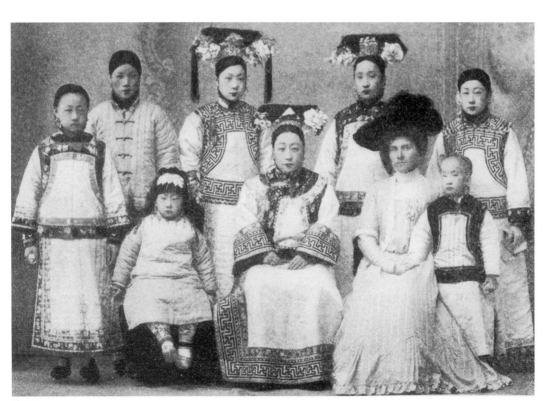

Fig. 85

Fig. 83 The Empress Dowager Cixi in the garden of the Summer Palace, wearing a full-length cape pleated into a neckband and falling straight to the hem, designed for cooler weather, ca. 1905. She is attended by her lady-in-waiting, Princess Der Ling.

Fig. 84 The Empress Dowager Cixi wearing a non-official semiformal robe emblazoned with *shou* characters, late 19th c. Note the neckband and nail extenders.

Fig. 85 Daughters-in-law of Prince Ding in informal dress, with Mrs Headland, wife of I. T. Headland, author of several books on China, ca. 1910.

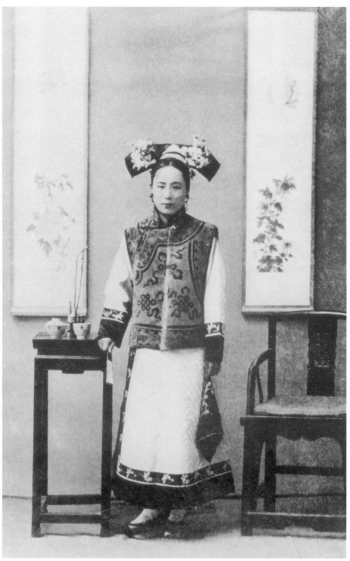

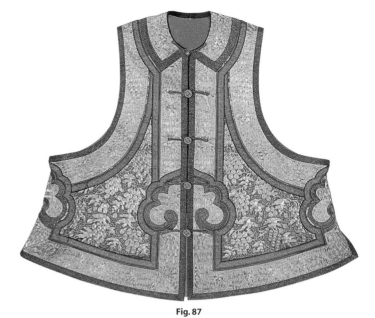

Fig. 87

Fig. 86 Manchu woman in non-official informal dress, consisting of a long robe and sleeveless waistcoat and headdress, late 19th c.

Fig. 87 Manchu woman's informal vest with fine couched gold and silver thread in a design of grapes and leaves on a blue and pink silk background, edged with bands of the key fret design to form the *ruyi* shape, a desire that all wishes will come true, the gold buttons bearing characters for "double happiness."

Fig. 88 Two seated Manchu women at a ceremony in a country yamen where a Manchu official held office, ca. 1904.

Fig. 86

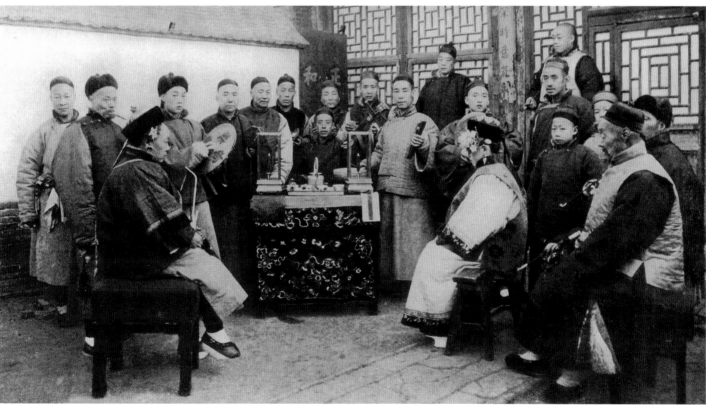

Fig. 88

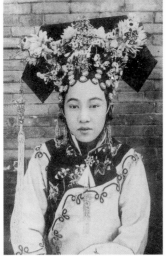

Fig. 89 **Fig. 90**

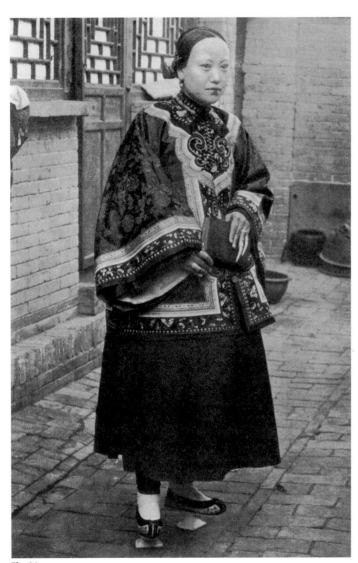

Fig. 91

birthday), when we were allowed to wear red, most of the year we were confined to a few colors – in spring and summer we dressed in pale blue or green, in autumn and winter a purplish brown. We wore our hair in a thick plait, tied at the end by a short red ribbon" (Holdsworth and Courtauld, 1995: 85).

On non-official occasions, Manchu women wore an unusual headdress called a *liang ba tou*, with batwing-like shapes formed from false hair or black satin arranged over a frame which was anchored with hairpins to the natural hair (Fig. 89). Literally "two handfuls of hair," the hair itself was originally set and shaped this way, but during the nineteenth century was replaced by black satin as being more practical and easier to maintain. As the Qing dynasty drew to a close, the headdress became larger. Artificial blossoms were placed at each side, silk tassels were hung down the sides, and the whole creation was embellished with jeweled ornaments (Fig. 90). However, older women continued to wear a smaller, less elaborate *liang ba tou* made of stiffened black satin formed over a cross-piece of gilded silver and mounted on a wire base.

Most people of gentility cultivated at least one long fingernail to show that they did not engage in manual work. To preserve the treasured nail, women – though not men – wore 3 inch (7 cm] long nail guards made of gold, silver gilt, enamel, or tortoiseshell in fili-gree designs of coins or longevity and other auspicious symbols. Often two different pairs were worn on the third and fourth fingers of each hand (Fig. 91).

Unlike Han Chinese women, Manchu women did not bind their feet. Instead, those from high-ranking families wore a special shoe, exaggeratedly elevated, with a concave heel in the center of the instep (Fig. 93). The bottom of the shoe was padded with lay-ers of cotton to prevent jarring when walking. The vamp was made of silk and embroidered with designs of flowers, birds, and fruit (Fig. 92). As well as allowing the Manchu women to imitate the swaying gait resulting from bound feet, the shoes also made them tower over the diminutive Chinese: "... the shoes stand upon a sole of four or six inches [10 or 15 cm] in height, or even more. These soles, which consist of a wooden frame upon which white cotton cloth is stretched, are quite thin from the toe and heel to about the center of the foot, when they curve abruptly downwards, forming a base of two or three inches square [5 or 8 cm]. In use they are exceedingly inconvenient, but ... they show the well-to-do position of the wearer. The Manchu are ... a taller race than the Chinese, and the artificial increase to the height afforded by these shoes gives them at times almost startling proportions" (Hosie, 1904: 157).

Empress Dowager Cixi is often shown raising the hem of her gown to reveal a splendidly decorated shoe. Even late in life, she retained her love of finery and the heels of her elevated shoes are dripping with strings of pearls matching her pearl collar. Shoes with concave heels must have been quite difficult to walk in, however, and for informal wear, and among the lower ranks of Manchu women, shoes with boat-shaped convex soles were worn.

Fig. 89 "Batwing" headdress made of false hair, worn by a Manchu noble-woman.

Fig. 90 "Batwing headdress" covered in black satin with jewels and artificial peonies, worn by a young Manchu woman.

Fig. 91 Manchu woman in North China wearing elevated shoes and nail extenders, ca. 1910.

Fig. 92 Uncut vamps in *kesi* for a pair of Manchu woman's shoes with a finely detailed design of phoenixes and peonies.

Fig. 93 Manchu women's shoes with a satin vamp embroidered with flowers and cotton-covered soles.

Fig. 94 Dragon robe for a young prince, with the Twelve Imperial Symbols and nine gold-couched five-clawed dragons embroidered onto yellow satin, ca. 1800.

Fig. 92

Fig. 93

Manchu Children's Clothing

The wife of an emperor, together with his many consorts and concubines, produced sufficient offspring to ensure the emperor's succession. The Kangxi Emperor, for example, sired thirty-five sons from among his fifty-six children. Since the eldest son in the imperial family was not the only one eligible to succeed as emperor, Qing rulers took care to have all their sons educated to a high standard, so that each could be capable of ruling. A school was established within the Inner Court of the Forbidden City, and here the young princes studied the Confucian classics in the Chinese, Manchu, and Mongol languages, and military skills like riding and archery. Their teachers were graduates of the capital's prestigious Hanlin Academy.

Sons of the emperor and members of the Manchu court wore smaller versions of court and dragon robes, although surviving examples are rare (Figs. 94, 95, 96). Apart from shades of yellow, other dragon robes were in colors determined by rank, such as brown and blue. Red was also included as being a color right for festive occasions (Fig. 97).

On other occasions, a surcoat bearing a rank badge was worn, along with a hat, court necklace, and boots, all miniature versions of those worn by adults (Figs. 98, 99). For informal occasions, the young princes wore a hip-length *ma gua* jacket over a side-fastening long gown or *chang shan*, or an ordinary gown without slits at the hem, or the *chang shan* alone (Figs. 100, 101, 103). A skullcap completed the outfit.

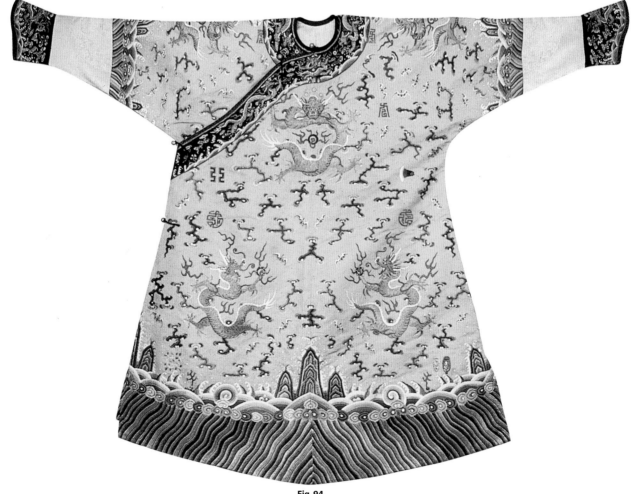

Fig. 94

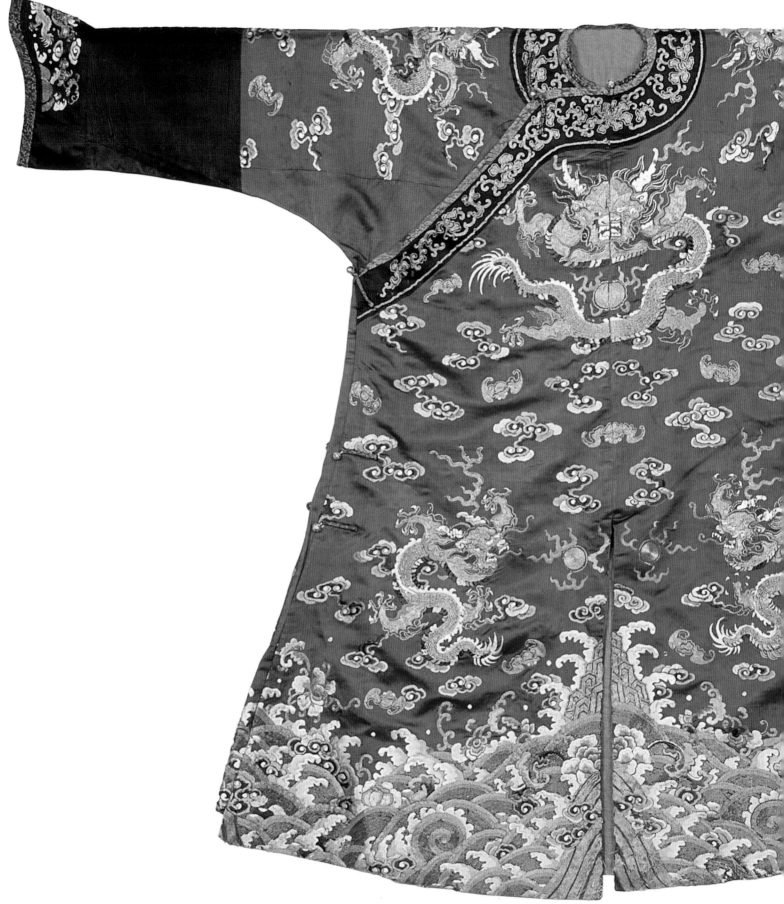

Fig. 95

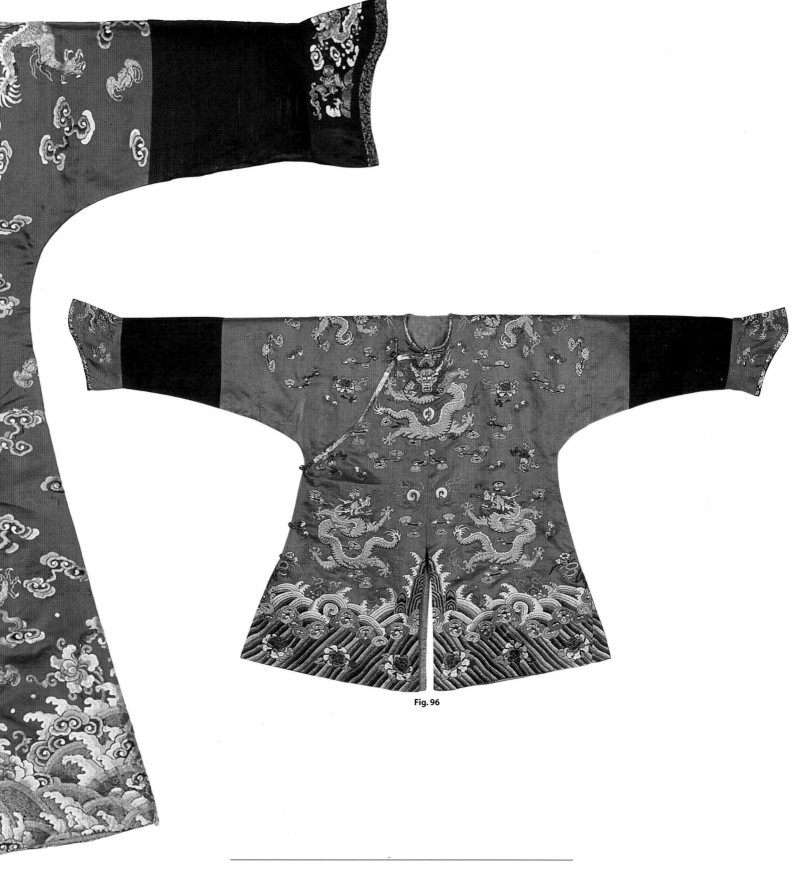

Fig. 96

Fig. 95 Child's dragon robe in maroon satin, with eight dragons in couched gold thread, the upper four front-facing, the four on the skirt in profile, surrounded by bats and clouds, the lower sleeves of ribbed dark blue satin, early 19th c.

Fig. 96 Child's red satin dragon robe, with eight dragons in couched gold thread, the upper four front-facing, the four on the skirt in profile, surrounded by flowers, bats, and clouds, the lower sleeves of dark blue satin, mid-19th c.

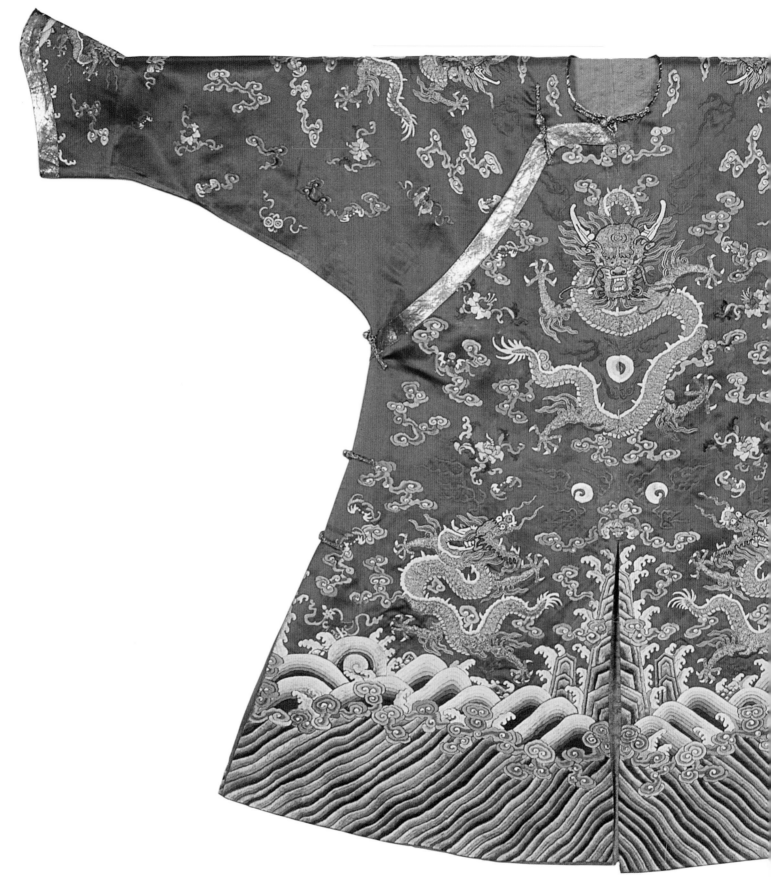

Fig. 97

Fig. 98

Fig. 99

Fig. 97 Child's brown satin dragon robe, with eight dragons in couched gold thread, the upper four front-facing, the four on the skirt in profile, surrounded by bats, flames, clouds, and auspicious emblems, mid-19th c.

Fig. 98 The Emperor Xuantong, known as Puyi, wearing a surcoat with an embroidered roundel over a fur-trimmed dragon robe, 1911.

Fig. 99 The future Guangxu emperor and his brother Prince Chun II (father of the last emperor, Puyi), wearing surcoats with square rank badges, ca. 1875.

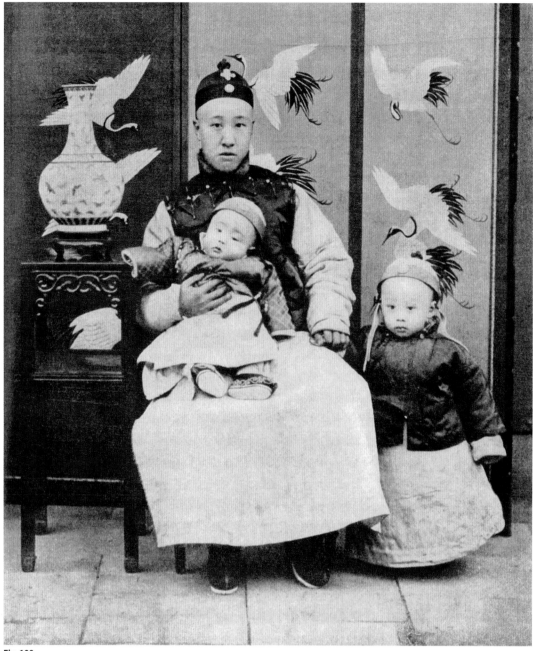

Fig. 100

Given the lowly status of women in China, young girls – even high-ranking ones in the imperial court – were denied any personal identity. They were always referred to by birth order, such as "elder sister" or "third sister." Princesses were not given personal names either, and instead took the identity of their fathers, and later their husbands. In lower-ranking families, women's births were not recorded in family genealogies at all. However, emperor's daughters, like imperial princes, were given ranks, which entitled them to certain privileges. Titles presented on a woman's marriage would also determine the title of her husband. These marriages were intended to forge political alliances, and were often to men from Mongol tribes, in a deliberate move to integrate Mongolia into the Manchu empire.

Young female members of the Imperial Household wore robes ranging in color from shades of yellow to turquoise, brown, and blue, depending on their status. Highly embroidered robes were worn on formal occasions, while for less formal wear they wore the *qi pao* or banner gown, a long gown which fell straight from the shoulders to the ground, fastening over to the right side, and a waistcoat (Figs. 102, 103).

Fig. 100 Prince Chun II with his sons, the two-year-old Puyi standing and his younger brother Pujie seated, all wearing informal black hip-length jackets over side-fastening long gowns, and skullcaps, ca 1907.

Fig. 101 Prince Yi Huan (grandfather of Puyi) with his sons, who are wearing shoes decorated as animals, ca. 1880.

Fig. 102 Manchu mother in a long gown and waistcoat with her daughter in a robe with a long vest trimmed with a fringe, ca. 1900.

Fig. 103 Manchu princesses wearing banner gowns, the young girls flanking them wearing waistcoats on top, ca. 1910.

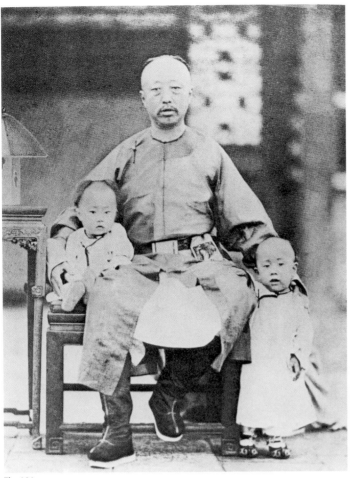

Fig. 101

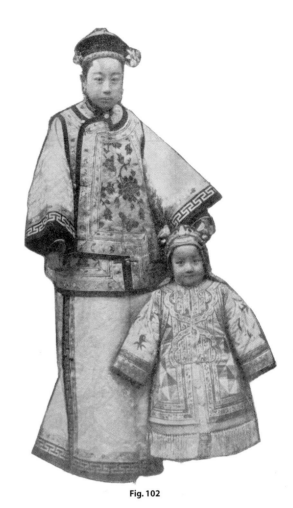

Fig. 102

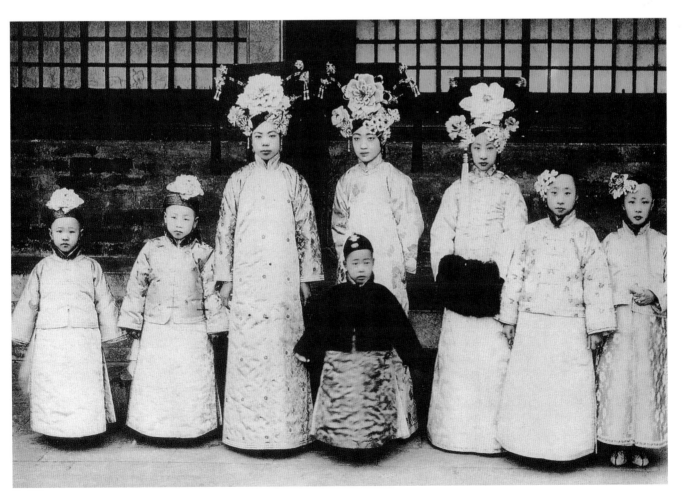

Fig. 103

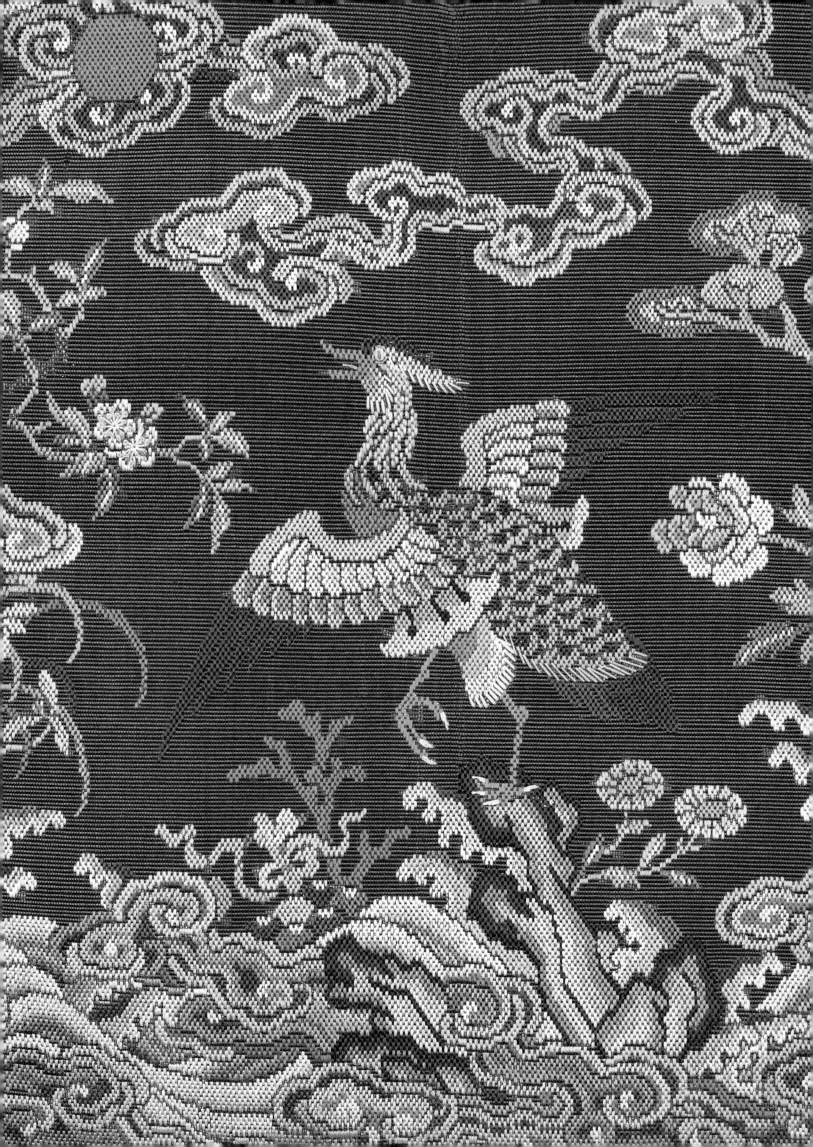

Chapter Three

THE ATTIRE OF MANDARINS AND MERCHANTS

Becoming a Mandarin

Once China was under the control of the Manchus, they adopted the system of government already established by the Ming dynasty, but modified it by applying checks to the weaknesses which had resulted in its collapse. Social status continued to be determined by the imperial government, which was run by officials known as mandarins (the word mandarin, *guan* in Chinese, is derived from the Portuguese word *mandar*, meaning "to command"). It was from a highly educated group of Manchu and Chinese men that the mandarins were selected. Although quotas were applied to the number of Manchu and Chinese admitted into the ruling class, from the very beginning the Manchu rulers allowed Chinese to enter both civil and military office at all levels. The Chinese were not only more able scholars than the Manchu, but there were many more of them familiar with an already established system.

There were two orders of mandarin. The first, and more highly respected, were the civil mandarins – scholar officials who administered the government of China – while the second were military officials responsible for internal stability and external defense. Within the two orders were nine ranks, each subdivided into principal and secondary classes. In the administrative hierarchy, civil officials were always placed higher than their military counterparts, since education and refinement, not courage, were considered the most important virtues. Each official was attached to a particular section of the administration, but during his career he could be assigned to judicial, administrative and fiscal duties, and could also be transferred from one post to another with little regard for his previous experience.

The main route to becoming a mandarin, and thus being eligible for appointment to office, was through success in a series of qualifying examinations based on the Chinese classics (Figs. 105, 106). An alternative route was for those with money and little ability to first purchase an academic degree and then an official rank and title. Some form of selection for office based on literary ability had been in place since the Tang dynasty, but it was during the Qing dynasty that the examination system reached its peak, and until its abolition in 1905 was the surest means of social and material advancement. The examinations were open to all males, with the exception of those classified as "mean people": boatman, laborers,

Fig. 105

Fig. 106

(Page 62) Fig. 104 Seventh civil rank badge portraying a mandarin duck embroidered in counted stitch on silk gauze, ca. 1800.

Fig. 105 Examination hall at Nanjing showing the individual stalls, which could accommodate 30,000 candidates, ca. 1900.

Fig. 106 "Cheat's handkerchief" in silk, both sides inscribed with minute calligraphy in ink of selections from the Chinese Classics, late Qing. Some robes had "cheat's lining" – white silk covered with tiny characters as an aid to passing the examination.

actors and musicians, executioners and torturers. The poorest man could become a distinguished official provided he had the talent and the time to study.

At the age of eighteen, the *jun xiu* ("man of promise") was ready to take his first examination before the magistrate of the district in which he lived. A pass entitled him to be called *tong sheng* or student. The next hurdle was the annual examination for the first degree, which was held in the prefectural city. A pass enabled the scholar to become a *sheng yuan* or government student, colloquially known as *xiu cai* ("budding talent"). Certain privileges accompanied a pass in this examination: the student became a member of the gentry, he was entitled to government aid to enable him to continue his studies, and he was exempt from corporal punishment (Figs. 107, 108).

The examination for the second degree was held in the eighth moon of every third year in the provincial capitals. Strict quotas were imposed nationwide, based on the size of the province. Out of some 10,000–12,000 entrants in each province, barely 300 would obtain their degree and be known as *ju ren* or "promoted men" (Figs. 109, 110). A final examination was held in Beijing for those

Fig. 107

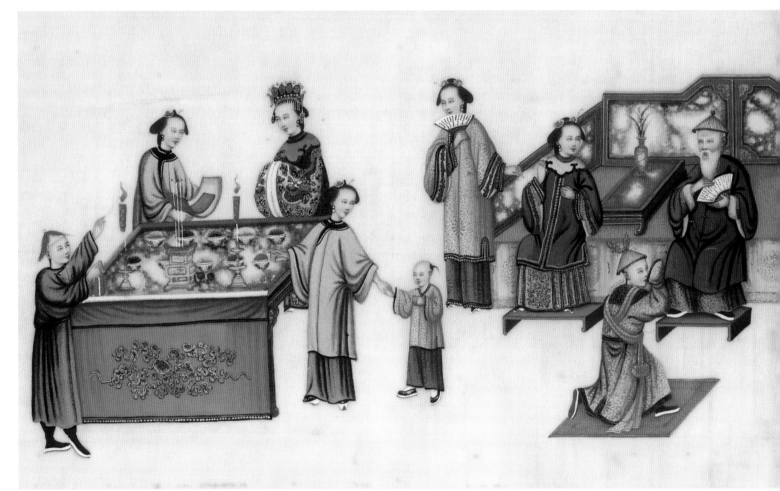

Fig. 108

Fig. 107 Long plain blue silk gown with a black border and horse-hoof cuffs, made for a graduate of the first degree.

Fig. 108 Painting by Tinqua of a graduate of the first degree at the ceremony to celebrate success after the examination, now entitled to wear a blue silk robe edged with black, a red scarf which crossed the chest twice to form an X, and gold foil hat decorations of branches and leaves, ca. 1854.

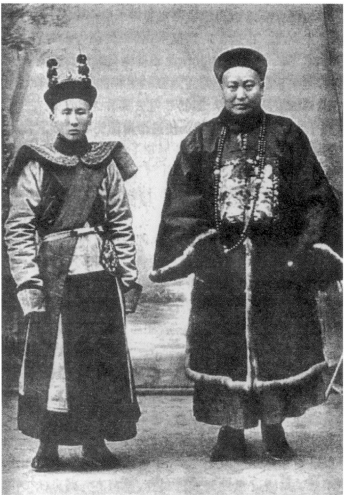

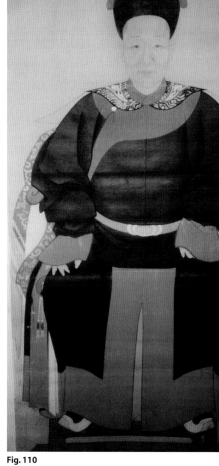

Fig. 109

Fig. 110

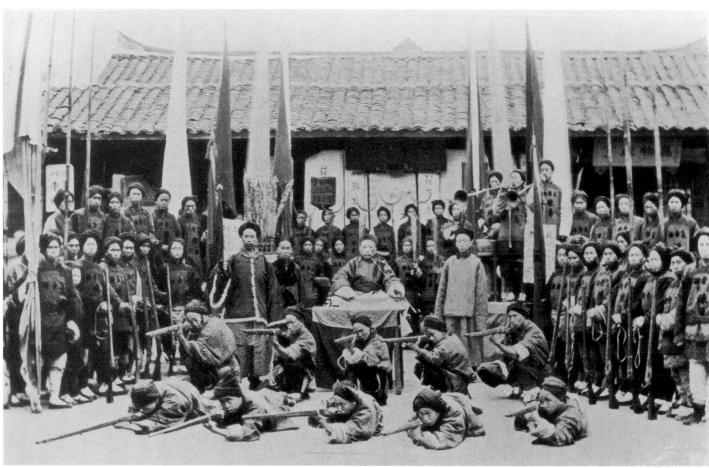

Fig. 111

Fig. 112

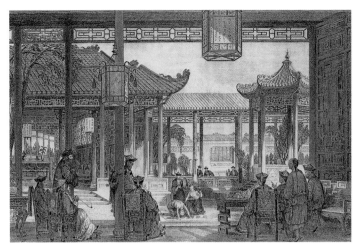

Fig. 113

Fig. 114

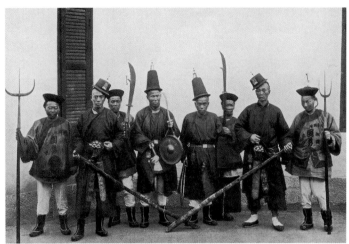

Fig. 115

who reached that high level. At the graduation ceremony, success-ful candidates were given an audience with the emperor, and were assured of a high position in the government.

Military examinations were based on physical feats rather than literary ability. A military degree was thus never held in high esteem by the intelligentsia, nor was it such an important requirement for military office as was the civil degree for civil office. Very often military promotions and appointments were made on the basis of family connections or financial considerations. Those with some military education could purchase a title as a short cut to military office, while the majority of officers in the Chinese *Lu Ying* or Green Standard Army rose through the ranks and did not obtain a title or degree first.

In addition to a literary test on a short military treatise, the examination for the first military degree tested the candidate's ability in archery, both on the ground and on horseback, and in swordplay (Figs. 111, 112). The emphasis on skill in archery con-tinued throughout the nineteenth century, at a time when other nations of the world had progressed to using modern firearms. The second degree was similar in content to the first. A graduate would then go to Beijing to take the third degree. Success meant immedi-ate employment in the army or navy anywhere in China.

In the provincial administration, the highest rank belonged to the viceroy or governor-general. He could be in charge of one, often two, and sometimes three provinces. In addition to his civil duties, he was also responsible for evaluating military officers and regulat-ing the Chinese Green Standard Army. The position of viceroy was considered to be one of the most important – and desirable – in the land as it involved direct communication with the emperor. Below the viceroy was the governor, a second-rank mandarin with similar powers, who was in charge of the civil and military affairs of a single province. Next came the treasurer of the provincial exche-quer, the provincial judge, followed by the salt and grain commis-sioners, marine inspectors, and other senior officials.

The province was divided into a number of prefectures, sub-divided into departments and districts. A prefect or magistrate and

Fig. 109 Graduate with his father, a mandarin, ca. 1900. The graduate is wearing a blue silk robe edged with black, with a red scarf crossing his chest twice, a *ling tou*, a *pi ling* collar, and a hat with two gold decorations.

Fig. 110 Ancestor portrait of a gradu-ate of the second degree, wearing a flared collar over a black gown with a wide blue border down the side opening, hem, center back and front splits, and cuffs. His hat has an eagle on top of the finial.

Fig. 111 Literary official reviewing candidates in West China, ca. 1900.

Fig. 112 Lifting the "300-catty stone" (ca. 399 lb/180 kg), part of the military examination to test the candidate's strength.

Fig. 113 Jugglers performing in the courtyard of a mandarin's yamen, ca. 1843.

Fig. 114 Mandarin in procession in his sedan chair, ca. 1843.

Fig. 115 An official's retinue, including men with bamboo poles to beat back the crowds and three-pronged forks for catching thieves by their clothes, 1902.

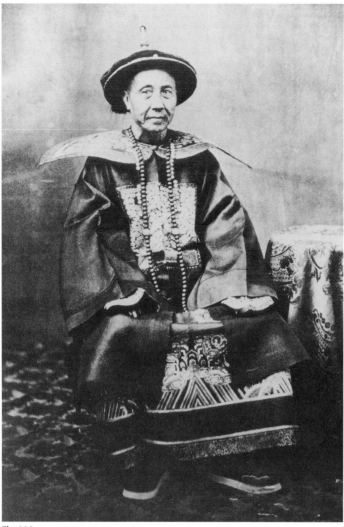

Fig. 116

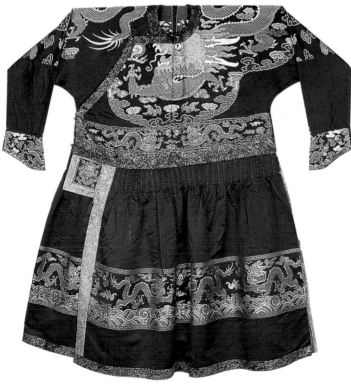

Fig. 117

several assistant magistrates administered each division. These lower-ranking mandarins, ranging from the fifth to ninth ranks, had many duties, at the same time acting as judge, tax collector, director of police, and sheriff of the district. They also assumed some military duties and, in an emergency, sometimes took an active part in military affairs (Figs. 113–115).

Court Dress

In order to establish full control over the Han Chinese, the Manchu emperors decreed that their customs, language, and particularly their style of dress, be adopted by the conquered race. Although Manchu customs and the Manchu language were generally not adopted by the Chinese, the regulations concerning dress did take root a means of unifying the country and of making Han Chinese officials indistinguishable from their Manchu counterparts.

Mandarins from the civil and military orders, both Manchu and Han Chinese, wore Manchu-style robes on formal occasions, such as official government functions, celebrations, and festivals. However, the Chinese were allowed to wear their Han-style robes on informal occasions. As with the dress of the imperial family and their courtiers, clothing was divided into official and non-official attire and subdivided into formal, semiformal, and informal.

High-ranking mandarins wore formal court dress on all important occasions and for court attendances (Fig. 116). First- to third-rank civil and first- and second-rank military mandarins were permitted to wear the first winter style *chao pao* in blue-black, with four *mang* in profile on the upper body and two *mang* on the front and back band of the skirt. The second style of winter and summer *chao pao*, also in blue-black, was worn by the first four ranks of both orders of mandarin. The upper part of the *chao pao* was embellished with four front-facing *mang*, while the lower part of the skirt had four *mang* in profile at the front and back. No roundels, like those worn by the emperor and heir apparent, were allowed on the skirt, although these did make an appearance towards the end of the dynasty when traditions were breaking down (Figs. 117, 118).

Mandarins from the fifth to seventh ranks wore plain blue silk damask *chao pao* with gold and black brocade edging and square badges on the chest and back containing *mang* in profile. The eighth and ninth ranks wore plain *chao pao* with no squares. Robes of this type belonging to lower-ranking officials are very rare today as it was usual for a mandarin to be buried in his court attire. Moreover, such plain items were not considered sufficiently valuable or interesting to early collectors.

The *pi ling* collar was intended for use only with the court robe, but evidence in the form of paintings and photographs reveals that it was also worn with the dragon robe and surcoat bearing a badge of rank when "full dress" was required (Fig. 119). The *pi ling* had either five long or five *mang* dragons, according to the wearer's rank, embroidered on a dark blue ground.

Fig. 116 Liu Changyu, Governor-General of Guangdong and Guangxi provinces, in official formal court attire comprising a summer hat, court robe, surcoat with a first-rank civil badge on the chest and back, flared collar, and court necklace, 1863.

Fig. 117 Summer court robe in dark blue satin and brocade, with brocade edging, decorated with two four-clawed dragons in profile on the chest and back, and four on the front and back skirt band, early Qing. No roundels on the skirt.

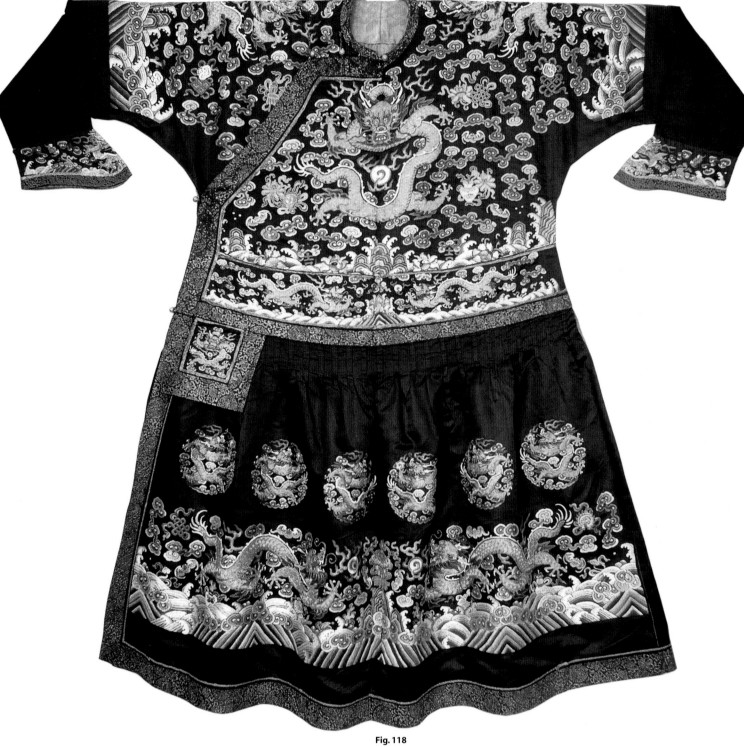

Fig. 118

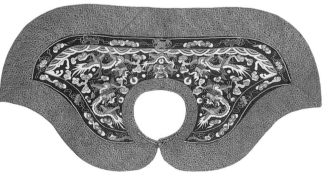

Fig. 118 Summer court robe belonging to an official, in dark blue satin with brocade edging, embroidered with gold couched dragons, satin stitch clouds, Peking knot Buddhist emblems, and six roundels on the skirt at front and back, mid-19th c.

Fig. 119 Flared collar with five four-clawed dragons embroidered in satin stitch on dark blue satin, late Qing. The wide gold brocade border indicates it would have been worn with a summer robe.

Fig. 119

Dragon Robes and Informal Dress

For less important court occasions and official or government business, semiformal official clothing was worn. Colloquially known as "full dress," this comprised a dragon robe worn with the *pi ling* collar, stiffened *ling tou* collar, hat, necklace, boots, and a surcoat bearing badges of rank known to the West as "mandarin squares" (Fig. 120).

First-, second-, and third-rank mandarins were distinguished by the nine *mang* on their robes (Fig. 121). Single dragons were placed on the chest and back and the two shoulders, while two were embroidered on the front and back hems. A symbolic ninth dragon was hidden under the front inside flap of the robe. Fourth- to sixth-rank officials wore robes with eight four-clawed dragons (Fig. 122). *Long,* normally restricted to use by the emperor, were also worn by lower ranks if they had been awarded the privilege. Towards the end of the dynasty, many were worn without permission.

Lower officials of the seventh to ninth ranks and unclassified officials were allowed five *mang* on their robes, but this does not seem to have been put into practice as low-ranking officials seldom had occasion to wear such robes. Moreover, those with a low income could not have afforded them, and those with more wealth would have used their money or influence to gain a higher rank. At the end of the dynasty, even the lowest of officials could have openly worn an eight- or even nine-dragon robe if the occasion warranted it.

Off-duty mandarins wore official informal clothing for events not connected with major ceremonies or government matters. Indeed, it was considered bad form to wear formal robes at home, when visiting friends, or on other private occasions. This ordinary dress consisted of a *nei tao* – a plain long gown of silk, usually reddish brown, gray or blue, cut in the same style as the *mang pao* and worn under a surcoat. Low-ranking officials also wore the *nei tao* under a surcoat on semiformal occasions.

Accessories

A mandarin was seldom seen without his hat, and then only in the private quarters of his home. Hats were worn irrespective of the degree of official formality. A winter hat with a turned-up brim of black satin, mink, sealskin, or velvet, and a padded crown covered in red silk fringing, was worn from the eighth month of the Chinese calendar (Fig. 123). For summer, beginning in the third month of the calendar, the hat was conical and made of split bamboo covered with silk gauze for high officials, and woven straw for lower-ranking public servants. Fringes of red silk cord or dyed horsehair covered the crown from apex to edge. When first introduced in 1646, an official noted that a shortage of materials in southern China meant they had to be cut out of baskets and straw mats (Wilson, 1986: 27). The split bamboo hats worn by high officials were made by villagers in Chengdu in Sichuan province. They took two days or more to weave, and the skill was passed down from generation to generation.

The use of hat finials and spheres meant that the rank of a mandarin could be determined at a glance. They were more conspicuous than badges of rank, especially as the badges were only worn on "full dress" occasions. Officials wore finials on their hats on ceremonial occasions. Above the ornamental base was a spherical shape with a small setting of transparent stone or piece of glass, and then

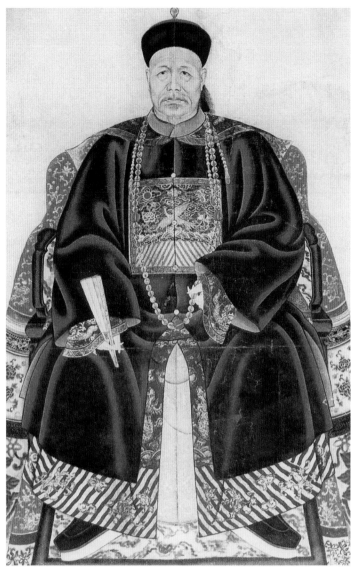

Fig. 120

above that the tall jewel depicting rank. The colors of the jewels – red, blue, white, and yellow – were based on Manchu banners. After the conquest of China, when the Manchu took over the Ming system of nine ranks, the small settings were added to depict the principal and the subordinate ranks. Then, in 1730, the Yongzheng Emperor added opaque stones to the transparent ones already in use, to denote subordinate rank. Previously, in 1727, he had introduced hat spheres, sometimes called "mandarin buttons" in the West, for less formal occasions to avoid confusion between ranks when insignia squares were not worn (Fig. 124). The buttons were made of either semiprecious stones or glass in descending order of rank: ruby, coral, sapphire, lapis lazuli, crystal, opaque glass, and gold or brass.

A hat decorated with gold branches and leaves was worn at a ceremony celebrating success in the examinations. Afterwards, for daily attire the man wore a hat with a finial in the shape of an eagle. The eagle, as it soars high, symbolizes a rapid rise in office; as it swoops low, it represents a desire for a long life. For graduates of the first degree, the bird was made of silver, or an alloy known as *bai tong* (white copper), which comprised copper containing a small amount of zinc and nickel, but resembling silver. Graduates of the next examination at provincial level wore the ornament made of silver with a gold bird on top. The *jin shi* or metropolitan graduate wore a gold ornament with three branches bearing nine leaves at the top.

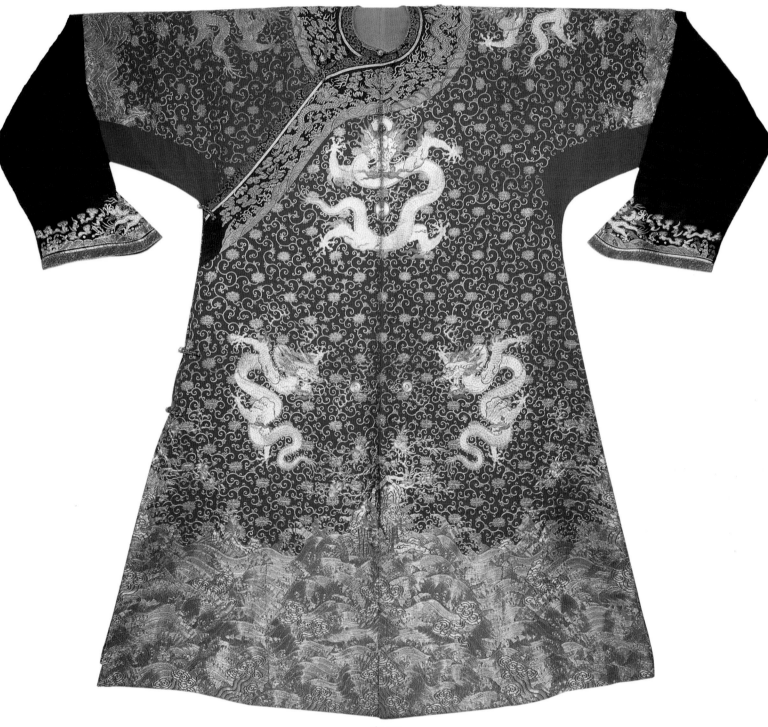

Fig. 121

Fig. 120 Ancestor portrait of a mandarin in "full dress" – dragon robe with a flared collar and a stiffened collar under a surcoat bearing a rank badge, winter hat, necklace, and boots, late 19th c.

Fig. 121 Dragon robe in blue satin lavishly embroidered with gold thread, five-clawed dragons, Qianlong period, with later replaced collar and cuffs.

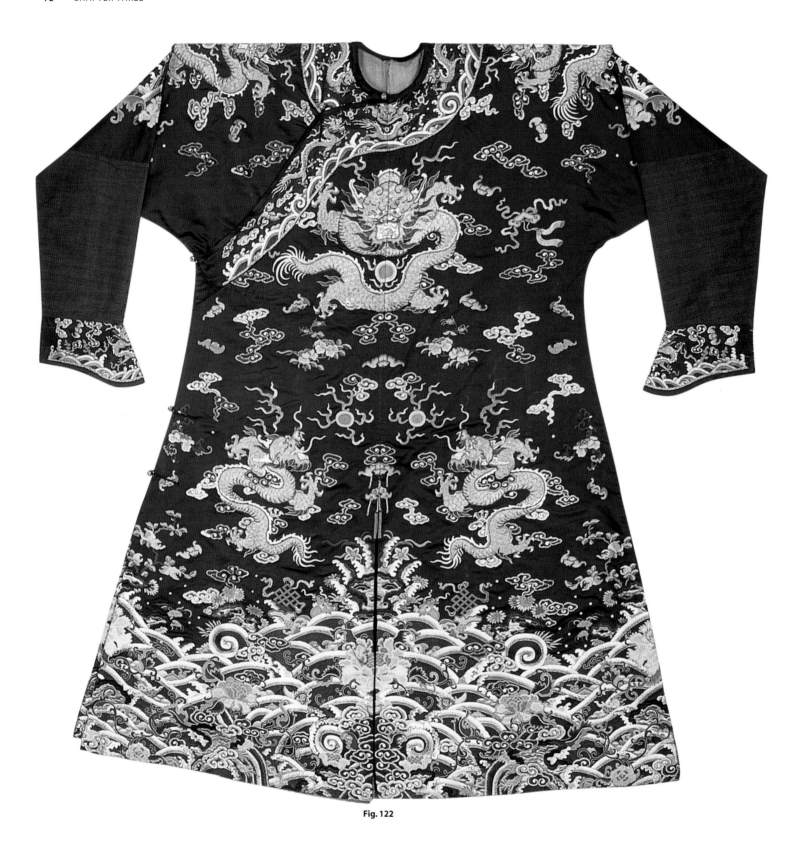

Fig. 122

Fig. 122 Dragon robe for a mandarin of the fourth to sixth rank, in dark blue satin, embroidered with eight gold couched dragons, bats, peonies, and Peking knot Buddhist emblems, satin stitch clouds, and chain stitch *li shui*, with slits at the back and front hem only, and ribbed silk sleeves, Qianlong period.

Fig. 123 Clockwise from back left: Mandarin's summer hat with fine silk fringing and coral hat button on a blue-and-white ceramic hat stand; stacking hat box for winter and summer hats, 19th c.; ivory hat stand, early 19th c.; Mandarin's winter hat with sealskin brim and crystal hat button; hat stand of wood inlaid with mother of pearl.

Fig. 123

On public occasions, mandarins of the fifth rank and above, who had permission, could attach peacock feathers or *hua yu* to their cap button. Peacock feathers were seen as a sign of great honor accorded by the emperor for exemplary services rendered. One, two or three overlapping peacock feathers were worn: the more eyes the greater the honor. However, towards the end of the dynasty, such feathers were openly for sale, with one example in the Victoria & Albert Museum in London still bearing the label from the Wan Sheng Yong Feather Shop in the main street in Beijing. Officials and officers of the sixth rank and below were allowed the use of black quills (*lan yu*) from the crow's tail (Fig. 125).

Mandarins also wore the *chao zhu*, the necklace of 108 semiprecious stones worn by the emperor and his court. Civil officials of the fifth rank and above, and military officials of the fourth rank and above, were required to wear the necklace, which could be made of any semiprecious stones other than pearls. The chain shown here is made of wooden and green and blue glass beads (Fig. 126).

Part of the Manchu traditional costume was a tightly woven girdle or belt in blue or blue-black silk, tied closely around the waist. The buckle of the belt and three similarly designed plaques were a further means of denoting rank. Materials for the plaques ranged from jade mounted in gold for the first rank, through gold, tortoiseshell, silver, and horn, although other materials could also be used (Fig. 129).

Fig. 124

Fig. 125

Fig. 124 Center back: Gold hat finial with a crystal and small blue stone setting. Right: Gilt hat finial topped with a bird for a provincial graduate. Top left: Plain gilt hat knob denoting seventh rank. Bottom left: Blue glass hat knob denoting third rank.

Fig. 125 From left: Flat wooden box for holding the adjacent crow's tail quill; lacquered cylindrical plume case made for a military officer for holding the adjacent double-eyed peacock feather, bearing the inscription: "The merit of a good officer: yield when required to yield, be stern when necessary," dated 1876.

Fig. 126

Fig. 127

The possession of a pair of boots was a demonstration of wealth and superiority. Boots could only be worn by officials and men with some position in society, as shown in this proverb of the day: "A man in boots will not speak to a man in shoes" (Sirr, 1849; reprint 1979, Vol. 1: 309). A mandarin's black satin knee-high boots were reinforced along the front and back seams with leather piping. The white soles were 3 inches (7 cm) thick (Fig. 127). Boots were expensive: a pair could cost as much as a servant's wages for the year (Wilson, 1986: 29). Blue padded and quilted cotton covers were made to button neatly over the boots for protection when not being worn.

Socks were worn inside the boots. For the cooler months, socks were knee length and made of silk, cotton, or linen, lined and padded with rows of stitching. Socks for warmer weather were shorter. Either embroidered or plain in blue or white silk or cotton, they could be worn over the hem of trousers when wearing shoes (Fig. 128).

Fig. 128

Fig. 129

Surcoats and Civil Rank Badges

After 1759, a calf-length, center-fastening surcoat was mandatory for formal occasions. All who appeared at court were required to wear it, regardless of their background or income. Made from blue or purple-black satin, the surcoat was called a *pu fu* or "garment with a patch" when a badge of rank was applied, or a *wai dao*, meaning "outer covering," when worn without a badge. For winter, the surcoat was often lined or edged with white fur (sable was reserved for mandarins of the third rank and above). For spring and autumn, the lining was cotton, and for summer the garment itself was made of silk gauze with no lining (Fig. 130).

The surcoat was loose fitting, opening down the center front, with side and back vents. The three-quarter length sleeves and the fact that the coat reached mid-calf enabled the wearer to show off the sleeves and the embroidered hem of the court or dragon robe under it. In addition, the simple shape of the coat made it an ideal "canvas" for the badges of rank attached to the front and back.

A fur surcoat of the same style, called a *duan zhao*, was worn for extra warmth with winter dragon robes. However, its use was restricted to the imperial family, imperial guardsmen, and the first three ranks of mandarins (Fig. 131).

Although the Manchu, on assuming power, made a break with Chinese traditions and retained their own national costume, in 1652, eight years after the conquest, they brought back the Ming custom of indicating rank by insignia squares. With slight modifications, they continued the system of demarcating the nine ranks of civil officials by birds embroidered on the squares and the military mandarins by animals. The ability of birds to fly high to heaven indicated the superiority of the civil mandarins over their military counterparts whose animals were earth-bound.

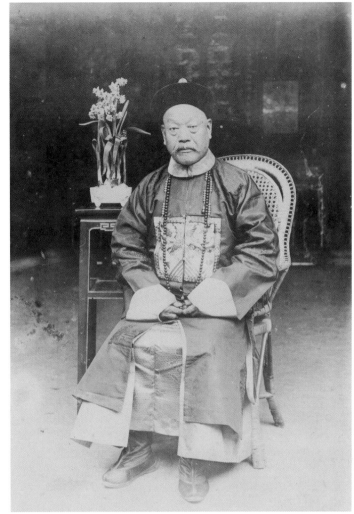

Fig. 130

Fig. 126 Woven rattan box containing a necklace of 108 carved wooden beads interspersed with four "jade" beads, the counting strings and counterweight of blue glass.

Fig. 127 Black satin boots with thick white soles, an inscription on the lining indicating they were made for a military official.

Fig. 128 Men's socks, one pair in white cotton, the other in blue silk, both with cotton soles, 19th c.

Fig. 129 Set of girdle plaques inlaid with mother-of-pearl and mounted in silver.

Fig. 130 Fourth-rank civil mandarin in official informal dress comprising a calf-length, center-fastening surcoat with a rank badge and stiffened collar, over a long plain gown, ca.1900.

Fig. 131 High-ranking mandarins wearing fur surcoats over their winter dragon robes, and winter hats with peacock feathers, 1906.

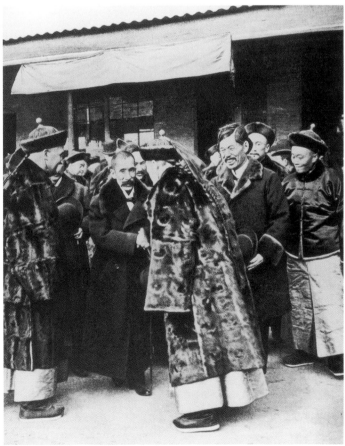

Fig. 131

Fig. 132

Fig. 133

Fig. 134

Fig. 135

Fig. 136

Fig. 137

Fig. 132 Second civil rank badge showing a golden pheasant surrounded by the Eight Buddhist Emblems embroidered in tent stitch on silk gauze, late 19th c.

Fig. 133 Badge for the wife of a third-rank civil mandarin showing the peacock and peacock feather embroidery on the rock. The gold background filled with clouds and white striations is typical of the transitional Yongzheng/ early Qianlong period.

Fig. 134 Fourth civil rank badge portraying a wild goose embroidered in white against a background of blue brick stitched clouds and Buddhist emblems outlined in gold, the *li shui* below couched in gold thread, ca. 1875.

Fig. 135 Fifth civil rank badge showing a silver pheasant embroidered in white silk against a background of elongated clouds and swirling couched gold thread, peacock feather embroidery partly missing on the rock, Kangxi reign.

Fig. 136 Badge for the wife of a sixth-civil rank mandarin showing an egret in a natural setting, Qianlong period, mid-18th c. Badges from this period were often smaller than before; this one measures 8 inches (20.5 cm) square.

Fig. 137 Eighth civil rank badge showing a quail embroidered in satin stitch against a cloud filled sky, first half 19th c.

Fig. 138 First civil rank badge in *kesi* depicting a crane against a cloud-filled sky, surrounded by five bats, first half of 19th c.

Fig. 139 Badge for the wife of a ninth-rank civil mandarin depicting a paradise flycatcher with three tail plumes, unlike later in the dynasty when two became the norm, ca. 18th c.

Fig. 140 Censor's badge depicting the *xie zhai* in couched gold and silver thread, mid-19th c.

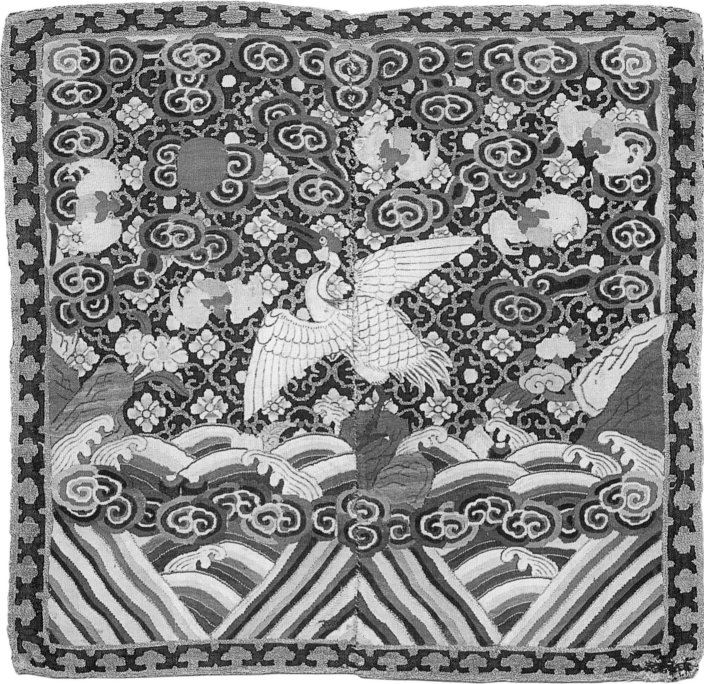

Fig. 138

Fig. 139

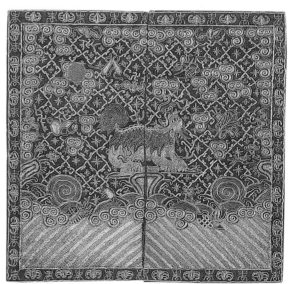

Fig. 140

Even though it had always been possible for a man to purchase a degree and, consequently a rank, this practice increased rapidly towards the end of the dynasty as the Qing government began selling ranks as a means of generating revenue. Ranks without office were sold even to merchants and tradesmen. This led to the practice of wearing appliquéd birds and animals, instead of those worked into the square, as the speed with which officials rose through the ranks meant that the base could be retained and the bird or animal simply changed.

For a civil official, the bird's head faced the wearer's right; for his wife, the badge was identical except the bird faced left. For a military official, the animal's head faced the wearer's left, and for his wife it faced right. Both birds and animals were depicted looking up to the sun disk placed in the top corner of the badge, which was a kind of rebus for "Point at the sun and rise high" (*zhi ri sheng rao*) (Cammann, 1953: 11).

The first civil rank was represented by the Manchurian crane, while ranks two to nine, in descending order, were represented by the golden pheasant, peacock, wild goose, silver pheasant, egret, mandarin duck, quail, and paradise flycatcher (Figs. 104, 132–139). It is sometimes difficult to distinguish between the different birds. Often the embroiderer had never seen the subject matter live, and would have to rely on doubtful representations for guidance. Unscrupulous officials would also try to have their rank symbol looking as much as possible like the one above it, even though emperors repeatedly issued edicts to stop this deceitful practice. In addition, towards the end of the dynasty the birds were also depicted in gold and silver threads, thus rendering color useless as a means of identification.

One further badge worn by officials with civil responsibilities was that of the Censor, whose role it was to report on the honesty and integrity of the other mandarins. The Censor was depicted as a mythical animal called a *xie zhai*, which symbolized justice (Fig. 140). It had a horn to gore wrongdoers and roared when it encountered unlawful behavior.

There were also badges worn which related more to occasion than rank. Elderly men who had continually tried to pass the examinations, and failed, and who held no official rank could wear what was known as a Four Character square. Such squares were of similar size to insignia rank badges, but in place of a bird there were four characters on the front square, *huang en qin zi*, or similar, implying they were "conferred by imperial grace." The back square bore a large *shou* character.

Fig. 141

Military Officials and Rank Badges

In addition to the Manchu banner divisions, a second regular army, the Green Standard Army or *Lu Ying*, was established by the Manchu as a form of provincial constabulary within the Qing administration. Made up entirely of Chinese, its name derived from the army's large triangular standard, which was made of green satin with a scalloped red satin border representing flames and a gold dragon embroidered in the center. The Green Standard Army was divided into army and navy and was responsible for the defense and internal security of the country. It was made up of two kinds of soldiers: those permanently employed, and those, named *yung* or "braves," who were called up to fight when required.

Manchu officers shared responsibility with Chinese officers for the Green Standard Army units. This regular army was organized by province, with a commander-in-chief stationed in the provincial capital or prefectural city. Below him were the brigadier-generals, colonels, majors and captains, sergeants, and corporals who were stationed in the smaller cities and towns, and who cooperated with the civil mandarins and village headmen in maintaining order.

There were nine ranks of military officials, both principal and subordinate (Figs. 142, 143). The lower ranks of military mandarins

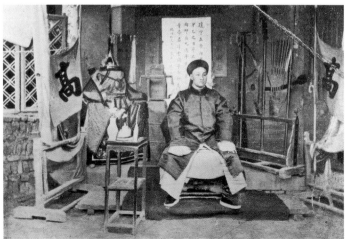

Fig. 142

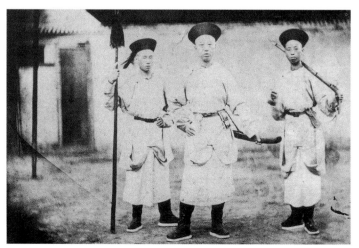

Fig. 143

Fig. 144

did not enjoy the same status as the equivalent civil ones and had to ride on horseback rather than be carried in sedan chairs, though this was not always observed towards the end of the dynasty. High-ranking military mandarins wore the same hats and robes as civil mandarins, distinguished only by an animal rather than a bird on the rank badge. Red horsehair or yak hair replaced silk fringing on summer hats of soldiers and guards. The hair extended beyond the brim to keep flies out of the eyes when on sentry duty. Lower ranks such as clerks and attendants wore shorter black velvet or satin boots made more flexible with thin leather or cotton soles.

The plain long gown (*nei tao*) worn by military mandarins had a section at the lower right-hand side above the hem, which fastened with loops and ball buttons and could be removed when riding on horseback (Fig. 141). Two kinds of hip-length jackets (*ma gua*) – originally a military garment that was later adopted for traveling – were worn with the *nei tao*. The first type fastened over to the right with the lower part cut away from the right-hand corner. The second type, also with a detachable lower section, fastened down the front, and was eventually worn by all officials up to the twentieth century.

Fig. 141 Military gown in blue jacquard silk gauze.

Fig. 142 Military official at home, his uniform and weapons displayed in the background, ca. 1900.

Fig. 143 Lower-ranking officers wearing the military version of the *nei tao* gown, and satin boots, 1863.

Fig. 144 First military rank badge in *kesi* showing a *qilin* surrounded by clouds, bats, and the Eight Daoist Emblems, ca. 1850.

Fig. 145

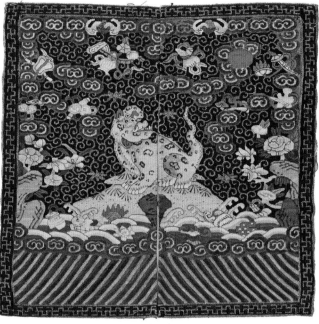

Fig. 146

Fig. 147

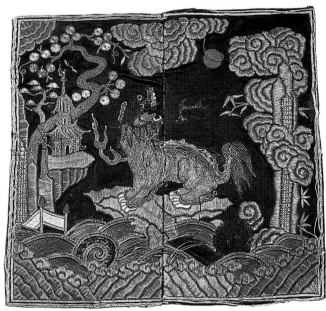

Fig. 148

Fig. 149

Fig. 145 Second military rank badge with a lion embroidered in satin stitch on a dark blue ground amidst clouds, flowers and bats, *li shui* below, early 19th c.

Fig. 146 Third military rank badge in *kesi* showing a leopard standing on a rock in a natural setting surrounded by bats and the emblems of the Eight Immortals, late 19th c.

Fig. 147 Fourth military rank badge for a provincial officer depicting a tiger embroidered in couched gold thread on a green satin ground. The striated clouds and absence of a sun disk indicate a first half 18th c. date.

Fig. 148 Fifth military rank badge showing a bear surrounded by Turkish-style embroidery of padded gold couched threads of trees and a pagoda on black satin, ca. 1750–80.

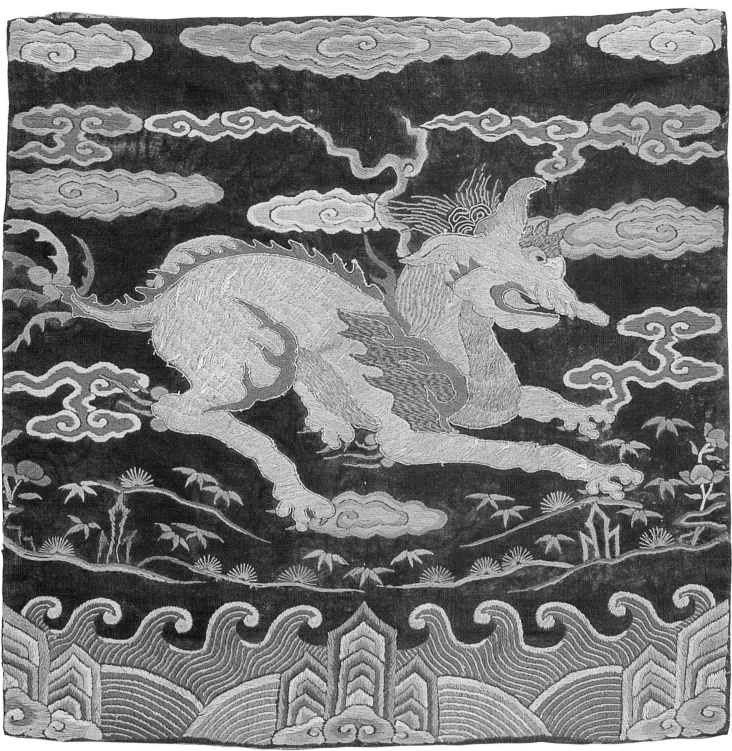

Fig. 150

Fig. 149 Sixth and/or seventh military rank badge bearing a panther embroidered in couched gold and silver thread and appliquéd onto the badge, late 19th c. Birds and animals were appliquéd to the badges in the late nineteenth century when it became more common to buy one's way up the ladder. This made it easier to remove the lower-ranking bird or animal and replace it with a higher one.

Fig. 150 Very rare example of what is possibly the eighth military rank, the rhinoceros, a horned animal running over land, embroidered in white and tan on a blue damask ground, Ming dynasty (1368–1644). Since there are no other known existing examples of this rank, it has been identified by comparing it with the woodblock illustrations in the Ming and Qing encyclopedias. Badges from this period were larger than those in the Qing: this one is 13.8 inches (35 cm) high and 14 inches (36 cm) wide.

Animals were often embroidered without any attempt to obtain a true likeness. The animal representing the highest military rank was the *qilin*, a composite beast with a dragon's head, a pair of horns, hooves, the body of a stag covered with large blue or green scales, and a bushy lion's tail (Fig. 144). It was believed to have great wisdom. Below the *qilin* were the lion, leopard, tiger, bear, panther (for the sixth and/or seventh rank), rhinoceros and sea horse (Figs. 145–150). Examples of the rhinoceros and sea horse are extremely rare, as they belonged to provincial soldiers who would have had to destroy them when the dynasty fell in 1911.

In the nineteenth century, the Manchu rulers were forced to recruit Chinese volunteer forces to assist in dealing with both foreign invasions and internal revolts. With official permission, many Chinese landowners raised units to fight the Taiping and other rebels. These were known as *yung* or "braves" from the character written in the circular badge on the front and back of the jacket. As these uniforms and weaponry were used infrequently, they were often pawned by the commanding officer (also a fairly common practice for special civilian dress among the general population). This occurred, for example, when the defeated military leader Li Hong-Zhang arrived in Shanghai after the Sino-Japanese war in 1894–5. The guard of honor was made up of two battalions of braves carrying weapons more appropriate for an armorer's museum than a military unit; attached to each was a pawnbroker's ticket (Cunningham, 1902: 75).

The traveler and writer Isabella Bird writes similarly on seeing Chinese troops on their way to the same war: "The uniform is easy, but unfit for hard wear, and very stagey – a short, loose, sleeved red cloak, bordered with black velvet, loose blue, black or apricot trousers, and long boots of black cotton cloth with thick soles of quilted rag. The discipline may be inferred from the fact that some regiments of fine physique straggled through Mukden [Shenyang] for the seat of war carrying rusty muskets in one hand, and in the other poles with perches, on which singing birds were loosely tethered.… Yet they made a goodly scenic display in their brilliant coloring, with their countless long banners of crimson silk undulating in the breezy sunshine, and their officers with sable-tailed hats and yellow jackets riding beside them" (Bird, 1898; reprint 1970: 209–10).

Clothing for Children of Mandarins

Sons who still lived at home or who had not taken public office, and daughters who had not yet married, could wear the dress of their father, except for his insignia of hat jewel, girdle plaques, and rank badge (Figs. 152, 153). Despite this ruling, children's rank badges surface from time to time, proving that traditional laws were often disregarded (Figs. 154–156). These badges all seem to be of the higher ranks since only the highest officials could have afforded to dress their children in official robes or would have had any need to.

Fig. 151 Children of a Chinese mandarin, the boy wearing a jacket with a rank badge over a dragon robe and boots; the girl in an *ao* upper garment and wedding collar over a skirt, ca. 1900. Since a girl was not entitled to wear a skirt until she married, this is probably a betrothal picture.

Fig. 152 The Governor of Shanxi with two of his sons, the one on the right in informal dress of a long, side-fastening gown and a red sleeveless waistcoat (*bei xin*), 1902.

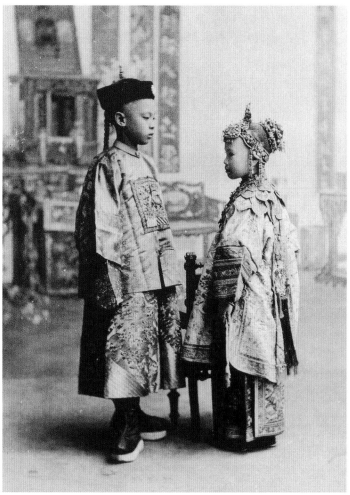

Fig. 151

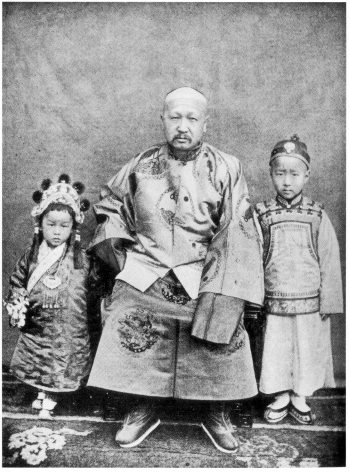

Fig. 152

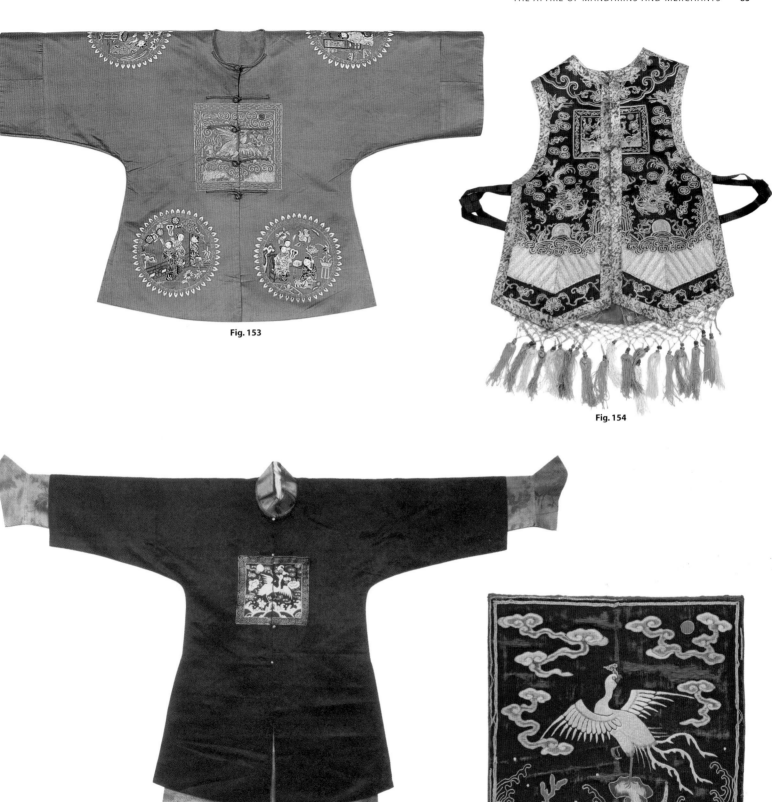

Fig. 153

Fig. 154

Fig. 155

Fig. 156

Fig. 153 Girl's orange/red satin surcoat with six embroidered roundels showing scenes of scholars and ladies in a garden surrounded by peaches for longevity and other auspicious symbols, the center front and back rank badges depicting the crane and bats embroidered in couched gold thread, ca. 1870–1900.

Fig. 154 Young girl's *xia pei* official vest, with fifth-rank civil badges at chest and back showing the silver pheasant. The vest is made of black satin, couched with gold and silver thread depicting dragons, cranes, bats and clouds above a *li shui* hem edged with multicolored tassels, late 19th c.

Fig. 155 Boy's black satin surcoat with a first-rank civil badge over a blue *nei tao* gown, mid-19th c.

Fig. 156 Young boy's fifth-rank badge with a silver pheasant embroidered in white floss silk on a black satin background, Yongzheng (r. 1723–35).

The Chinese Merchant Class

Many Chinese merchants and landowners were exceedingly wealthy and their lifestyles superior to that of a mandarin, especially as the latter's salary was not high and he had many expenses. The homes of these rich merchants were often located in the suburbs of a city and were concealed from the eyes of onlookers by high walls. A large garden usually surrounded the house, with small lakes stocked with fish and lotus flowers, bridges, willow trees, pavilions, and winding paths (Fig. 158). Gardens were very important to the Chinese gentry, who viewed them as a retreat, a refuge from business affairs, and a place in which to revive the spirits.

Chinese mansions were renowned for their ornate architecture and collections of rare books, paintings, and calligraphy. Inside was a series of courtyards, large and small, and adjacent parallel halls of various sizes. The main rooms were graced with massive columns, paneling, latticework, and woodcarvings, and were replete with carved furniture, scroll paintings, and calligraphic couplets: "… in the houses of the wealthy there is no little elegance. The stiff-backed chairs and tables are of carved ebony or inlaid with mother-of-pearl or marble. The divan is supplied with mats and cushions on which the guests may recline and smoke their opium, while they may sip their tea and take their refreshments from choice China on the little marble-topped tea trays or tables arranged around the room" (Graves, 1895: 28).

During the Qing dynasty, the Han Chinese had slimmed down the voluminous Ming robes. After their conquest by the Manchu, they also incorporated some features from Manchu garments in

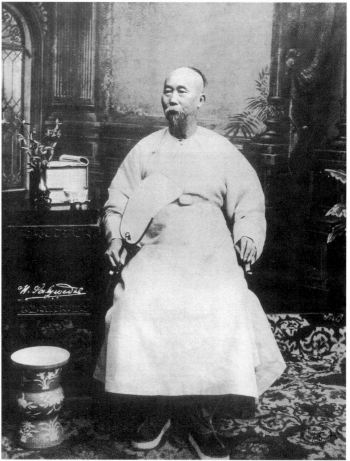

Fig. 157

Fig. 158

Fig. 159

Fig. 160

their *chang shan* gowns, including the curved front opening, which echoed animal skin origins, and the fastening of loops and buttons, again of nomadic derivation. The Chinese gown was adapted to suit a more sedentary way of life than the *nei tao*: the center back and front slits were closed and the sleeves became long and tapering without the horse-hoof cuffs. A hip-length *ma gua* jacket with wider sleeves was worn over the *chang shan*, while a sleeveless jacket was worn on less formal occasions (Figs. 157, 159–163).

Silk was used to make the garments, often gauze for summer and satin for winter, while the lower classes wore cotton. Black gummed silk (*hei jiao chou*) was popular for its durability and coolness in hot weather (Fig. 164). In winter, gowns were wadded with silk or lined with cat or dog fur, as well as goatskin and sheepskin, for extra warmth. These fur-lined gowns would pass from father to son as part of his inheritance, since the styles changed little over the years. It was also the custom for rich and poor alike to pawn their fur-lined garments during the summer months, as they would be stored better.

Wearing pawned clothing was a common habit, as this description of the celebrations to mark the start of Lunar New Year reveals: "Everyone will appear, if possible, in long robes and jackets of silk

and satin, with their red-buttoned and tasselled skull caps on…. These fine clothes can be hired, the price being gradually lowered as the hours of the first six days pass by. We complained once of the very late arrival of a caller, who should have been among the first to salute us. He replied that money was scarce and he was obliged to wait for the cheapest day to secure a fine robe already donned and doffed by a dozen others" (Moule, 1914: 201).

No special clothing was worn for sleeping or for under outer garments, and nightwear or underwear was often an older or thinner version of the top garment. The bamboo vest or jacket was one exception, and worn up to the beginning of the twentieth century. "Bamboo clothing is made from the finest branches of the tree, worn in summer next to the skin to keep the light cotton shirt or inner jacket from irritating the skin when moist from perspiration…" (Dudgeon, l884) (Fig. 165).

On informal occasions, men wore a close-fitting skullcap made up of six segments; this was also worn as everyday wear by the lower classes. Called a *guan pimao* or melon cap, as it resembled a half melon, or else *xiao mao*, meaning "small hat," the cap was made of black satin or gauze and topped with a red or black knotted silk cord knob, which was changed to blue if the wearer was in mourning.

Fig. 157 Merchant wearing a long side-fastening gown (*chang shan*) with long tapering sleeves, belted round the waist, with boots. He is holding a fan.

Fig. 158 Home and garden of a wealthy salt merchant in the Western suburbs of Guangzhou, 1792.

Fig. 159 Chinese merchants, with elderly woman and child, wearing gowns with long tapering sleeves, ca. 1890.

Fig. 160 Merchant and son, both wearing the long gown and waistcoat, with a melon cap and black cloth shoes.

Fig. 161

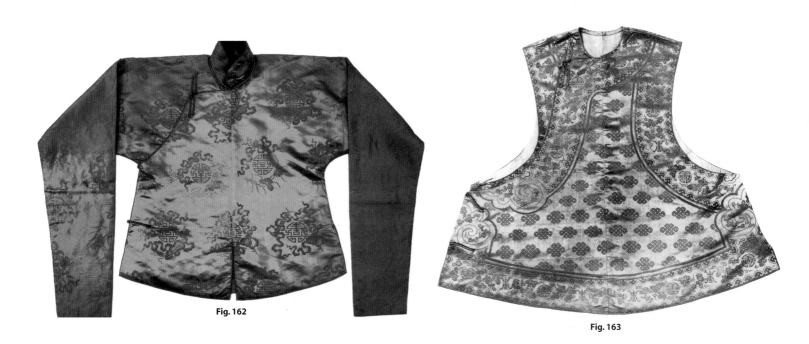

Fig. 162

Fig. 163

Fig. 161 Group of Chinese mathematicians wearing the *chang shan* below the hip-length jacket, Beijing, ca. 1870.

Fig. 162 Dark cream silk damask padded jacket with long tapering sleeves and *shou* characters

surrounded by emblems of the Eight Immortals, ca. 1870.

Fig. 163 Rust silk damask waistcoat with the Endless Knot design, mid-19th c.

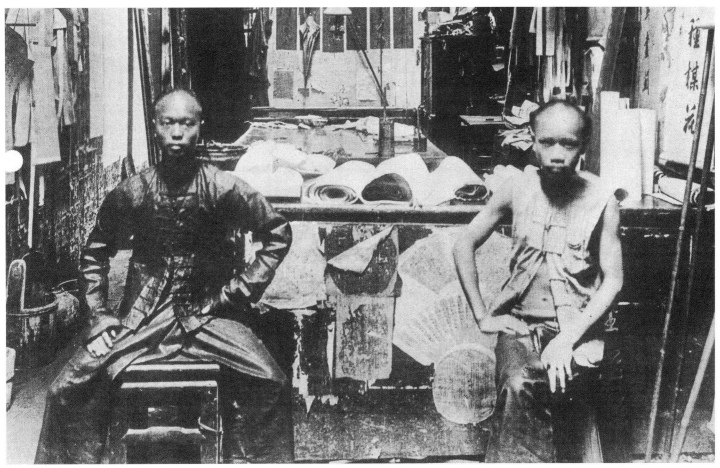

Fig. 164

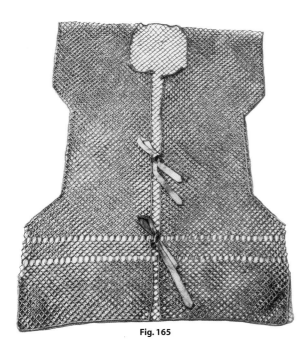

Fig. 165

For summer, the hat was often lined with rattan for ventilation. Some hats were stiffened and sold in circular cardboard boxes, while others were soft and folded into six for easy storage in triangular boxes or paper pouches. The skullcap continued to be worn well into the middle of the twentieth century, but the shape changed from the earlier flatter crown to a more rounded one. Hoods, buttoned under the chin, developed from the skullcap for wear in the bitterly cold weather of northern China (Fig. 166).

Some skullcaps had an attached queue or pigtail. As a sign of subjugation, all Chinese males had to shave the front of their head and wear their hair in a single plait in the style of the Manchu rulers. The plait resembled a horse's tail, the animal whose speed and stamina had helped in the conquest of China. At first, this ruling was bitterly resented, but was later accepted and became most respectable. As a punishment, the queue could be cut off, and to be called *wu bian* ("tailless") was a great insult. At the end of the nineteenth century, when men went to study or travel overseas, they removed the queue, and on their return wore a cap with a false one attached. In practice, however, most queues were lengthened by the addition of some false hair. Wearing the queue was forbidden after the dynasty fell in 1911 and the practice soon died out.

Fig. 164 Two shop assistants, the one on the left wearing a jacket and trousers in black gummed silk, the one on the right in cotton waistcoat and black gummed silk trousers, ca. 1900.

Fig. 165 Bamboo vest constructed from tiny pieces of hollow bamboo sewn together in a diagonal pattern, the edges of the neck, sleeves, and underarms trimmed with cotton binding, the neck fastened with a ball button and loop, the front pieces held together with ties, 19th c. Some garments had sleeves and others were sleeveless.

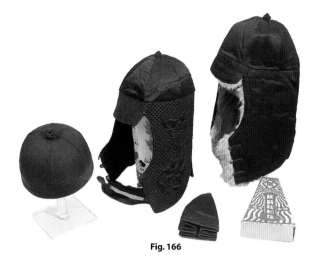

Fig. 166

Fig. 167

Fig. 168

Shoes were worn by the gentry for informal wear in the private quarters of their homes, and were also in regular use by the lower ranks. Like the boots, some shoes had a stiff sole several inches thick, made of layers of paper, to raise the vamp and keep it dryer in wet weather. The vamps were made of black satin, cotton, or velvet, plain or appliquéd; leather was used only for the trimming or binding. There were two main styles for men, one with a rounded toe curving back to the sole, the other with a wide toe the same width as the heel (Fig. 167). Like the boots, the inflexible sole was made shorter than the uppers in order to give sufficient spring for walking.

Lengths of tightly woven silk with silken fringes at each end were used as puttees and wound spirally round the leg, over the trousers and socks from ankle to knee, for protection and support. Thickly padded kneepads were useful for cushioning the knees when required to perform the full kowtow whereby the person knelt three times, one after another, each time knocking the head three times on the ground (Fig. 168).

Purses and Their Contents

Since robes lacked pockets, small items were often tucked into the sleeves. "Sleeve editions" (small books concealed by candidates in the examinations) and even "sleeve dogs" (Pekinese or lap dogs) were carried there. Generally, however, daily necessities were suspended from the girdle.

The absence of pockets was cause for comment among many nineteenth-century writers: "One of the most annoying characteristics of Chinese costume, as seen from the foreign standpoint, is the absence of pockets.... If he has a paper of some importance, he carefully unties the strap which confines his trousers to his ankle, inserts the paper, and goes on his way. If he wears outside drawers, he simply tucks in the paper without untying anything. In either case, if the band loosens without his knowledge, the paper is lost – a constant occurrence. Other depositories of such articles are the folds of the long sleeves when turned back, the crown of a turned-up hat, or the space between the cap and the head. Many Chinese make a practice of ensuring a convenient, although somewhat exiguous, supply of ready money, by always sticking a cash in one ear. The main dependence for security of articles carried, is the girdle, to which a small purse, the tobacco pouch and pipe, and similar objects are attached" (Smith, 1894: 128).

Purses were popular and acceptable gifts to mark special occasions and some original yellow and red boxed sets still survive. Certain shops specialized in their manufacture; as with many other trades, there was a street in Beijing devoted to their sale. Women also spent many hours producing exquisite purses for their loved ones, and it was the custom for the emperor to reward his courtiers and officials, especially at the Lunar New Year, with purses containing jeweled charms.

Fig. 166 Clockwise from left: Man's silk gauze skullcap; quilted hood; silk hood lined with fur; folded "Horse" brand skullcap made in Shanghai with its original box.

Fig. 167 Left: Pair of shoes in blue satin trimmed with black satin with the *shou* character on the toe. Right: Pair of shoes with an appliquéd design of clouds of black velvet on beige silk.

Fig. 168 Kneepads in black silk flanked by a pair of black woven silk puttees with a damask design at the ends.

Fig. 169 Official set of five purses made for presentation to a high official. Clockwise from top left: Rectangular *da lian* purse for valuables; fan case; spectacle case; and pair of drawstring purses.

Fig. 169

Fig. 170

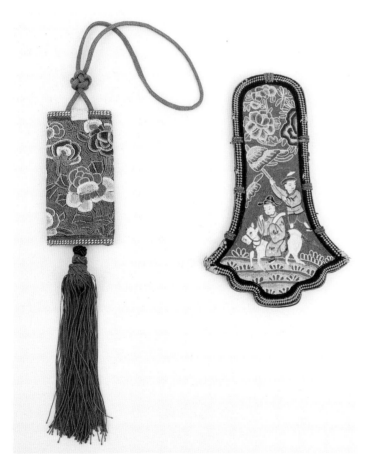

Fig. 171

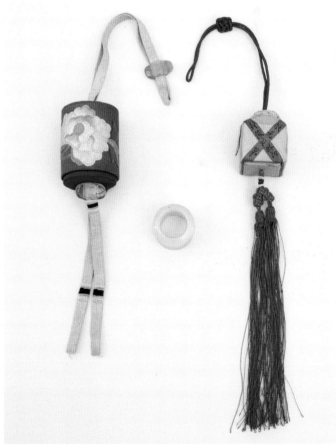

Fig. 172

Fig. 170 Left: Paintbrush holder embroidered in Peking knot with peonies, vases, ritual vessels, and books. Right: Paintbrush holder resembling a fan holder but with a cord passing through the center to create divisions for brushes. Made of black satin reversing to blue, and a poetic embroidered inscription on the front stating its purpose.

Fig. 171 Left: Rectangular key holder, suspended from a cord (the key was attached and hidden inside the holder), embroidered in Peking knot with peonies. Right: Bell-shaped key holder with the design in Peking knot and satin stitch of a successful scholar shielded by a servant carrying an umbrella. Only persons of high rank were entitled to have an official umbrella.

Fig. 172 Left: Red silk case with peonies painted and appliquéd in silk made to contain a pair of thumb rings like the jade one shown here. Right: Seal box in yellow silk with a red silk cross bearing characters in black ink hyperbolically stating that the owner has gained first place in the examinations. The yellow silk and the shape of the box are a miniature version of imperial seals and it would have been presented as a symbolic gesture.

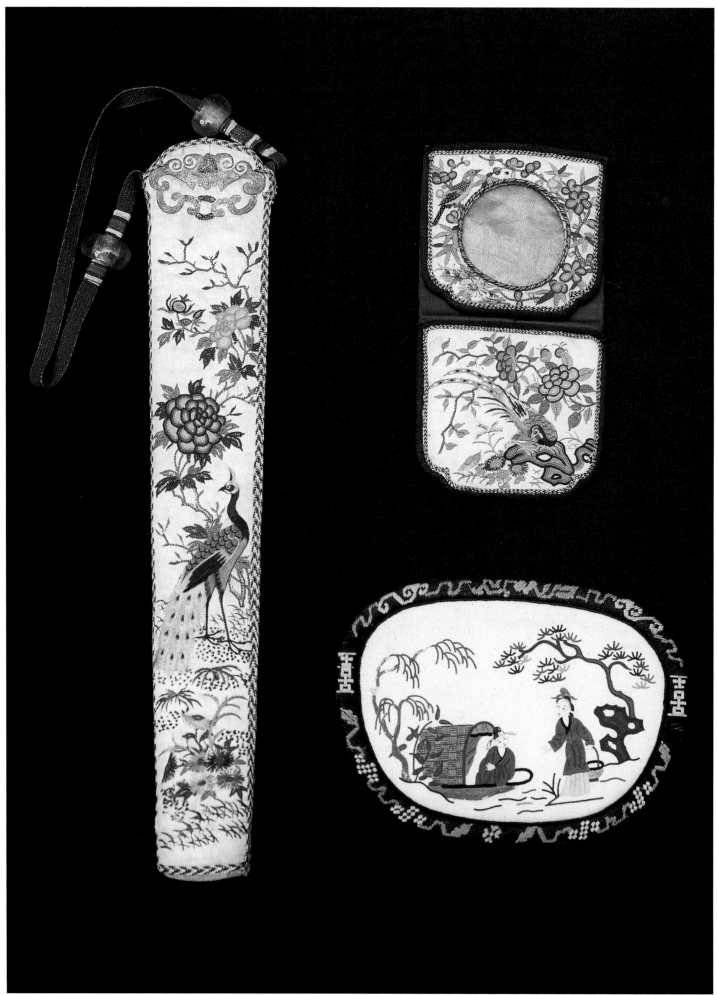

Fig. 173

By the end of the nineteenth century, more purses were added to the original ones mentioned earlier, which made it necessary to hang them over the girdle as well as from the rings (Fig. 169). These were known as the "Official Nine" and consisted of most of the following: a pair of drawstring purses, a *da lian* purse (a flat rectangular purse used to carry money), a watch purse (Fig. 173), an oval purse, a spectacle case, a fan case, a thumb ring box, a tobacco pouch, a holder for brushes and ink (Fig. 170), a case for carrying visiting cards (Fig. 174), and a key holder (Fig. 171).

The thumb ring was originally a leather band worn by archers to assist in drawing the bow (Fig. 172). Later, the ring became an ornament worn by the literati, first on the right thumb and then on both thumbs. Such was the importance of the thumb ring that on his birthday, when the emperor gave presents to invited guests at a feast, among the gifts of vases and scroll paintings would be archers' rings.

Seals or chops were carried and used as personal signatures, as well as signs of possession in a country where many people were illiterate and unable to write their name. Seals were carved from a variety of materials, such as jade, ivory, and soapstone, and carried in specially made little boxes.

Calligraphy and painting were two of several gentlemanly accomplishments. Chinese men needed a purse to carry their bamboo-handled brushes and sticks of solid ink, which were ground with water to produce ink.

Snuff made from ground tobacco spiced with aromatic herbs was introduced to China by Europeans during the Ming dynasty as a remedy for nasal congestion. But because the Chinese literati grew their fingernails long, it was not easy for them to take snuff from boxes, as was the custom in the West. Moreover, the humid climate, especially in South China, meant that snuff kept in boxes deteriorated quickly. Thus, tiny bottles with a small spoon fixed to the stopper were used to hold the snuff. The snuff was transferred by the spoon to the back of the left thumb and then inhaled. The bottles were easy to carry, either tucked into the sleeves of robes or suspended in a small purse (Fig. 175).

Fig. 174

Fig. 173 Having a pocket watch was a sign of wealth and was flaunted by those who could afford one. Left: Fan case with a third civil rank peacock and peonies. Top right: Watch purse with a design of a second civil rank golden pheasant and peonies. Bottom right Oval purse with a scene of a river and figures.

Fig. 174 Visiting cards were carried in a rectangular holder with a pull out drawer. Left: Holder made of black silk over stiff card, embroidered with couched gold thread in a design of ritual vessels. Right: Holder made of counted stitch on silk gauze over a card base, with the design of a bat against a key fret background.

Fig. 175 Snuff bottle holder in red silk over stiffened card, with a design in raised Peking knot of a crane in a garden.

Fig. 175

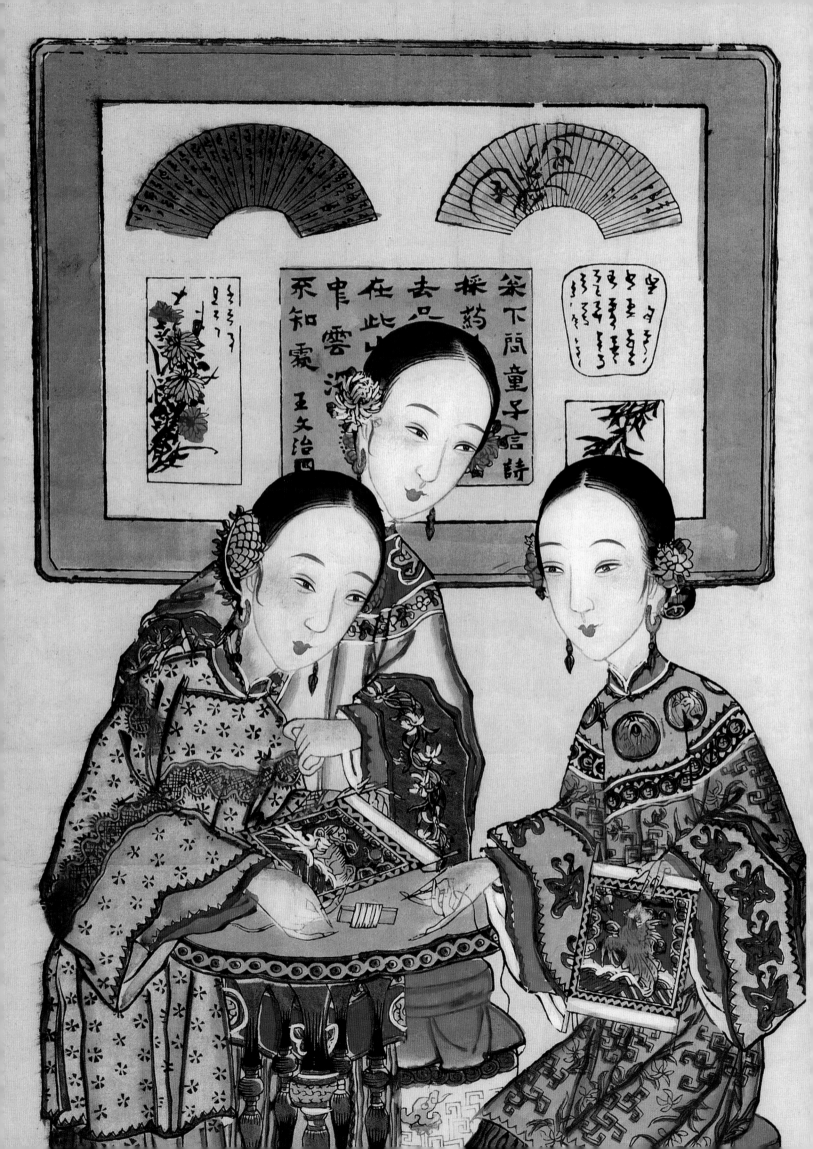

Chapter Four

THE ATTIRE OF
CHINESE WOMEN

At Home

It was the custom in Chinese families that on marriage a bride went to live with her husband's family. These extended families, in which many daughters-in-law served a powerful matriarch, meant that three or more generations might live under one roof, not always harmoniously. The most important role for the new wife was to produce a son or, more importantly, many sons. If she did not, she would be vilified by her mother-in-law, cast off by her husband in favor of other women, and pitied by all she met. Indeed, such was the low status of women and girls that if a father had only daughters he was considered to be childless.

The women and younger members of the family were cloistered in the domestic apartments and the schoolroom located behind the offices of the mandarin or merchant (Fig. 179). Here, women spent their time gossiping, looking after children, attending their mother-in-law, and helping in the kitchen (Figs. 177, 178). An extensive garden was a feature of many wealthy homes, and a place where women could walk freely. Within the high walls, artificial landscapes were created, with pleasure houses, gazebos, and zigzag bridges (Figs. 180, 183; see also Fig. 158).

One of the main diversions for women was embroidery (Fig. 176). Almost every garment worn by a middle- and upper-class Chinese was embellished with embroidery, as were all the soft furnishings for the home: door curtains to keep out drafts, table cloths, bed hangings, bed covers, and pillows. From the time she was young, a girl was taught to embroider as a feminine accomplishment, and prior to marriage was required to prove her skills to her prospective husband and mother-in-law. Preparing these embroidered articles could take as long as two years to produce before the wedding could take place. In the Qing dynasty, the designs and application of embroidery reached a peak during the relatively stable and peaceful reigns of the Kangxi, Yongzheng, and Qianlong emperors, especially the latter who did much to foster the arts. Embroidery became an industry in itself.

Up to the end of the nineteenth century, wealthy households employed servants to sew the many articles of clothing and household furnishings the family required (Fig. 184). The task was given to wives and daughters of tradesmen and artisans, while in poorer families, men and children also embroidered to supplement the household income. Clothing made by workers in the small cottage industries that abounded could also be bought from itinerant pedlars or shops (Fig. 182). In the cities there were streets specializing in one particular item, such as ladies' jackets, men's shoes, and so on (Fig. 181). Sewing machines were introduced into China at the end of the nineteenth century, making production much faster.

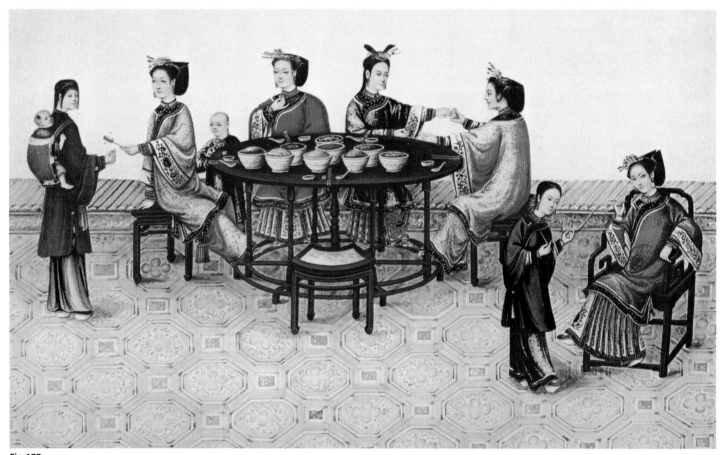

Fig. 177

(Page 92) Fig. 176 Detail of a painting of three Chinese ladies embroidering rank badges.

Fig. 177 Painting by the Guangzhou artist Tinqua of Chinese women seated at the dining table, while a servant carries a baby on her back, ca. 1854.

Fig. 178 Women in northern China preparing food while sitting on a heated brick bed (*kang*), ca. 1894.

Fig. 179 Home of a rich official in Beijing named Yang, seated, with his son standing. Upstairs are his wives and concubines and the younger children of his household, ca. 1870.

Fig. 178

Fig. 179

Fig. 180

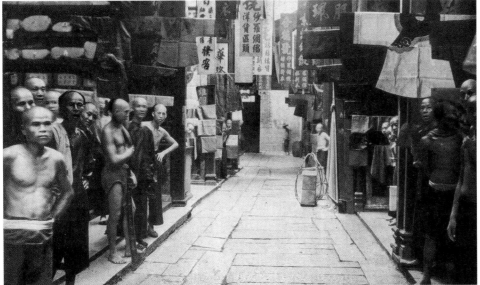

Fig. 180 Chinese women strolling in the garden of a wealthy merchant, Howqua, in Guangzhou, ca. 1850.

Fig. 181 The Street of Tailors in Guangzhou, ca. 1900.

Fig. 181

Fig. 182

Fig. 182 "A Chinese pedlar carries hand-kerchiefs, garters, fans, pockets, tobacco-pouches, &c. for sale, upon a bamboo frame.… He thus can easily carry the whole upon his shoulder…." He also sells silks and other items for embroidery.

Fig. 183 Chinese women by a pavilion in the garden of a wealthy salt merchant in Guangzhou, ca. 1840.

Fig. 184 Young girl working at an embroidery frame, Suzhou, early 20th c.

Fig. 183

Fig. 184

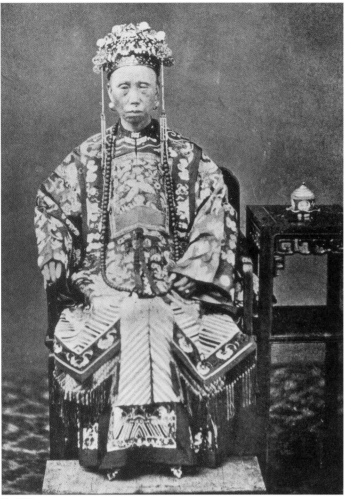

Fig. 185

The Mandarin's Wife

Han Chinese women were persons of little consequence within the Manchu regime, except those whose families were connected with the court in Beijing. However, within the family itself senior women had status and were well respected, particularly by the younger daughters-in-law, and were accorded a position of honor at important domestic events and festivals. They were not required to wear official attire. Most, in fact, were keen to retain their pure Chinese identity and took care not to wear Manchu-style clothing. At the beginning of the Qing dynasty, wives of Chinese officials were expected to continue wearing Ming costume, but gradually Ming conventions were forgotten and aberrations crept in.

The dynastic laws made no reference to the dress to be worn by Han Chinese women, but it appears from written accounts of the period that there was an accepted code based on class and occasion. The wives of Chinese noblemen or high-ranking officials were expected to wear quasi-official formal dress on ceremonial occasions when their husbands wore the court robe (Fig. 185). This consisted of a dragon jacket or *mang ao*, a stole called a *xia pei*, a dragon skirt, and a coronet (Fig. 186).

The *mang ao* was a loose-fitting jacket with wide sleeves, a plain round neck, and a side opening from neck to underarm, similar to Ming robes. It sometimes had side extensions to give greater bulk. This considerable use of silk fabric indicated the wealth and importance of the family. A man's principal wife wore red, the dynastic color of the Ming, and therefore considered auspicious, while the second wife wore blue and the third wife green.

Originally, the jacket was undecorated, but portraits from the eighteenth century show that it began to be decorated with dragons. From the late eighteenth and early nineteenth centuries, between two and ten *mang* were embroidered according to the status of the wearer (Fig. 187). Lower-ranking officials' wives also wore the *mang ao* as part of their bridal dress. A rigid hooped belt called a *jiao dai* was worn around the *mang ao* and held in place by loops at the sides of the jacket. It was made of bamboo and covered with red silk with ornamental plaques, akin to those worn by men in the Ming dynasty to denote rank.

The *mang ao* was worn over a *mang chu* or dragon skirt, in red or green silk, with dragons and phoenixes embroidered on the front and back panels. The skirt was first worn on a woman's wedding day and thereafter on formal occasions, always over trousers or leggings. Wearing a skirt was seen as a symbol of maturity, and was reserved for married women.

The skirt comprised a pair of pleated or gored aprons with panels back and front. They wrapped around the body, and were attached to a wide waistband, which was secured with ties or loops and buttons. The waistband was made of cotton or hemp to prevent the skirt from slipping down, while the skirt was of silk. Because the skirt was worn with a knee-length jacket, the panels

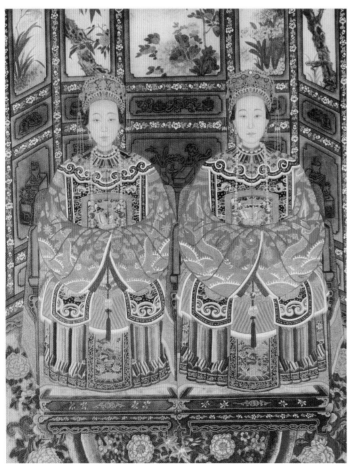

Fig. 186

Fig. 185 Wife of the Han Chinese official Huang Cantang, Governor of Guangdong, in full court dress comprising a dragon jacket, *xia pei* or stole, dragon skirt, and "phoenix crown," ca. 1862.

Fig. 186 Painting of two wives of a mandarin, the bird on the rank badges on their stoles artfully concealed by the sleeves of their jackets to imply a higher rank, 19th c.

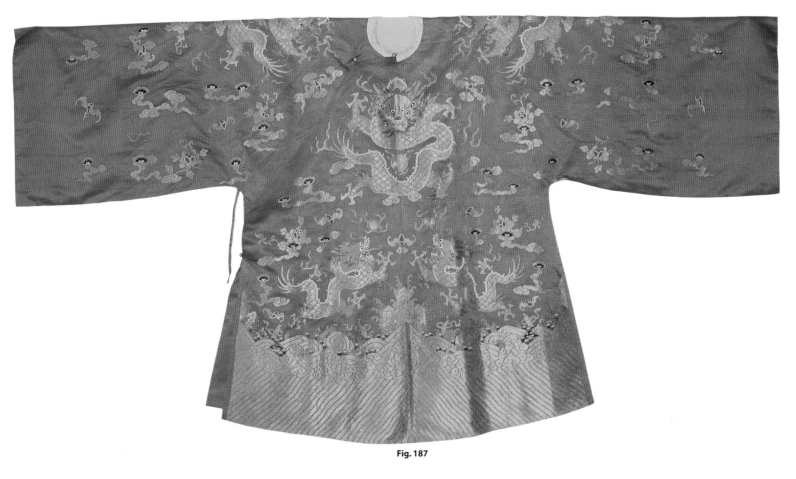

Fig. 187

Fig. 188

Fig. 187 Dragon jacket in red satin with ten four-clawed dragons and clouds embroidered in couched gold thread, ca. 1800.

Fig. 188 Green dragon skirt in *kesi*, the front and back panels embroidered with five-clawed dragons surrounded by bats and the Eight Buddhist symbols, the godets embroidered with standing and descending phoenixes, possibly made for a wedding, mid-19th c.

were only embroidered up to the point where the jacket met the skirt. The back and front panels were often identical and edged in braid. The skirt allowed ease of movement because of the many narrow pleats caught down in a honeycomb or fish-scale pattern, or godets to the left side of the panels, widening towards the hem (Fig. 188), swinging gracefully as the wearer walked

The stole or *xia pei* worn over the *mang ao* was also first worn on a woman's wedding day and later at events of special importance connected with her husband's status. It developed from a Ming stole into a wider, sleeveless stole held together with ties at the sides, reaching to below the knees and finishing with a fringe at the pointed hem. The *xia pei* was made of *kesi* or satin and decorated with dragons in profile and *li shui*, and there was a space on the front and back for a badge of rank corresponding to that of the husband (Fig. 190).

To offset the plain neckline of the *mang ao* and *xia pei*, and also to add status, a detachable collar with four lobed corners, known as a cloud collar or *yun jian*, was worn over the jacket and stole. The lobes at the four corners were positioned over the chest and back and at each shoulder, often in three widening layers. The lobes indicated the cardinal points, with the wearer's head the cosmic center. Some multi-lobed collars were highly decorated, with numerous petals radiating from the neckband over the shoulder (Figs. 189, 192). Others were embellished with elaborate tassels.

A coronet, called a "phoenix crown," modeled on those worn by empresses in earlier Chinese-ruled dynasties, especially the Ming, was worn on formal occasions. This headdress is formed over a copper wire base, and covered with kingfisher feather inlay flowers, butterflies, phoenixes with pearls, and tiny mirrors to deflect bad spirits (Fig. 191).

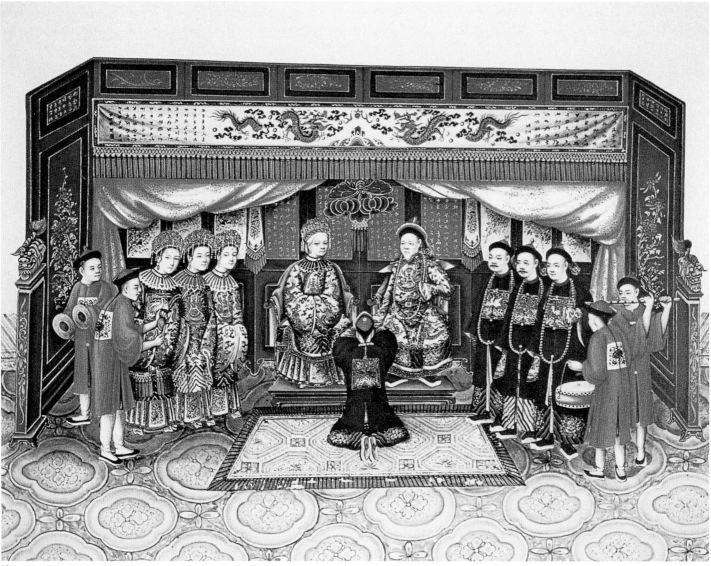

Fig. 189

Fig. 189 Painting by the Guangzhou artist Tinqua of a newly proclaimed mandarin kowtowing to his parents as other family members look on, all wearing official dress, including the women, who wear surcoats with rank badges, collars, and stoles, ca. 1850.

Fig. 190 *Xia pei* stole in dark blue silk with ties at the side, embroidered with gold couched dragons, satin stitch clouds and bats, Peking knot birds of the first, third, and fourth ranks on the front and the fifth, seventh, and ninth on the back, and a fourth-rank civil badge of couched gold thread, 19th c.

Fig. 191 Coronet or "phoenix crown," worn for formal occasions, made of copper wire covered with kingfisher feather inlay flowers, butterflies, phoenixes with pearls, and tiny mirrors to deflect bad spirits.

Fig. 192 Detachable "cloud collar" with four lobed corners worn by an older woman, 18th c. The design on the lobes, in counted stitch on silk gauze, is of the *shou* character surrounded by the Eight Buddhist emblems. In the four corners round the neck is the double *dorje*, a very powerful Buddhist emblem implying invincibility and impregnability against demons.

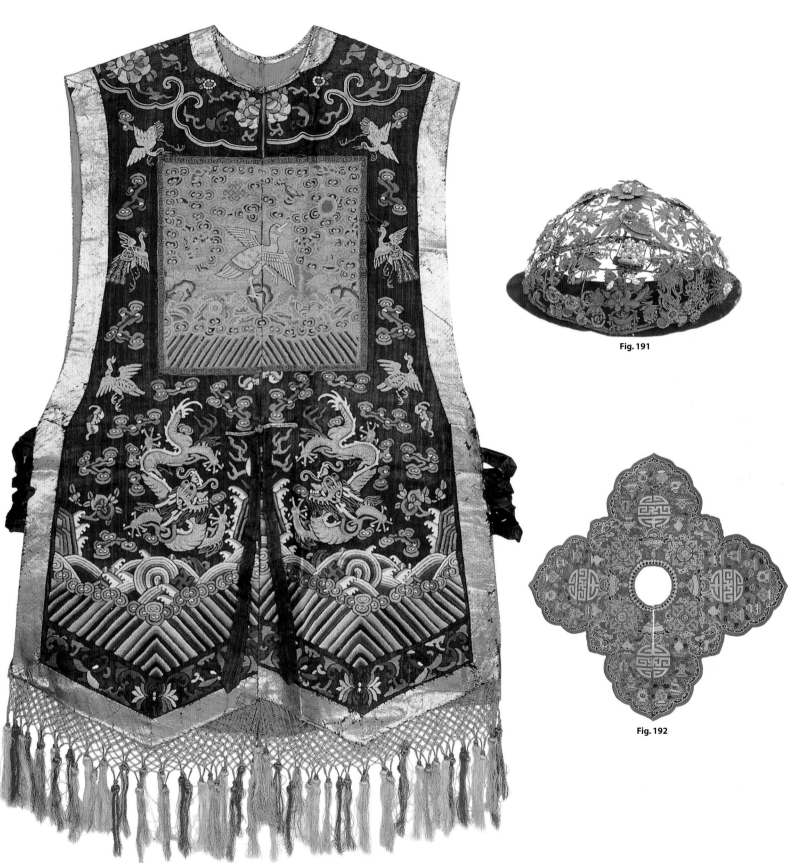

Fig. 191

Fig. 190

Fig. 192

Formal Wear

On occasions when a mandarin wore a dragon robe and his wife accompanied him, she would wear a surcoat and a highly decorated skirt. Although the surcoat was cut like the man's and opened down the front, towards the end of the dynasty it became more elaborate, with wide bands of embroidered satin forming deep cuffs. For "full dress" occasions, rank badges were attached to the front and back. Two short lappets hung down each side at the center front, echoing the *zai shui* pointed kerchief worn by Manchu women, but with less adornment (Figs. 193, 194). Completing the outfit, a *chao zhu* or mandarin chain, similar to the husband's, was worn with the surcoat and a more formal *xia pei* stole, but with the position of the three counting strings reversed.

Wives and unmarried daughters of Qing officials took the same rank as that of their husband or father. At first the badges were identical, but around the middle of the eighteenth century the custom began of depicting the wife's bird or animal facing in the opposite direction to that of her husband. In this way, when

Fig. 193

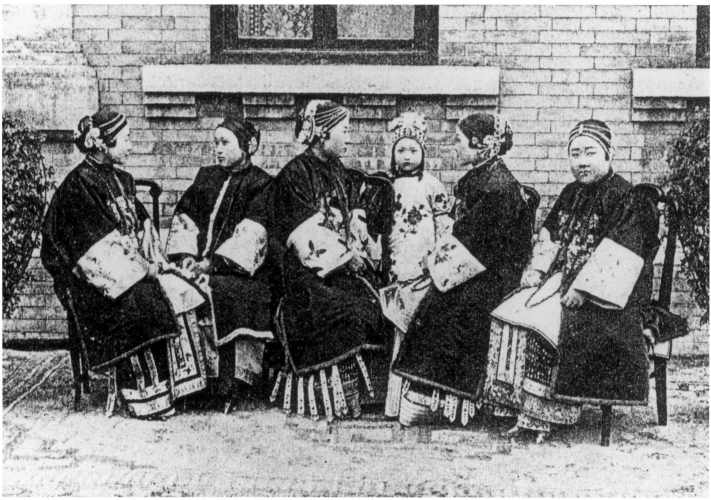

Fig. 194

Fig. 193 Black silk damask surcoat with a sixth-rank civil badge on the chest and back, couched gold and silver embroidery on the blue satin sleeve bands, with lappets representing a form of pointed kerchief, ca. 1900.

Fig. 194 Wives of high-ranking Chinese officials wearing surcoats bearing rank badges, headbands, and elaborate skirts with streamers, late 19th c.

Fig. 195 Insignia badge belonging to the wife of a second-rank civil mandarin depicting a golden pheasant embroidered in brightly colored satin stitch, ca. 1900.

Fig. 195

the husband and wife sat together in state, with the wife on the left of her husband, the animal or bird on their rank badges would face each other. Later on, at the end of the nineteenth century, the badges were made even more distinct when the embroidery formed a circle inside the square, or else became a complete roundel (Figs. 195, 196).

Birthday badges were worn by both men and women, and presented by family members to be worn on major birthdays, such as the sixtieth, seventieth, etc, on formal clothing. Auspicious motifs, such as the bat, phoenix, coins, and peaches, were embroidered in satin stitch around the edges or in the center (Figs. 198, 199).

Prior to her marriage, a woman would have the hairs on her forehead removed by a "fortunate" woman with many sons, using two red threads, to give a more open-faced look. This process was known as *kai mian*, literally "opening the face." (The practice, which dates back to the Shang dynasty (ca. 1600–ca. 1050 BCE), continued to be performed in Hong Kong in the 1990s.) The hair was then put up into a bun. A shaped, embroidered band was worn across the forehead for warmth, as pulling the hair back caused the hairline to eventually recede with this style. Only married women wore these bands and they were made or bought as part of the wedding dowry (Fig. 197).

Fig. 196

Fig. 197

Fig. 198

Fig. 196 Rank badge in *kesi* belonging to the wife of a seventh-rank civil mandarin, showing a mandarin duck surrounded by bats and four of the emblems of the Eight Immortals, ca. 1900.

Fig. 197 Left: Headband of yellow silk with an extended back flap, with a lion, butterflies, bats, flowers, and two horses over a *li shui* border embroidered in satin stitch. Right: Headband with a short flap embroidered with plum blossoms, the front depicting a scholar and horse successfully returning from an examination being greeted by his wife embroidered over a gold paper cut. Below: Headband of black satin with a reverse appliqué design at the sides and decorated with kingfisher feather dragons, jewels, and pieces of jade.

Fig. 198 Birthday badge embroidered with designs of flowers above *li shui*, a phoenix in the center, a border of bats and longevity characters, probably made for a woman, early 20th c.

Fig. 199 Birthday badge depicting bats for happiness, peaches for longevity, and coins for wealth above *li shui* embroidered in satin stitch, late 19th c.

Fig. 199

Semiformal and Informal Dress

For semiformal public occasions, the mandarin's wife wore the surcoat without a rank badge, corresponding to the "half dress" worn by her husband. At other times, such as private functions, the wife of a mandarin wore the *ao*, an elaborately decorated upper garment made from self-patterned silk damask, with broad plain or embroidered bands at the sleeves, neck, hem, and curved opening (*tou jin*). The curved front overlap of the *ao*, fastened with toggles on the right-hand side, was based on the Manchu tradition of using animal skins. While such skins required no reinforcement, after the mid-eighteenth century contrasting bias-cut borders outlined the edges of the *ao* to neaten and strengthen it and, later, to decorate it.

From the middle to the end of the nineteenth century, the woman's *ao* was cut very large, reaching the calf, and with wide sleeves. Bulky garments were a sign of wealth and dignity. Large quantities of silk fabric, which took a long time to produce, also reflected the status of the wearer. At this time, too, elaborate borders of contrasting colors edged with braid, and sometimes

Fig. 201

Fig. 200

lace, following fashion influences from the West, outlined the curved edge, sleeves, and hem (Figs. 200–203a, b, 204).

The *ao* was worn with a skirt or *gun*, which was often very colorful and decorative (Figs. 205–208). Certain colors indicated marital status. For example, older women wore black, while widows wore white as it is a color the Chinese associate with death. "Marrying the wearer of a white skirt" meant marrying a widow (Doolittle, 1895, Vol. 1: 100).

Informal dress for unmarried women consisted of the *ao* worn over loose trousers or *ku*. The *ao* had narrower, plainer borders at the neck and curved opening, and was also often made of cotton (Fig. 209). For warmth, a sleeveless side-fastening waistcoat edged with braid could be worn over it. The trousers were cut as straight tubes of fabric, with gussets to form the crotch, and were attached to a cotton or hemp waistband. The hems of the trousers were decorated with bands of silk or embroidery, which sometimes, but not always, matched the *ao* worn with them (Fig. 210). Leggings were also worn under the skirt in place of trousers (see Fig. 210). These were made separately for each leg and were fastened with a button or ties to a band round the waist.

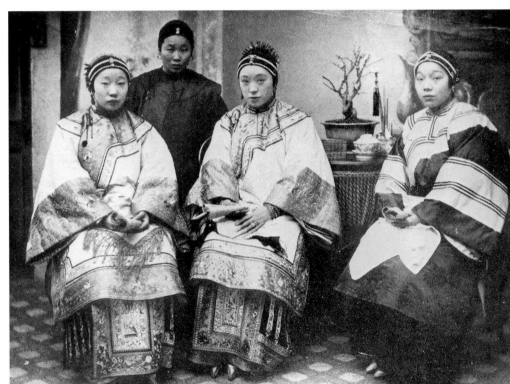

Fig. 202

Fig. 200 Woman wearing a semiformal jacket and skirt and holding a fan.

Fig. 201 Woman's jacket in red silk damask, embroidered all over with figures in a garden setting, the children playing, the adults enjoying a variety of leisure pursuits, the deep cuffs of the jacket edged with embroidered bands, mid-19th c.

Fig. 202 Three ladies, with their servant, wearing semiformal dress comprising a bulky, elaborately embroidered upper garment (*ao*) and skirt (*gun*), late 19th c.

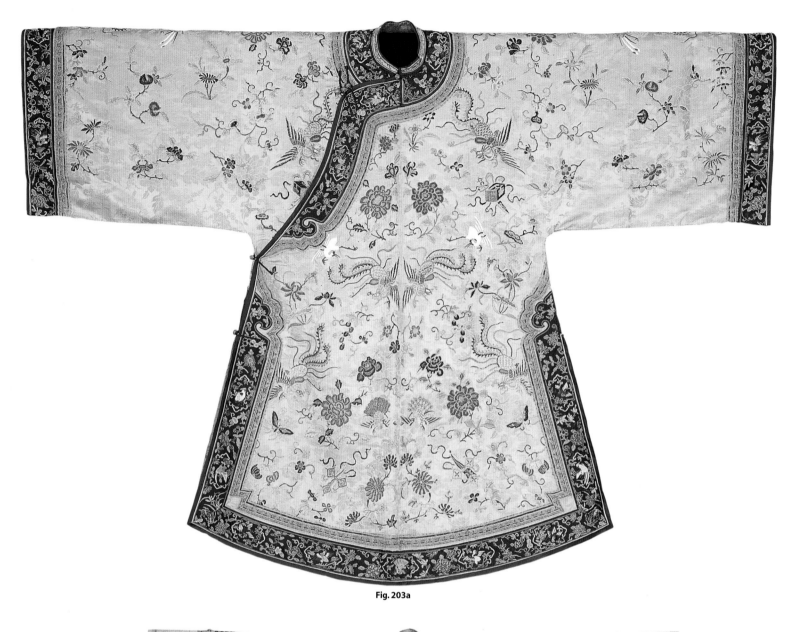

Fig. 203a

Fig. 203a, b Front and back of woman's jacket in turquoise satin embroidered all over with peonies, phoenixes, cranes, peacocks, and butterflies in Peking knot.

Fig. 204 Turquoise silk *ao* with a wide three-type border of plain bias-cut silk in pale pink, braid, and black lace, late 19th c.

Fig. 204

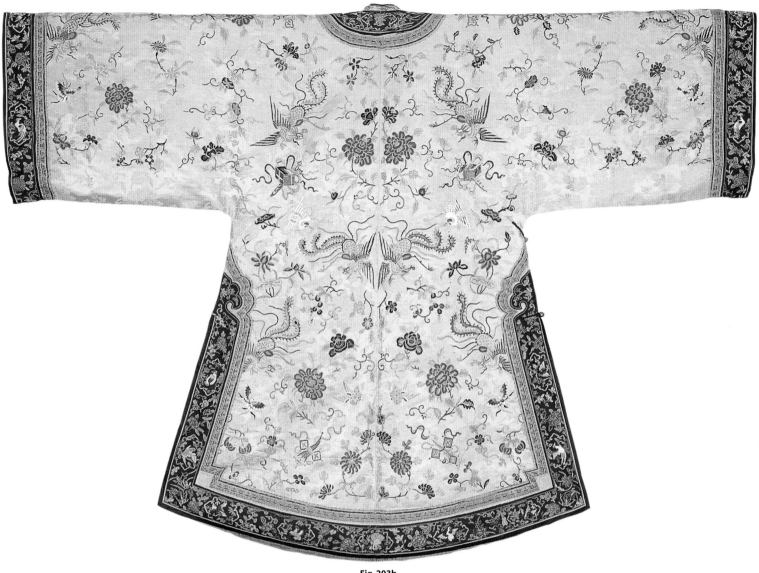

Fig. 203b

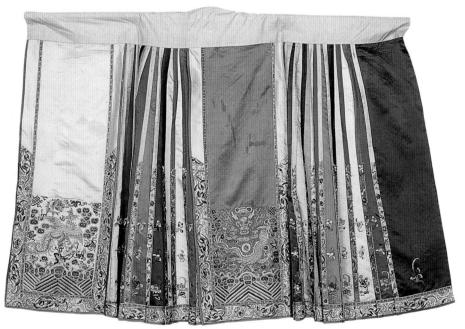

Fig. 205

Fig. 205 Skirt with multicolored embroidered dragons and phoenixes on the godets and panels at the back and front.

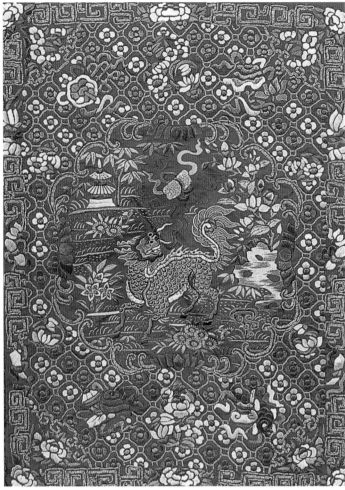

Fig. 206

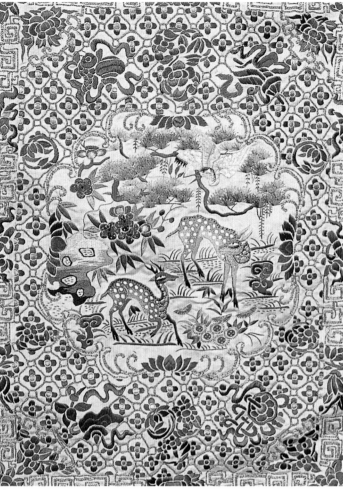

Fig. 207

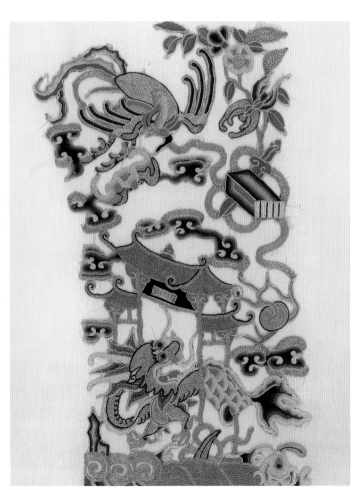

Fig. 208

Fig. 206 Detail of a panel from an older woman's skirt featuring the *qilin*, a symbol of great wisdom, surrounded by Buddhist emblems, flowers, and *lingzhi*, the sacred fungus said to give immortality, all embroidered with couched gold thread and satin stitch, late 19th c.

Fig. 207 Detail of the other panel from the skirt showing deer, a symbol of an official's salary, hence high status and wealth, surrounded by cypress trees and *lingzhi*, both symbols of longevity, late 19th c.

Fig. 208 Panel of Peking knot and couched gold thread embroidery to be used for a skirt. The design of a carp leaping through a gate and emerging as a dragon denotes a man passing the imperial examinations. Above the gate is a phoenix, symbolizing high achievement, a bat for happiness, and a set of books.

Fig. 209 Matching jacket and skirt in cream silk damask edged with pink bias-cut satin and braid, coins, and bats, outlined with piping; hemp waistband.

Fig. 210 From left: Trousers in lilac silk with an embroidered band and braid at the hem; leggings in blue silk jacquard embroidered with flowers at the hem in the "three blues" (light, medium, and dark blue), a color combination worn only by married women; leggings in blue satin tapering to the ankle, decorated with chrysanthemums in couched gold and silver thread.

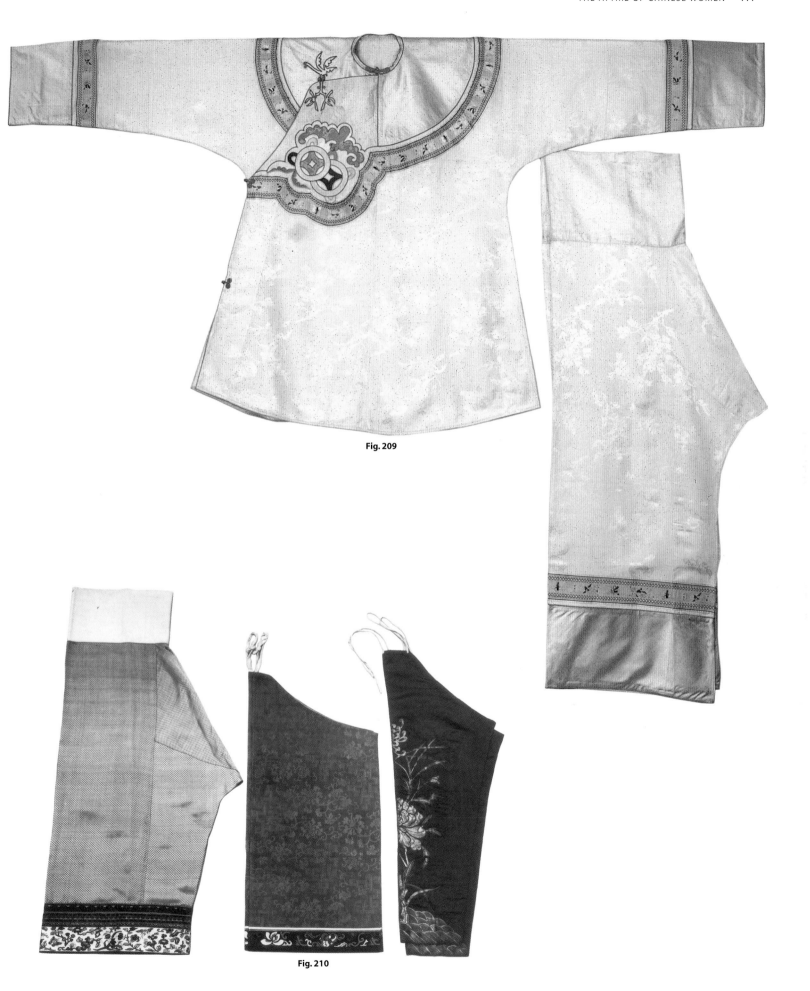

Fig. 209

Fig. 210

Fig. 211

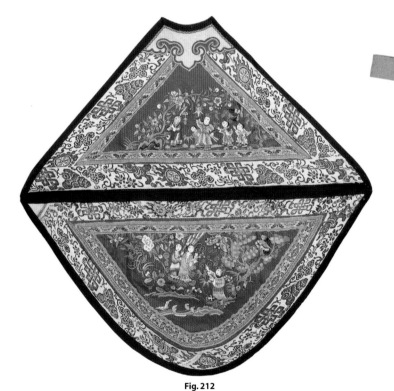

Fig. 212

Fig. 213

Fig. 211 Bamboo jacket made of fine tubes of hollow bamboo sewn together in a diagonal pattern and edged with cotton, 19th c.

Fig. 212 Woman's diamond-shaped *dou dou* (chest apron) worn as underwear, embroidered with figures in a garden, the edges trimmed with braid depicting the Eight Buddhist emblems.

Fig. 213 Money belt, the embroidery depicting a child wearing a *dou dou* sitting in a lotus flower, 19th c.

A bamboo jacket or vest was worn over a cotton under-jacket to aid air circulation and protect the outer jacket from being stained with perspiration in the hot weather. The one shown here was made of fine tubes of hollow bamboo sewn together in a diagonal pattern and edged with cotton (Fig. 211).

Chinese women wore a small apron or *dou dou* next to their skin to cover their breasts and stomach (Fig. 212). Made of cotton or silk and richly embroidered with auspicious symbols, the *dou dou* had developed from a bodice worn during the Ming dynasty, and continued to be worn up until the early years of the twentieth century by both women and children. The apron was narrow at the neck and had a wider curved base, and was held close to the body by a silver chain or tape around the neck and waist. The bottom half of the apron often comprised a pocket stretching the full width of the garment. Another type of apron, sometimes called a money belt, consisted of a shallow embroidered pouch for daily necessities (Fig. 213). It was worn around the waist and over the stomach and was fastened with tapes at the back.

Accessories

In addition to a liberal application of cosmetics, women spent many hours dressing their hair in the style of the time and the region. One writer describes how his sister would "make freshly the jelly-like liquid with which she polished her hair. For this she used very thin shavings of a wood called *wu-mo* or *pau-hua-mo*, which, after being steeped in water for a short time, formed a jelly-like liquid. After combing her hair out straight, my sister would brush it with this liquid and comb it again. She then dressed her hair according to the fashion of the time" (Chiang Yee, 1940: 52) (Fig. 214). Many ornaments or artificial flowers were added depending on the style of the region (Fig. 215).

A large number of hairpins made of gold, enamel, silver, or semiprecious stones, such as jade or coral, and fashioned into the shape of insects, birds, or butterflies were inserted into this stiff arrangement (Fig. 216). Those inlaid with kingfisher feathers in the form of bats, butterflies, and flowers were particularly popular (Fig. 218).

Han Chinese women pierced their ears and wore earrings made from a variety of materials, such as gold, jade, silver, coral, pearls, with kingfisher feather inlay to form auspicious emblems (Fig. 218). Equally elaborate rings were made of enamel, jade, semiprecious stones, and gold, inlaid with many different stones (Fig. 219). They also wore bracelets, anklets, nail extenders, and other items of jewelry made of jade, gold, silver, gilded silver, or enamel. (Women from poorer families wore jewelry made of *bai tong* as it resembled silver but was much cheaper.) Bracelets and anklets, generally worn in pairs, were made of gold, silver, enamel, horn, ivory, fragrant woods, jade, and other semiprecious stones decorated and inlaid with similar materials in the design of flowers and auspiciousemblems. Pendant charms made of jade, amber, or gold were also hung from the top button on the side of the *ao*. Other pendants were made of filigree metal in the shape of a potpourri container, and held fragrant herbs to sweeten the air.

Needle cases were made of silver or *bai tong*, often enameled, and pinned to the gown or attached to the top button. Originally, needles were made of ivory, bone, bamboo or porcupine quills. Later, in the nineteenth century, when steel needles were imported from Germany, they were expensive and needed to be kept in a safe place (Fig. 220).

Elaborately carved silver or *bai tong* chatelaines were also fastened to the top button on the upper garment. They comprised sets of three or five chains hanging from a central plaque, ending with a selection of tongue scraper, toothpick, nail cleaner, ear pick, and tweezers (which were also useful when making knotted fabric ball buttons and decorative loops used to fasten clothing) (Fig. 221). Long silver pendants with small silver charms filled with little bells, which tinkled as the wearer moved to scare away evil spirits, were another popular item (Fig. 221).

Fig. 214 Young woman having her hair combed by a servant. The woman, from southern China, has tiny bound feet while her servant has natural feet and is wearing boat-shaped shoes with thick soles, 1868.

Fig. 215 Young woman, her hair decked out with jade and coral hair ornaments, wearing earrings and bracelets, ca. 1850.

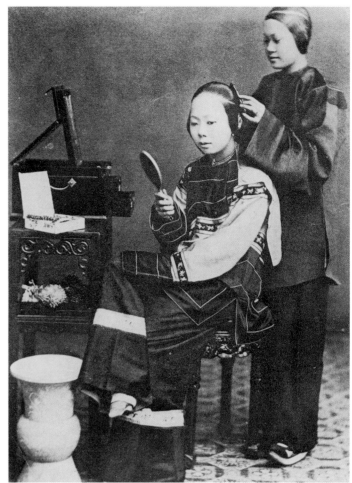

Fig. 214

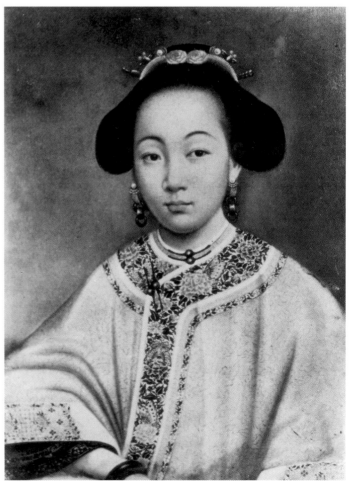

Fig. 215

Fig. 216

Fig. 217

Fig. 216 Young woman from Shantou in southeast China with her hair swept up and studded with hairpins in the style of butterflies and other auspicious symbols, ca. 1870.

Fig. 217 Chinese women holding *pien mien* fans, ca. 1905.

Fig. 218 Hairpins inlaid with kingfisher feathers. Above: Pair of hairpins incorporating bats. Center: Hairpin in the shape of a butterfly. Bottom left: Hairpin with bats and five strings of pearls and coral beads. Bottom right: Oval hairpin composed of flowers and butterflies.

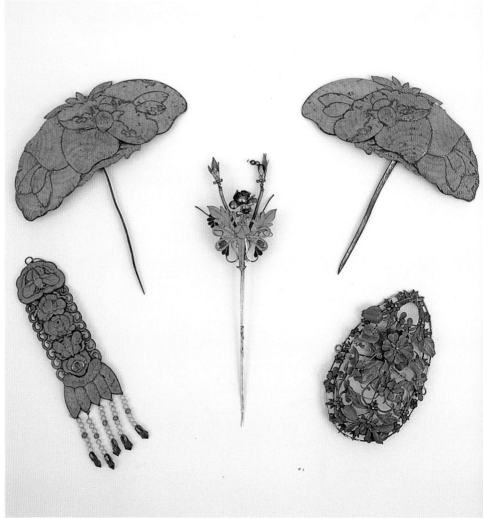

Fig. 218

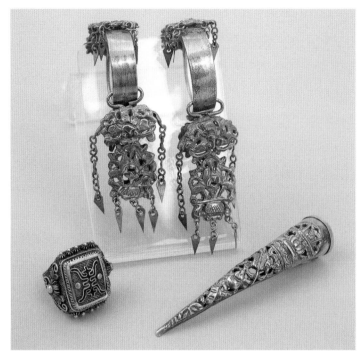

Fig. 219

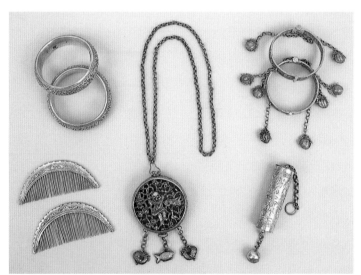

Fig. 220

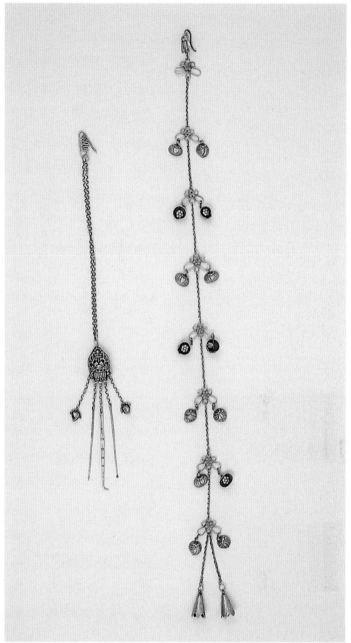

Fig. 221

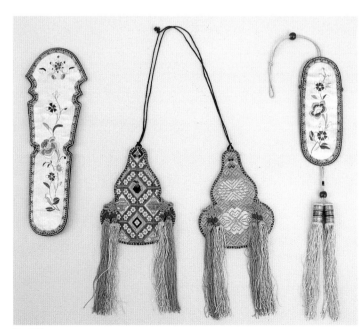

Fig. 222

Fig. 219 Above: Pair of hooped silver earrings in the design of bats and flowers, ca. 1900. Left: Silver ring with the *shou* character for long life in the center. Right: Silver nail guard engraved with Daoist emblems.

Fig. 220 Clockwise from top left: Pair of silver bracelets carved with designs of birds and flowers; silver pendant for holding potpourri, with an openwork design on the front of a laughing child, coins, bats, and flowers, and hanging charms of two cockerels flanking a fish; pair of silver anklets with hanging peach stone charms filled with bells; silver needle case decorated with figures in a procession of a successful graduate; two silver combs.

Fig. 221 Left: Chatelaine in silver comprising an earpick, nail cleaner, toothpick, and two peach stone charms hung from a floral plaque. Right: Silver pendant with small bell charms.

Fig. 222 Four women's purses made in Shanghai, early 20th c. Left and right: Matching fan case and spectacle case in cream silk with pink silk on the reverse, and edged with gold couching. Center: Pair of tobacco pouches made of voided satin stitch with a geometric design on one side and a floral one on the reverse, with decorative tassels at each side.

Unlike men, women did not wear a girdle around the waist, so purses were often hung from the top button of the *ao*. Both men and women smoked tobacco as it was thought to have medicinal properties. Gourd-shaped purses, often suspended from the stem of the pipe by a cord, were filled with tobacco, opening at one side only so that the long-stemmed pipe could be inserted (Fig. 222).

Rigid round or oval fans called *pien mien* had been popular since the Tang dynasty. They were made of bamboo or ivory with silk stretched across the frame and embroidered or painted. This type of fan continued to be carried through to the end of the nineteenth century (Fig. 217).

Bound Feet

The Han Chinese tradition of binding women's feet to make the feet appear as small as a lotus bud was thought to have started between the end of the Tang dynasty and the beginning of the Song. Legend has it that a favorite consort of the emperor danced for him having bound her feet to represent a new moon. The style was quickly adopted by women at court, and gradually spread outside court circles until it was almost universal in China. Bound feet restricted women's movements and made them subservient to men. Further-

more, the smell and size of the small foot, together with the woman's teetering gait, produced erotic associations for men, and few mothers would risk their daughters being unable to marry if allowed to have natural feet.

The Manchu, on taking power, tried unsuccessfully to ban the custom, but most Chinese women continued to bow to pressure and bind their daughters' feet. It was not until the end of the nineteenth century that the practice started to decline. Various anti-footbinding societies were formed by Westerners to promote its demise. Mrs Archibald Little, the wife of a Yangtze River merchant and scholar, was a leading exponent of the Natural Feet Society and very active in the fight at the turn of the century to denounce footbinding. It was banned by the new Republic in 1912, and gradually died out, although there was resistance to having natural feet in much of the country for some decades after that.

Footbinding began at any time when the girl was between the ages of three and twelve. The feet were usually bound to a length of 5 inches (13 cm); the "3 inch (7 cm) lotus" was quite rare, and only for those women who had servants to support them while walking (Fig. 223). In some cases, a woman was carried on a servant's back. "The appearance of the deformed member when uncovered is shocking, crushed out of all proportion and beauty, and covered

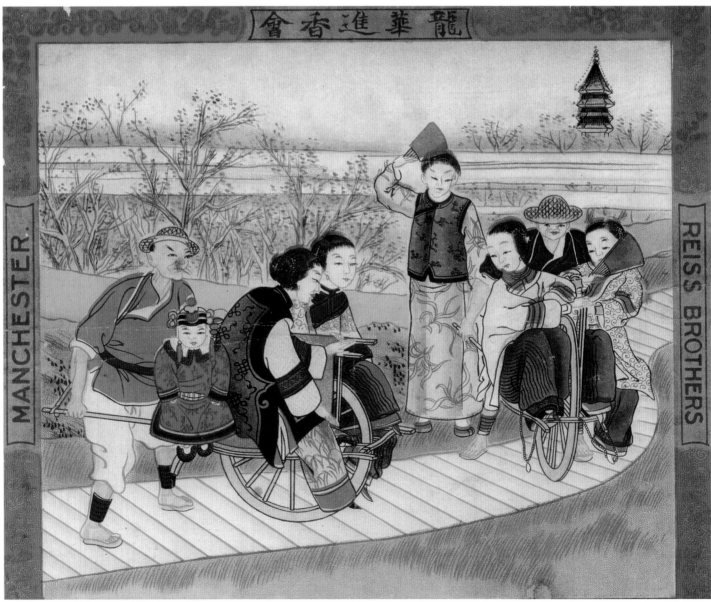

Fig. 223

Fig. 224

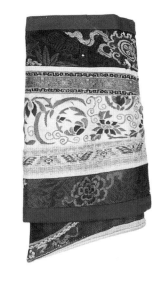

with a wrinkled and lifeless skin like that of a washwoman's hands daily immersed in soapsuds" (Wells William, 1883; reprint 1966, Vol. 1: 768) (Fig. 224). A binding cloth about 4 inches (10 cm) wide and around 100 inches (250 cm) long, of woven silk or cotton, either natural or dyed indigo blue, was tightly wrapped around the foot, starting at the toes which were forced in towards the sole. The bandage was wrapped around the heel to further force the toes and heel in towards each other (Fig. 225).

The method of binding varied from region to region. Sometimes, a wet cloth was used so that as it dried it tightened to give greater support. At other times, a small block of wood was inserted under the heel for support and the bandages wrapped over. Following a visit to Shantou, a treaty port in Guangdong province, Mrs Little wrote that girls' feet were not bound until they were almost thirteen so they could do more work, at which time "the foot is already too much formed for it to be possible to do more than narrow it by binding all the toes but the big one underneath the foot. An abnormally high heel is however worn, and this gives to the foot,

Fig. 225

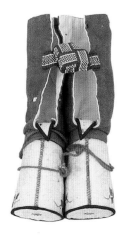

Fig. 226

Fig. 223 Advertisement of manufacturer Reiss Brothers of Manchester, depicting a group going to a temple, the women with bound feet being pushed in Shanghai wheelbarrows.

Fig. 224 Close-up of the bound feet of a woman showing one foot naked and the other in a shoe and ankle cover.

Fig. 225 Painting of a lady in the process of binding her feet.

Fig. 226 Boots are worn with ankle covers decorated with braid and embroidery. Top: Pair of boots with hidden inner heel supports (one shown center right), with attached ankle covers made of coarse blue cotton with metal stays (one shown center left). Bottom left: Rare pair of unused supports, with the blue and white woven cotton tapes still tied together, from the Shantou region referred to by Mrs Little. Bottom right: Small pair of supports with yellow embroidered heels with attached heel tongues.

placed slanting upon it, the appearance of being short. There is often a little round hole at the tip of the shoe through which the great toe can be seen" (Little, 1902: 339–40).

As well as making the foot appear even smaller, raising the heel made walking easier. Supports for bound feet came in several guises. A woman could cheat by putting a support shaped like an embroidered cotton reel inside her boot. The heel of the foot was raised by placing it on the support, which was then secured with tapes around the lower leg. Boots with rigid ankle covers had metal stays inside to support the leg and conceal the bandages (Fig. 226).

As part of her dowry, a woman would make several pairs of shoes as proof of her needlework ability as well as her small feet (Figs. 227, 228). First, she would make the vamp of silk or cotton and embroider it. Then, she would make the heel and sole from densely layered and stitched white cotton. Finally, she would join the vamp to the sole. A heel tongue and loops at the sides enabled the shoes to be pulled onto the foot more easily. After her wedding, a bride gave each of her main female in-laws a pair of shoes at a special ceremony known as "dividing the shoes."

There were some regional differences in shoes. In general, those from the north, especially Beijing, had a "bow" shape – an exaggerated curved sole and heel in one piece – often with leather reinforcements at the toe and heel. In the late nineteenth century and early twentieth century, style-conscious women from Shanghai, then becoming the fashion capital of China, preferred a multiple heel, while those from the southern provinces, such as Guangdong, wore shoes often made of black cotton or silk, with a fairly flat heel (Fig. 229).

Some shoes had embroidered soles for wearing indoors, while those made for burial had soles embroidered in blue or white, the traditional colors of mourning.

Leggings or tube-like ankle covers were worn to cover the bandages used for binding the feet. Leggings were made of silk with an embroidered hem, which hung over the shoe. They were fastened with ties or puttees around the calf, and the under-trouser legs tucked inside the leggings (Figs. 230, 232). The tops of the socks were wide enough to be pulled over the foot, where they were held in place with ribbons. Bandages were changed after bathing, but the shoes and leggings or ankle covers were the last items of clothing to be removed inside the curtained bedchamber, the small feet and their smell being a strong aphrodisiac.

Not all women bound their feet. In southern China, especially in Guangdong, and in Hong Kong, women from the Hakka ethnic group had natural feet and wore normal sized shoes, like those women who had been persuaded to give up foot binding. "At Canton [Guangzhou] the women with natural feet wear what is called the boat shoe, being shaped like the bottom of a boat, on which they can balance backwards and forwards. Boatwomen and working women do not bind there, which has given the foreigner, who so often gets his idea of a Chinese city from Canton, the impression

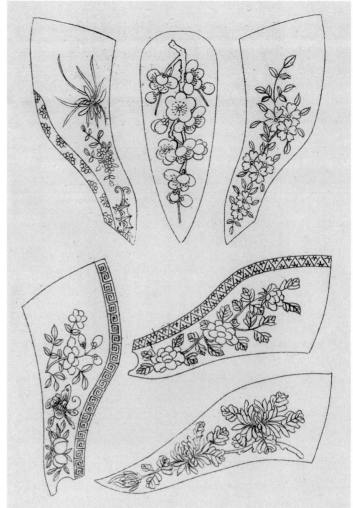

Fig. 227

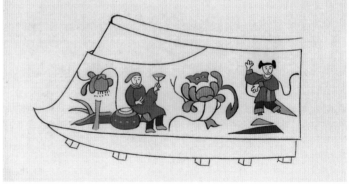

Fig. 228

that this is the case all through China. Alas! in the West [of China] women even track boats with bound, hoof-like feet, besides carrying water, whilst in the north the unfortunate working women do field work, often kneeling on the heavy clay soil, because they are incapable of standing…" (Little, 1902: 343) (Fig. 231).

Fig. 227 Pattern designs for bound feet shoes from a woodblock printed pattern book, 3rd year of the Republic, 1914.

Fig. 228 Pattern for bound feet shoes from a woodblock pattern book, showing a design of flowers and children playing. The metal cleats under the shoe are designed to raise and protect the silk embroidery from the dirt of the streets.

Fig. 229 Left: Boots for the bedchamber in red silk embroidered with lotus flowers and bats, symbols of purity, fruitfulness, and happiness. Top center: Shanghai-style shoes with multiple heels, the red satin embroidered with satin stitch and couched gold thread, 4 inches (11 cm) from heel to toe, made for a bride on her wedding day. Below center: Shoes for the bedchamber in red satin, the color contrasting with the white of the limbs, with bells inside the heels to fuel erotic associations. Right: Flat shoes in pink satin, embroidered with butterflies and the phoenix, 7 inches (18 cm) from heel to toe, made for women who had had their feet bound too long for them to regain their natural size, early 20th c.

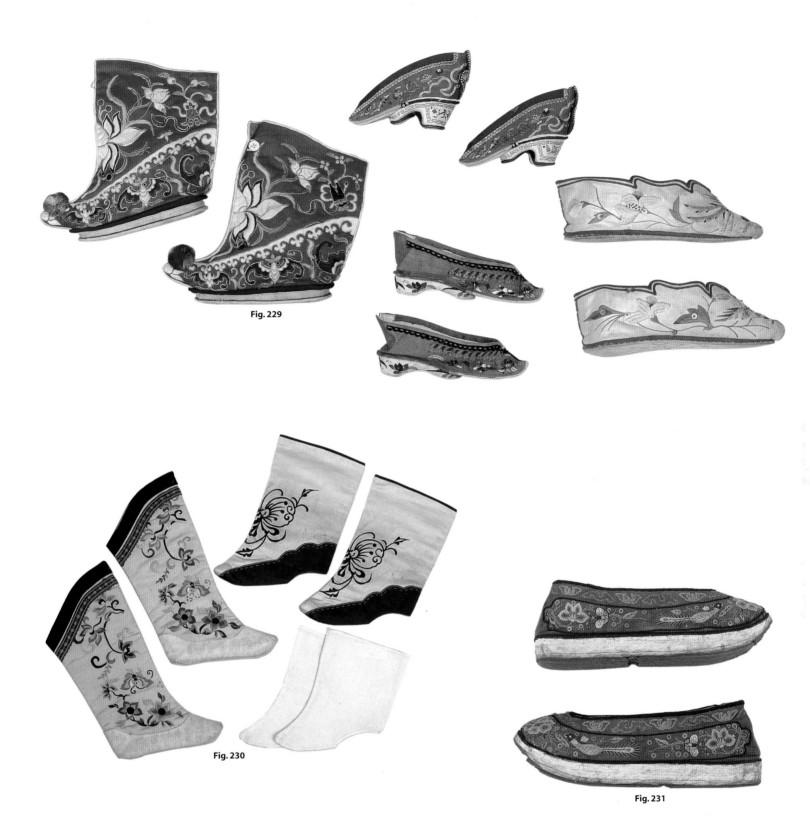

Fig. 229

Fig. 230

Fig. 231

Fig. 230 Left: Pair of padded socks in peach silk, lined with cotton and embroidered with flowers and butterflies in the "three blues," with cotton soles and heels. Top right: Pair of socks in pale green silk embroidered with black, with deep blue soles and a cutaway heel. Bottom right: Pair of socks made of fine white cotton with cutaway heels. All are worn over binding cloths.

Fig. 231 Boat-style shoes for natural feet, the vamp of purple silk embroidered in Peking knot with flowers and the phoenix, the sole made of several layers of paper, and the outer layer made of leather.

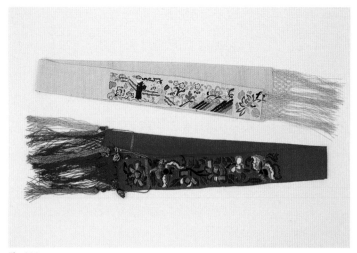

Fig. 232

Wedding Attire for Men and Women

The marriage ceremony in China has always been of great significance. This was true, not only for the bride and groom, but also for their immediate families and for the community in which they lived. The union was seen as a means of maintaining good ties and of establishing a firm bond between another family or village. The marriage was always an arranged one, with a matchmaker being called upon to consult horoscopes in an effort to find a son a suitable mate, and it was likely that the couple had not seen each other before the actual wedding day. This custom still continues in some rural areas.

The ceremony was the subject of elaborate preparations. An auspicious day was chosen according to the Chinese almanac, and the question of dowry and other gifts settled. The day before the wedding, the bride would undergo the *kai mian* custom to give a more open-faced look (see page 103). Her hair was then styled in the manner of the married women of her class.

A custom in some areas entailed the bridegroom's family sending to the bride "a girdle, a headdress, a silken covering for the head and face, and several articles of ready made clothing, which are usually borrowed or rented for the occasion. These are to be worn by the bride on entering the bridal sedan to be carried to the home of her husband on the morning of her marriage" (Doolittle, 1895, Vol. 1: 72). Wearing a veil to conceal the bride's face is known to have taken place as early as the Song dynasty.

The number of clothes worn by the bride and groom was important and conformed to the *yin* and *yang* principle, with an even number (*yin*) of garments for the female and an odd number (*yang*) for the male. The wedding attire worn by the groom was based on Manchu official dress. If the man was an official, a center-opening surcoat with badges of rank fixed to front and back was worn over a dragon robe. A plain surcoat and long blue gown were worn if he was not. A red sash or two, symbols of a graduate of the civil service examinations, were draped over the shoulder and tied at the waist. A winter or summer hat was worn with the insignia showing his rank as a mandarin, if he had such status. Fixed at each side of the hat were the two gilt sprays of leaves, which were part of the graduation dress.

The bride would be dressed in a red embroidered dragon jacket or *mang ao* around which was a hooped belt (*jiao dai*). Not every bride wore the *mang ao*. Some who were less wealthy wore a plain red silk or cotton *ao* (Fig. 233), sometimes with a detachable

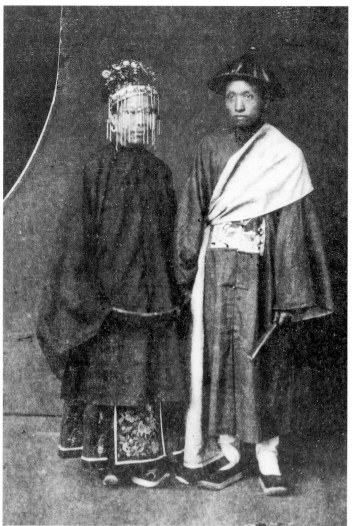

Fig. 233

four-pointed "cloud collar" (*yun jian*) to compensate for the plain neck of the *mang ao* (Fig. 234). The jacket was worn over a dragon skirt or *mang chu*, a pleated skirt with panels at the front and back decorated with dragons and phoenixes. The symbolism of dragon and phoenix, which represented the emperor and empress of China, was meant to emphasize the relationship between the imperial family and their subjects, and indicated the couple were "emperor and empress" for the day. The color of the skirt varied according to personal taste, although red or green were the most common. In order to raise the status of the skirt, it often had streamers attached to the pleated parts. In some instances, an overskirt was worn, consisting of two elongated pointed embroidered panels at front and back, and loose streamers at the sides attached to a cotton waistband (Fig. 235). This ensured that the skirt itself could be worn on other, less important occasions after the wedding. If the couple were of sufficiently high rank, the bride wore a stole (*xia pei*) over this outfit. After the wedding day, this would be worn on formal occasions.

On the appointed day, the bride left her home in a richly decorated sedan chair, closed and hidden from view (Fig. 238). When the wedding procession arrived at the groom's home, he would knock on the door of the chair with his fan; the bride then stepped out and the groom raised the red veil over the bride's head (Fig. 237). Even so, her face remained obscured by her heavy decorative headdress, which had many strings of pearls covering her features (Fig. 236).

Fig. 232 Above: Pair of puttees in tightly woven pale green silk with fringing at each end, and embroidered at one end with a design of flowers and figures in a garden. Below: Pair of puttees in red silk with blue embroidered flowers and butterflies, and bells and fringing at the ends.

Fig. 233 Cantonese bride wearing a plain cotton *ao* with a rigid hooped belt and a "phoenix crown," the groom wearing a surcoat with rank badges and a red sash, ca. 1870.

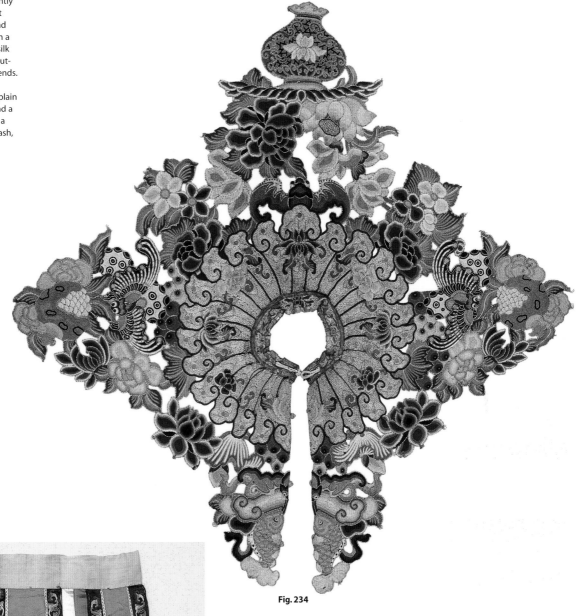

Fig. 234

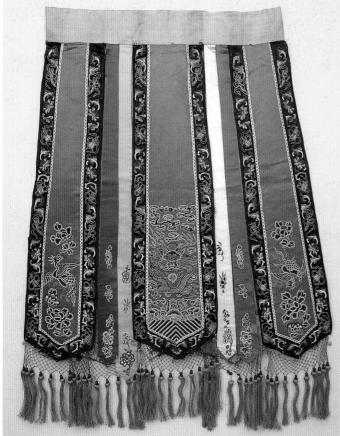

Fig. 235

Fig. 234 Detachable wedding collar covered completely with Peking knot outlined with couched gold thread, ca. 1800. The design is of peonies in a vase at the center back, two fish at the center front opening, four bats around the neck, and pomegranates over each shoulder. The radiating lobes round the neck are all embroidered in couched gold thread.

Fig. 235 Overskirt with red silk pointed panels, streamers and fringing, embroidered Peking knot phoenixes standing and descending, and dragons, mid-19th c.

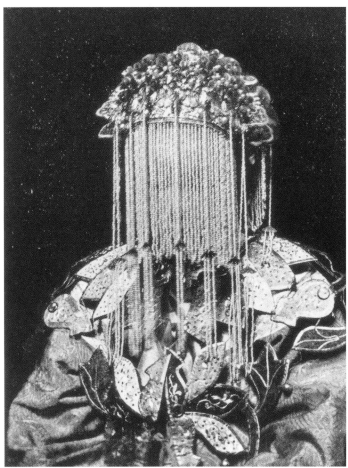

Fig. 236

Fig. 237

Fig. 238

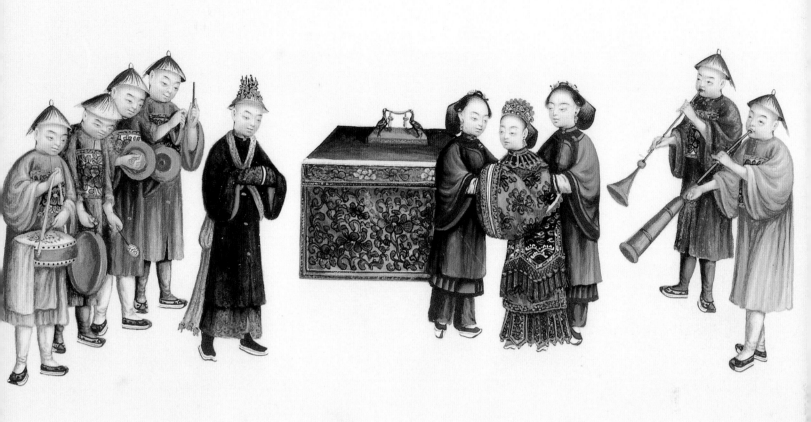

Fig. 239

After prostrating themselves before the altar, the couple was escorted to the bridal chamber. "The bride tries hard at this time to get a piece of her husband's gown under her when she sits down, for, if she does, it will ensure her having the upper hand of him, while he tries to prevent her and to do the same himself with her dress. The strings of pearls on her coronet are now drawn aside by the maids in attendance, in order that the bridegroom may have an opportunity of seeing the features of his bride" (Ball, 1900; reprint 1982: 370).

If at this point the groom was not happy with the appearance of his prospective bride, he was quite at liberty to send the girl back. However, if he was satisfied with her looks, the bride then kowtowed to her new in-laws and the pair offered them tea, thus establishing the bride as a member of the family (Fig. 239). Following a feast, friends and relatives made personal remarks at the bride's expense, often late into the night.

On the third day, the ancestors were worshipped again, and the couple paid a visit to the bride's parents. After this there was little communication between the bride and her family, as she was now considered to belong to her husband's family, and it was quite likely she would not see them again.

Funeral Attire for Men and Women

The Qing court and wealthy families continued the Ming dynasty tradition of having lavish funeral processions, and of being buried in great finery with many treasures. Those men who had held a position of power and authority wished to arrive in the next world with ample proof of their status (Fig. 240).

Preparations for burial, particularly with regard to the outfit in which a person would be buried, would start when he or she reached their sixtieth birthday, the end of the natural cycle of twelve times five. (This was actually the sixty-first birthday according to the Western calendar, since the Chinese system of numbering years means a baby is one year old at the moment of birth.) Inevitably, elderly men's birthdays were celebrated more grandly than those of elderly women. The most splendid celebrations marked a new decade – the sixtieth, seventieth, and so on.

Burial clothing for the wealthy was either made to measure or purchased ready-made from specialist shops. There were certain superstitions attached to the choice of clothing. Brass buttons were never used for fastening as they would weight the body to the earth, and, in general, buttons were avoided as the Chinese phrase for

Fig. 236 Bride wearing a jeweled head-dress, the numerous strings of pearls concealing her features, which were not parted until the last moment of the wedding ceremony. The coronet is decorated with artificial flowers, ca. 1900.

Fig. 237 Bride, her head covered with a silk square, and groom, with a servant, 1905.

Fig. 238 Bride being carried in an elaborately decorated wedding sedan chair, the bearers having the character for "double happiness" on the back of their jackets.

Fig. 239 Painting by the Guangzhou artist Tinqua of a bride and groom during the tea ceremony, 1850s.

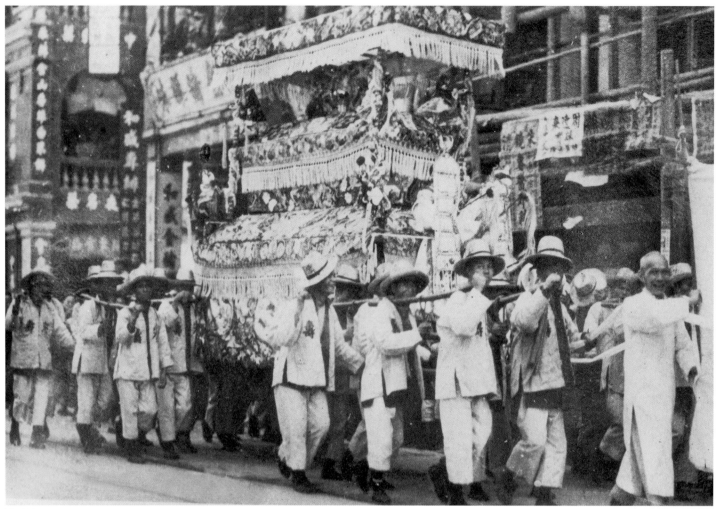

Fig. 240

buttoning a gown, *kou niu*, is similar to that meaning to detain somebody against their will. No fur was used on the clothing in case the deceased be reborn into the body of an animal. As it is considered more fortuitous, burial clothing is called *shou yi* (long-life garment) rather than a more literal expression.

The number of clothes worn for a burial was very important: "It is an established custom that, if three garments are put on the lower part of the person, five must be put on the upper part. The rule is that there must be two more upon the upper than upon the lower part of the corpse. Oftentimes there are nine upon the upper and seven upon the lower. Sometimes rich families provide as high as twenty-one pieces for the upper part of the corpse, and nineteen for the lower part" (Doolittle, 1895, Vol. 1: 175). For women, as a rule, there were six pieces on the upper part and four on the lower.

Next to the skin was a bleached cotton or ramie under-*shan* (upper garment fastening to the right) and under-*ku* (trousers), which would have been first worn for marriage, then put aside for burial. Two or three *shan* were placed over these garments, followed by the finest attire worn in life. High officials wore the *chao pao* court robe, lower ranks the *nei tao* long plain gown, as well as a surcoat, winter hat, and satin boots. Badges of rank were attached to the surcoat. Summer official dress was never worn, as winter apparel was considered to be more in keeping with death. Men without official rank wore the black *ma gua*, with the blue gown worn for ancestor worship or specially made for the occasion, plus a skullcap, shoes, and stockings.

For burial, the wives of mandarins were dressed in their bridal clothes, which had also been their official dress. These would consist of a *mang ao* dragon jacket, *mang chu* dragon skirt, *jiao dai* hooped belt, and *xia pei* stole. A phoenix crown was placed on the head and boots of red silk pulled over the bound feet. The deceased would also be adorned with many hairpins, rings, and bangles decorated with deer, tortoise, peach and crane – all symbols of longevity, good fortune and happiness.

Wealthy men without official rank were buried in a *shen yi* or "deep garment." This was made of deep blue silk, edged with a band of bright blue or white, and tied at the underarm. This large, enveloping garment with bell-shaped sleeves, similar to Ming robes, fastened over to the right or down the center front. It was worn with a long cowl hood and black satin boots.

A variation of the *shen yi* was the longevity jacket or *bai shou yi*, literally "one hundred longevity character garment" (Fig. 241). Made from deep blue or black silk edged with bright blue or white, it had *shou* longevity characters embroidered all over in gold, which were thought to have the power to extend the wearer's life. It either fastened over to the right like the "deep garment" or had a center front opening. It was only worn by the wealthy and was prepared in advance, sometimes being given to a parent by affectionate offspring. As most men with power and authority preferred to be buried in their official attire, longevity garments were usually presented to women. The longevity jacket was worn with a white pleated skirt edged in blue satin and decorated with many *shou* characters embroidered in blue (Fig. 242).

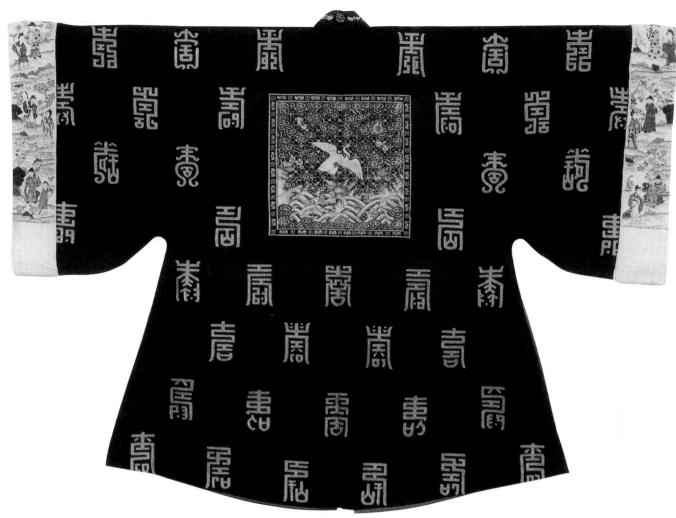

Fig. 241

There were five grades of mourning costume or *wu fu*. The first, and most important, was for parents or husband. A dress of undyed, unhemmed coarse hemp was worn with a headdress of hemp, grass sandals, and bamboo mourning staff. This grade of mourning lasted twenty-seven months. Wearing hemp in this unfinished state symbolized the greatest manifestation of poverty by the son, and represented the traditional idea of giving all one's possessions to the deceased to ensure a comfortable life in the next world. This sacrifice was also demonstrated by the dead person's rich finery. The second grade was for wife, grandparents, and great-grandparents, for whom the mourning period was one year. They were accorded a dress of undyed, hemmed coarse hemp, with a hemp headdress, shoes, and bamboo mourning staff. The third grade was for brothers, sisters, and other close relatives, and a dress of coarse hemp was worn during the nine months of mourning. A fourth grade, lasting for five months, was for aunts and uncles and consisted of a dress of medium coarse hemp. The final grade was for distant relatives and lasted for three months; here finished hemp was worn.

Fig. 242

Fig. 240 Chinese catafalque being carried by professional mourners, early 20th c.

Fig. 241 Back view of a longevity jacket (*bai shou yi*) for the wife of a first-rank mandarin, made in black satin with gold couched *shou* characters and embroidered sleeve bands, with a first-rank civil badge at the front and back, mid 19th c.

Fig. 242 Longevity skirt in white satin with *shou* characters embroidered in blue, 19th c.

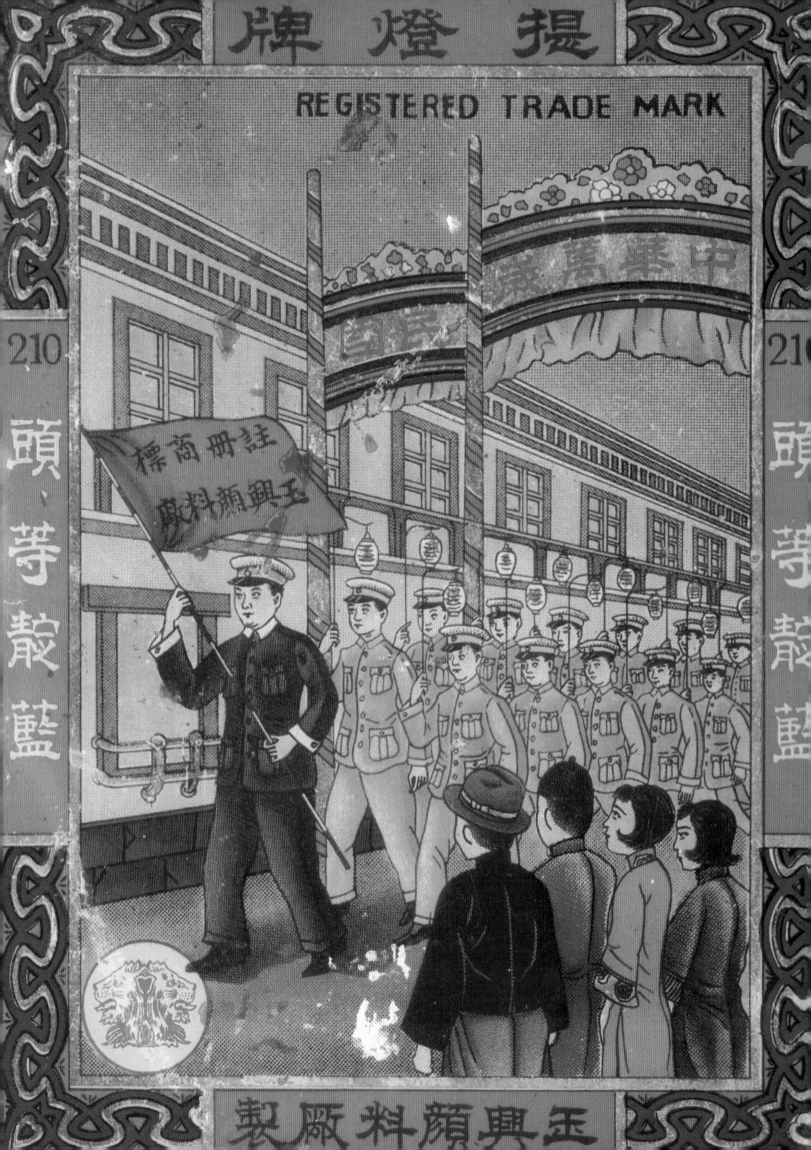

Chapter Five

REPUBLICAN DRESS
1912–1949

The New Republic

By the early twentieth century, the Qing dynasty was crumbling, brought on by rebellions, economic disasters, and foreign imperialism. In 1911, the Revolutionary Alliance Party or *Tung Men Hui*, led by a Western-educated medical doctor more interested in politics than helping the sick, brought about the downfall of the Manchu government. The last emperor, the infant Puyi, abdicated in 1912, and Dr Sun Yatsen from Guangdong province became the first President of modern China. He held office for just six weeks before standing down in favor of a powerful northern general, Yuan Shikai, whose ambition was to continue the empire under his rule.

In 1914, as President of the Republic, Yuan Shikai revived an important ceremony, the Sacrifice at the Temple of Heaven, formerly carried out only by emperors, and proclaimed the beginning of a new dynasty. A robe and hat specially designed for him to wear

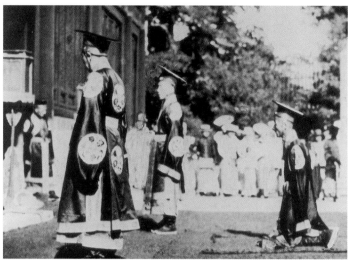

Fig. 244

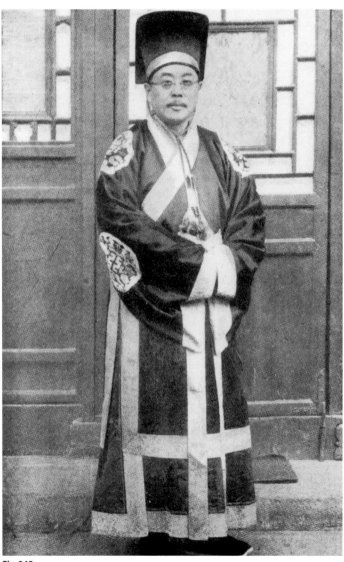

Fig. 245

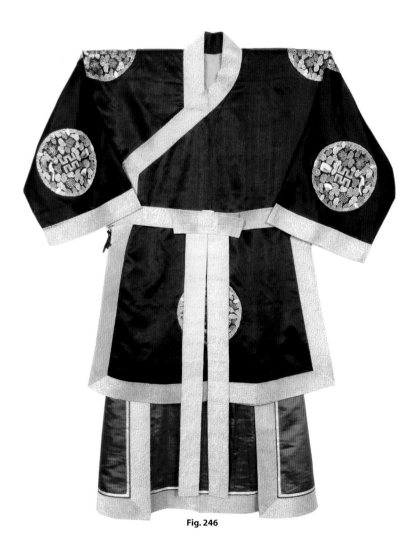

Fig. 246

(Page 126) Fig. 243 Picture on a can of dye produced for a manufacturing company in Shanghai showing young men marching through the streets in the Zhongshan-style uniform.

Fig. 244 Zhang Zuolin, a first-rank official in Yuan Shikai's government, wearing a hat and black satin robe edged with brocade and modeled on the old Chinese ceremonial attire, the robe having nine roundels containing nine of the Twelve Symbols – one on each shoulder, two on the lower front skirt, one on each lower sleeve, two on the lower back skirt, and one on the upper back.

Fig. 245 Third-rank official in Yuan Shikai's government wearing a robe with five roundels at the sacrificial ceremony at the Temple of Heaven in Beijing.

Fig. 246 Gown of black satin edged with blue/gold brocade, tied under the arm and lower down at the side and with seven roundels with seven symbols, made for a second-rank official. Worn over a purple satin gored skirt edged with blue/gold brocade and narrow gold braid. The skirt is composed of two parts, the wider for the back overlapping the narrower front section, and tied at the waist. Belt and sash/bow made of blue/gold brocade. Belt fastens with a heavy brass buckle and sash/bow hooks over the top.

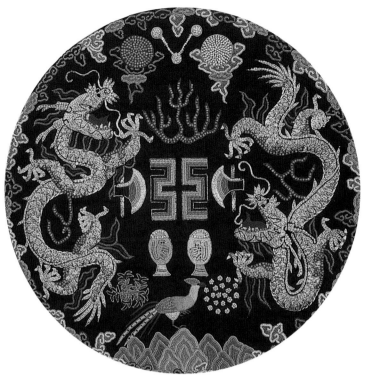

Fig. 247

Fig. 248

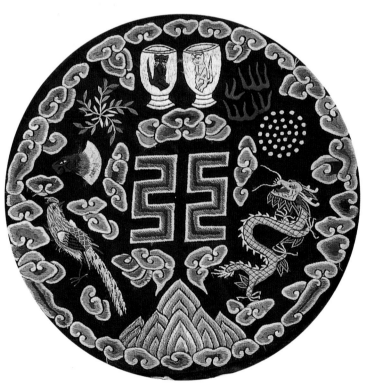

Fig. 249

Fig. 250

Fig. 247 Roundel from a set of twelve, each containing all Twelve Imperial Symbols, made for President Yuan Shikai, 1914. Seed pearls form the constellation of three stars, the moon, millet, and edge of the gold dragons. Coral beads form the sun and flame motif. Other symbols – the axe, *fu*, cups, phoenix, waterweed, and mountain are embroidered in Peking knot.

Fig. 248 Woodblock print from the Republican Regulations of the back apron skirt for the President, composed of four gored panels embroidered with clouds and *li shui* and edged with brocade; the separate front apron skirt has three panels. The apron skirt for first- to fourth-class officials was plain with a brocade border. The fifth-rank skirt was plain with edges outlined with a narrow braid.

Fig. 249 Roundel in black satin made for a first-rank official with nine symbols. Roundels for officials in descending ranks had to be progressively less colorful, without the use of gold thread, which was only permitted on roundels for the President.

Fig. 250 Roundel in black satin for a third-rank official containing five of the Twelve Symbols embroidered in blue and white. The robe would have had five roundels – one on each shoulder, one on each lower sleeve, and one in the center back.

at the Temple of Heaven were based on the regalia worn by the Han and Ming emperors at sacrificial ceremonies. The robe, made of black satin with a border of gold brocade, fastened over to the right, and was emblazoned with twelve roundels containing the full Twelve Imperial Symbols (Fig. 247).

Officials who participated in the ceremony also wore gowns of black satin but theirs were edged with bands of blue brocade. The laws laid down for Republican dress decreed that first-rank officials should wear nine roundels with nine symbols on their robes (Figs. 244, 249); second rank, seven roundels with seven symbols (Fig 246); third rank, five roundels with five symbols (Figs. 245, 250); fourth rank, three roundels with three symbols; the fifth, and lowest, rank wore a robe with neither border nor roundels.

The gown was worn over an apron skirt of purple satin edged with blue/gold brocade (Figs. 245, 246, 248). Around the waist was a belt of matching brocade with a separate bow and long ties. A flat hat made of black satin with couched gold thread embroidery completed the outfit. Some hats had strings of pearls that hung over the face similar to the hats of the earlier Chinese emperors.

Formal Dress for Men

Yuan Shikai's reign was short-lived for he died in 1916. Dispute over the control of Beijing intensified, and another turbulent period in China's history followed. With the collapse of imperial rule, and after failed attempts to restore the monarchy, dragon robes and their attendant regalia were gradually phased out, although Puyi, the deposed Xuantong Emperor, continued to live in the northern section of the Forbidden City until November 1924.

After the establishment of the Republic in 1912, government ministers were required to wear Western-style dress. From the end

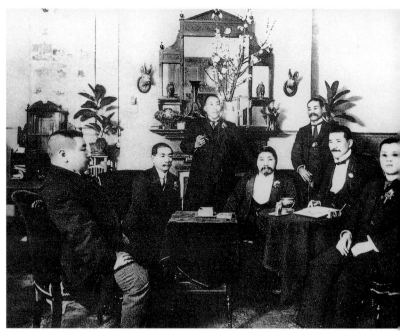

Fig. 251

of the nineteenth century, Western influences had begun to affect the clothing traditions of men involved in commerce and industry. Now, more and more foreign businesses entered the country and a mixture of Western and Chinese dress was common, especially in the main ports and cities. People began to travel and work overseas and their "home remittances" affected the lifestyle of those left behind, while many returning students adopted Western dress.

Regulations published in government gazettes laid down the correct official attire for both men and women (Figs. 252, 253). Women were expected to wear an embroidered Chinese-style

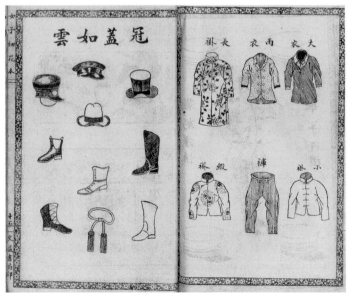

Fig. 252

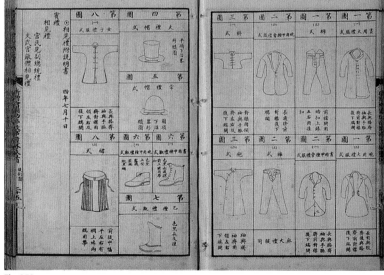

Fig. 253

Fig. 251 Dr Sun Yatsen and other luminaries wearing Western evening dress, discussing the formation of a provisional government in Shanghai, 1911.

Fig. 252 Page from a woodblock printed book showing hats and clothes, 1913.

Fig. 253 Pages from a compendium first published in 1920 showing a mixture of Chinese and Western clothes for men and women prescribed as official dress in the early Republican era, Shanghai; reprinted 70th impression, 1929.

Fig. 254

jacket with a skirt based on the Qing style, but made in one piece, not two. For formal day wear, men had to wear a black jacket and trousers in the Western style with a bowler hat, and for evening, a Western-style dinner suit and top hat (Figs. 251, 252). At other times, a Western suit or a long, side-fastening Chinese gown with a hip-length jacket on top (*chang shan ma gua*) could be worn (Fig. 255). It was stipulated that the various forms of male and female dress were to be made from Chinese or "national," as opposed to foreign, materials. It is clear that despite its foreign origins and appearance, the new dress, designated for all ceremonial occasions, great and small, was to be utilized as an instrument of the newly re-established national pride in China, and of being Chinese.

The *chang shan ma gua* was worn with either a black skullcap or a Western-style felt trilby (Figs. 254, 256). Since the overthrow of the Manchu, Han Chinese men were no longer required to wear the queue, but many continued to shave their heads, often completely. To keep out the winter cold in the north, a black satin hat, lined with fur, was worn with earflaps and a back flap attached to

Fig. 255

Fig. 254 Four generations of a merchant family, aged between thirteen and eighty-five. The men are wearing the *ma gua* hip-length jacket with the long gown, while the young boy wears a sleeveless *bei xin* waistcoat over his gown, 1913.

Fig. 255 Staff of the Sincere department store which opened in Shanghai in 1917, some wearing Western dress, others Chinese dress.

Fig. 256

Fig. 257

the hat. Black cloth shoes, often made of felt, with thin leather soles, replaced the high black satin boots.

When the capital moved south to Nanjing in 1927, the traditional *ma gua* and *chang shan* were established as formal, official wear for men, and were worn for important ceremonial occasions such as weddings and when worshipping in temples and ancestral halls. When worn as formal wear with the *ma gua*, the long gown was usually blue, but when the gown alone was worn it could be gray, brown, or black. A stand-up collar replaced the narrow collar binding at the beginning of the twentieth century. For less formal occasions, a sleeveless center- or side-fastening waistcoat was worn over the gown.

By the mid-1930s, men in China's major cities had adopted many aspects of Western dress, including plus fours, patterned socks, knitted sweaters, and straw boaters (Figs. 257, 258). At the same time, although life went on as normal, defense forces began mustering as war loomed, with the Japanese occupying some parts of China. The Sino-Japanese War, which lasted from 1937 to 1945, brought about many changes in society, not least the way people dressed. Many more men wore Western suits and ties to work, while

a more traditional two-piece outfit of jacket and trousers was worn for informal occasions. The jacket was cut like the long gown, but without the inside flap on the right-hand side, and it opened down the center with seven buttons. Patch pockets were added to the front. The sleeves were cut longer and wider, and the cuffs of the under-garment were sometimes turned over the top jacket or coat. Detachable white cuffs turned back were worn for an added touch of elegance. The jacket and trousers were often made in matching silk or wool mixtures.

The Sun Yatsen Suit

During the first half of the twentieth century, military uniforms also underwent great change, becoming more Westernized with elements from many nations. What later became China's national dress is credited to Dr Sun Yatsen, often referred to as the Father of Modern China. Sun Yatsen is reputed to have brought a Japanese student uniform to Rongchangxiang, a clothes shop on Nanjing Road in Shanghai, and asked the Western-trained tailor to design a suit based on the style, with a fitted jacket, closed stand-up collar,

Fig. 256 Three men in a park wearing *chang shan ma gua*, two with trilby hats, one with a skullcap, 1920s.

Fig. 257 The last emperor, Puyi, playing golf after giving up the throne. He is wearing a flat cap, plus fours, and a Fair Isle sweater.

Fig. 258 Man in a Shanghai department store wearing a straw boater and Western suit and shirt.

Fig. 259 Dr Sun Yatsen wearing the Zhongshan-style uniform, 1924.

Fig. 260 Mao Zedong in a Zhongshan suit, later becoming known as the Mao suit, 1936.

Fig. 261 In the late Qing and early Republican era, many young people studied abroad, and new schools and new Western-style student uniforms appeared.

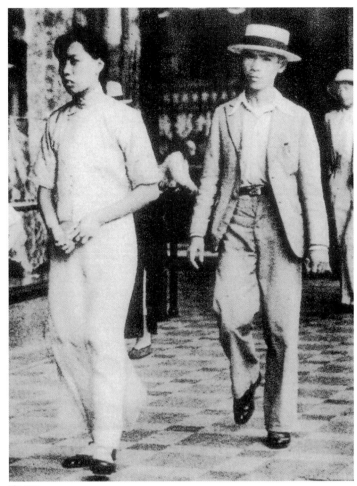

Fig. 258

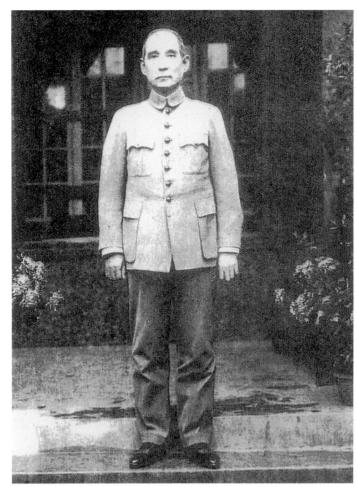

Fig. 259

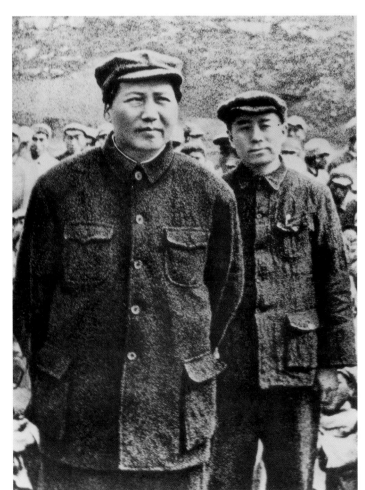

Fig. 260

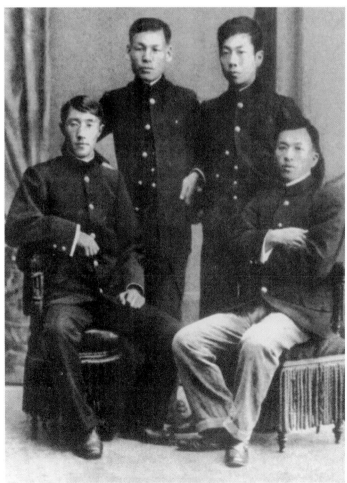

Fig. 261

and center front opening (Fig. 259). It became known as the Yatsen suit, or *Zhongshan zhuang*, Zhongshan being the county of his birth in Guangdong province. Another school of thought believes it was based on existing Chinese student uniforms in Hong Kong, which were "very similar to that worn by British soldiers…. It was but a short step from the high collared tunic with breast pockets worn by these Hong Kong students to the Sun Yatsen suit of the Republic…" (Scott, 1958: 65–6).

The new Republic adopted the Yatsen style for its officers, worn with a hard flat peaked cap and trousers pushed into knee-high boots. In the early 1920s, the outfit was redesigned with a high turn-down collar, four gusseted patch pockets on the front of the jacket, and a fastening of five or seven buttons (Fig. 261; see also Fig. 243). The four pockets were said to symbolize the Four Cardinal Principles of conduct cited in the *Book of Changes*: propriety, justice, honesty, and a sense of shame. The fitted jacket, which demanded an erect posture, was in deliberate contrast to the flowing, loose, and slightly effeminate gowns of earlier times.

After Sun Yatsen died from cancer in 1925, Chiang Kaishek became commander-in-chief of the Nationalist armies of the Guomindang. The Guomindang established itself as the Nationalist government in 1928, and the following year stipulated that the Sun Yatsen suit be official dress for civil servants. The leader of the opposing Communist Party, Mao Zedong, had founded the Red Army to fight against the Nationalist government in August 1927. Mao Zedong adopted the modified Sun Yatsen suit, and soldiers and officers of the Red Army wore the suit as military attire. This later became known as the Mao suit (Fig. 260). Communist sympathizers also adopted the style, including many women, such as Jiang Qing who married Mao in 1939, and American secret agent and foreign correspondent Agnes Smedley. Wearing it was seen as an anti-fashion statement at a time when the popular and curvaceous cheongsam accentuated a woman's figure.

Women's Dress 1912–1925

The atmosphere of change in the late Qing period and the formation of the Republic in 1912 brought about wide-sweeping reforms for women, including women's clothing. Footbinding was legally abolished, and girls were granted a formal place in the educational system, with some daughters from wealthy families being sent overseas to study.

A number of educated women, especially those in major cities like Shanghai and Guangzhou, adopted Western fashions, a trend which had begun at the end of the nineteenth century when a number of Chinese women in the public eye started wearing Western dress. These women may have been influenced by missionaries or by other Western women with whom they came into contact, or even by foreign magazines and newspapers, which were increasingly available. But the tightly corseted dresses, large hats, gloves, and

Fig. 262

Fig. 263

Fig. 262 Pale green silk *ao* with appliquéd black piping decoration around the edges, and a black satin skirt with elaborate fringing and piping decoration, ca. 1915.

Fig. 263 Gray damask silk skirt with appliquéd motifs and braid decoration, 1915–20.

Fig. 264 Shanghai "sing-song" girls wearing headbands and the fashionable, exaggeratedly high collars on the *ao*, ca. 1915.

Fig. 265 Chinese lady wearing Edwardian-style dress and hat, 1909.

Fig. 266 Woman in a high-collared sleeveless tunic over a blouse and paneled skirt, ca. 1915.

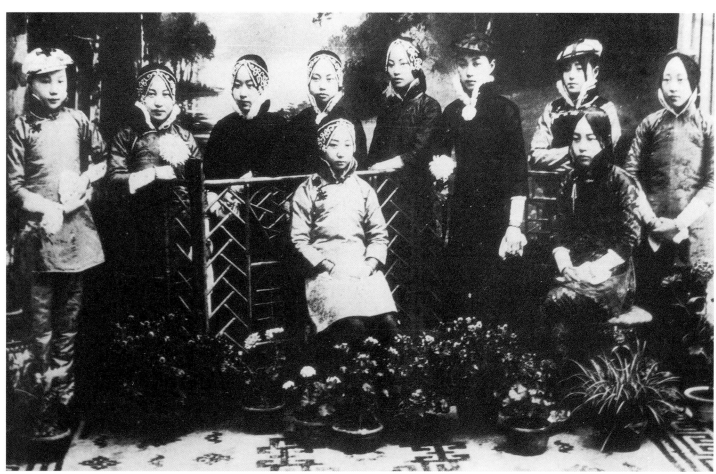

Fig. 264

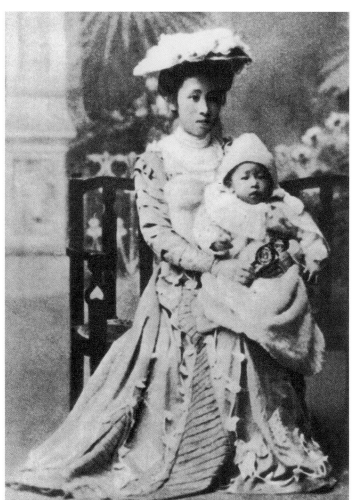

Fig. 265

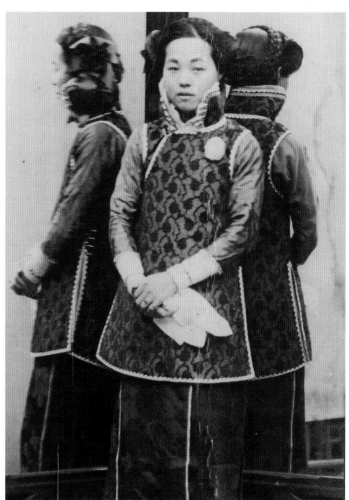

Fig. 266

parasols of the Edwardian era looked costume-like on the diminutive Chinese figure, and the trend was short-lived (Fig. 265).

With growing emancipation for middle- and upper-class women, accelerated by the May Fourth Movement in 1919, the bulky robes worn in the past were discarded, being considered outdated and cumbersome. Gradually, a style of dress evolved which was more in keeping with the current way of life yet which continued to maintain the Chinese style. The *ao* upper garment became slimmer and longer, reaching to below the knee; the sleeves narrowed to the wrists; the side slits were shortened, reaching to the lower hip, and all the edges of the *ao* were trimmed with narrow braid instead of the wide bands of embroidery popular in the past (Fig. 262). The collar became as high as it would ever be, with the corners sometimes turned down. Some exaggerated collars reached up to the ears to meet the wide headband, thereby accentuating the wearer's oval face (Figs. 264, 266).

The *ao* was worn over an ankle-length skirt, usually black, which had now become a one-piece garment with panels at front and back attached to pleats or godets at the sides (Figs. 262, 263). Unmarried women who wore the *ao*, donned trousers that were narrower and made in softer colors, often pastels, and usually both garments forming a matching set (Fig. 269).

By the early 1920s, the upper garment had become more fitted and shorter, extending only to the top of the hip, and with a rounded hem. Sleeves became three-quarter length, although very fashionable women preferred wide rounded cuffs, and the collar was reduced to a more comfortable width (Figs. 267, 268, 270–272). With the shortening of the upper garment at the beginning of the 1920s, the skirt became plainer and hem lengths rose gradually. The skirt was now cut in a simple flared style, very often of black silk damask, and worn by both married and unmarried women (Fig. 274). By this time, the wide waistband had been replaced by a narrow band through which a cord or elastic was threaded (Fig. 273). Cloaks were worn with evening dress, a fashion also popular in the West at this time (Figs. 277–280).

In the home, the austere, formal Chinese interiors of a generation earlier were replaced by drawing rooms filled with comfortable European-style upholstered furniture (Fig. 276). Labor-saving devices and servants who were still available meant that wives of wealthy businessmen had more time for new outdoor pursuits such as golf, horse-riding, and driving a car, as well as old favorites like mahjong. Some women studied to become teachers and nurses, or took up employment as secretaries, telephone operators, or waitresses as these service industries developed.

A move away from embroidered clothing to patterned materials like woven jacquards meant those women with more leisure time could enjoy embroidering for its own sake. Previously, woodcut pattern books or paper cuts were used as templates for design. Now, many Shanghai companies produced series of embroidery design books for women to copy (Figs. 275, 281).

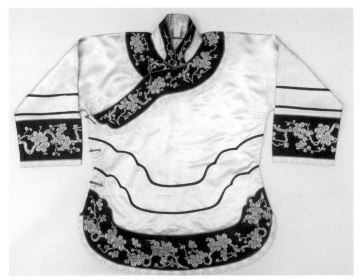

Fig. 267

Fig. 268

Fig. 267 Pale green satin *ao* with wide black satin bands embroidered with couched gold plum blossom, Shanghai, 1920s.

Fig. 268 "Sing-song girls" of Hangzhou wearing the short *ao* with rounded hem and skirt, 1922.

Fig. 269 Studio photograph of a girl wearing an *ao* and matching trousers.

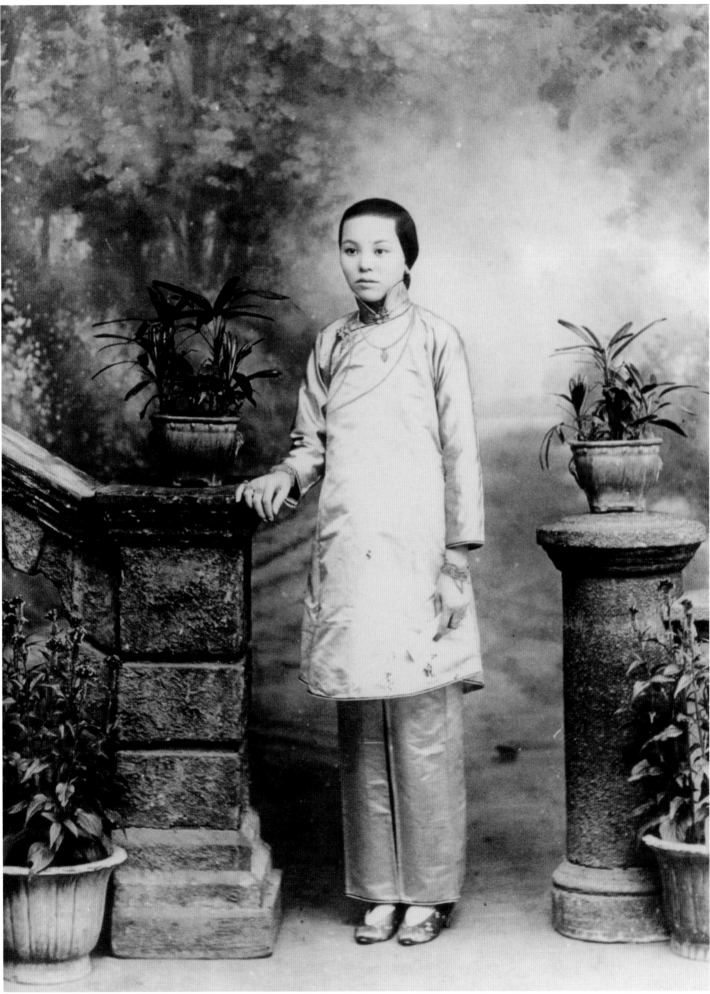

Fig. 269

Fig. 270

Fig. 270 Pink and cream patterned silk jacquard *ao* edged with sequins, Shanghai, 1920s.

Fig. 271 Rust red, brown, and cream patterned silk jacquard *ao* lined with Mongolian lamb, Shanghai, 1920s.

Fig. 272 Lilac patterned silk jacquard *ao* edged with sequined braid, 1920s.

Fig. 273 Matching cream silk *ao* and skirt embroidered with floral sprays, the hem edged with sequins and beads, and with an elastic tunnel waist, Shanghai, 1920s.

Fig. 271

Fig. 272

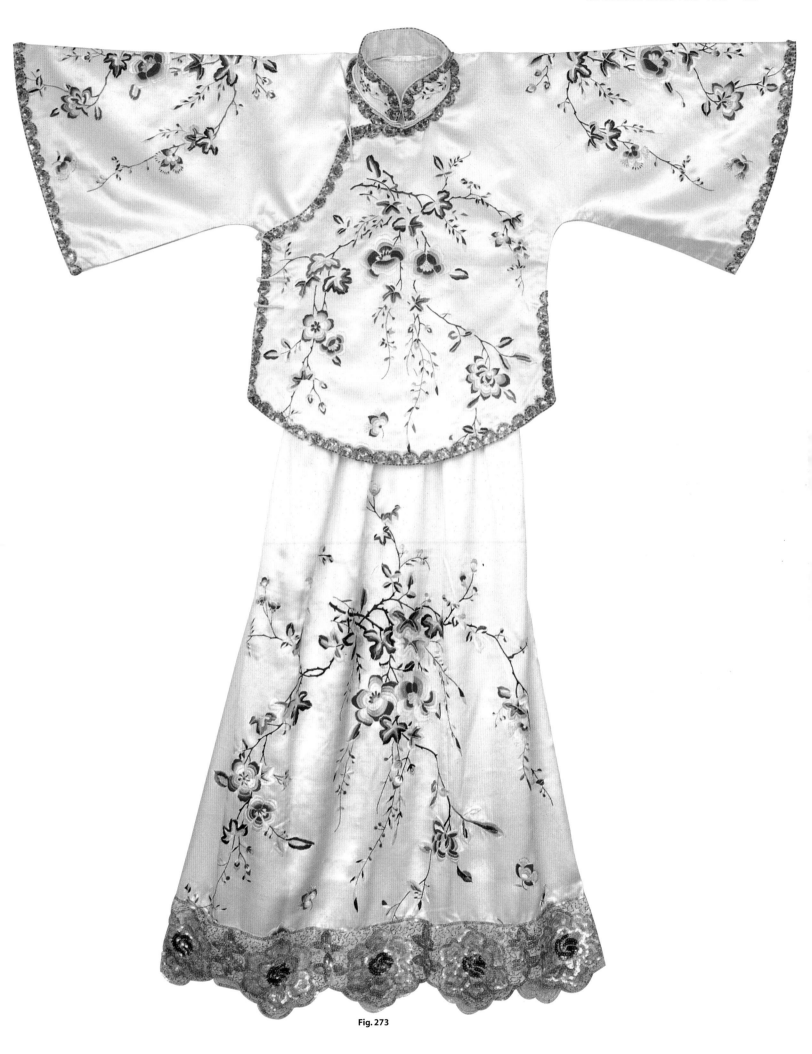

Fig. 273

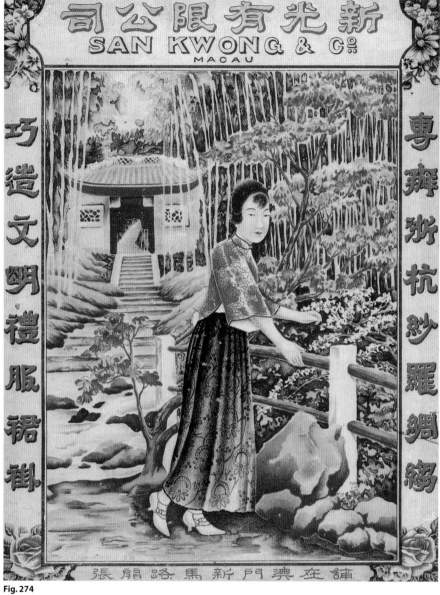

Fig. 274

Fig. 275

Fig. 276

Fig. 274 Cover of a tailor's box from San Kwong & Co., on the main street of Macau, announcing he can make wedding attire and dresses for special occasions, 1920s. Tailors' shops flourished as fewer servants meant clothes were made outside the home.

Fig. 275 Back cover of *The Cross Stitch Book No. 12*, published by Lee Hwa Women's Embroidering & Co., Shanghai, showing a woman in the shorter *ao* and black skirt sewing at a table.

Fig. 276 Woman knitting in the living room of a contemporary Chinese home filled with a mixture of soft furnishings and heavy Western-style cupboards and bureau, 1930.

Fig. 277

Fig. 278

Fig. 279

Fig. 280

Fig. 281

Figs. 277–280 Set of four pictures with pasted silk clothing depicting the seasons, Shanghai, 1920s. Left to right: Spring, girl with lime green top and purple skirt; Summer, girl with purple top and pale turquoise skirt; Autumn, girl with sleeveless top, blouse, and blue skirt; Winter, girl with red cloak and black fur collar and hem.

Fig. 281 Back cover of *The Cross Stitch Book*, No. 12, published by the Mei Hwa Art Embroidery Co., Shanghai.

The Rise of Department Stores

The gap between mandarin and merchant had always been wide. Since the Qin dynasty (221–206 BCE), society in China had been divided into four classes. The most respected was the scholar-gentry official, the mandarin, who often combined the political power of holding office with the economic power of land ownership in his home district. Next was the farmer, representing the peasantry, who fed the rest of the population. Then came the artisan, a skilled worker. The last comprised the merchant and shopkeeper who merely traded goods supplied by others.

With the abolition of the gentry class, however, came the rise and acceptance of the middle-class businessmen. New businesses developed, among them photo studios, cinemas, and tailors' shops. Running a pawnshop continued to be a profitable business, providing an early form of banking and money lending, the forerunner of banks. The foreigners who had settled in Shanghai after it became a Treaty Port in 1842 brought fresh ideas from the West.

One innovation was the concept of the department store. In the past, itinerant pedlars went from house to house supplying women cloistered at home with personal items they needed, such as cosmetics, perfume, embroidery silks and materials. Now these and many more products were available under one roof.

The first department store, Hall & Holtz Ltd, established by a British merchant, began as a bakery before opening as a department store in 1847 on Nanjing Road (Figs. 282, 286). Most of its clients were expatriates. Another Western-run store, Whiteaway, Laidlaw & Co. Ltd, opened in 1904, also on Nanjing Road, was a favorite with both foreigners and wealthy Chinese. Later, it opened branches in other major cities in China and Hong Kong. Lane Crawford, a store already established in Hong Kong, also opened in Shanghai. Metropolitan goods stores sold upmarket items such as jewelry and gifts. Other shops, which sold imported foreign items, were known as Cantonese goods shops since they were often owned by merchants from Guangdong. They also sold goods based on imported Western styles but made by Cantonese artisans (Figs. 283, 285).

Fig. 282

Fig. 282 Nanjing Road, Shanghai, home to the "Big Four" department stores.

Fig. 283 Advertisement for Chien Hsiang Yi Pao Chi, "Dealers in All Kinds of Silk Foreign and Cantonese Goods," Tianjin, early 20th c.

Fig. 283

Before the founding of the Republic, the east section of Nanjing Road was regarded as foreigners' territory, but after 1912 Chinese businessmen who had spent time overseas moved in, and the foreign-run stores began to decline. Four big department stores, the "Big Four," all founded by Cantonese merchants, opened – Sincere in 1917 (Figs. 284, 287–290) (already in Hong Kong and Guangzhou), Wing On in 1918, Sun Sun in 1926, and the Sun Company in 1936, which attracted mainly Chinese customers (Figs. 291, 292). They had the backing of Sun Yatsen who had encouraged the development of department stores as a way of modernizing China.

The "Big Four" attracted huge crowds, for as well as selling a large variety of local and imported goods, they issued catalogues and

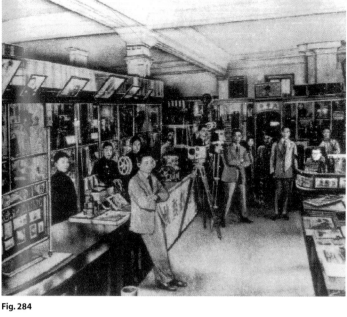

Fig. 284

Fig. 285

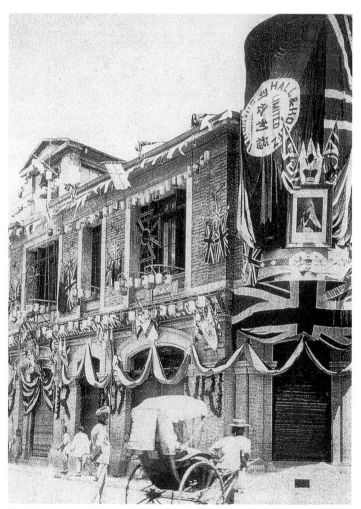

Fig. 286

Fig. 284 Staff of the Sincere department store, Shanghai, some in Western dress, others wearing Chinese dress.

Fig. 285 Advertisement for the Changde Yee department store, specializing in silks and clothing, Yingkou, Dongbei, Manchuria (now Liaoning province), announcing that the store provides trustworthy service and good prices, does not cheat, and does not allow bargaining, early Republican period.

Fig. 286 Hall & Holtz Ltd department store on Nanjing Road, Shanghai, decorated with flags and bunting and a portrait of Queen Victoria on the occasion of the diamond jubilee celebrations of her reign, June 22nd, 1897.

Figs. 287–290 Cover of *Sincere's Ladies Dress Show Bulletin*, Sincere department store, Shanghai, ca. 1929, and three pages showing a dress and cloak, a lilac Western-style dress, and a combination Chinese- and Western-style dress.

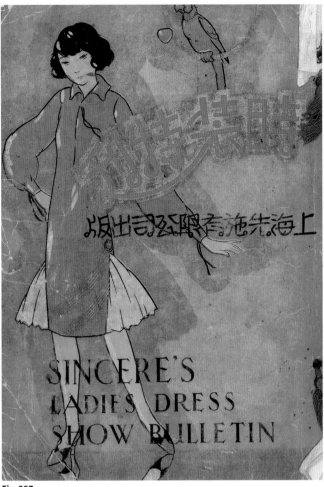

Fig. 287

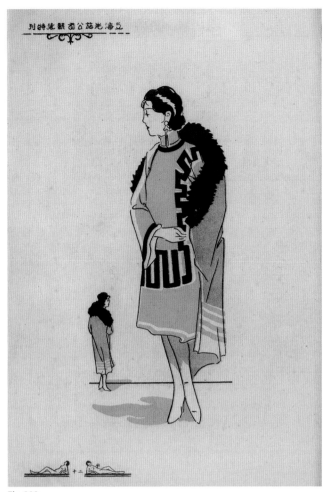

Fig. 288

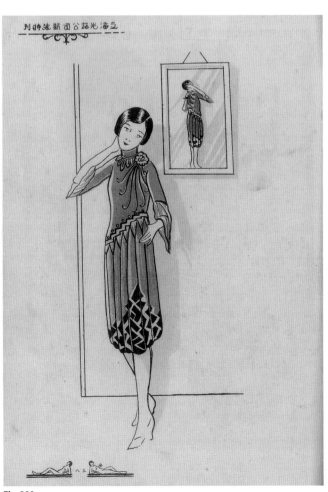

Fig. 289

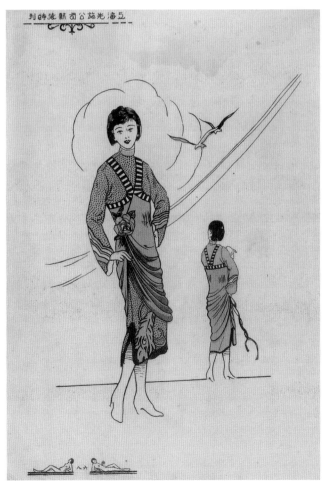

Fig. 290

Fig. 291

held fashion shows (Figs. 287–290), and offered other forms of entertainment, with gardens and amusement parks on the roof. Wing On and Sincere vied with each other to build the tallest store in Shanghai. The Sun Company boasted air conditioning, and was the earliest store to install hydraulic elevators: a riot ensued when everyone tried to ride in them. The Sun Sun Company built the first ballroom in Shanghai, as well as a radio station from which it advertised the products and amenities available in its store. (When Shanghai was liberated in May 1949, the Sun Sun Company was the first to broadcast songs for the People's Liberation Army.)

This section of Nanjing Road became a mecca for the fashionable folk of Shanghai, and the busiest part of China's most cosmopolitan city. By day, it was the upright business capital of China with majestic banks and grand hotels lining the Bund. At night, its fun and frivolous spirit emerged, giving the city the nickname "Paris of the East." Nanjing Road was the longest shopping street in China (as it still is), while in the fashionable French Concession smart shops in chic sycamore tree-lined streets like Rue Lafayette and the Avenue Joffre, flaunted the latest fashions.

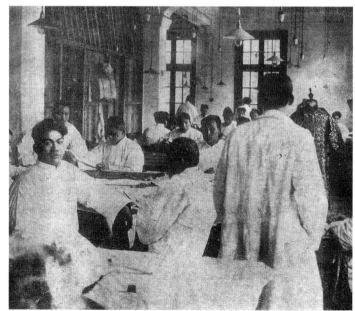

Fig. 292

Fig. 291 Sun Co. Ltd department store's wrapping paper, advertising stores in Hong Kong, Guangzhou, and Shanghai, mid-1930s.

Fig. 292 Sincere's tailoring department, Shanghai, ca. 1929.

Fig. 293 Earliest style of cheongsam with a straight cut *tou jin* opening, a round stiff collar, and side seams falling straight, made of yellow silk embroidered with floral sprays, ca. 1925.

Fig. 294 Early cheongsam with contrasting sleeves, ca. 1925.

The Cheongsam

With most fashion activities taking place in Shanghai, it was not surprising that the next development in Chinese dress should take place there. This was the creation of the cheongsam, the iconic garment by which Chinese women are still known throughout the world, and which provides constant inspiration for fashion designers in the West. By the middle of the 1920s, the top and skirt had combined to form a one-piece garment, also called a *qi pao*, literally "banner gown," as it resembled the style worn by Manchu women in the past. At the time it was considered a very daring style, revealing the shape of a woman's figure as never before (Fig. 294).

In 1927, when Nanjing became the capital of the Republic of China, two styles of clothing were designated formal wear for women. The first was a black jacket and blue skirt cut in the style of earlier outfits, with the banded collar jacket, with three-quarter length sleeves, reaching to the top of the hip and fastening down the right-hand side with ball buttons and loops. The second style was the cheongsam, which soon became the fashionable choice of most women. The cheongsam fell straight from the shoulders to the hem in an A line, stopping just below the knees, corresponding to the shorter dresses worn in the West at the time. The narrow stand-up collar opened on the right to form a diagonal slit to the underarm, which continued to the hip, and was fastened with press-studs, or more usually with loops and ball buttons. The sleeves were shortened to elbow length and widened and given a curved edge. The garment was decorated with embroidered sprays of flowers or edged with bands of embroidery (Figs. 293, 295, 296).

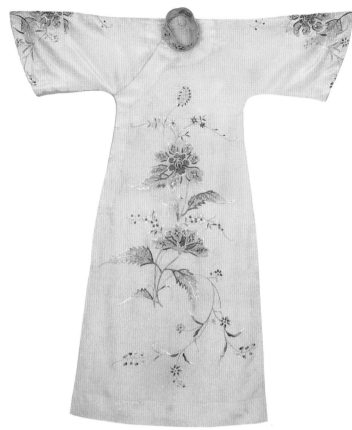

Fig. 293

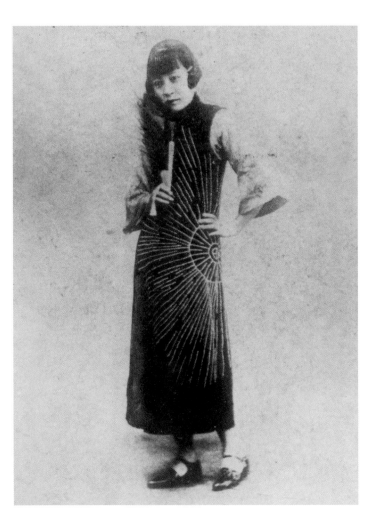

Fig. 294

The film industry in the 1930s in Shanghai was big business. Its sixty theaters, catering to three million inhabitants, accounted for more than 20 per cent of the cinemas in China. Movie stars were treated like royalty and their admirers eagerly devoured their tastes in fashion as described in detail in fan magazines. Women with style copied the permanent wave favored by Shanghai movie stars. With their glamorous poses, wavy hair, arched eyebrows, and coy looks, their influence was pervasive (Fig. 298). Suggestive poses in line with the permissive attitudes prevalent in Shanghai reinforced their appeal.

During the 1930s, hemlines dropped to the ankle, and by the middle of the decade they covered the feet in some cases (Figs. 297, 299–301). Gradually, the cheongsam became quite a fitted garment. Some, worn by very fashion-conscious women, had side slits reaching right up to the thigh. These styles were provocative and accentuated a woman's sexuality, emphasized by legs clad in silk stockings (a recent innovation) and high heels.

In the 1940s, the cheongsam reached to mid-calf or the ankle and, for more conservative women, had long sleeves. It was often fur-lined or wadded with silk. For younger, more fashionable woman, the garment remained slim-fitting, but the sleeves were shortened to caps or the garment was sleeveless. The collar was outlined along the top and bottom edges with piping, which matched that at the hem and sleeves. Decorative flower ball buttons were placed on the collar and opening, which often extended to the left side, though this side did not always open (Figs. 300, 302). The traditional top and trousers continued to be worn by unmarried women and those who enjoyed the freedom of movement that trousers offered.

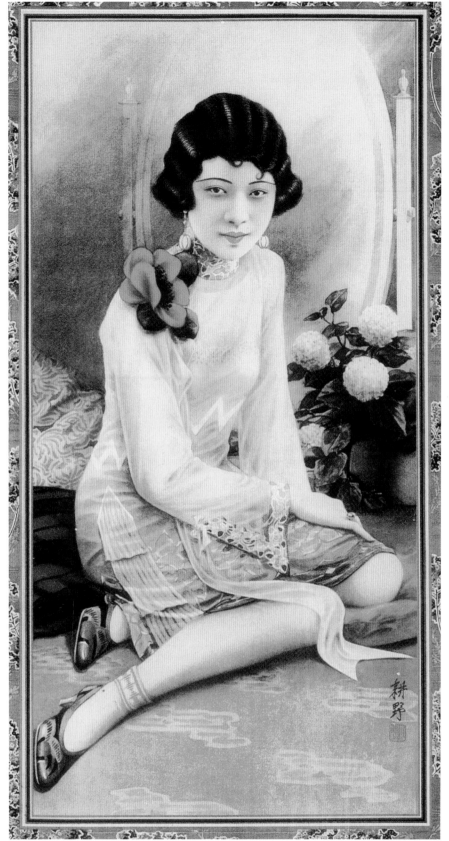

Fig. 295

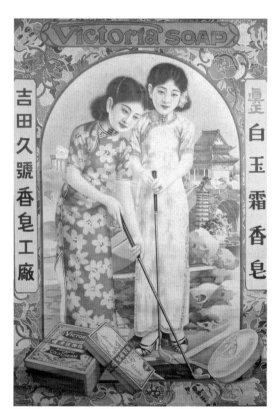

Fig. 296

Fig. 297

Fig. 295 Poster of a fashionable young woman with permed hair wearing a 1920s-style cheongsam. The flower worn at the shoulder was considered very chic.

Fig. 296 Cover of a dress box from Wing On Cheung store, Guangzhou, showing taxi dancers (paid dance partners) at a tea dance.

Fig. 297 Poster advertising soap and cold cream showing two girls wearing the ankle-length cheongsam, Shanghai, ca. 1935.

Fig. 298 Cover of a dress box from Wah Lun Hip store, 14 San Ma Lo, Macau, illustrated with a young woman in a provocative movie star pose, ca. 1930s.

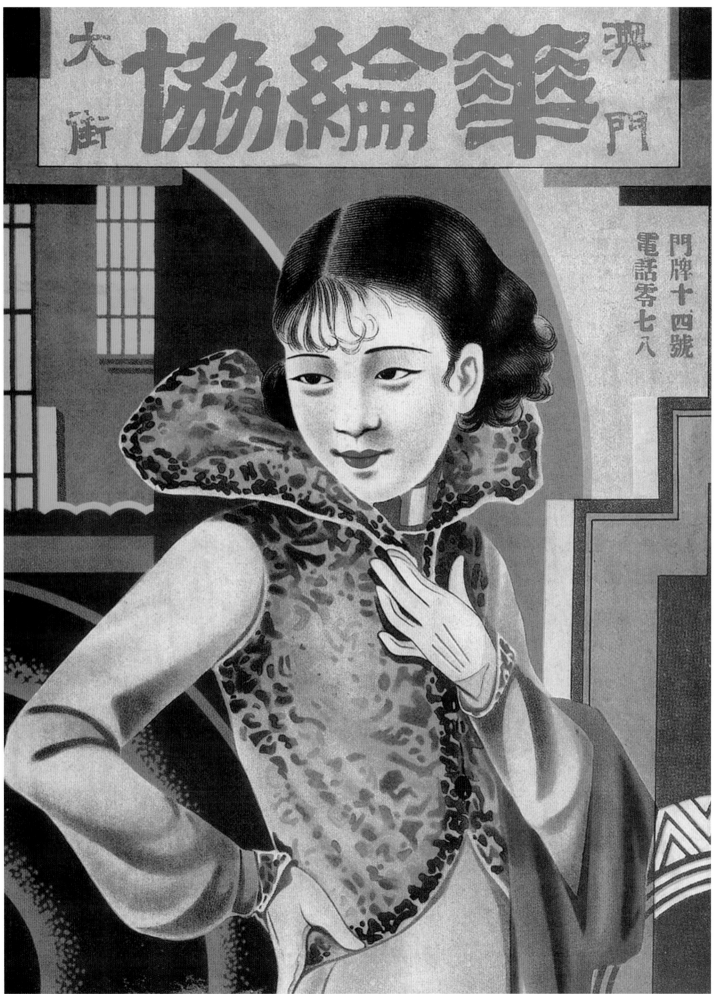

Fig. 298

Fig. 299

Fig. 300

Fig. 301

Fig. 302

Fig. 299 Dye advertisement for the Yin Dan Shi Lin Company showing two elegant women in long cheongsams with very high collars choosing fabric at a tailor's.

Fig. 300 Women wearing cap-sleeved cheongsams at the Happy Valley Race-course, Hong Kong, 1940s.

Fig. 301 Family group all in traditional Chinese dress, except for the oldest boy in the front row, Shanghai, 1930s.

Fig. 302 Lilac and black flower patterned silk jacquard cheongsam, 1930s.

Western Dress and Wedding Attire

Western dress gradually became more popular, initially with those involved in the movie industry, and then for many other fashion-conscious women, first with evening wear, then daywear (Figs. 303, 304). Fashion magazines, dress patterns, and knitting patterns were imported and were admired, inspiring locally produced versions in the main cities like Shanghai. Western-style sportswear was adopted, especially for swimming and athletics, as sport had become a nationwide activity. Fashion-conscious urban women also wore Western-style shoes, and men took to wearing black leather shoes, but the traditional black cotton shoes with white cotton padded soles continued to be popular for informal wear and by the lower classes until the end of the twentieth century.

A number of men began to don Western suits or morning dress for their marriage ceremonies, and some middle- and upper-class brides in cities like Shanghai, and latterly Hong Kong, also adopted Western-style white wedding dresses (Fig. 307). Other men continued to wear the prescribed male formal attire established after the founding of the Republic, with the gown and jacket (*chang shan ma gua*) acceptable attire for the groom in place of a surcoat (Fig. 306). A Western-style white wedding dress was often worn for the photo session (still an important part of the ceremony today) in Hong Kong and Shanghai by Eurasians or Chinese who had gone overseas, but who wore traditional Chinese style for the marriage service. Sometimes women wore the traditional *ao kun* with a white veil for the wedding. An alternative to this was a calf-length embroidered red satin dress, cut like the cheongsam, which was worn with silk stockings and Western court shoes (Figs. 305, 311).

Conventional brides wore a slimmer, more fitted black satin jacket that opened down the front over a red or pink satin skirt with panels at front and back attached to the side gores (Fig. 309). Both garments were embroidered with auspicious flowers and birds as well as – sometimes instead of – the dragon and phoenix. The embroidery, together with a semblance of the *li shui* diagonal stripe pattern of couched gold and silver thread, contributed to a very ornate and glittering outfit. After the wedding, the jacket and skirt were worn for special events, including the Lunar New Year.

By the middle of the twentieth century, the jacket was also made in red to match the skirt, and the outfit was then called a *hong gua*. The dragon and phoenix predominated in the design, often with the metal couched threads covering the entire area of satin. By this time, it was far more usual to hire these expensive outfits than to have them specially made. The elaborate headdress continued to be worn, although sometimes a specially made tiara took its place (Fig. 308). Instead of red shoes made for bound feet, the bride wore flat slippers embroidered with the dragon and phoenix. A special bag suspended from a cord around the bride's neck was used to hold the lucky money (*li shi*) given to the couple during their wedding (Fig. 310).

Fig. 303

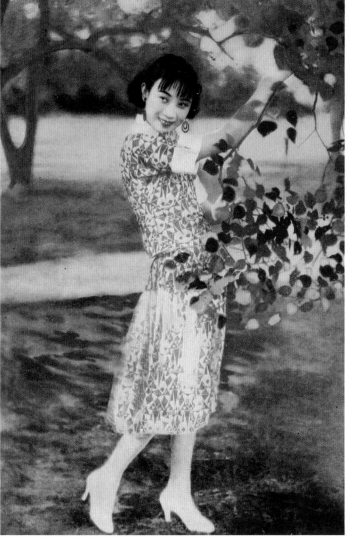

Fig. 304

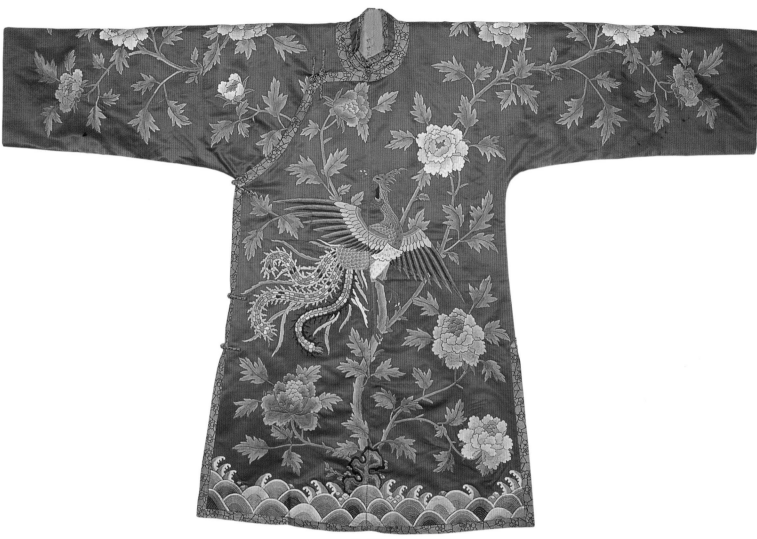

Fig. 305

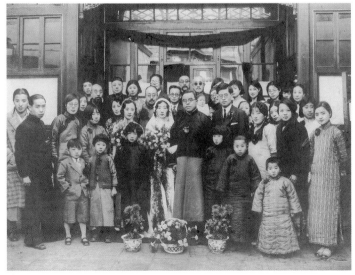

Fig. 306

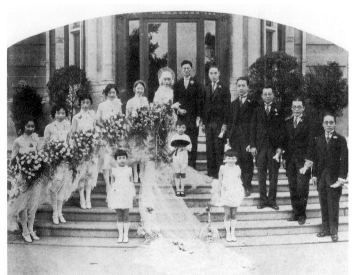

Fig. 307

Fig. 303 Cover of book of Western-style knitting patterns, Shanghai, 1947.

Fig. 304 Butterfly Wu, the most famous movie star in China at the time, wearing Western dress, 1930.

Fig. 305 Red satin wedding gown embroidered with peonies and phoenixes, the gold brocade edging and *li shui* at the hem echoing those on dragon robes. Characters written inside the neck indicate the outfit was made in the 25th year of the Republic (1936), Shanxi province.

Fig. 306 Bride in a white Western-style wedding dress, the groom in *chang shan ma gua*, Shanghai, 1930s. Others in the group wear a mixture of Western and Chinese dress.

Fig. 307 Bride and groom with attendants, all in Western dress, 1930.

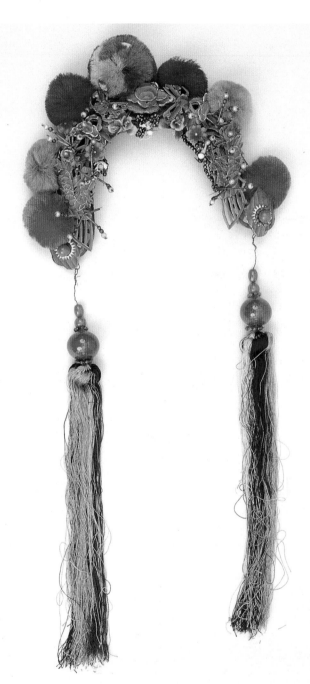

Fig. 308

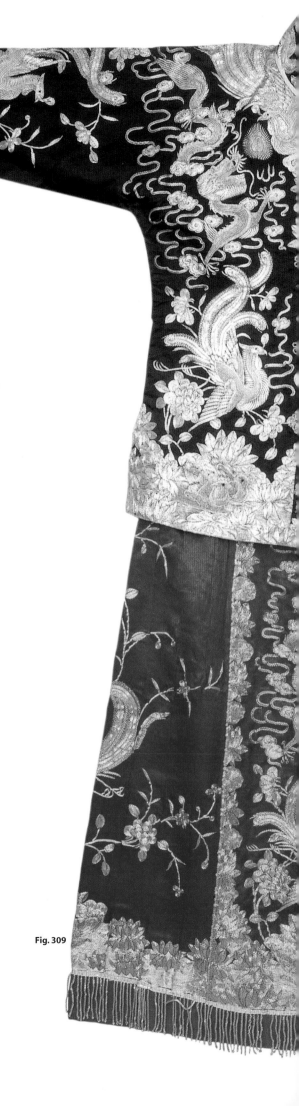

Fig. 309

Fig. 308 Wedding tiara with puffballs on wires with bells behind, kingfisher feather inlay phoenixes and flowers, silk flowers, and red glass balls from which hang long silk tassels, early 20th c.

Fig. 309 Black satin jacket and red satin skirt heavily couched with gold and silver thread in a dragon and phoenix design, with lotus flowers and mandarin ducks, symbols of purity and marital fidelity, mid-20th c.

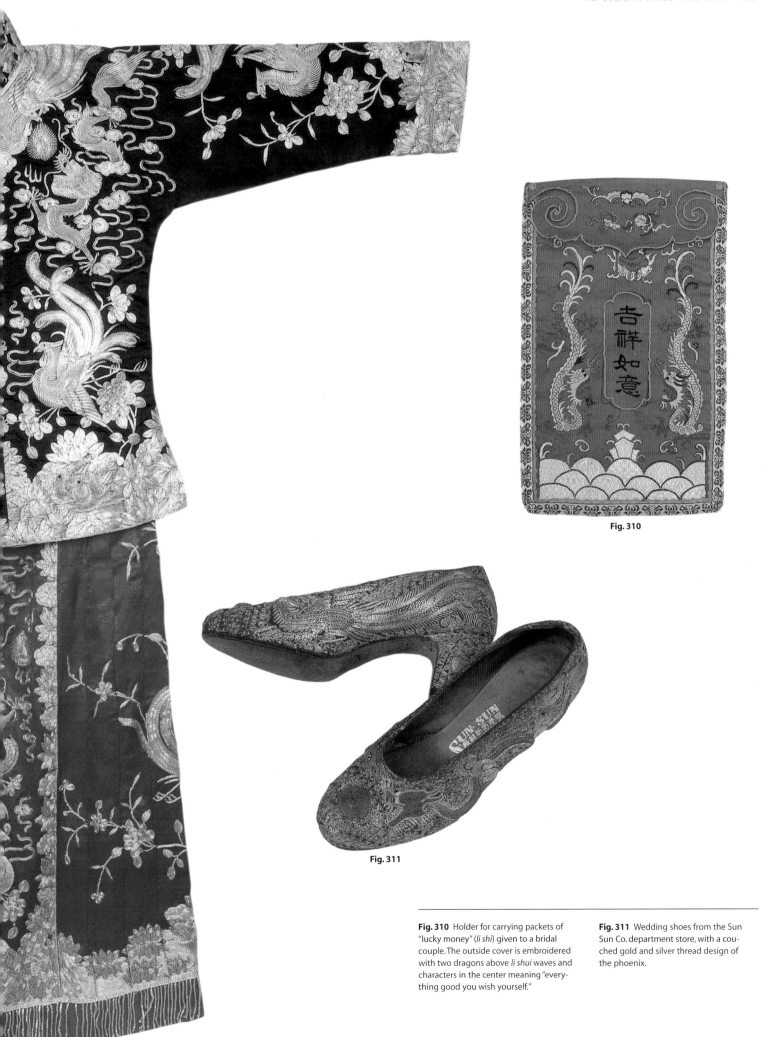

Fig. 310

Fig. 311

Fig. 310 Holder for carrying packets of "lucky money" (*li shi*) given to a bridal couple. The outside cover is embroidered with two dragons above *li shui* waves and characters in the center meaning "everything good you wish yourself."

Fig. 311 Wedding shoes from the Sun Sun Co. department store, with a couched gold and silver thread design of the phoenix.

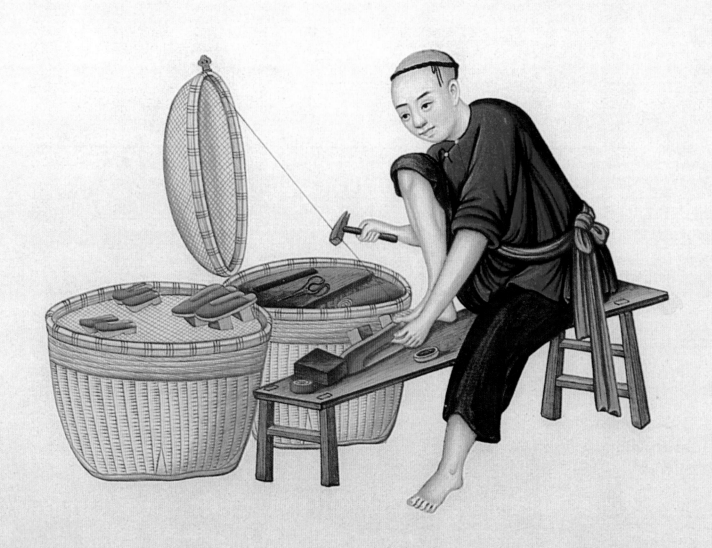

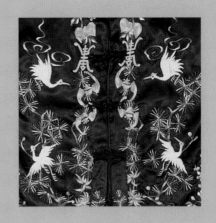

Chapter Six

CLOTHING OF THE LOWER CLASSES

Life of the Common People

Life for common folk in China was hard and their clothing reflected this. Silks and satins were seldom seen and, if so, were reserved for festive or special occasions. Everyday clothing was made of hard-wearing fabrics such as hemp and cotton, dyed in somber colors, reflecting the difficulty and uncertainty of life.

Men in the lower classes were employed as artisans, stone-cutters, sedan chair and rickshaw bearers, and laborers, and were known collectively as coolies from the word *ku li*, literally "bitter strength" (Figs. 313, 314). Women worked for wealthy families as amahs or servants, and were employed individually to wash, clean, cook, sew, look after children, and do general chores (Figs. 315, 316). Others worked in cottage industries such as silk production, or in factories in the major cities.

The majority of the population, however, lived and worked on the land. In traditional China, agriculture was considered an honorable profession, next in importance to serving the emperor as an official. Fishing was another means of livelihood for country folk, especially in southern and central China, around the extensive coastline, and along the numerous rivers and waterways.

Cotton was worn by the majority of the population, and grown on a large scale throughout the country, from the small cottage industries involving all members of a family to the large cotton-producing areas especially around Shanghai and the Yangtze River Delta. It was usually dyed blue or black, though a purplish tint was popular for a while, achieved by using ox blood to overdye black. Egg whites were used in some regions to produce a glossy look. This could also be obtained by calendaring, attained by rolling a heavy stone back and forth over the fabric.

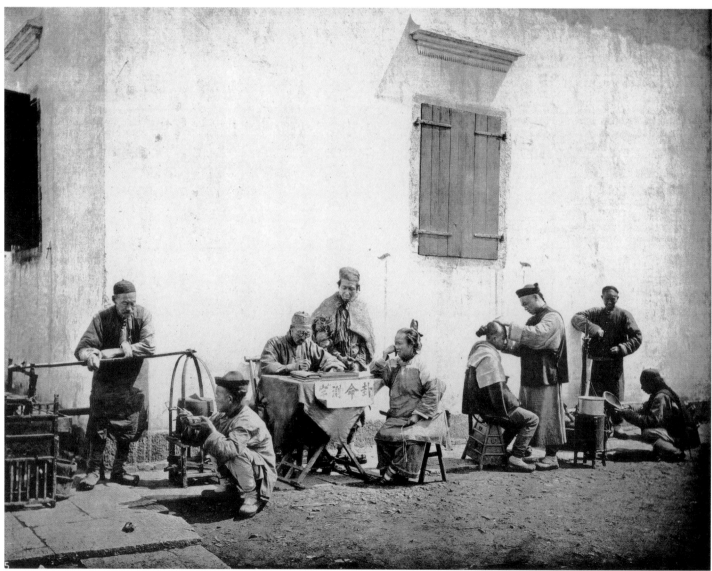

Fig. 313

(Page 156) Fig. 312 Shoemaker making clogs, mid-19th c.

Fig. 313 Street scene showing a hawker selling food, a letter writer composing a letter for a woman, a barber, and a spoon seller, Jiujiang, ca. 1870.

Fig. 314 Itinerant barber wearing a long gown (*chang shan*) and jacket, his long queue visible below his melon cap, Hong Kong, ca. 1870s.

Fig. 315 Servant with bound feet buying fruit from a hawker, ca. 1912.

Fig. 316 Servants or amahs with their charges, wearing the *shan ku* in black gummed silk in the Botanical Gardens, Hong Kong, 1913.

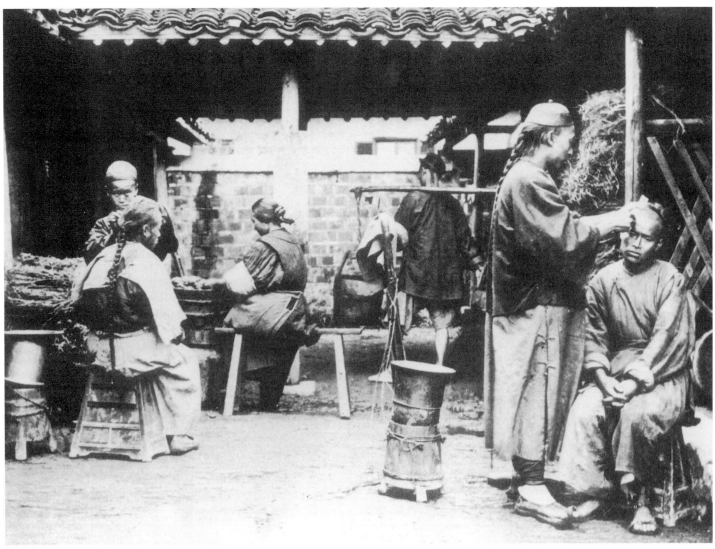

Fig. 314

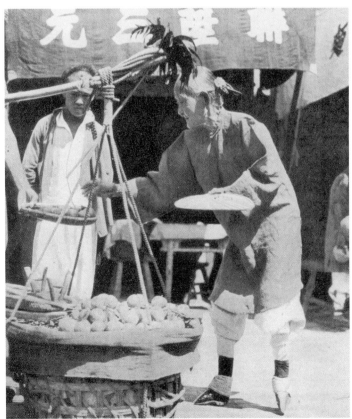

Fig. 315

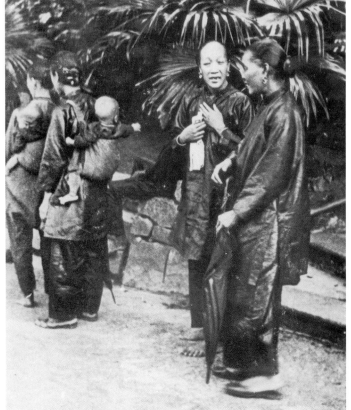

Fig. 316

Hemp, grown in some villages up until the 1920s, was a popular fabric as it was both cool and hardwearing. Other regional fabric treatments were developed, such as black gummed silk (*hei jiao chou*), in the district of Shunde in Guangdong province. Boat people, in particular, favored black gummed silk as it was easy to wash and was waterproof, but it was popular with all strata of society in Hong Kong and the Pearl River Delta, especially during the 1920s and 1930s because of its coolness.

The tradition of women making clothes by hand, first as part of their wedding dowry and then for their families, gradually died out after the Sino-Japanese War of 1937–45. Mass-produced fabrics became widely available and clothing was often either made to measure by local tailors or bought from market stalls, itinerant pedlars, and hawkers.

Working Clothes

A long gown restricted movement, deliberately implying the wearer led a sedentary life as a scholar and gentleman, so it was not a practical garment for the lower classes. Their dress comprised a simple *shan ku*, a pajama-like outfit which is still worn in some rural areas. This was a thigh-length version of the long gown, worn over a pair of loose-fitting trousers. It was a plain, functional outfit well suited to the climate and the lifestyle of the working class.

The *shan ku* in the nineteenth century was a large, long garment with wide trousers, but during the twentieth century the *shan* gradually became shorter and more fitted, with a narrow neckband. Fabrics for the *ku* were similar to those used for the *shan*, although the two garments were not always made as a set. The main garments were usually dyed black, blue, or gray, but the waistband of the trousers, which was invariably made of a lighter fabric, was generally blue or natural white. In Guangdong province, a white waistband was called *bai tou dao lao*, literally "white head, old age" – a way of referring to the white waistband as well as a wish for a long and happy marriage.

In the late nineteenth century, the *shan* was discarded by men in favor of the center-opening jacket (Fig. 317). Patch pockets were added to the front, as many as three or four on the outside, and often two or three inside. These hidden pockets were called *dai kou*, literally "pocket mouths," implying that the wearer had many mouths to feed at home (Fig. 319).

Coolies, sedan chair bearers, rickshaw pullers, farmers, and others who worked outdoors wore clothing made of rice straw or palm fiber as protection against the elements (Fig. 318). Their clothes were paired with a straw hat with a shallow crown and brim.

The straw raincoat (*suo yi*) had been worn for centuries in China: "Watermen, peasantry, and others employed in the open air, are generally provided with a coat made of straw, from which the rain runs off … in addition to this they sometimes wear a cloak, formed of the stalks of *kow-liang* [*kao liang*] (millet), which completely covers the shoulders; and a broad hat, composed of straw and split bamboo, which defends them both from sun and rain. A Chinese thus equipped … may certainly defy the heaviest showers" (Alexander, 1805).

Dried leaves from palm trees or rice straw, depending on the region, were employed for making the raincoats. Layers of leaves or straw were first folded then stitched to the layer above with string made from rice straw. The layers at the top were made wider to form a cape. In some cases, "the stalks of the stubble are sewed to a

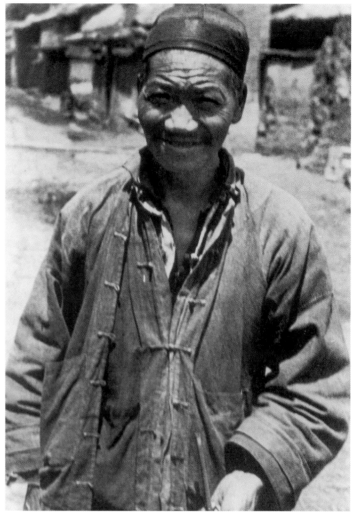

Fig. 317

clumsy weft of the same substance, the meshes of which are very wide" (Breton, 1812, Vol. 4: 35). A similar method of construction was applied to palm fiber capes worn in Shantou. These were made by stripping pieces of fiber from the bark of the palm, flattening and sewing them together to form a cloak, some 30 inches (75 cm) square, which was secured round the neck by sewing the edge to a length of rope. They are still used in some areas of Western China.

Straw aprons were a necessary item when threshing rice. Constructed in similar fashion to the raincoat, they comprised four layers of rice straw or palm leaves, reaching from chest to knee, and hung around the neck by a long string made of rice straw. Wrist covers of plaited straw and cotton mittens protected the hands when cutting rice or grass (Fig. 320).

The lower classes wore no special kind of underwear. Old *shan ku* were worn underneath the upper garments, and for sleeping in. However, some farmers and coolies wore a knotted string jacket as an under-garment. Opening down the front, it was made of rice straw twisted into string joined together in an open weave design

Fig. 317 Coolie wearing layered jackets and a melon cap, ca. 1937.

Fig. 318 Coolie in a straw hat, straw raincoat, and straw apron, Hong Kong, ca. 1915.

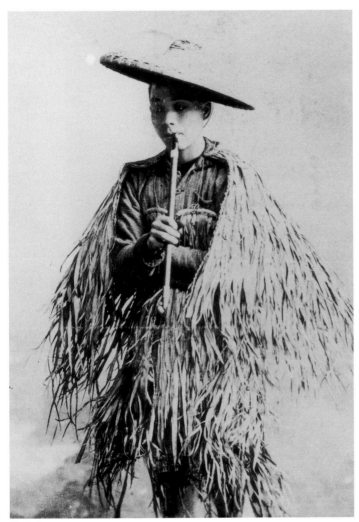

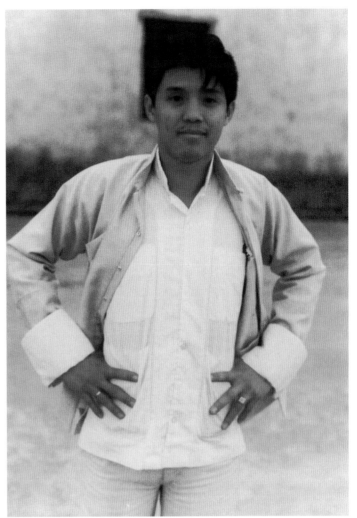

Fig. 318

Fig. 319

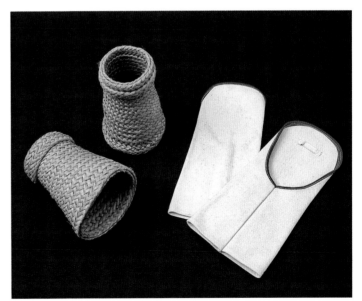

with a decorative row of weaving above the hem and sleeve edges. The shoulder and top back were made of a double layer of indigo-dyed or natural cotton or hemp to prevent chaffing when carrying heavy loads (Fig. 322). In the latter part of the twentieth century, under-*shan* began to be worn by women, made in the same style as the outer garment, but in lighter fabrics such as polyester and cotton prints. There are normally pockets on the under-*shan*, which are always missing on the outer-*shan*, and the sleeves are short, or it is sleeveless.

Many peasants wore no shoes at all, preferring to go barefoot in the fields, except in the coldest weather when rice straw sandals or black cloth shoes were worn. Men working in wet conditions, such as in the fish markets and at the ports, wore wooden clogs, crudely hewn from a block of wood about 2 inches (5 cm) thick, with an upper foot strap made of rubber. An earlier version worn by villagers and laborers, dating back to the nineteenth century, was a kind of backless shoe with a wooden sole and leather upper fashioned from buffalo hide (Figs. 312, 321, 323).

Fig. 320

Fig. 319 Young man wearing a jacket with four outside pockets and two inside pockets, and with four pockets on the under-jacket, Tsang Tai Uk, Hong Kong, 1979.

Fig. 320 Canvas mitts and woven rattan wrist covers, Hong Kong, ca. 1970.

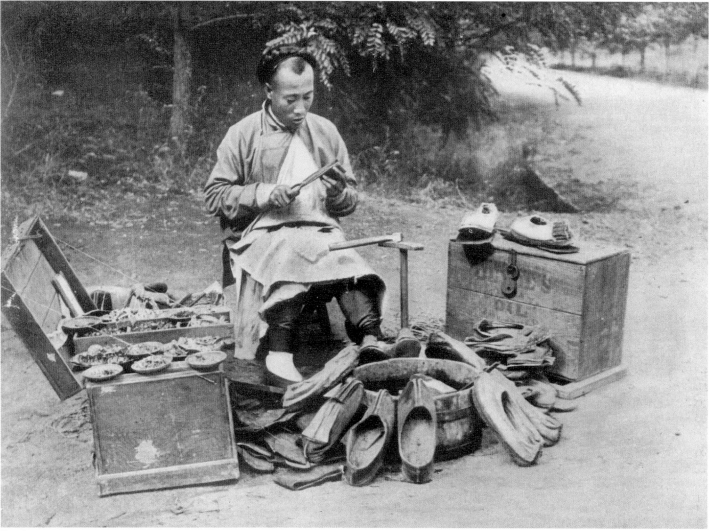

Fig. 321

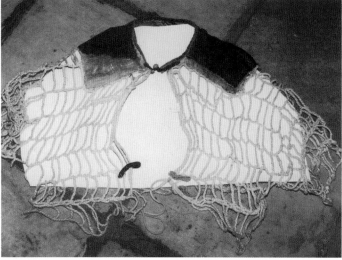

Fig. 322

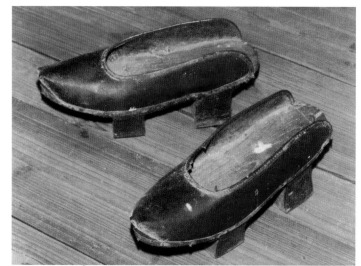

Fig. 323

Fig. 321 Itinerant cobbler repairing black cloth shoes, late 19th c.

Fig. 322 Jacket made of rice straw with indigo dyed hemp shoulder parts, Tsuen Wan, Hong Kong.

Fig. 323 Wooden clogs with leather uppers, Sheung Shui, New Territories, Hong Kong, late 19th c.

Fig. 324 Village elders in long gowns, jackets, and melon caps and holding fans at a Da Jiu ceremony. This Daoist ritual is usually held every ten years, and everyone who can returns from overseas to the clan village to affirm their relationship with the gods, Tap Mun, Hong Kong, 1979.

Fig. 325 Insignia square of the ninth civil rank worn by a village elder at a Da Jiu ceremony, 1970s.

Fig. 324

Farming Communities

Cantonese

In Chinese society, a clan is a group of individuals all descended from one male ancestor. Originally, the clan lived in the village founded by the first ancestor, and often a whole village was settled and controlled by a single clan. Clan organizations were central to the way rural communities conducted their affairs. Today, clans only exist outside mainland China.

In Hong Kong, many Cantonese villages were settled before the beginning of the Qing dynasty. The Tang clan, for example, can trace its lineage in the rural New Territories to the tenth century when its founding ancestor arrived from Jiangxi province. These and other Cantonese landowners established themselves in walled villages as protection against pirates and other marauders. Some of these clans have tens of thousands of descendants and have become very wealthy and powerful.

Festivals and rituals were, and still are, an important part of the year, marking the development of the individual and the agricultural calendar as well as worshipping the local gods. At important village festivals, senior male members of the clan or village elders would dress in the style of the scholar officials of the Qing dynasty (Fig. 324). A black *ma gua* was worn over a blue or gray *chang shan*, together with a black skullcap, white socks, and black cloth shoes. Some village elders might also wear the ninth civil rank badge on the front and back of the *ma gua* (Fig. 325).

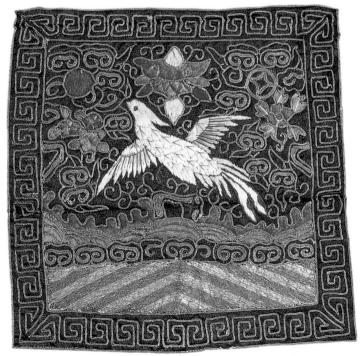

Fig. 325

No man was considered properly dressed unless he carried a fan, which was used not only to cool the air but also to gesticulate and emphasize a point. Xinhui in Guangdong province was the center of an ancient industry making fans from the leaves of the *pu kui* palm (*Livistonia chinensis*) (Fig. 326). One tree could produce enough leaves to make between five and fifteen fans per year over a period of a hundred years. The ends that were trimmed off the leaves used to make straw raincoats were utilized for the cheapest fans, while the finest quality palm leaves were turned into fans with bound edges. Folding paper fans and fans made from crows' feathers were other types (Fig. 327).

Conical hats made of bamboo splints and leaves were a common sight throughout rural China, especially in the provinces south of the Yangtze, worn by farmers as protection against the sun and rain (Fig. 330).

Women in the rural areas wore a band called a *fa lap* high on their forehead when not working in the fields, similar to those worn by women in the Qing dynasty, especially during the cooler months. Made or purchased as part of the dowry, they were the prerogative of married women (Fig. 329). Some were elaborately decorated with pearls, beads, and sequins, often with a jade or gold ornament at the center, while others were covered completely with small glass beads in a floral design.

As well as being a means of dressing up otherwise somber apparel, gold jewelry was a prudent way of investing one's earnings. The pure metal was stamped with a jeweler's mark, thus binding the jeweler by guild law to buy back the article at any time by weight. Silver was not so prized and was thus often gilded to look like gold, although peasants purchased items in *bai tong*. Jade, thought to have properties promoting long life, is still widely worn.

Women in the rural areas dressed their hair with many colorful and elaborate hair ornaments, especially on festive occasions. Cantonese women wore bright pink wool embellishments, together with a flat gold hairpin with oval ends, which they pushed into a bun (Fig. 331).

Carved silver bangles were worn around the wrist, while jade bangles were, and still are, popular with all ages: "A married woman sometimes wears two, one on behalf of her husband. If the bangle is broken by a blow, it is considered that the jade absorbed the shock which would otherwise have broken the wrist" (Burkhardt, 1955–9, Vol. 1: 180).

Pendants with gold or jade charms provided protection against evil. The most popular were carved jade Buddhas, coins with a hole in the center surrounded by lucky symbols, and the *Ba Gua* or Eight Trigrams, a mystical symbol showing eight groups of broken and unbroken lines arranged in a circle, sometimes with the yin–yang symbol of creation in the center. Women had pierced ears and sported gold earrings.

Aprons were part of the everyday attire of farming women, irrespective of the task at hand. They were also a way of distinguishing ethnic groups, since each wore a distinctive style. The two types, referred to as summer and winter aprons, related more to the age of a woman than to the season. Cantonese women seldom wore the winter apron, which was full size with a split skirt, preferring instead the smaller summer apron made of black cotton trimmed at the upper sides with narrow blue or green piping (Fig. 332). The decoration across the top was made of folded colored cotton, sometimes with two fabric rosettes and loops to hold the silver neck chain (Figs. 328, 339). There were other local variations (Fig. 338).

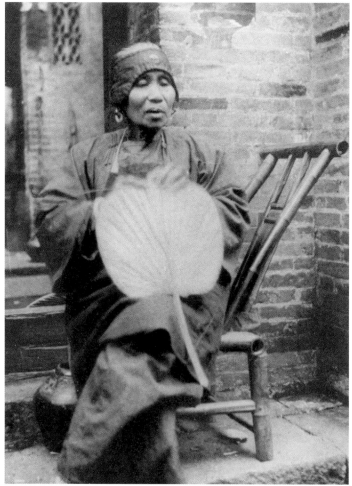

Fig. 326

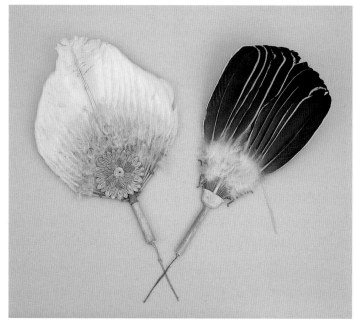

Fig. 327

Fig. 326 Cantonese villager wearing a plain headband, making a palm leaf fan, Xinhui, Guangdong province, ca. 1925.

Fig. 327 Left: Woman's feather fan. Right: Man's feather fan, early 20th century.

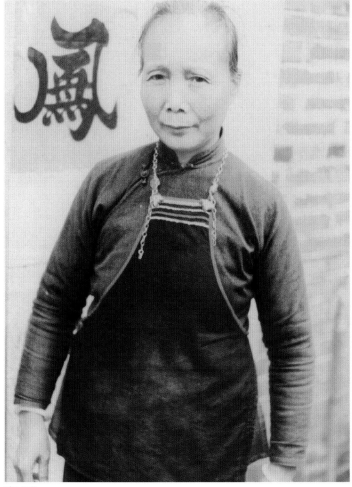

Fig. 328

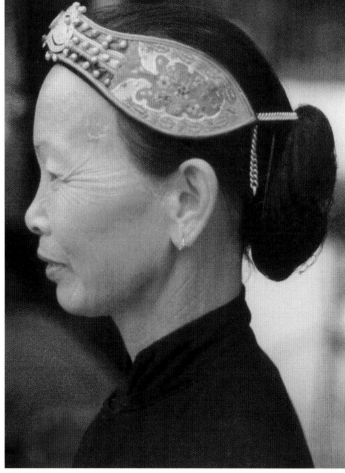

Fig. 329

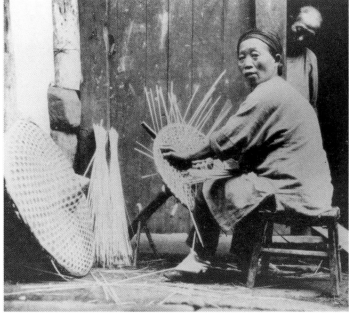

Fig. 330

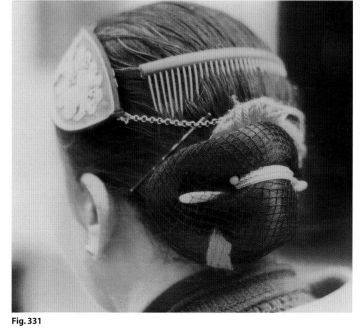

Fig. 331

Fig. 328 Cantonese woman wearing an apron and silver apron chain, New Territories, Hong Kong, 1979.

Fig. 329 Cantonese woman wearing an embroidered and jeweled *fa lap* headband, Yuen Long, Hong Kong, 1979.

Fig. 330 Cantonese villager in Guangdong province making a conical hat from bamboo splints and leaves, 1920s.

Fig. 331 Cantonese woman wearing a *fa lap*, with hair ornaments in her hair bun, New Territories, Hong Kong, 1979.

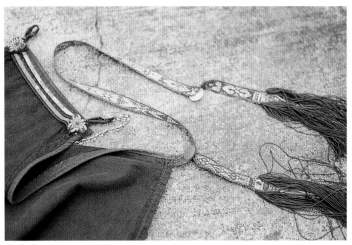

Fig. 332

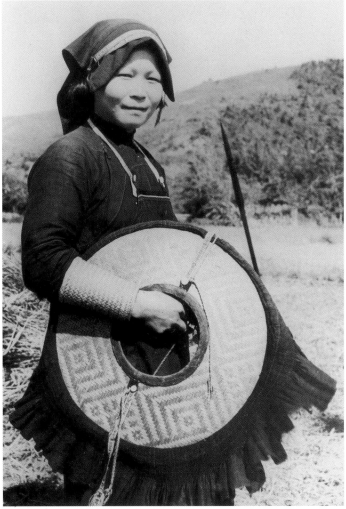

Fig. 333

Hakka

Another large group of farming people are the Hakka (Kejia), a term meaning "guest people" or "strangers," who originated from northern China. Persecutions over the centuries caused them to move further and further south until they eventually reached the southern provinces of Fujian and Guangdong, and also Hong Kong, where they settled during the Qing dynasty. Being latecomers to these areas, the Hakka tended to live and farm in the poorer, more mountainous areas (Figs. 334, 335).

Some Hakka women still wear the *liang mao* or "cool hat" when working outdoors for protection from the weather and flies. This is a flat, circular shape of woven straw and bamboo with a hole in the center and a black, sometimes blue, cotton fringe around the edge about 6 inches (15 cm) deep. A black headcloth (*bao tou*) was worn around the home and is still seen today. It is made from a simple rectangle of black cotton or black gummed silk, with one-third of the length turned back to the right side along a seam, and held in place by a woven patterned band (*hua dai*) made of cotton and silk (Fig. 333).

These bands were a Hakka tradition, adopted also by Cantonese women, and were a means of brightening up their dark clothing. Measuring about 3/8 inch (1 cm) wide and between 13 inches (33 cm) and 43 inches (110 cm) long, the bands worn by the Hakka were made either of white cotton with a pattern in colored silk or completely in silk (Fig. 336), while the Cantonese wore only those made in multicolored silk (Fg. 332). The skill of making the patterned bands was handed down from mother to daughter, and a woman about to be married would make several bands – for herself, for her prospective mother-in-law, and for other female relatives. Some became treasured possessions to be kept in her dowry chest for wearing on special occasions.

The distinguishing features of the bands were the individual patterns, which comprised good luck symbols, most frequently a wish for good fortune and many sons. Originally, the pattern woven through the center of the band indicated a woman's marital status: a young married woman wore red or pink, an older married woman black or blue, and an unmarried woman, green or purple (Johnson, 1976: 81–91). These patterned bands are still worn today, made by elderly women and sold in the market towns.

Hakka women wore both summer and winter aprons as part of their everyday attire. Their summer aprons were made of blue or black cotton embellished across the top with rickrack braid and decorative stitching, and held in place with a silver chain which had silver coins at each end for threading through the loops on the apron (Fig. 339). A woven patterned band went across the back at waist height. Winter aprons utilized the top part of a summer apron. A length of striped or patterned cotton formed the waistband, while the apron skirt was made of brown glazed cotton (Fig. 337). The apron was fastened across the back with a long cotton or silk patterned band.

Fig. 332 Cantonese summer apron with silk woven bands, a Hakka tradition adopted by Cantonese women, 1979.

Fig. 333 Hakka woman wearing a headcloth secured by a woven band, apron, and wrist covers, holding a *liang mao* "cool hat," Hong Kong, 1940s.

Fig. 334 Hakka woman threshing rice in the New Territories, Hong Kong.

Fig. 335 Hakka woman in headcloth and large *shan ku* working at a rice winnowing machine, 1909.

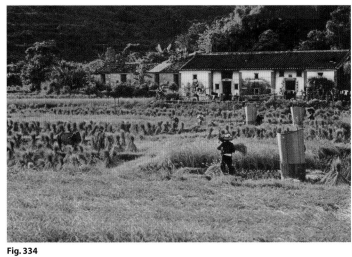

Fig. 334

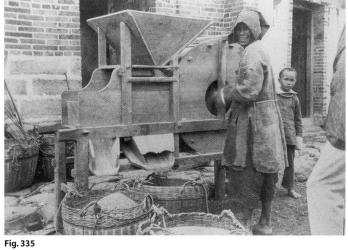

Fig. 335

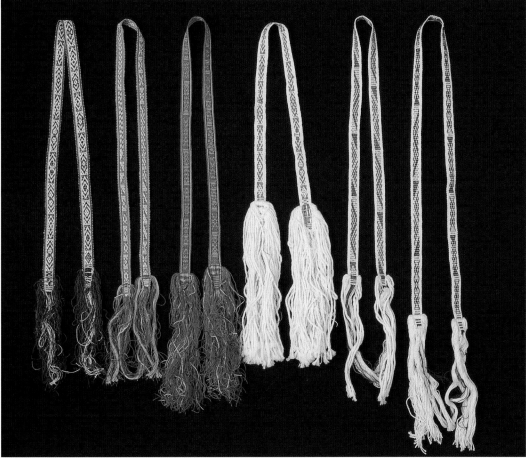

Fig. 336

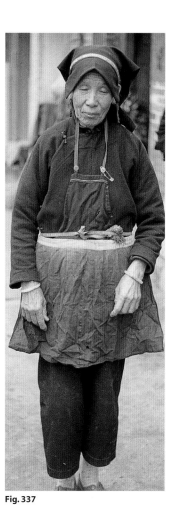

Fig. 337

Fig. 336 Hakka woven bands, mid-20th c.

Fig. 337 Hakka woman wearing a head-cloth and winter apron, Tai Po, Hong Kong, 1979.

Fig. 338 Han Chinese woman wearing a blue cotton headcloth and cotton apron with an embroidered flap at the front, Kunming, 1992.

Fig. 339 Apron chain comprising a link chain and silver coins from the reigns of Queen Victoria and King Edward VII, Soko Islands, Hong Kong, 1979.

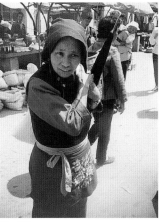

Fig. 338

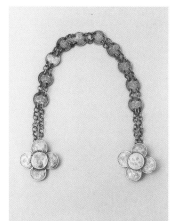

Fig. 339

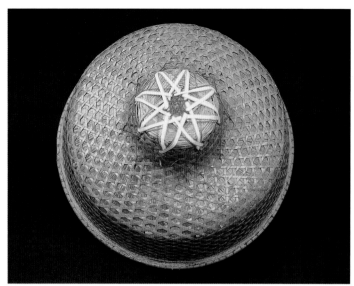

Fig. 340

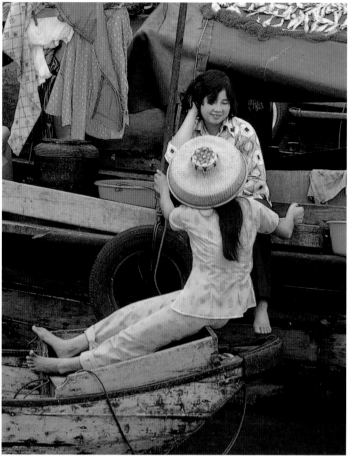

Fig. 341

Fishing Folk

Tanka

Women from the group of fishing people in southeast China known as Tanka (*Daan ga*) wore a distinctive style of *shan ku*. They preferred lighter, brighter colors, such as pale green or blue, turquoise, yellow, and pink, especially the younger women and those newly married and for special occasions (Figs. 341, 342). Older women wore darker colors and favored black gummed silk. The *shan* and *ku* matched in color, the former being fitted, often darted at the waist, with long tight sleeves, a narrow collar band, and sometimes a little piping for contrast.

Tanka men and women both wore a bamboo hat with a domed crown and turned-down brim, made in the fishing ports along the southern coast of China. Many people continue to wear them today. Men's hats were undecorated, but often women asked for the crown of their hats to be embellished with colored plastic cord in the form of an elaborately woven star (Figs. 340, 341). Sometimes the star decoration extended to the brim. The star was said to bring safety and luck to the wearer while at sea. Patterned bands made of small beads threaded onto nylon fishing line were used to anchor the hat, since bands made from cotton or silk were uncomfortable to wear if they got wet. The owner would sometimes incorporate the characters of her name into the band.

Tanka boatwomen in Guangdong, Hong Kong, and Macau also wore a headscarf in cooler weather. This was a large folded square of black cotton with an embroidered border in red, orange, or purple in a zigzag pattern (Figs. 343, 344). A flexible metal or bamboo bar was placed in the folded edge of the triangle to frame the face and protect the eyes from the sun. Younger women wore scarves of brightly checked cotton with the same multicolored embroidery design along the edges (Fig. 345).

Fig. 340 Tanka bamboo hat with star decoration on the crown, 1980s.

Fig. 341 Tanka boat girl wearing a bamboo hat with a woven star on the crown, Cheung Chau, Hong Kong, 1980s.

Fig. 342 Tanka women wearing pale green *shan ku* at a Da Jiu ceremony, Tap Mun, Hong Kong, 1989.

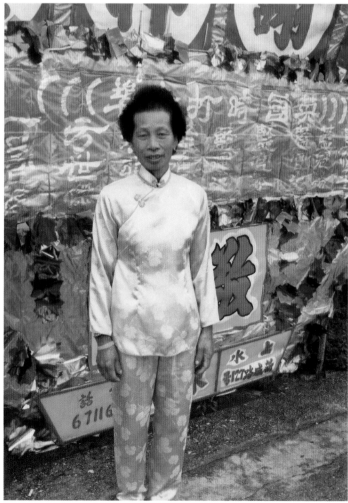

Fig. 342

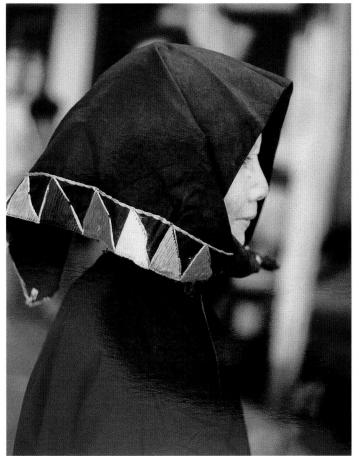

Fig. 343

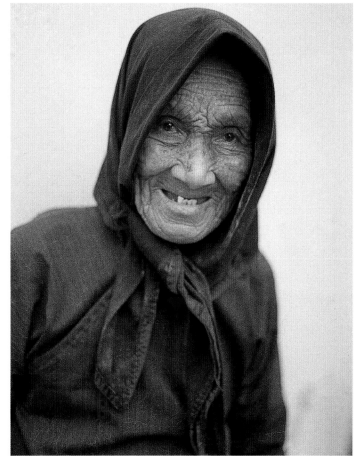

Fig. 344

Fig. 343 Tanka boatwoman wearing a black cotton scarf edged with colored diagonal embroidery, 1988.

Fig. 344 Elderly Tanka fisherwoman wearing a black cotton scarf with the red triangular embroidered design round the hem, Tai Po, Hong Kong, 1979.

Fig. 345 Tanka checked headscarves with decorative triangular edging.

Fig. 345

Hoklo

Women belonging to the Hoklo group from Fujian and Guangdong also wore a more fitted style of *shan* with a deeply curved hem over black *ku* trousers Theirs was distinguished by bands of black gummed silk round the sleeve edges and *tou jin* opening, while the very narrow collar consisted of rows of piping. Colors were bright, often lightish blue for daily use and purple, deep blue, or deep turquoise for special occasions (Figs. 347, 349).

Hoklo boatwomen were particularly fond of dressing their hair with colorful and elaborate ornaments, especially on festive occasions (Figs. 346, 347). Jade and gilt butterfly pins, gilt and diamante stars, and pink wool flowers were pushed into a large, sometimes false, hair bun. Silver and gold hairpins hung over the right ear attached by chains to the rest of the ornaments (Fig. 350).

The womenfolk had no particular hat for everyday wear, and instead borrowed freely from the other groups, usually Cantonese or Hakka straw hats which were kept in place with a beaded band (Figs. 348, 351).

Fig. 346

Fig. 347

Fig. 348

Fig. 346 Hoklo woman's hair bun decorated with pink wool and rosettes, Sha Tau Kok, Hong Kong, 1979.

Fig. 347 Hoklo women celebrating the Dai Wong Yeh festival, Tai Po, Hong Kong, 1979.

Fig. 348 Hoklo woman in a Hakka hat with a beaded band, Sha Tau Kok, Hong Kong, 1988.

Fig. 349 Hoklo *shan* upper garment in blue polyester edged with black gummed silk and multicolored embroidery along the side seams, Sha Tau Kok, Hong Kong, 1988.

Fig. 350 Hoklo women's false hair bun with hair ornaments for wearing at festivals, Hong Kong, 1979.

Fig. 351 Hakka hat worn by Hoklo women in Hong Kong, 1988.

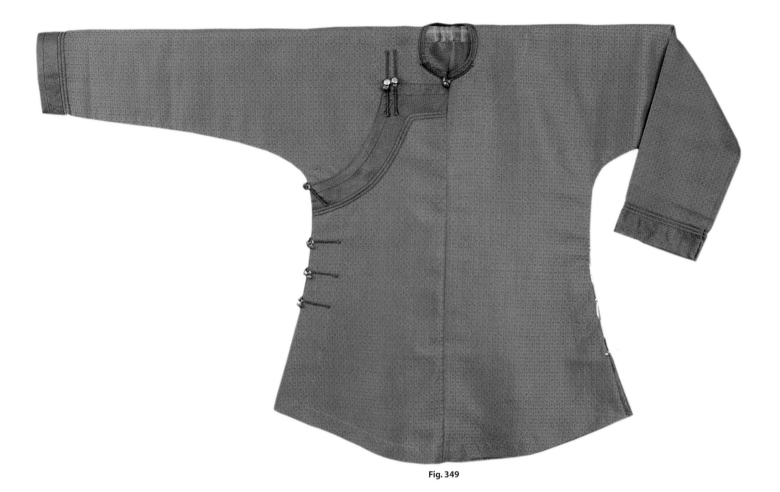

Fig. 349

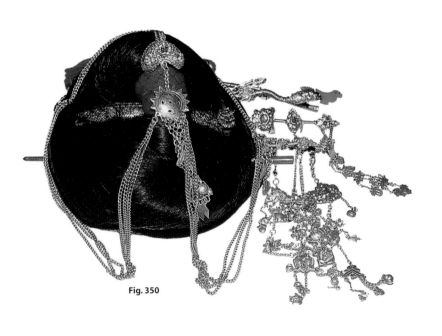

Fig. 350

Fig. 351

Wedding Clothes and Customs

Wedding attire for men in some rural areas of Hong Kong and Taiwan in the latter half of the twentieth century continued to be the long blue gown with the red sash, plus the kind of hat decorations – gilt branches and leaves – which had been part of the civil service graduate's attire, but were here placed on each side of a Western trilby or a skullcap (Figs. 352, 353).

The traditional bridal outfit for a Cantonese or Hakka woman living and working in rural areas was quite simple – a *shan ku* and matching skirt made from homespun hemp, cotton, usually blue or black, or black gummed silk. The wedding ceremony might be the only time the bride wore a skirt, since it was not a practical garment for country life. Even after the dynasty came to an end, these skirts resembled those of the Qing in cut and style, but they were always devoid of decoration with perhaps just a narrow braid edging on the panels and along the hem.

In the middle of the twentieth century, Cantonese and Hakka brides began to wear a matching skirt and jacket (*hong gua*) with a richly decorated cape collar and an ornate headdress, all usually hired for the occasion (Figs. 354–356). The headdress was decorated with beads, sequinned motifs, colorful puffballs on wires, and tassels down the sides. The bride carried a pink feather fan. Red shoes or painted wooden sandals completed the outfit. Custom dictated she should change her shoes after worshipping the ancestors to signify a new start in life.

The bride's make-up, heavily applied by a specialist, was an important aspect of the complete attire, complementing the elaborate decoration on her clothes and the several pieces of gold jewelry she received as part of her dowry – ornate necklaces and bangles, with long life, double happiness, and dragon and phoenix symbols on them. In the past, heavy silver bangles were worn around each ankle. Superstition dictated that brides, especially Hakka women in the rural areas of Hong Kong, wear a small convex metal disk around the neck, highly polished to resemble a mirror, to frighten away bad spirits. A bride might also wear a small cotton bag round her neck, suspended from a cord, in which to put the *li shi* or lucky money packets traditionally given to newlyweds.

In the more remote areas of the New Territories, the Hoklo retain some of their old traditions relating to the wedding ceremony. Although they moved onto the land several decades ago, they continue to practice traditions carried out at sea, including "rowing the dragon boat" with the couple to their new home (Fig. 357). However, the traditional dress of a Hoklo bride, comprising a colored upper garment (*shan*) edged with black worn over a heavily embroidered red satin skirt (Fig. 359) and the large numbers of hairpins given as part of the dowry (Fig. 358) are seldom seen today. Similarly, with more of the Tanka boat people settled on land, their brides no longer wear the earlier style of a short, fitted *shan* in a brightly patterned cotton fabric, and have adopted the *hung gua*.

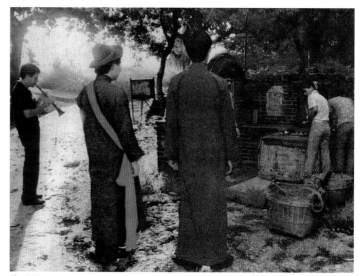

Fig. 352

Fig. 353

Now that many of the once rural areas of Hong Kong have become urbanized, brides throughout the territory may have at least four changes of clothing on the wedding day. In the morning when the groom comes to collect her, a bride wears the traditional *hong gua* to offer tea to her future in-laws. For the ceremony at the registry office or church, she wears a white wedding dress in Western style. She will also have had photographs taken in a studio, park, or other beauty spot wearing this dress. At the dinner reception in the evening, the bride will wear the *hong gua* again for photos taken with relatives. She will later change into evening dress and, depending on her preference, this can be Western style or a Chinese cheongsam. Some brides will even change into another evening dress of a different style and color at the end of the evening to say farewell to the guests. The groom is dressed throughout in a Western dinner jacket, bow tie, and cummerbund.

Fig. 352 Cantonese bridegroom in a long blue gown, crossed red scarf, and trilby hat announcing his forthcoming marriage, to To Dei Gung, the earth god of his village, New Territories, Hong Kong, 1986.

Fig. 353 Gilt sprays worn in the Cantonese groom's hat on his wedding day, Sheung Shui, Hong Kong, 1992.

Fig. 354 Hakka bride and groom, the bride stepping into rattan sieves to avoid walking on the ground until she

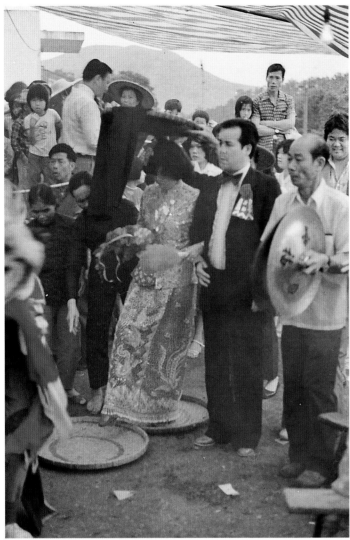

Fig. 354

Fig. 355

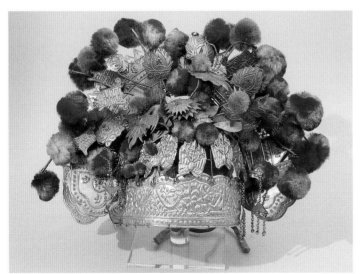

Fig. 356

Fig. 357

reaches the bridegroom's home, Sai Kung, Hong Kong, 1979.

Fig. 355 Cape collar in red satin with sequins, beads, and tassels, worn over the bridal jacket, Taipo, Hong Kong, ca. 1950.

Fig. 356 Coronet made from stamped metal and puffballs, southern Guang-dong province, first half of 20th c.

Fig. 357 Hoklo wedding procession, with close friends and relatives "rowing" the bride and groom to their marital home, Sha Tau Kok, Hong Kong, 1989.

Fig. 358

Fig. 359

Funeral Attire

In the mid-twentieth century, burial clothing for a man of means in Hong Kong and Taiwan was the hip-length jacket (*ma gua*) worn over a long gown and padded trousers, a black skullcap, white silk socks, and black satin shoes (Fig. 363). He was also buried with a handkerchief, a white paper folding fan, a walking stick, and a silver coin placed in his mouth to pay the spirits in the next world. If he had held an important position in life, he wore a replica of a mandarin's winter hat (Fig. 360). Two embroidered squares, usually representing the ninth civil rank, the paradise flycatcher, would be stitched to the front and back of his jacket (Fig. 361).

If a bride had been fortunate enough to own her bridal outfit, this would have been carefully stored in a dowry chest after her wedding ceremony to be worn at the next important milestone, her sixtieth birthday, and on subsequent occasions until, finally, her burial. If not, burial clothing could be purchased from specialist shops. Ready-made clothes for poorer people were often pasted together of the cheapest satin or even paper; richer people had most of their outfit made to measure from silk, with only the final items purchased at the last minute by relatives, speedily made by pasting them together.

Until recent times, two kinds of women's burial clothing were on sale in the New Territories of Hong Kong. The first comprised a shiny black satin rayon jacquard jacket with a "mandarin square" on front and back to be worn over a dull black figured rayon *shan* upper garment over a white cotton *shan*. A skirt in fabric to match the jacket was worn over cotton *ku* trousers. The second set consisted of an embroidered jacket and skirt, cut like a formal jacket, and a pleated and paneled skirt in Qing style (Fig. 362). On the deceased's head was placed the headdress she had worn at her wedding – or a cardboard replica (Fig. 368) – and on her feet embroidered shoes and white socks (Fig. 365). A mirror, comb, handkerchief, patterned fan, and silver coin accompanied her to the next world.

As the twentieth century advanced, the period of conspicuous mourning became much shorter, and by the end of the century only two grades of mourning clothes remained – undyed coarse hemp for close relatives in deepest mourning, and fine cream hemp for others, although this has now been replaced by unbleached calico.

Mourning attire was not cut and sewn into actual garments, but was generally just torn and folded into shape. A man wore a long wide band tied around his head, the ends hanging down the back, with a small piece of red cloth stitched in the center to attract good luck. A woman wore a piece of cloth folded and sewn down one side to make a half-open bag which was placed over her head so that her face was covered, and she could only look down at her feet (Figs. 364, 366).

Up to the latter part of the twentieth century in Hong Kong, after the ceremony female mourners wore wool flowers in their hair – white for parents or husband, blue for grandparents, and green for great-grandparents. After a hundred days, a pink wool flower was worn for the last three days to show that the mourning period was nearly over. Men wore a small piece of black ribbon fastened to an upper garment during their six-week mourning period. Wearing wool flowers and black ribbons was known as *dai xiao*, literally "wearing filial piety."

Fig. 358 Part of a set of 35 intricate gilded silver hairpins set with glass jewels, made for a fisherwoman's dowry, southern Guangdong province, 1930s.

Fig. 359 Hoklo wedding skirt in red satin decorated with a typical Hoklo "false cloud" design, Hoi Feng, Guangdong province, ca. 1980.

Fig. 360 Replica of a mandarin's winter hat with red fringing and a wooden center ornament, part of a man's burial dress, Hong Kong, 1979.

Fig. 361 Crude representation of a ninth civil rank badge for a woman, also worn by a man with the bird the opposite way, stitched to the front and back of a jacket

for festivals, major birthdays, and, finally, as burial attire, Hong Kong, 1979.

Fig. 362 Cantonese and Hakka woman's burial jacket and skirt in black satin embroidered with cranes and cypress for longevity, *shou* characters, and bats for happiness, New Territories, Hong Kong, 1988.

Fig. 363 Man's black satin brocade shoes with the *shou* character for long life on the front, worn at important birthday celebrations and for burial, Hong Kong, 1979.

Fig. 360

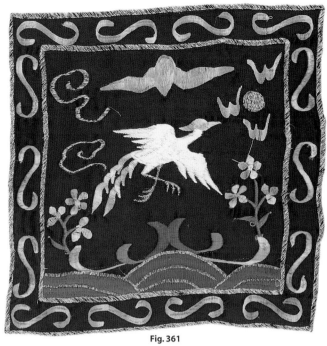

Fig. 361

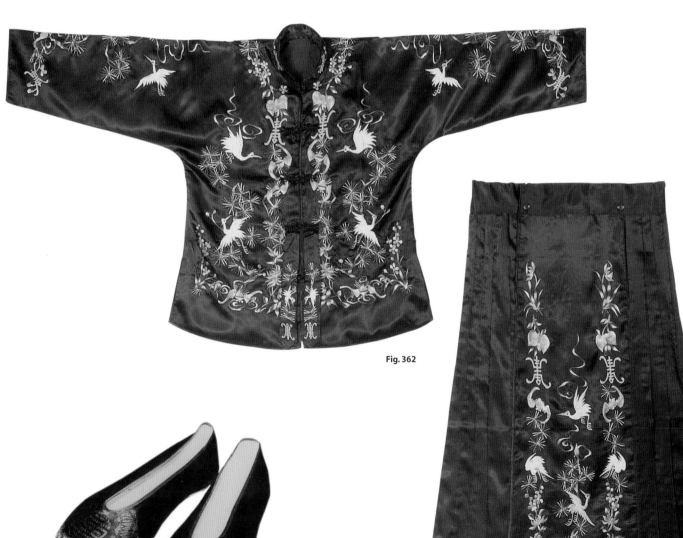

Fig. 362

Fig. 363

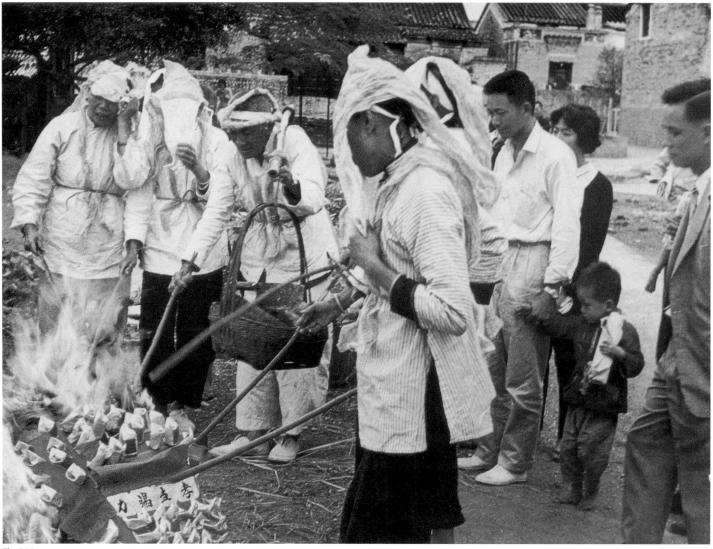

Fig. 364

Qing Ming, a solar ceremony held on April 5th or 6th, and Chong Yang, held on the ninth day of the ninth month of the lunar calendar, are two occasions in the year when the whole family will make a pilgrimage to the graves of earlier generations to leave offerings. Clans, which now are only acknowledged in Hong Kong and Taiwan, accord great importance to these ceremonies, as do all Chinese in these territories. Paper offerings of clothing may be burnt as the name of the recipient is spoken; the smoke thus transports the gifts to heaven.

As well as clothing, more elaborate offerings of bamboo splints covered with paper are made by specialists in the art. Today they include replicas of apartment blocks, luxury cars complete with uniformed chauffeurs, computers, mobile phones, and television satellite dishes (Figs. 367, 369). New items like computer games and PDAs are sometimes sent, since some people like their relatives to stay up to date.

Fig. 365

Fig. 364 Group of mourners wearing undyed hemp and unbleached calico "garments" at a ceremony to mark the end of mourning, Hong Kong, 1960s.

Fig. 366 Funeral procession for a fisherman, the mourners wearing hemp over white clothing, Sha Tau Kok, New Territories, 1988.

Fig. 365 Women's burial shoes in black silk embroidered with *shou* characters and cranes, Hong Kong, 1979.

Fig. 367 Paper offerings for sending to the departed ancestors in a shop in Tai O, Hong Kong, 2005.

Fig. 368 Hakka woman's burial crown made of cardboard and decorated with colored pompoms, Taipo, New Territories, Hong Kong, 1979.

Fig. 369 Festival of the Hungry Ghosts with paper offerings, such as a house with servants, ready to be burnt and sent to the ancestors, Aberdeen, Hong Kong, 2005.

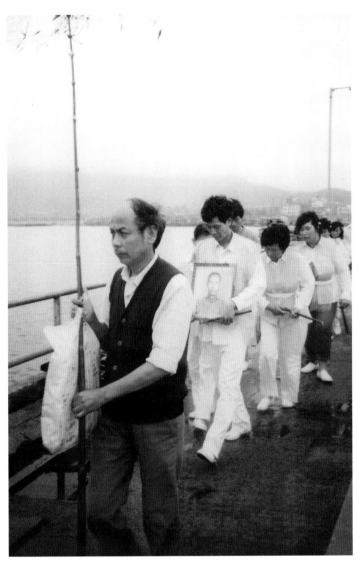

Fig. 366

Fig. 367

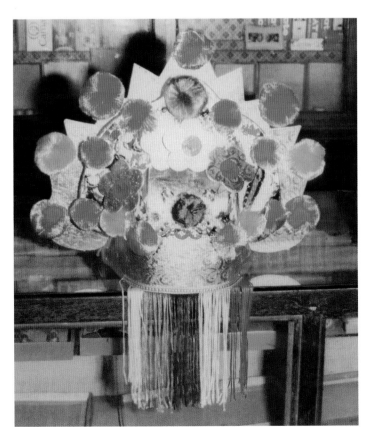

Fig. 368

Fig. 369

Chapter Seven

CLOTHING FOR CHILDREN

Life in the Qing Dynasty

The preference for sons in a Chinese family is not a new phenomenon; only one exacerbated by the one-child policy of the late twentieth century. For centuries Chinese parents have strived to have many sons , since in poorer families boys were needed to help with manual labor (Fig. 371). For those more fortunate, the success of sons in the imperial civil service examinations, which were not open to girls, brought continuing wealth and honor to the family and clan. Moreover, male heirs were needed to ensure the continuation of the clan as well as to perform the very necessary ritual ceremonies of ancestor worship, since girls married out and went to live with their husband's family.

China has always been a predominantly agricultural society, and until recent times a lack of good medical care, coupled with poor awareness of basic hygiene, meant that many babies did not survive. Symbolism and superstition play an important part in Chinese folklore, with certain objects or species being endowed with protective or propitious properties. Because the Chinese language is homophonic, many things are symbolic simply because their name sounds the same as something that is thought to be lucky. For instance, the homonym *fu* stands for both "bat" and "happiness," and hence the bat is a popular symbol.

It is not surprising, then, that children's clothing has been embroidered with flowers, fruit, animals, and insects for centuries, all designed to ward off evil as well as to bring future success to the wearer. Fierce animals, such as the tiger, lion, and dog, were frequently depicted for protection. The Five Evil Creatures, or Five Poisons, consisting of a snake, three-legged toad, scorpion, spider, and centipede, were often shown together as a talisman. Cats, too, were embroidered onto clothing because of their ability to see in the dark and thus see evil lurking. The deer was another common motif. The word for deer, *lu*, and for "an official's salary" are the same. The deer was thus an emblem of good fortune and was often shown with the God of Longevity. The three most popular mythological figures, Fu, Lu, and Shou, denoting good fortune, an abundance of good things, and long life respectively, were also added to many articles of children's clothing and to accessories.

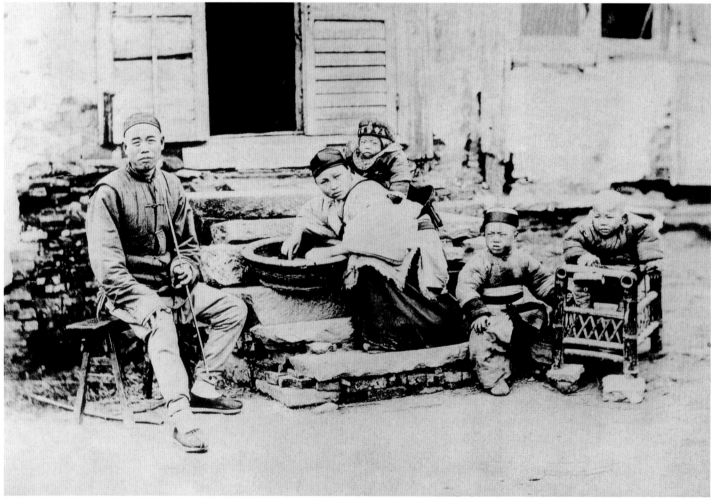

Fig. 371

(Page 178) Fig. 370 Child on his mother's knee dressed in finery for his first birthday celebration. The two older boys are wearing the *chang shan*, the one on the left with a *ma gua*, the one on the right with a *bei xin* waistcoat, early 20th c.

Fig. 371 Father and mother with their three young sons, 1875.

Fig. 372 Set of cotton clothing comprising a red *shan*, green waistcoat, white navel cover, and red and green divided trousers, presented to a baby by its grandmother at the first-month celebration, Hong Kong, 1950s.

Birth to One Year

When a child was born, it was washed and wrapped in swaddling clothes made from cast-off clothing of other family members. So tentative was its existence that until the child was a hundred days old, no name was given, and it was referred to only as "baby" or "little one." Neither the child nor its mother would venture out of doors until the end of the first month after birth, at which time a celebratory feast was held for family and friends. Eggs colored with red dye were distributed to well-wishers who were then expected to give the child a small gift, often items of jewelry to ward off evil.

Cutting the child's hair was also governed by superstition. When the baby was about a month old, a lucky day was chosen for shaving the head. This was said to make the real crop grow thicker and to prevent it from falling out in later life. At a second cutting some months later, the crown was shaved but two circular sections of hair, one above each ear, or even a whole ring, was left around the bald spot. The purpose of these tufts of hair was to enable the parents to seize them when the child was in danger of being whisked away by bad spirits.

The baby would receive his first name about this time. It was very common, however, especially with boys, to use an animal's name or even that of a girl. It was thought that the evil spirits would be fooled into thinking the boy was either an animal or a girl, and thus of no importance.

At this point, the maternal grandmother would present sets of clothing for the infant, tailored along the same lines as the parents', to replace the swaddling clothes. These would comprise a red center-opening or side-fastening jacket, a green sleeveless waistcoat and divided trousers, a navel cover, and a hat (Fig. 372). Later, an embroidered navel cover with lucky symbols on it might replace the earlier plain one (Fig. 374). Everyday wear was made of cotton, with silk and satin being reserved for special occasions. Colors were bright, with reds and pinks favorites because these hues were considered auspicious.

Often an apron (*dou dou*) was the only item of clothing worn by the child in the hot summer months until it was two or three years old. As long as the garment was embroidered with lucky charms, the mother felt the child was quite safe (Fig. 373). A padlock was given to the child, made of silver or *bai tong* alloy inscribed with propitious characters and symbols around the neck to "lock the child to earth" (Fig. 376). A padlock could be also embroidered onto clothing (Fig. 375). A neck ring with a padlock and peach stone charms served the same protective purpose (Fig. 377).

Apart from giving jewelry, another popular custom was to present the mother with small pieces of silk and embroidery for her to sew together to make the child a jacket, all those contributing thus joining in to wish the child good fortune and protection from evil. Known as a "hundred families jacket," it is seen on children in paintings from the Song dynasty (Fig. 378).

Different hats were worn, first for protection against evil spirits and then, as the child grew older, to attract good fortune when taking the important examinations (Fig. 379). The first style was worn from the age of one month, usually presented to the child by the maternal grandmother. Made from a strip of red satin or cotton gathered into a circle at the top, it was called the "rice bowl" style in the south, as it resembled an upturned rice bowl (Figs. 379, 380). It was embroidered with designs of flowers, fruit, and Chinese characters wishing the child long life and good fortune.

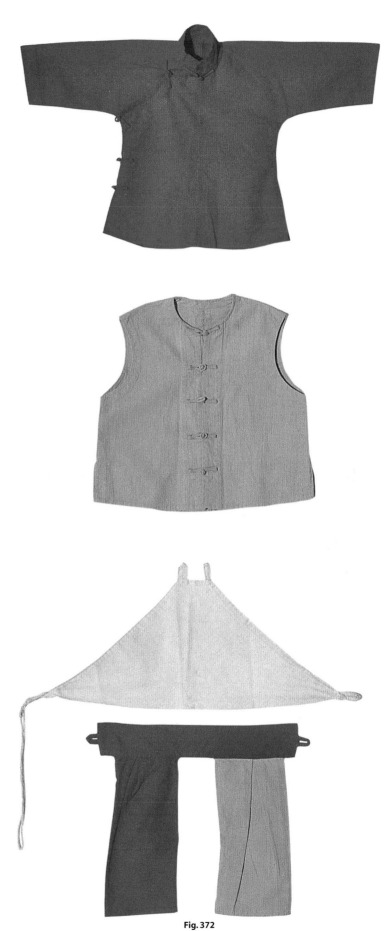

Fig. 372

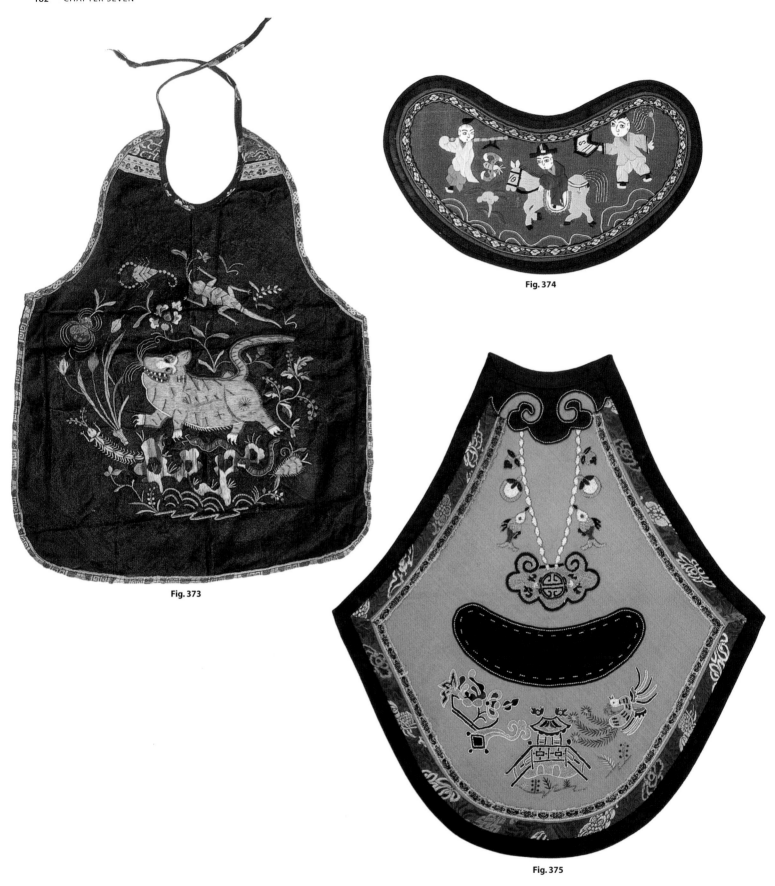

Fig. 373

Fig. 374

Fig. 375

Fig. 373 Apron (*dou dou*) in black silk with the design of a tiger in the center surrounded by the Five Poisons and *lingzhi*, the sacred fungus, symbol of immortality, and flowers, late 19th c.

Fig. 374 Navel cover in red silk embroidered with a scene in satin stitch of a scholar returning successfully from an examination.

Fig. 375 Apron in red silk with a wide opening like a mouth for a pocket, above the "mouth" a padlock with peach and fish charms embroidered in Peking knot, below the opening a scene of a bridge, phoenix, and *ruyi*, mid-19th c.

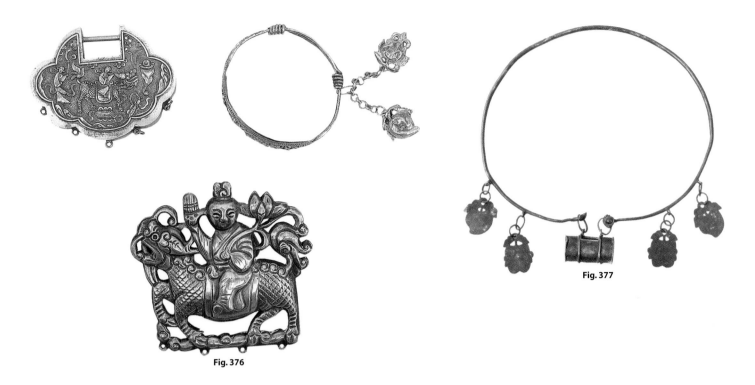

Fig. 376

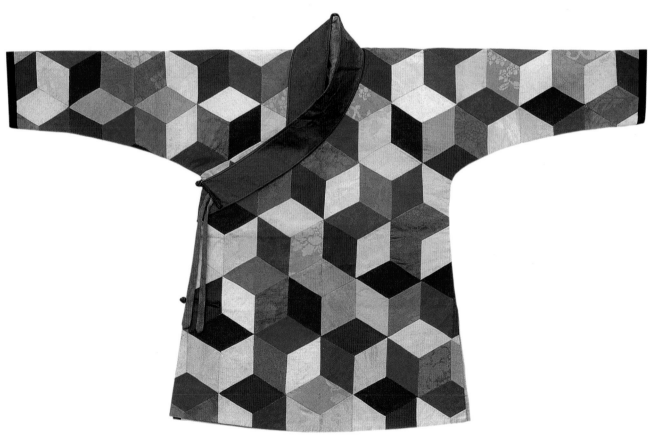

Fig. 377

Fig. 378

Fig. 376 Clockwise from top left: Silver padlock, silver anklet with bell charms, and amulet in *bai tong* of Shou Xing riding a *qilin*.

Fig. 377 Silver neck ring large enough to go over a child's head, with a padlock and peach stone charms, designed to be the equivalent of a dog collar to fool the evil spirits into thinking the child was an animal, and therefore of no value, 19th c.

Fig. 378 Silk patchwork gown, or "hundred families jacket," the style based on the habit of a bonze or Buddhist monk who begs for alms, 19th c.

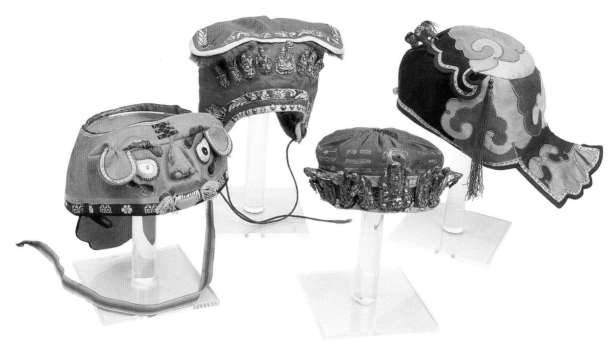

Fig. 379

The second type, also worn in infancy, was similar to the first, excwpt that the top of the crown was more open. It often took the form of an animal such as a tiger, dog, or pig, with a face at the front and a padded tail at the back (Fig. 379).

When the child was about a year old, he wore a "dog head" cap to fool bad spirits into thinking he was an animal and of no value (see Fig. 379). This cap was made of black or red cotton or silk, plain or patterned, with a seam running from center front to center back. A horizontal cut about a third of the way up the front was folded down to give the impression of dog's ears.

Carrying a baby on the mother's back had been the custom in China for centuries, especially in the southern provinces (Fig. 381). For any woman who had to work in the fields, on a boat, or around the home, it was also a safe and convenient place to keep a child out of mischief. If the family did not have servants, it fell to older girls to carry the younger siblings in the same way. Traditionally, the maternal grandmother presented the child with a baby carrier when it was a month old and allowed to leave the house with its mother for the first time (Fig. 382). This was made from a square of cotton or hemp cloth, dyed purple-black or indigo blue, with long strips of fabric extending from the corners of the square to form straps. The centers were embroidered with silk, or occasionally wool, or else left plain. At the end of one or both lower straps, the corners were folded over to the center to form a pocket in which to carry coins.

Like the child's other accessories, footwear was often made in the form of a dog, cat, tiger, or pig to frighten away bad spirits (Fig. 383). Features such as large eyes to see evil lurking, large ears to hear it, and whiskers to feel it combined to suggest the creature being represented. Usually made of red cotton or satin, with brightly embroidered uppers and padded cotton soles, some shoes even had bells on the toes to produce an audible warning for the spirits.

On special occasions, very young children wore satin bootees when carried in a baby carrier. Viewed from the front as the mother and child approached, they looked very colorful as most were made of red, orange, or purple satin, and were frequently

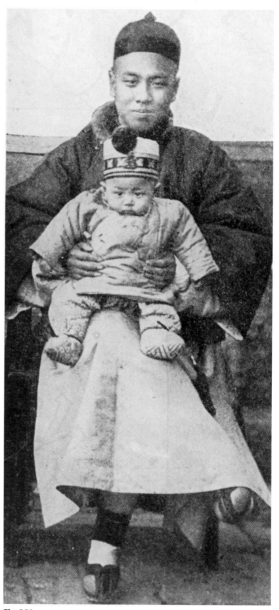

Fig. 380

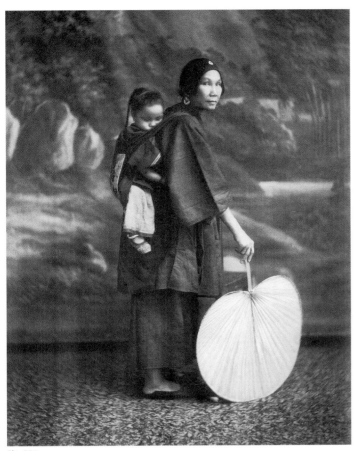

Fig. 381

Fig. 382

embroidered with designs of the dragon or phoenix, a mythical bird signifying goodness and benevolence and the hope that the wearer would rise high in society. Fish, with the homophonic Chinese sound meaning "superfluity" and a symbol of abundance in all things, and deer, symbol of advancement and good fortune, were also depicted. Often padded animals and birds were suspended above the toe on wires and long colored tassels were hung from the front, together with multicolored pompoms.

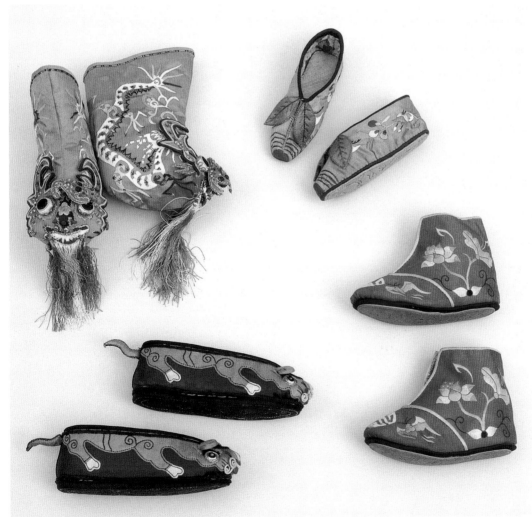

Fig. 383

Fig. 379 Left to right: Hat with an open crown in the style of a tiger with the character for "king" embroidered at the center, the tiger being considered the king of beasts; "dog head" hat in red silk with tufts of fur in the ears and a row of amulets of the Eight Immortals and Shou Xing; "rice bowl" hat in red silk with amulets across the front depicting the Eight Immortals with Shou Xing in the center, and *Ba Gua* symbols embroidered around the edges; multicolored "dog head" hat, late 19th c.–early 20th c.

Fig. 380 Young boy wearing a "rice bowl" hat with an amulet center front and bootees, his father wearing a black skull-cap, 1900.

Fig. 381 Cantonese woman carrying a young child in a baby carrier on her back, ca. 1880.

Fig. 382 Baby carrier in black hemp and coarse pink and red cotton, with a pocket at one end of the strap, the central satin panel lavishly embroidered with flowers, peacocks, and *shou* characters, late 19th c.

Fig. 383 Clockwise from top left: Orange satin bootees with an embroidered dragon curling round; shoes made to represent the pig; red satin bootees with a design of lotus flowers, bats, and the *shou* character on the toes; shoes in the design of a tiger, all early 20th c.

First Birthday Celebrations

A child's first birthday was celebrated with a great feast to which all family and close friends were invited. A boy was dressed in a silk embroidered jacket, either center- or side-fastening, in the style favored during the Ming dynasty (Figs. 370, 386). This was worn with embroidered divided trousers comprising two pieces of cloth attached to a broad cotton waistband, joined from ankle to knee, but leaving the area covering the buttocks free (Fig. 385). This style, still seen today, dates back hundreds of years and is illustrated in a Ming dynasty children's reader first published in 1436. As women gained more emancipation in the early years of the twentieth century, girls' birthdays were also celebrated (Fig. 387).

At his first birthday feast, a boy was expected to indicate his future career (Fig. 384). Chiang Yee, writing about his family in the

Fig. 384

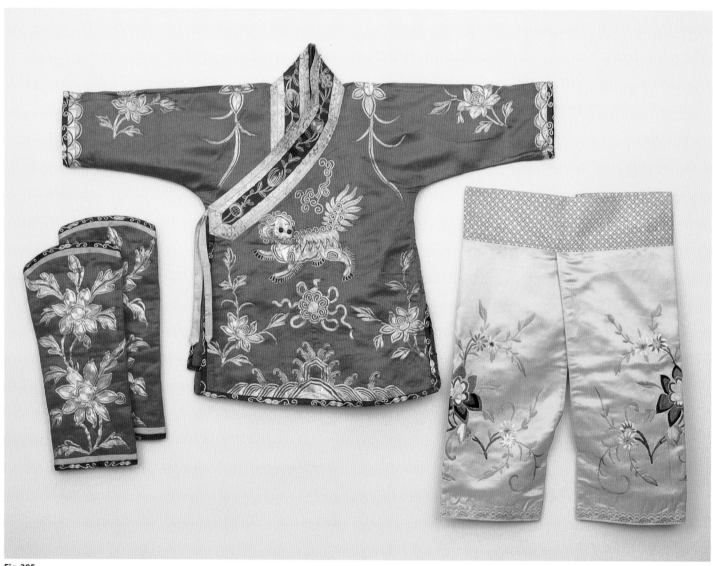

Fig. 385

Fig. 384 Even in fairly recent times, the *zhua zhou* ceremony took place on the boy's first birthday, supposedly to determine his future career, Hubei province, ca. 1985.

Fig. 385 Red satin jacket fastening across to the right in the Ming style, embroidered with couched gold thread in the design of a *qilin*, representing wisdom; red satin embroidered leggings; green satin divided trousers embroidered with flowers, Shanghai, early 20th c.

Fig. 386 Child's red silk damask jacket with green neckband, embroidered with all twelve creatures of the zodiac. On the front: the dragon, hare, and goat, flanked by the monkey and dog; on the shoulders: the ox and snake; on the back: the tiger, rooster, and pig, flanked by the rat and horse, early 20th c.

Fig. 387 Girl's red satin dress made for her first birthday, embroidered with Shou Xing, symbolizing long life, and the Heavenly Twins, symbolizing harmony, early 20th c.

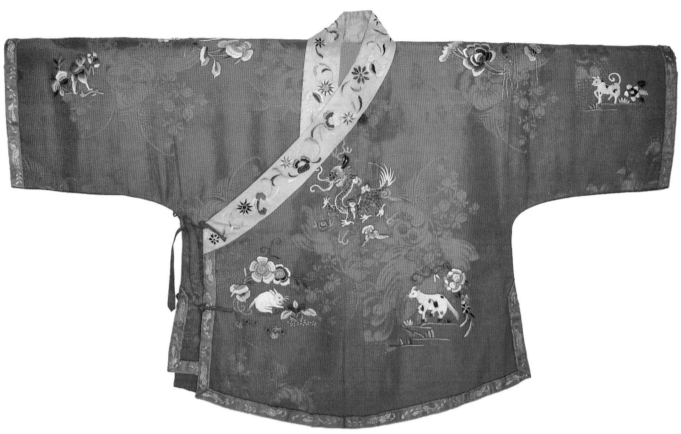

Fig. 386

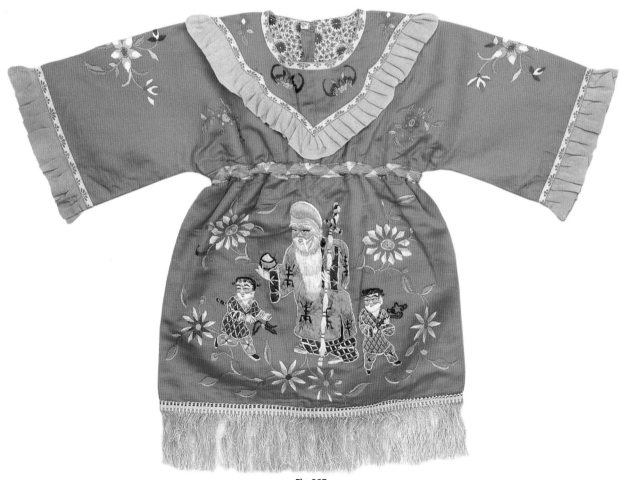

Fig. 387

early twentieth century, describes the *zhua zhou* ceremony for his baby nephew, who was set "in the center of a huge round table, in the midst of an assortment of articles representing the various professions he might enter – inks, brushes, an abacus, a sword, scissors, a very small hammer, an official seal, herbs, and so on. He was encouraged to pick up anything he liked. This is called *Cha-chou* [*zhua zhou*], the Grasping Celebration of the first year of age. At first he did not know what was expected of him, and stared round inquiringly at the assembled company. Then, seeming to realize we were all waiting for him to do something, he stretched out both hands … and after a while picked up a green herb, which was not actually very near him. Grandmother smilingly announced that he would be a medical man when he grew up." Needless to say, Chiang Yee remarked later, when his nephew grew up he never did become a doctor (Chiang Yee, 1940: 203).

Young Children's Clothing

From the age of four or five, boys wore a long gray or blue silk gown, and over this a side-fastening waistcoat (*bei xin*), colorfully embroidered and edged with braid. The waistcoats of younger children were embroidered with lucky symbols to protect the growing child (Figs. 389, 390). Boys from well-to-do families wore the *ma gua* with the *chang shan*, or even the *nei tao* and surcoat, for formal events and at Lunar New Year.

Children of this age also wore animal hats representing the lion, tiger, or dog, but they were more elaborate and made to emulate the strength and ferocity of the animal (Fig. 391). All the hats had ears to hear evil approaching, large protruding eyes to spot danger, and a mouth full of bared teeth. Some animal hats had another animal perched on top of the hat to provide even greater protection. An embroidered back flap was added to cover the back of the neck in cold weather. The wind hat was specially made for winter. Shaped like the dog head hat, or with the crown gathered into a circle, the long back extension kept the neck warm in cold weather. This type was often lined and padded, some being embroidered with flowers and birds, while others had a fierce animal face. Hats worn on festive occasions and for the Lunar New Year were shaped more like a crown. These were often decorated with colorful pompoms (Fig. 388).

Infants and young children wore collars over their jackets or gowns, some made of five or six segments, others elaborately subdivided into many smaller sections, each segment decorated with auspicious symbols (Figs. 392–395). In the northern provinces, collars were frequently shaped like the body of a fierce animal, particularly the lion or tiger (Figs. 396, 397). When worn, the animal appeared to be coiled round the child's neck to give greater protection. Others depicted a smiling child or a number of children (Figs. 398, 399). Shoes in the form of an animal continued to be worn by young children (Fig. 400).

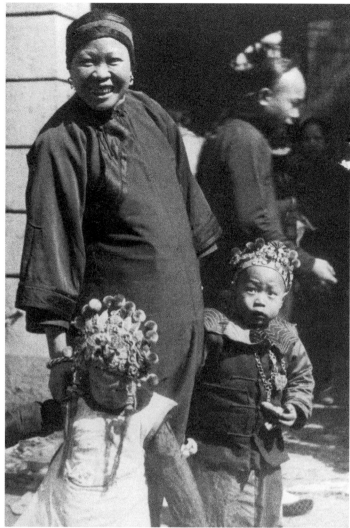

Fig. 388

As with babies, young children wore many charms to protect them from harm. The God of Longevity was a popular amulet on a child's neck ring, either mounted or standing beside a deer or *qilin* holding the peach of immortality in one hand and a staff in the other (Fig. 401). The *qilin* was also used as an auspicious symbol for children as it was thought to have great wisdom, as well as symbolizing a desire for a large family of sons who would do well in the civil service examinations (see Fig. 376). A jade Buddha, suspended around the neck during childhood, was another popular charm, and remains so today.

Amulets protraying the God of Longevity, Shou Xing, and the Eight Immortals were stamped out of a thin sheet of silver or brass and frequently stitched across the front of the child's hat. One or more Laughing Buddhas, friendly figures believed to be able to dismiss misery and unhappiness from the world, were also placed across the front of the cap. Other amulets depicted Chinese characters for good fortune and long life, and especially the *Ba Gua*, also

Fig. 388 Two young children wearing crowns, collars and padlocks at the Lunar New Year, Hong Kong, 1909.

Fig. 389 Child's waistcoat made of hemp covered in cross-stitch embroidery of a padlock to "lock the child to earth," 20th c.

Fig. 390 Child's waistcoat covered in silk brick stitch embroidery of the phoenix, peony, and sacred fungus, 19th c.

Fig. 391 Animal hats. Left: Double hat, with a lion riding on the back of a dog with a wind flap; the dog was always made in black, while the lion was usually green with a long silky mane. Right: Hat in the shape of the *qilin*, with the two horns extended, flames issuing from its nostrils, a ball suspended from its mouth, while on its back is a child riding a tiger. Center: Tiger wind hat with a padded tail in orange satin marked, in this case, with "eyes," usually with black stripes, with tiny mice in each ear.

Fig. 389

Fig. 390

Fig. 391

Fig. 392

Fig. 393

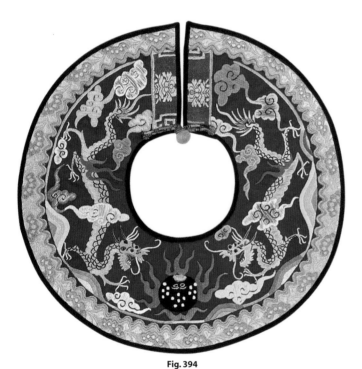

Fig. 394

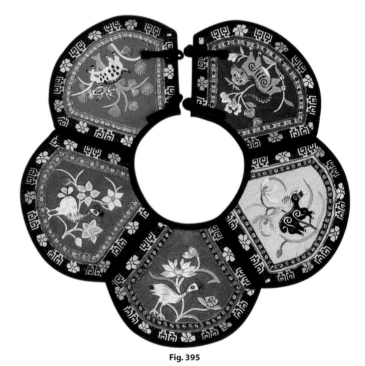

Fig. 395

known as the Eight Trigrams, which was placed in the center of the cap. This was a mystical symbol showing eight groups of lines arranged in a circle, each group consisting of combinations of broken and unbroken lines, arranged in three ranks, and often having the *yin yang* symbol of creation in the center. The Trigrams were the basis of the ancient system of divination and philosophy. Wearing such an ornament was said to safeguard the wearer from harm and ensure his continued good fortune. Religious and mythological figures were also used as amulets, their antiquity ensuring longevity and good luck.

Fig. 392 Child's collar formed of six embroidered bats, each attached to a cloud motif.

Fig. 393 Collar with auspicious fruit embroidered onto silk, including the pomegranate, peach, Buddha's hand, as well as persimmon, an emblem of joy.

Fig. 394 Collar in a continuous circle with a design of two four-clawed dragons chasing the flaming pearl against a background of clouds and mountains, possibly made for the son of a mandarin.

Fig. 395 Collar with five segments containing two birds and three animals – the horse, deer, and lion.

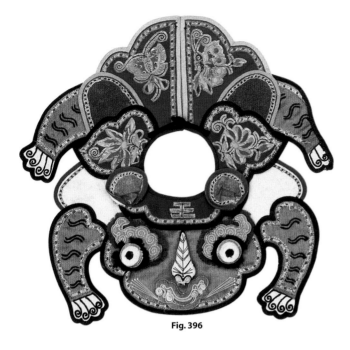

Fig. 396

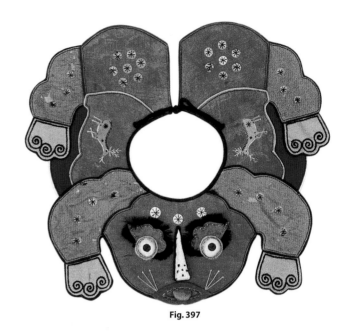

Fig. 397

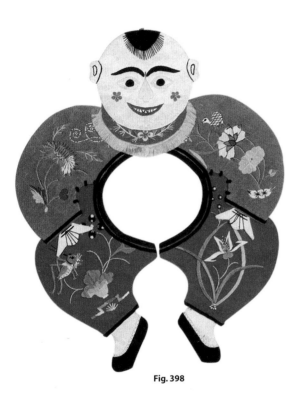

Fig. 398

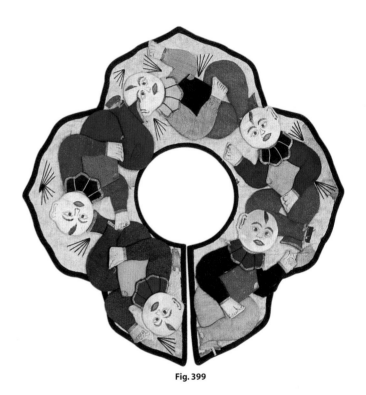

Fig. 399

Small bells were also worn by young children in the hope that their tinkling noise would scare away bad spirits. Bells were part of the sets of charms given to the baby at the first month celebration. They were often attached to the cap strings at the back of hats. More often, a single large brass bell was tied to the child's ankle with red thread, the red color itself believed to be propitious and to ensure long life, or, alternately, two anklets were worn, either made of jade or silver with charms containing bells suspended from them. Jade, silver, or *bai tong* bracelets were also worn round both wrists, and continued in use in later life.

Fig. 396 Very colorful tiger collar. These fierce animals have certain features in common: large eyes to spot evil lurking, a prominent nose to sniff it out, ears alert, and a mouth bared with teeth ready to devour the evil; claws well-defined.

Fig. 397 Collar in the form of a lion decorated with sequins and embroidery, its features exaggerated to highlight its protective function.

Fig. 398 Collar in the form of a smiling child.

Fig. 399 Collar formed of five boys each wearing a collar, *dou dou*, trousers and jacket, a desire for a large and happy family.

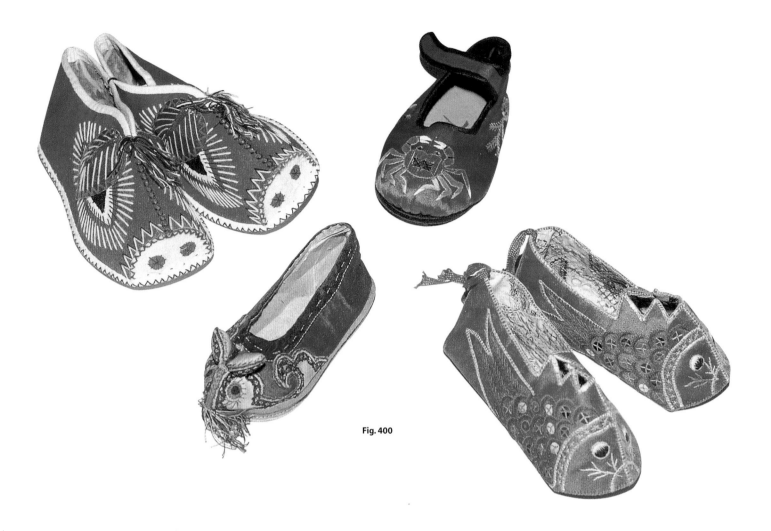

Fig. 400

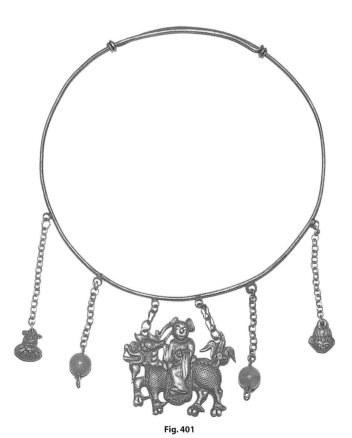

Fig. 401

Older Boys' Clothing

Education, literacy, and scholarship were always greatly prized, and from an early age, where possible, sons were groomed to take the civil service examinations. Families employed private tutors, or else the clan would establish a private school or study hall in order to educate prospective candidates.

At first boys were expected to memorize between twenty and thirty characters each day, rising to 100, 200, or several hundred daily as they became more proficient. By the time a boy was fifteen, he was expected to have learnt over 400,000 characters (Miyazaki, 1981: 16). These were culled from essential school texts such as the *Three Character Classic*, the *Analects of Confucius*, and the *Book of Changes*. Reciting from memory to the teacher, often a failed examination candidate himself, was known as "backing the book" (Fig. 403). Traditionally, subjects such as geography, science, and foreign languages were considered irrelevant.

Even the games boys played related to their main objective. One board game, called *Shengguan tu* (the Game of Promotion), represented the career of a mandarin from the highest to the lowest grade, according to the examination system. It was played with four dice, rather like Snakes and Ladders, and the object of each player was to secure promotion over the others. Unfortunately, not all boys were given the time and opportunity to study, and many had to take what menial jobs they could (Fig. 402). For these boys, life was hard and they became coolies working very long hours.

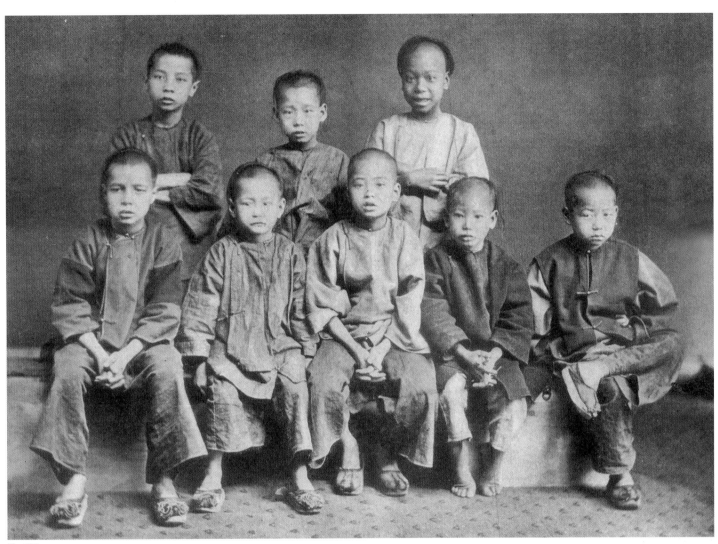

Fig. 402

As a boy grew older, the hat he wore was less symbolic of protection against evil than of bringing success for the future (Fig. 404). Such was the reason for the "scholar cap," given to the boy in the hope that he would do well in the official examinations. At the back of the hat were two streamers and two pointed "feathers," similar to those on the gauze caps worn by scholars and officials during the Ming dynasty. Another type, called an eagle hat, had upturned wings said to represent an eagle, which, as it soared high, ensured that the wearer would rise high in office; as it swooped low, it was hoped the wearer would live to become a grandfather.

Another style of hat was one with a false fringe and queue made of black twisted silk thread. The crown was made of stiffened cardboard, covered with silk, and divided into eight sections, each embroidered, often with emblems of the Eight Immortals.

The plain black skullcap, like those worn by men, was worn on a daily basis. The cap was made of stiffened black satin in six segments fixed to a narrow brim and topped with a black or red

Fig. 403

Fig. 400 Animal shoes and slippers worn by young children, decorated with auspicious motifs, such as the crab, fish, and rabbit.

Fig. 401 Silver neck ring with Shou Xing riding the *qilin* and peach stone charms, for wisdom and longevity.

Fig. 402 Street boys wearing the *shan ku*, ca. 1900.

Fig. 403 "Backing the book," students wearing the *shan ku* with a melon cap, reciting from memory to their teacher, late 19th c.

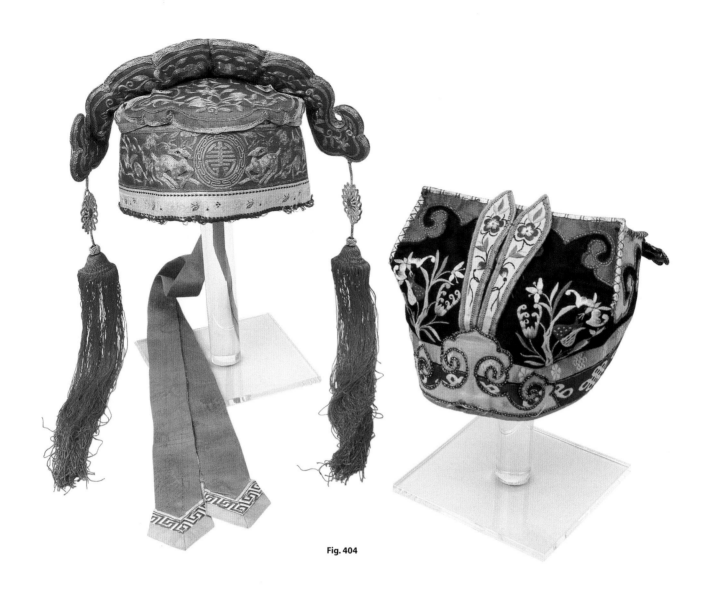

Fig. 404

Fig. 405

button or silk pompom. Also called a melon cap, it was worn with the long gown and *ma gua*, and always seen at the Lunar New Year, even in recent times.

Older boys wore black satin boots on formal occasions, if their father was of high enough rank, but for everyday wear they wore shoes made of satin with a thick white sole made of paper and finished with a layer of leather, similar to those made for men but more colorful. The vamp was often embroidered with auspicious flowers and insects, and had a center seam reinforced with leather, which extended over the rigid sole to provide sufficient spring for walking. Another style with a flat sole and a rounded toe was made in woven straw, for wearing in the summer in the southern provinces (Fig. 405).

Fig. 404 Left: Eagle hat of pink silk decorated with couched gold thread embroidery of flowers, deer, and the *shou* character, with long pink tassels at each side and green streamers at the back. Right: Scholar's hat with two pointed "feathers" at the back, the front embroidered with cranes and flowers and the brim with Endless knots.

Fig. 405 Left: Woven straw shoes. Right: Boy's black satin shoes.

Older Girls' Clothing

With the value placed on having sons, many parents abandoned their baby daughters, especially in the Year of the Tiger, for it was thought that girls born under that sign would grow up to be fierce women and therefore unwanted wives. The majority of abandoned girls died, but those more fortunate were taken to orphanages. As they became older, some were adopted by families as future domestic servants, others became the future concubines of wealthy merchants. Sadly, many were destined for the brothels. Even today, despite efforts through education, many baby girls are aborted, killed, or neglected since most parents in China prefer sons. The result is a nation of "little emperors" as the child is doted on not only by his parents but also by two sets of grandparents.

Girls did not receive any formal education, but some, especially the daughters of officials and the sisters of graduates, managed to acquire a little learning. For the most part, girls were expected to help around the house and tend to the younger children if the family did not have servants. They were taught to embroider from an early age, both to provide the many articles needed within the household and, in some cases, to contribute to the family's income. Often, if a family had many girls, a number might be sold into better-off families to work as domestic servants. There was then the possibility that when the girl came of age, she might become a wife or concubine to one of the sons in the family.

Throughout the nineteenth century, girls wore the bulky side-fastening *ao* and trousers cut along the same lines as their mothers, but without the skirt which was the prerogative of married women. The *ao* was often covered with embroidery and trimmed with bands of yet more embroidery (Figs. 406, 408, 409). Young girls wore a scaled-down version of the *ao* with trousers, and their hair was braided into two little pigtails (Fig. 407). In place of hats, girls generally wore earmuffs, slipped over the ears to keep them warm.

Six pairs are shown in Fig. 410, from the top: a pair in black satin edged with fur, with ties to keep them together; the characters indicate a wish that the earmuffs may keep the wearer warm for three winters. Next to them is another pair in black satin edged with fur, this time with flower vases, one holding plum blossoms, the other chrysanthemums, willows, and a bowl of flowering narcissi, usually seen at the New Year. Below is a pair made of black satin with a deer, a crane, and a cypress tree, symbols of a high salary and a long life. Next to them is a pair of purple satin earmuffs with orchids and sacred fungus. On the bottom row is a blue and yellow pair with a fierce looking animal in the center; next to it is a pair with five bats around a central *shou* character and with five more bats and five *shou* characters around the edge, wishes for happiness and longevity. Earmuffs were not, however, confined to any sex or age group, and were worn even by men at times, especially in the harshest of winters. For children, they were sometimes trimmed with fur to represent an animal thought to have protective powers.

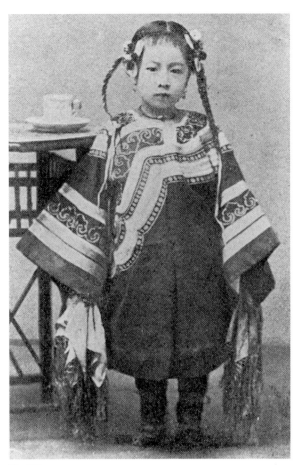

Fig. 406

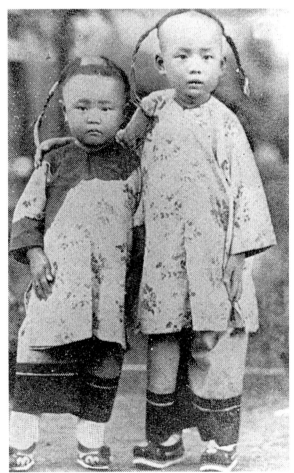

Fig. 407

Fig. 406 Young girl with bound feet wearing an oversized *ao*, late 19th c.

Fig. 407 Two young girls wearing the *ao* and trousers, with their hair in pigtails, ca. 1900.

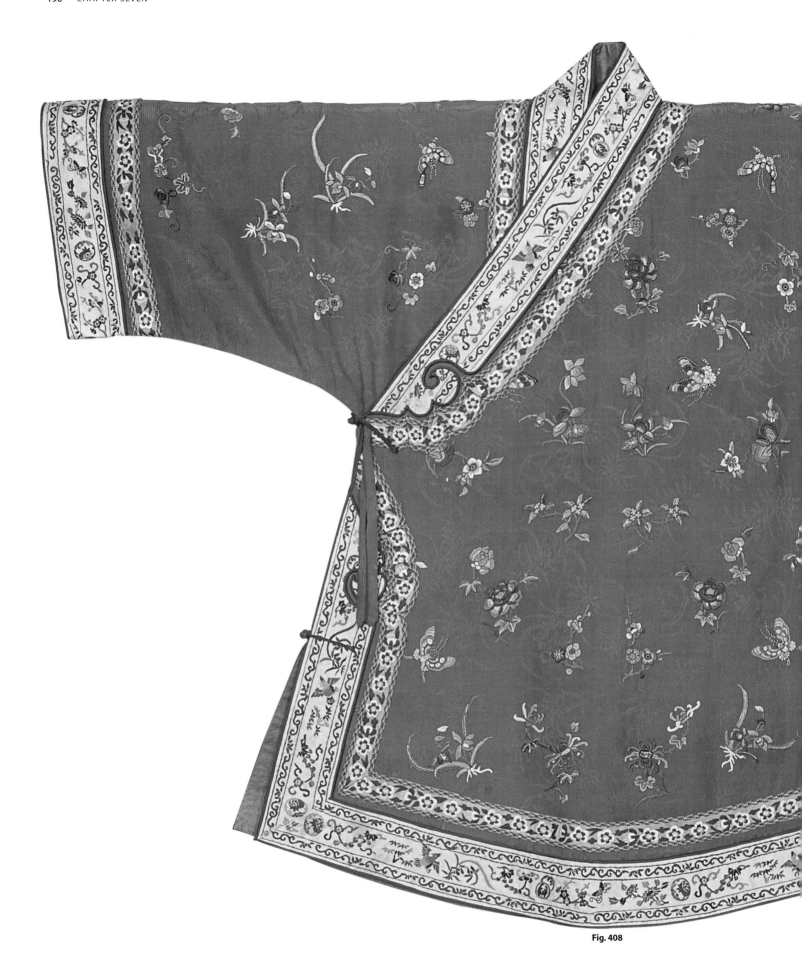

Fig. 408

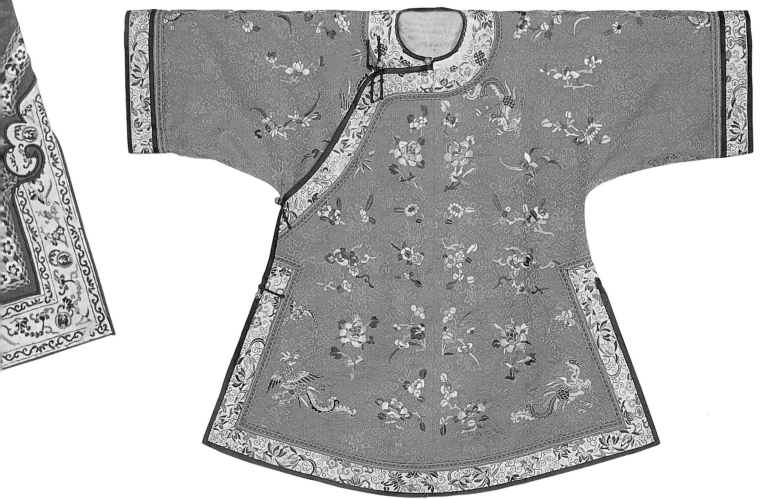

Fig. 408 Young girl's red silk damask *ao* embroidered with flowers and butterflies, edged with embroidered bands, 19th c.

Fig. 409 Young girl's green silk damask *ao* embroidered with flowers, butterflies, and a phoenix, edged with embroidered bands, mid-19th c.

Fig. 409

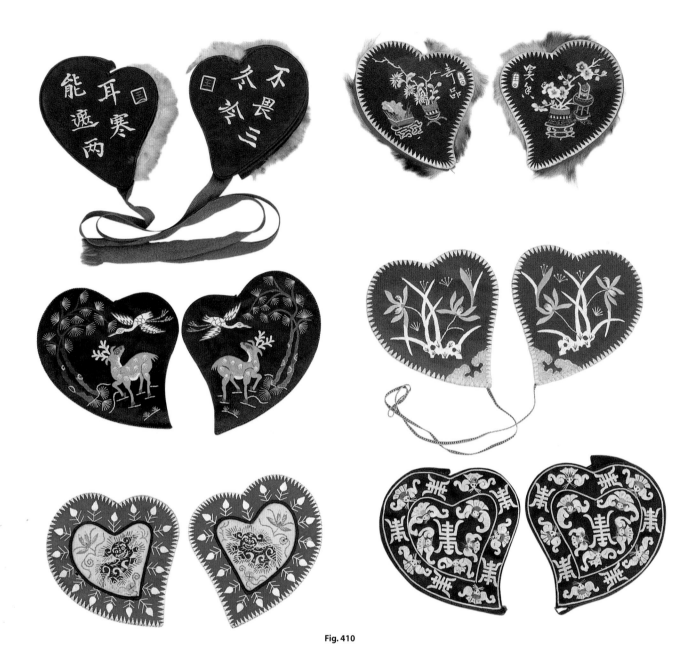

Fig. 410

Fig. 411

Footbinding began when a girl was between three and ten years old (Fig. 411). A mother who did not yield to tradition – and there were a few who did not impose this painful custom on their daughters – would render them unmarriageable and they would become a liability to their parents for the rest of their lives. Daughters did not inherit family property, but they often received items of gold jewelry as dowry. This gave the brides considerable wealth, and ironically, the only ones in the family who had private assets. If the family was prosperous, this kind of inheritance could be substantial (Ko, 2001: 50).

Fig. 410 Six pairs of earmuffs, padded, lined, and shaped like a heart, they slipped over the ears to keep them warm.

Fig. 411 Left: Shoe on a plaster of paris mold of a bound foot, the attached label identifying it as being a "Baptist Missionary Society demonstration model" from Fujian province used in the nineteenth

Dress in the Twentieth Century

By the beginning of the twentieth century, conditions had improved for many girls due to greater emancipation for women and other outside influences affecting China. Girls began to be formally educated and were even sent away to school (Fig. 412). To take advantage of this greater freedom of expression, they discarded the bulky clothing of the previous century and wore a slimmer version of the *ao* with a plain black skirt (Fig. 413).

During the Republican period, young male students wore a military-style school uniform and cap (Fig. 414). This uniform (*xuesheng fu*), comprising a fitted jacket buttoned down the front and a stand-up collar and Western trousers with a stripe down the outsides of the legs, was based on an early form of the Sun Yatsen suit (see Fig. 259). Young schoolboys also wore Western dress of jacket and shorts (Figs. 416, 417). Sailor suits, first introduced for children by Queen Victoria in 1846, became popular both in the West and in China (Fig. 415). The Queen had admired the sailor's uniforms when on a cruise, and asked her tailors to make one for her son, the four-year-old Prince of Wales.

Fig. 412

Fig. 413

century to demonstrate footbinding, possibly as part of the fight by missionary societies to abolish the custom. The shoe is made of red silk with a cotton heel tongue and loops. Right: Shoes for bound feet, measuring 3 1/2 inches (9 cm) from heel to toe, made of brown silk with a cotton heel tongue, worn by a very young girl.

Fig. 412 Schoolgirls sewing, wearing the traditional *ao kun*, their feet unbound, Xiamen, ca. 1912.

Fig. 413 Girls wearing the white *shan* and black skirt, exercising at the Shanghai Girls' Boarding School, 1912.

Fig. 414

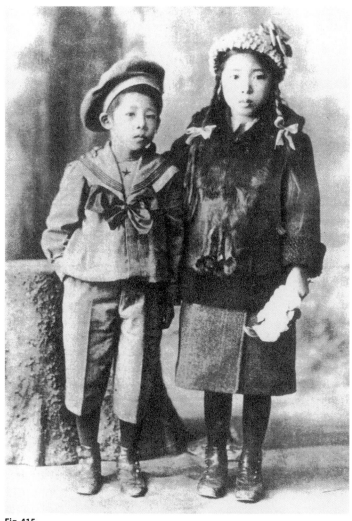

Fig. 415

Fig. 416

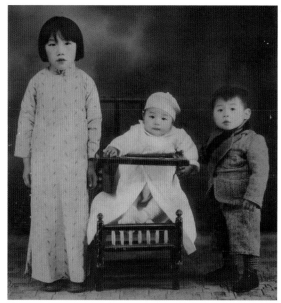

Fig. 417

Fig. 414 Page from a woodblock printed book showing boys in a rally wearing Republican military dress, 2nd year of the Republic, 1913.

Fig. 415 Two children in Western dress, the boy in a sailor suit, the girl in a jacket and skirt, early 20th c.

Fig. 416 Family group, the eldest boy in Western dress and school cap, the parents and younger children in traditional dress, 1920s.

Fig. 417 Baby in a carriage flanked by a young girl in a long cheongsam and a boy in Western dress, 1920s.

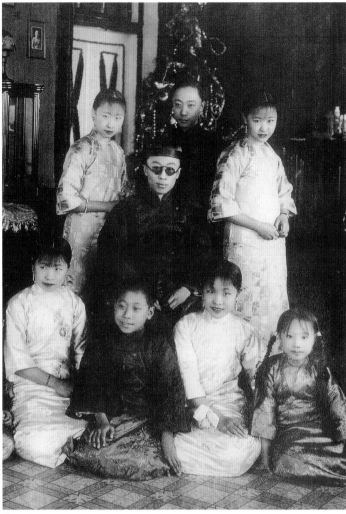

Fig. 418

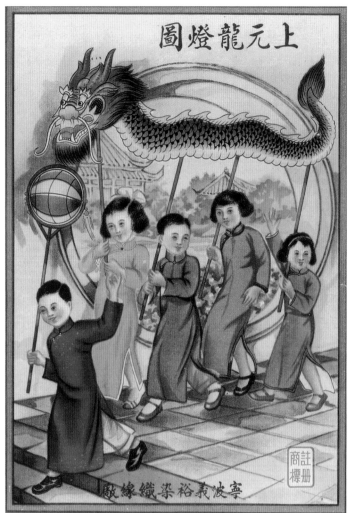

Fig. 419

Better educational opportunities for girls in the mid-1920s brought about the need for a school uniform which reflected the Chinese style of dress to replace the Western-style gym slips worn at some schools. With the development of the women's cheongsam after 1925, which was also worn by girls, a plain cotton version, with wrist-length or short sleeves and short slits at the side of the hem, was chosen for the school uniform (Figs. 418–420). The style is still worn by students at several schools in Hong Kong today.

Western fashions gradually filtered into China, and department stores in the 1950s issued catalogues showing the latest styles for girls, including pinafores, skirts, and blouses (Fig. 421). Along with sailor suits, which continued to be popular, boys in the 1950s also wore romper suits, shirts, and short pants (Fig. 422). Clothing styles changed considerably during the second half of the twentieth century, especially after the Sino-Japanese War and the takeover of China by the Communist Party in 1949. These changes are discussed in the next chapter. But in the rural areas, and especially in Hong Kong and Taiwan, many traditional styles and customs were maintained.

Fig. 418 The deposed Emperor Puyi with his younger brother and his sisters who are all wearing cheongsams, Tianjin, late 1920s. Sumptuous dragon robes had given way to simple cheongsams in less than twenty years.

Fig. 419 Dye advertisement from the Yi Yu Dyeing Company showing children in long gowns performing a dragon dance, Ningbo, 1930s.

Fig. 420 Two girls in their school uniform, the cheongsam, ca. 1960s.

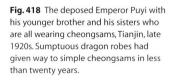

Fig. 420

Fig. 421

Fig. 422

Fig. 421 Page from a catalogue of the Chinese Merchandise Emporium showing girls in dresses and pinafore dresses, boys in sailor suit and shorts, 1955.

Fig. 422 Page from a catalogue of the Chinese Merchandise Emporium showing a boy in a sailor suit and boys' romper suits, 1955.

Baby Carriers

As babies grew into toddlers, they continued to be transported in baby carriers (Fig. 424). Land dwellers in Guangdong province and Hong Kong favored a style with a decorated center square and straps, which were a continuation of the top and bottom edges. The child and carrier were placed on the mother's back, then two straps were brought over her shoulders, with two more under the arms, to be tied in a knot in front; the child was carried with the feet encircling the mother's waist. The floral printed cottons on a red background of many of these carriers are reminiscent of Indian cotton chintzes sent to China in the eighteenth and nineteenth centuries.

The center designs of these carriers comprised a selection of auspicious emblems – a pair of mandarin ducks symbolizing marital fidelity; pomegranates for abundance in all things, especially sons; lotus flowers for purity and fruitfulness; butterflies for conjugal happiness; and the Chinese characters for double happiness, long life, and good fortune (Fig. 425). The centers were decorated in several ways – embroidered, brocade or crocheted pictures, white canvas squares with red cross-stitch, or interwoven strips of cotton. At the center top of the square was a small folded triangular piece of cloth, originally five layers thick, but later only one layer. It was considered to be a lucky charm and symbolized the Five Blessings – wealth, health, happiness, long life, and the right to a natural death.

In other provinces, such as Guizhou and Yunnan, the carriers were made of a large rectangle with a folded flap along the top edge. Floral embroidery or appliqué was arranged in the center of the square and/or along the flap. Long straps along the top crossed over

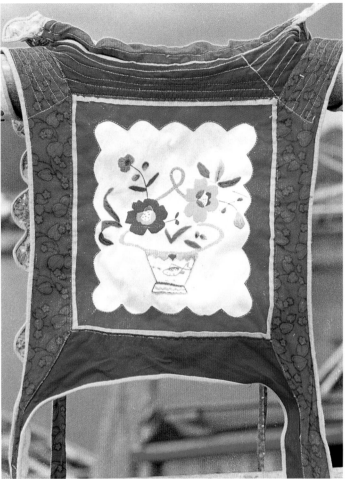

Fig. 423

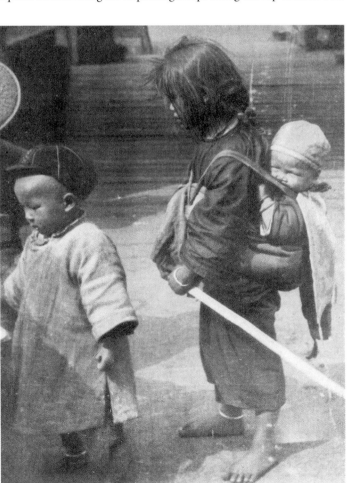

Fig. 424

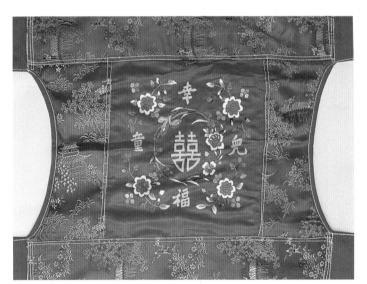

Fig. 425

Fig. 423 Tanka baby carrier with an embroidered center, Sha Tau Kok, Hong Kong, 1979.

Fig. 424 Young girl carrying her brother on her back in a baby carrier, ca. 1930s.

Fig. 425 Farming-style carrier in red satin brocade with the character *shuangxi* embroidered twice in the center to denote "double happiness," and thus associated with marriage. This carrier may have been made to be presented at a wedding. mid-20th c.

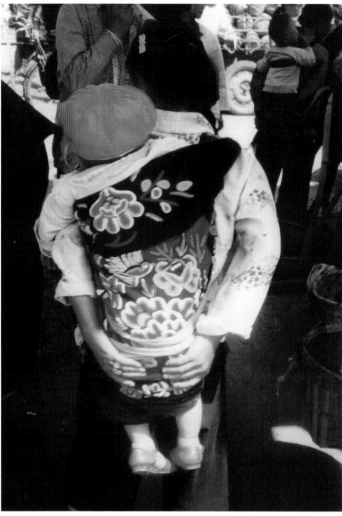

Fig. 426

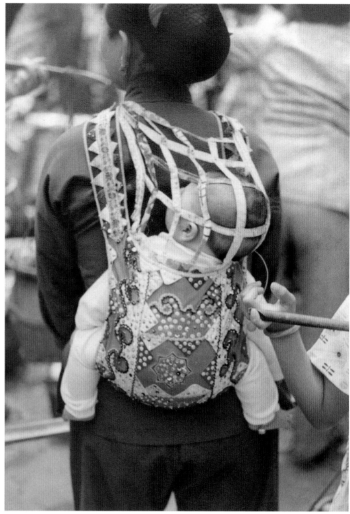

Fig. 427

the mother's shoulders and chest, then round the child's body at the back, so that the child was carried with the feet hanging straight down (Fig. 426).

The Tanka and Hoklo fishing people favored a style with a slightly smaller center and longer straps fixed diagonally to the four corners of the square, with reinforcing stitching at these points (Fig. 423). The centers on these carriers did not usually feature embroidery, but were made up of oddments of colored strips and triangles of cotton. These were appliquéd on to the center square, and continued up the top straps so that when worn the decoration was visible as far as the knot. This patchwork effect was reminiscent of the "hundred families coats" of the nineteenth century. Hoklo boat women made special carriers for festivals and celebrations with bells to frighten away the bad spirits, plus tassels, fringing, beading, and appliqué in a multitude of colors (Fig. 427).

Another style for the boat people was the simplest of all, being a plain, undecorated strip of red cotton or hemp, approximately 9 feet (3 m) long by 1 foot (30 cm) wide (Fig. 430). This related to

the tradition for a bridegroom to wear a strip of red cloth draped across one shoulder of his long gown and tied on the opposite hip. After the wedding day it was put aside for later use as a baby carrier, by winding the strip of cloth twice round the child, then tying a knot in front of the wearer.

Highly decorated baby carrier covers were used to protect the child when the weather was cold, as well as on special occasions. Those made by the Hoklo boat women were embellished with embroidery, appliqué, braid, tassels, and bells, much like the carriers themselves, and were beautiful works of art which could take many months to complete (Fig. 428). Simpler baby carrier covers, made of two layers of brightly patterned cotton stitched together so as to be reversible, were used by other ethnic groups. The layers of cotton were pleated into a smaller band at the top, and two sets of ties held the cover in place around the child. More decorative covers made of red silk, padded and embroidered with auspicious symbols, some with fur lining and hoods, were given as gifts at the Lunar New Year (Fig. 429).

Fig. 426 Baby carrier in black velvet, the floral design embroidered in wool, Kunming, Yunnan province, 1992.

Fig. 427 Hoklo fisherwoman with her baby in an embroidered and appliquéd carrier with a head support, Dai Wong Yeh festival, Tai Po, Hong Kong, 1979.

Fig. 428 Hoklo baby carrier cover embroidered with beads, bells, and rickrack braid, made by the mother for her baby, Sha Tau Kok, Hong Kong, 1979.

Fig. 429 Mother with her child in a red satin baby carrier cover embroidered with flowers and a phoenix, Xian, 1983.

Fig. 430 Strip of red cotton cloth used for a Hoklo baby carrier, Tai Po, Hong Kong, 1979.

Fig. 428

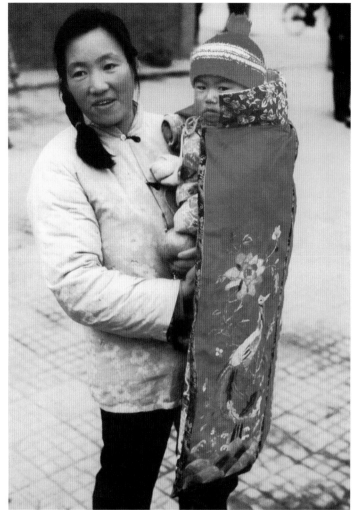

Fig. 429

Charms

Charms continued to be worn to protect children from evil spirits, including that of the old tradition of the padlock and chain (Figs. 432, 433). Hoklo children wore an enameled *bai tong* padlock in the shape of a butterfly, symbol of happiness and long life (Fig. 431).

Paper charms were especially favored for the children of the Hoklo fishing people. The charm was written on yellow paper then wrapped in red cloth and pinned to the child's clothing, or suspended from a string or metal ring around the child's neck, who – in summer on the boat – might otherwise be completely naked (Fig. 434).

Red thread was also propitious and thought to ensure long life. An old tradition dictated that after the birth of a baby, neighbors and friends give pieces of thread, which were then combined into a tassel and hung on the baby's clothes. Called the "hundred families tassel," it signified a wish from many families for good fortune for the child.

Another tradition of the use of thread seen in the border areas of the New Territories in Hong Kong, was where two pins were placed horizontally on the front of the little embroidered cap, worn by a baby from the age of one month. The mother would wind red and green thread around the pins to signify a desire for a long and happy life for her child, and said to fortify the memory. Red cord was often tied around the wrists or ankles of the child, and sometimes also fastened to the jade bangle or silver anklet to stop it falling off (Fig. 435).

Fig. 430

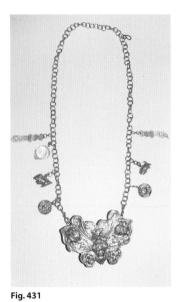

Fig. 431

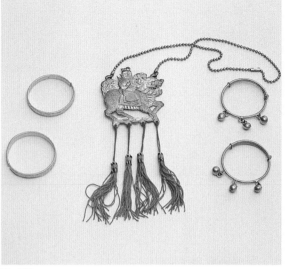

Fig. 432

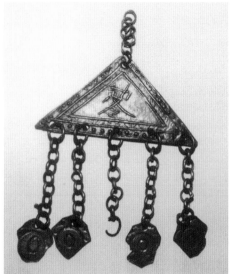

Fig. 433

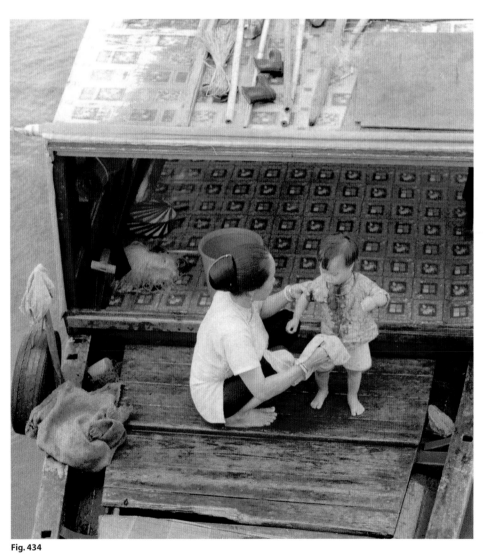

Fig. 434

Fig. 435

Fig. 431 *Bai tong* enameled padlock in the shape of a butterfly worn by Hoklo children, Hong Kong, 1960s.

Fig. 432 Set of inexpensive jewelry to be given to an infant – a pair of bracelets, a necklace with Shou Xing on the *qilin*, and a pair of anklets with bells, showing how some traditions survive , Beijing, 1980s.

Fig. 433 Hoklo triangular silver charm with peach stones (one missing).

Dress for Special Occasions

Festivals continue to be held throughout the year, the most significant being the Lunar New Year, which falls between late January and mid-February. It was the custom, and still is, to wear new clothes for the occasion to mark the start of another year. Children are dressed in brightly colored clothing, especially reds and pinks.

During the rest of the year, it is rare to see a child dressed in traditional clothing. Nevertheless, the Hoklo boat people in Guangdong and Fujian provinces and Hong Kong are very superstitious and maintain their old customs, particularly regarding dress, long after those in the urban areas have lost them.

Hoklo women were prolific embroiderers and made many gaily decorated clothes, baby carriers, and hats for their young children for daily use throughout the year and especially at festivals (Figs. 436, 437). A style of hat worn by Hoklo children at the first-month celebration and on other occasions comprised of a strip of material joined at the back and slightly gathered along the top edge (Fig. 442). Above the ears and at the center front were pleated fabric rosettes, while braid and beads decorated the edges. The whole effect was very colorful, some hats even having little animals and charms on wire that danced in the breeze.

On festive occasions, Hoklo boys and girls up to the age of about seven wore black cotton waistcoats trimmed with red, yellow, and blue binding and appliqué (Figs. 438, 440, 441). Boys wore them with shorts, while the girls wore matching skirts. Elaborate collars made of a circular piece of cotton with a back opening, decorated with beads, sequins, braid, colored cotton appliqué, and beaded tassels hanging all round the edge, were also worn on these occasions (Fig. 439). These were made by the mother or bought from an embroiderer living locally.

The death of a young child was understandably a time of great grief for a family, though it was a fairly common occurrence given the uncertain start to life due to poor hygiene. The body, soul, and spirit are believed to make up three parts, with the body and soul in the grave, and the spirit in the spirit tablet in the ancestral hall. It was acceptable to worship at either the grave or the spirit tablet. Paper offerings for children are quite rare and usually take the form of toys. In recent years, though, clothing is sometimes offered, otherwise adult clothing is sent seeing that size does not matter (Fig. 443). These offerings are intended to be burnt, and thus offered up to the dead child.

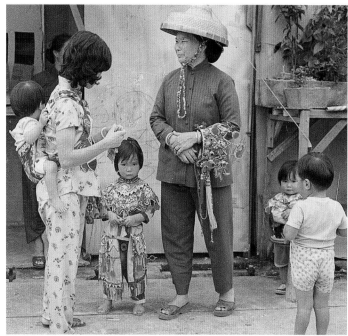

Fig. 436

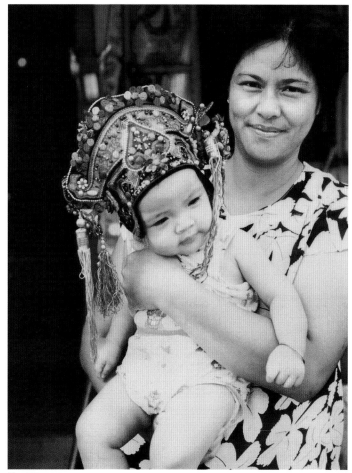

Fig. 437

Fig. 434 Hoklo mother and son on a sampan, the child wearing a paper charm wrapped in red cotton around his neck, and also a metal neck ring, Sha Tau Kok, Hong Kong, 1979.

Fig. 435 Jade bracelet and red cord on a child's wrist, bells on the ankle, Lantau Island, Hong Kong, 1979.

Fig. 436 Children dressed up for the Hoklo Dai Wong Yeh ceremony in Tai Po, Hong Kong, 1979.

Fig. 437 Hoklo child wearing a crown, Sha Tau Kok, Hong Kong, 1988.

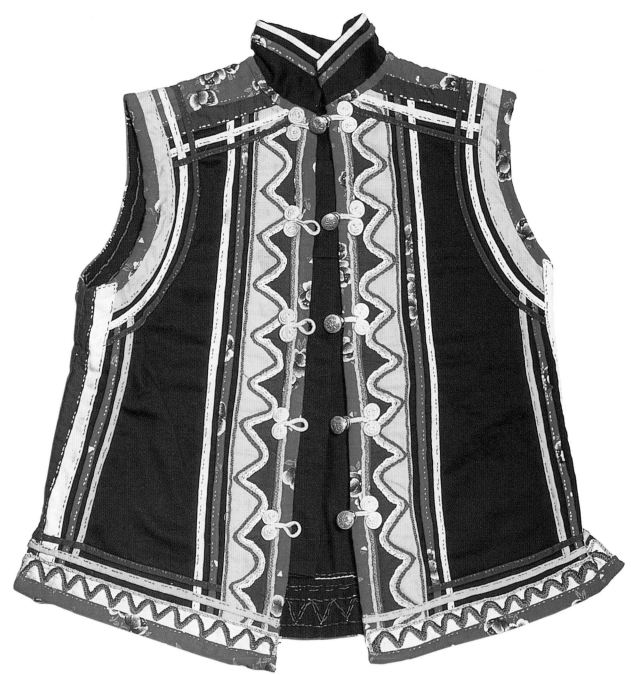

Fig. 438

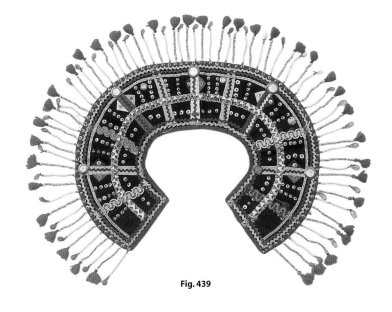

Fig. 439

Fig. 440

Fig. 441

Fig. 442

Fig. 443

Fig. 438 Hoklo child's black cotton jacket decorated with blue, yellow, red and white cotton appliqué around the edges, ca. 1975.

Fig. 439 Hoklo child's beaded collar worn at festivals, Sai Kung, Hong Kong, 1979.

Fig. 440 Hoklo child's maroon cotton romper suit trimmed with yellow and green binding, southern China, 1950s.

Fig. 441 Hoklo child's cotton jacket with colored edges, southern China, 1950s.

Fig. 442 Hoklo child's black cotton open-crown hat embellished with sequins, embroidery, and tassels with padded birds and butterflies, 1970s.

Fig. 443 Boxed set of offerings for a dead child comprising a blouse, jeans, socks, and sandals with Mickey Mouse on the toes, Sha Tau Kok, Hong Kong, 2005.

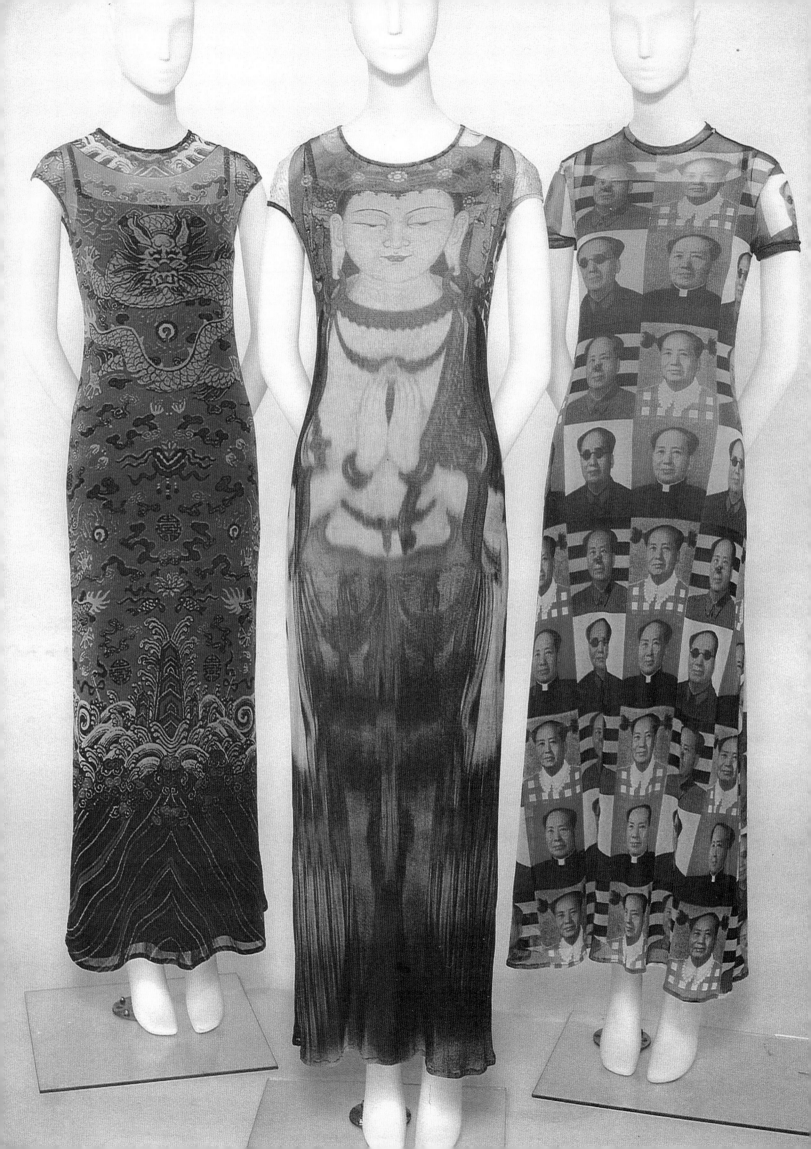

Chapter Eight

DRESS IN NEW CHINA
1950–2006

The First Fifteen Years

Outside Hong Kong where life, especially in the rural areas, continued with little change once it had recovered from the war shortages, the 1950s signaled the start of more turbulent times in China. After eight years of fighting the Japanese, followed by four years of civil war, China's economy was in tatters.

In 1949, the Communists caused the Nationalist forces to collapse, and the battered armies and the Guomindang led by Chiang Kaishek withdrew to the island of Taiwan. The Chinese Communist Party (CCP) proclaimed the establishment of the People's Republic of China and assumed power in the country, controlling most of mainland China. Traditional ways were cast aside as the leaders planned to transform China from a primarily agrarian economy dominated by peasant farmers into a modern, industrialized socialist society. For the next three decades, the country was in more turmoil and effectively closed to the West.

The years from 1949 to 1953 were a time of consolidation, reconstruction and reform. The Communists believed in the power of mass movements, and these took place regularly over the next thirty years (Fig. 445). Companies were seized from Chinese and foreign businessmen as the state took control. Fear of Western imperialism meant religion was strictly controlled and missionaries were forced to leave as restrictions were tightened on freedom of expression and thought. A ban was imposed on all religious and spiritual institutions and ceremonies.

Besides economic changes, the party implemented major social changes in the countryside. In 1950, the Agrarian Reform

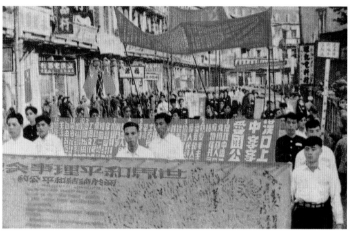

Fig. 445

Law was passed, which officially ended land ownership in China. By the summer of 1952, land and property belonging to wealthy landowners had been seized and given over to 300 million peasants. The following year, the Chinese government began collectivizing farms, and in 1958 private land ownership ended as the rural people's communes were established. With between ten and a hundred villages in one commune, these dominated agriculture until the early 1980s. Peasants were forbidden to engage in any private production and prohibited from moving from the countryside to the city. Propaganda posters and pictures of Chairman Mao Zedong replaced traditional forms of art in every home (Fig. 447).

Many Chinese people tried to join the Communist Party even though it was a long and complicated process, since being a party member was essential to improving one's status and brought with it valuable privileges. Cadres were appointed in every workplace, engaging in political and ideological work.

In 1958, more controls were imposed on the economy in order to increase agricultural production and speed up industrialization (Fig. 446). The Great Leap Forward produced fantastic results in terms of output, but the steel made in backyard furnaces was so mediocre it was useless. Because of inadequate planning and unrealistic expectations, the program was a disaster, crippling the economy. Bad weather caused poor harvests, and later estimates suggested the subsequent famine killed over 20 million people. Without the government's strict and efficient rationing system countless more would have died.

The failure of the Great Leap Forward generated criticism from Russian leaders and led to the Sino-Soviet Split in 1960 when Russia withdrew all economic and military aid. China's emphasis on self-reliance, as well as its fear of foreigners and foreign ways, brought about economic isolation and stagnation. At the same time, Mao had differences with other Communist Party leaders like Deng Xiaoping, who advocated more moderate policies.

Fig. 446

(Page 212) Fig. 444 Three dresses featuring, from left, a dragon robe design, Guan Yin, and Mao Zedong, Mao Collection, Vivienne Tam, 1995.

Fig. 445 Mass demonstration held in Hankou, Hubei, supporting the "Resist American, Aid Korea" campaign, with

participants throwing themselves into the patriotic movement and formulating and executing the patriotic pledge.

Fig. 446 At work in the countryside, with Communist slogans formed along the edge of the farms, Guangdong province, 1950s.

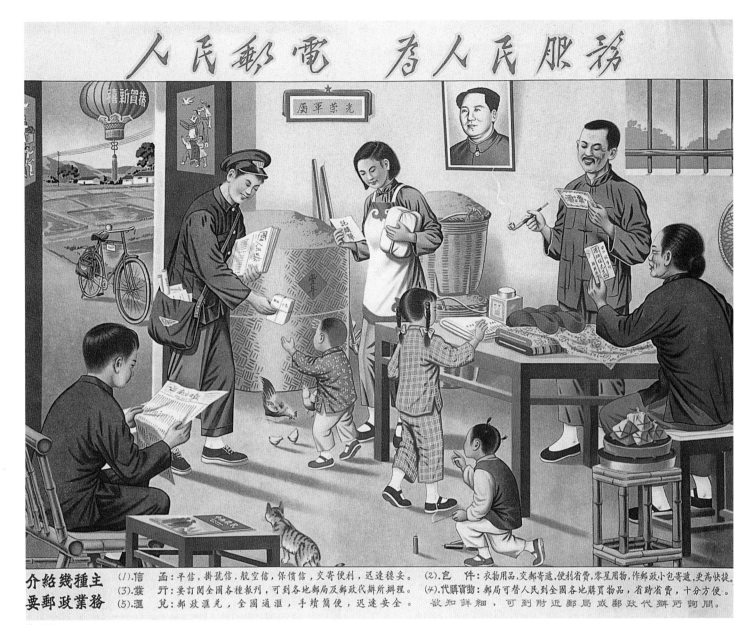

Fig. 447

Clothing Styles

Though later there would be drastic changes in lifestyle and culture, including clothing, at the start of the new People's Republic, a mixture of traditional Chinese, Western, and Chinese Communist dress was worn. Young unmarried women, in particular, preferred Western sweaters, skirts, and slacks, complemented by Western hairstyles such as the permanent wave (Figs. 448, 449). For a time in the 1950s, when Soviet fashion was popular, some left-wing women and those working in government departments wore the one-piece dress (*bulaji*) or Lenin outfit (*Liening fu*) (Fig. 451). Women of the lower classes and those on the farms made do with cotton *shan ku* pajamas in floral patterns or simple checks.

In the cities and towns, businessmen sported Western suits, shirts, and ties, and for casual wear, slacks and shirts. There was a gradual introduction of more utilitarian dress for lower-ranking workers, comprising overalls and white shirts worn with rolled-up sleeves, flat caps, and a canvas satchel (Figs. 450, 452). In the countryside, peasants continued to wear the traditional jacket and *ku*.

In Hong Kong at this time, men wore white short-sleeved shirts with a breast pocket and trousers to the office, along with black cloth slippers or Western leather shoes or, depending on occupation and seniority, a Western suit, shirt, and tie. Away from work, the jacket and *ku* or *chang shan* long gown was the preferred choice of clothing, with the *chang shan* and padded jacket favored in cold weather (Figs. 453, 454). In the rural areas, traditional dress

Fig. 447 Propaganda poster printed for the Guangdong Mail and Telegraphic Service Co. announcing that the company serves the people, Canton, January 1953.

Links with other Communist countries are shown, with the seated woman reading a letter from North Korea, a man holding

an overseas remittance, another woman handing a mail order to the postman, the seated young man reading the local daily

paper, and the postman bringing news from further afield in China, *The People's Daily*, from Beijing.

Fig. 448

Fig. 449

Fig. 450

Fig. 451

continued in use, and today village elders wear the *chang shan* on formal and festive occasions as a show of respect for old traditions.

Many women in Hong Kong continued to wear the cheongsam, albeit with certain modifications. Shoulder seams were introduced in the 1950s, which formed a sloping shoulder effect, the collar was rounded for a softer effect, and the hemline rose gradually to reach mid-calf. By the end of the decade, the garment, which was always made to measure by local tailors, had become very fitted with a high-waisted look created by the use of bust and waist darts, while the indented hem at the sides accentuated the curvaceous look (Figs. 455, 456). The dress had set-in sleeves, either cap or long and narrow, and was fastened with press-studs at the *tou jin* opening and a zipper – used for the first time – down the side. The cheongsams worn by Nancy Kwan in the 1960s film *The World of Suzie Wong* became a hit overseas. For more casual wear, a top shaped like a cheongsam but reaching only to the hips was worn over loose trousers.

At this time, there was a dramatic drop in infant mortality rates, largely because of the availability of clean water and the establishment of maternity clinics. This led to a rapid growth in population, and for the first time there was free public education (now no longer free). Yet this did not necessarily help the lot of many girls. From the early 1900s, emancipation for women had meant girls could receive an education, but after land reform, when poor families were assigned parcels of land, women's rights regressed. Women were required to work long hours in the fields and were forbidden from moving to the cities in search of work.

Fig. 448 Book of Western knitting patterns published in Huahai Zhong Road, Shanghai, 1950.

Fig. 449 Catalogue of the Chinese Merchandise Emporium, also known as China Products Co. Ltd, showing women's and men's casual wear, Shanghai, 1955. Founded in 1933, the Chinese Merchandise Emporium, whose main store was on Nanjing Road, was the only department store in China selling exclusively domestic products. It had branches in other major cities, including Hong Kong.

Fig. 450 Catalogue of the Chinese Merchandise Emporium showing men in work attire of overalls, flat caps, and satchels, Shanghai, 1955.

Fig. 452

Fig. 451 Page from the *Popular Movie* magazine, 1957, showing a Soviet-influenced one-piece floral print dress (*bulaji*) or Lenin outfit (*Liening fu*), with a four-button front opening, gathered skirt, and contrasting collar, cuffs, and belt.

Fig. 452 Advertisement from the Fu Xing Xiang Hat factory, Qingdao, 1951, with political undertones, of a special promotion of men's headwear aimed at strengthening ties between the city and the countryside, the man on the left wearing a Western trilby and jacket, and holding sheaves of corn, the one on the right in a green shirt, blue overalls, and a soft cap.

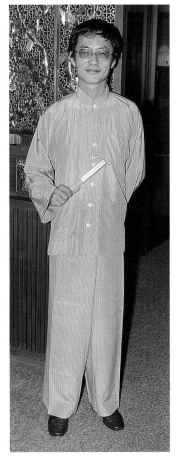

Fig. 453

Fig. 454

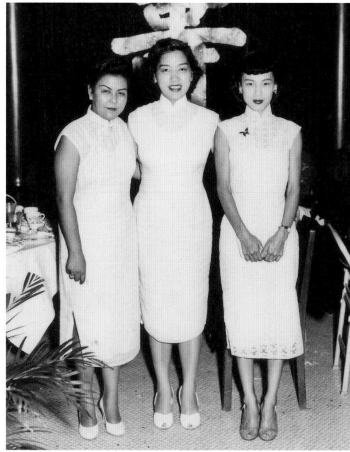

Fig. 455

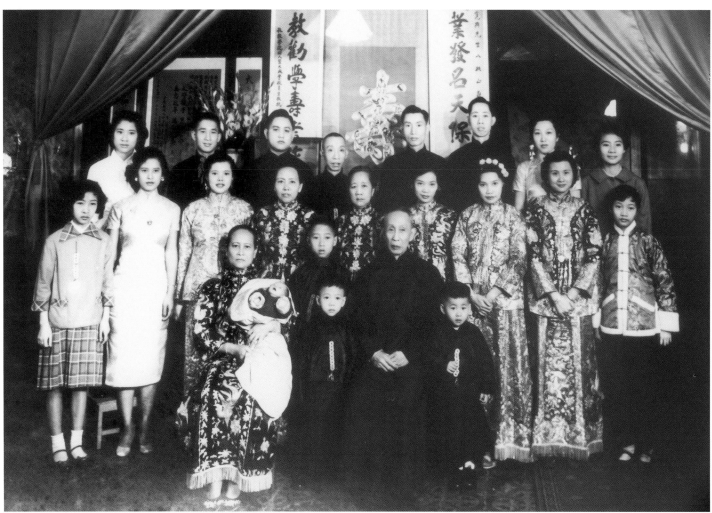

Fig. 456

Fig. 457

Fig. 458

Fig. 459

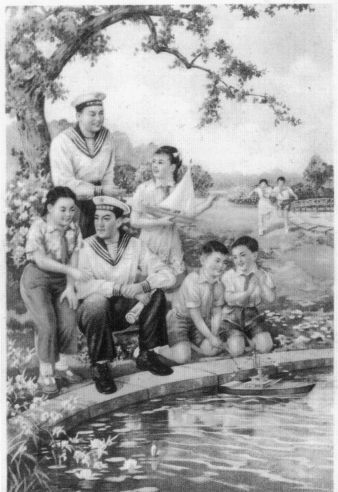

Mass organizations favored by the Maoists impacted on everyone's lives and the fervor of the times affected young and old alike (Fig. 457). The All-China Federation of Democratic Youth, founded in 1953, and the Young Pioneers were composed entirely of children (Fig. 459). The Young Pioneer movement was first established in the Soviet Union when the Communists took over in 1917. The movement was set up to involve all children as part of its overall program to encourage Communist ideology. Children whose fathers were working class soon became Young Pioneers, but if the father was considered an intellectual, such as a teacher, landowner, or factory owner, the children did not qualify until much later, if at all.

The only uniform item of clothing was a triangular red cotton scarf, tied with a reef knot at the neck. For girls in China it was worn with a white blouse and patterned pinafore skirt or, when on parade, a dark blue-green skirt. Boys wore white shirts and plain blue-green shorts or dungarees (Figs. 458, 460). Today, all children can be Young Pioneers and wear the red scarf if they perform well at elementary school, and at middle school can become Youth Members, which may have advantages in their future lives.

Fig. 460

Fig. 453 Urban-style cream silk jacket and *ku*, Hong Kong, post-1945.

Fig. 454 Painting of a man in a long gray *chang shan* worn over Western trousers and leather shoes, ca. 1950.

Fig. 455 Three women in cheongsams at a wedding reception, Kowloon, Hong Kong, 1954.

Fig. 456 Family celebration in Hong Kong with wives, daughters, and daughters-in-law wearing cheongsams and *hong gua* skirts and jackets, 1956.

Fig. 457 Young children in traditional and Western dress, captioned "We want to drive to Beijing to see Chairman Mao," Guangzhou, 1956.

Fig. 458 Children in Western dress with red scarves of the Young Pioneers, with Vice Chairman Zhu De, Guangzhou, 1956.

Fig. 459 Members of the All-China Federation of Democratic Youth wearing white shirts, navy tunics or trousers, and red neck scarves, 1953.

Fig. 460 Two sailors and children in Western dress with red scarves of the Young Pioneers, captioned "Uncle, our fleet is sailing," Guangzhou, 1956.

The Mao Suit

The founding of the Communist Party had a more pronounced effect on national dress than any other event in the country's history. The modified Sun Yatsen suit (*Zhongshan zhuang*), once a military garment but now evolved into a civilian one, was worn by Chairman Mao Zedong and leaders of the Communist Party at the founding ceremony in Tiananmen Square on October 1st, 1949. It would eventually be worn by everyone the length and breadth of the country, regardless of sex, age, or class.

The style bore strong connotations of power, and its appropriation by Mao was seen as proof that he was inheriting Sun's mantle of authority. The key Communist leaders seldom wore anything other than the Mao suit – as it became known in the West – and this further enhanced its popularity. The tailored jacket, with set-in sleeves, buttoned up the front to the neck, had a close-fitting collar with rounded corners, and four patch pockets with flaps. It was worn with Western-style trousers and leather shoes. Mao and the other leaders habitually wore gray suits, but depending on the occasion they also wore dark blue ones (Fig. 461). The only time Mao was seen in Western dress was on informal occasions, such as when visiting peasants in the countryside, where he wore an open-neck white shirt and trousers.

During the first few years of the new Republic, the Mao suit was not mandatory wear – there was a choice of dress for the rest of the population – but those keen to show their support for the new order and their socialist credentials quickly adopted it. The earlier anti-fashion connotations of the Mao suit disappeared as it became standard dress for the majority, and was on sale in smart city department stores alongside Western dress (Figs. 462, 463).

With the numerous political campaigns launched in the 1950s to wipe out feudalist ways and capitalist thinking, the use of civilian dress began to be regarded as suspect and politically incorrect. It was considered bourgeois for men to wear Western business suits or for women to don glamorous cheongsams. Simple, austere styles of dress were considered more in keeping with socialist principles. Fear of being called a "bourgeois rightist" or an "anti-communist" limited what people wore, at least outside the privacy of their homes. Photographs of Mao wearing worn clothing were used

Fig. 461

extensively as a propaganda tool to foster nostalgic feelings of heroic deeds and the achievements of earlier times. Wearing patched or worn clothes was seen as being ideologically sound.

Most people wore the *zhifu* or uniform, also known as *junbian fu*, or military plain clothes, because of its links with military

Fig. 462

Fig. 463

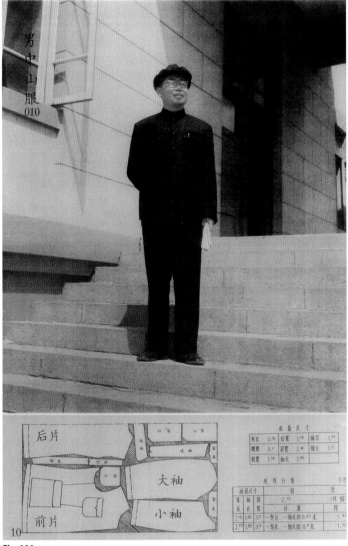

Fig. 464

fact, wearing army uniforms was usual for much of the population. Green army caps, soft black cloth shoes with rubber soles, and army satchels were common accessories. All classes wore thickly padded army cotton overcoats and fur balaclava hats in winter.

The Great Leap Forward did more to encourage the wearing of the Mao suit than any other factor. During this time of tremendous hardship, how a person dressed mattered less than whether he could find enough to eat. Ration coupons were issued in 1961 and these controlled "the sale of cotton thread, synthetic fiber, stockings, bed sheets, shirts, woolens, silk, underwear and yarn, in addition to the pre-existing restrictions limiting each adult person to 2.5 meters of cloth and 500 grams of cotton per annum" (Sang Ye in Roberts, 1997: 43) (Fig. 466). Though the quota of cloth did rise slightly over the years, rationing meant there was little choice but to wear clothes until they fell apart, or buy a Mao suit. The only kind of fabric not requiring ration coupons was called "patriotic wool," made from leftover threads from the factory floor mixed with a small amount of good wool. It was of poor quality and rough on the skin.

Children were not expected to wear the Mao suit. In the cities, women discarded traditional Chinese dress for their children in favor of Western styles but cut them out as economically as possible, bearing in mind the very small quotas of cloth and thread allowed. Old clothes were recut and handed down to the younger children. In the countryside, and in poorer areas, children continued to wear the traditional cotton *shan ku* in cotton checks, stripes, or patterned fabrics (Figs. 475, 476).

uniforms. These cotton suits differed from the Sun Yatsen suit in that there were various modifications to the jacket, which had an open-neck collar, sometimes concealed pockets with a flap, other times two top pockets. Since materials were expensive and labor was cheap, many tailors offered services in refashioning Western suits into the *zhifu*.

Though the Mao suit was purportedly classless, in reality it was not. In the early 1950s, when no one received a salary, the government issued clothing to the people. "The lowest-ranking official received a modified Sun Yatsen suit made from coarse grey cloth; a middle-ranking official one of polyester drill; and a top-ranking department or bureau chief one of wool" (Roberts, 1997: 22–3) (Figs. 464, 465). Everyone, from workers and peasants to intellectuals, wore the Mao suit, which became a universal uniform, in dark blue or gray, while many civilians wore greenish-yellow, the color worn by the army to show support for the revolution. In

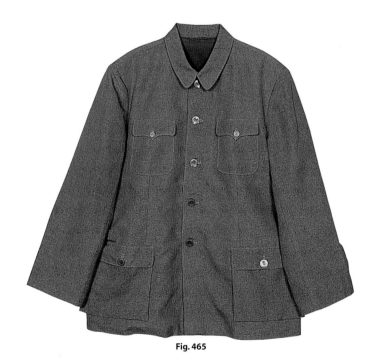

Fig. 465

Fig. 461 Mao Zedong wearing the Mao suit, March 1949.

Fig. 462 Catalogue of the Chinese Merchandise Emporium featuring hats, the parents and grandparents in Mao-style two-piece outfits, the children in Western dress, Shanghai, 1955.

Fig. 463 Catalogue of the Chinese Merchandise Emporium showing men and women in Mao suits, the couple on the left wearing styles for younger people, the woman seated on the right wearing a Lenin jacket, Shanghai, 1955.

Fig. 464 Cadre in the *Zhongshan* uniform, and pattern below, in the catalogue of samples from the Fourth Tailoring Commune department, Tianjin, 1973.

Fig. 465 Gray barathea jacket for a high-ranking cadre, ca. 1960s–1970s.

The Cultural Revolution 1966–1976

Fearing counter-revolutionary tendencies in the Chinese leadership in the early 1960s, Mao Zedong tried to regain his authority with another mass movement. He was by now in poor health and was anxious to get China back on the course he had envisioned. In 1966, he launched the "Great Proletarian Cultural Revolution," now known in China as "Ten Years of Chaos," to purge his opponents and to try to restore his ideal of a Chinese revolution. The first three years were the most fervent, but after 1969 the situation cooled.

Students were released from schools and universities to serve as a huge vigilante force. Countless numbers of *zhiqing* or city youth were sent to the countryside to learn from and labor with the peasants (Fig. 471). Young people felt it was time to change history. They formed bands of Red Guards to "smash the Four Olds": old ideas, old culture, old customs, and old habits. Red Guards, who wore "national-defense green" army-style uniforms with red armbands bearing yellow characters to show affiliations, reported on and disrupted the lives of former landlords, and persecuted artists, writers,

Fig. 466

Fig. 467

Fig. 466 Selection of ration coupons from different provinces, for varying lengths of cloth and with political slogans, these ones dated between 1968 and 1973.

Fig. 467 Meeting in the commune, the senior cadre wearing a gray Mao jacket and holding a copy of the Little Red Book, the others in blue, with members of the People's Liberation Army in green, ca. 1970.

intellectuals, and those with foreign connections. Many who were considered undesirable had half their head shaved to make them stand out from the rest. Valuable books and collections of antiques were ruined, but everyone owned a Little Red Book containing quotations of Mao Zedong (Fig. 467). Chaos reigned as temples, works of art, and anything else associated with traditional Chinese or any foreign culture was destroyed. Streets were renamed to reflect the new order. The sale of Western goods and so-called luxury items like cosmetics, jewelry, and high-heeled shoes was banned. The cheongsam was viewed as decadent and thus disappeared (Fig. 469). The Sun (Daxin) Department store in Guangzhou (the largest department store in South China) was, like most one-time fashionable stores, dimly lit, its dusty glass counters offering a small selection of essential items like thermos flasks and enamel bowls.

In 1967, traditional Chinese operas were replaced by a number of "revolutionary" operas and ballets approved by Mao's wife Jiang Qing (Fig. 468). Intense with ideological content, a common theme in the performances was the class struggle between the oppressors, often an evil landlord, and the people.

Fig. 468

Fig. 469

Fig. 468 Members of the China Ballet Troupe in a performance of the *Red Detachment of Women*, one of several revolutionary ballets showing the downfall of class enemies, played constantly during the Cultural Revolution.

Fig. 469 Celebrating the sixteenth anniversary of the victory of the Chinese Communists, the last time the cheongsam would be seen on the mainland until the late 20th century, 1965.

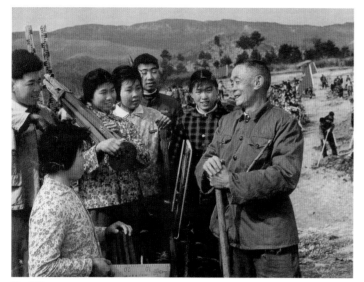

Fig. 470

Fig. 471

Fig. 472

Traditional Chinese dress was categorized as one of the "four olds" and thus the Mao suit was established as the finest and most desirable form of dress. In December 1966, "The Capital City Red Guard Rebels' Victory Exhibition opened at Peking's [Beijing's] Exhibition Center, formerly known as the Soviet Union Exhibition Center. The 'spoils of war' put on show included more than two million 'outlandish outfits' from Peking alone, which had been confiscated in the four months preceding the event. Only army uniforms, modified Sun Yatsen suits, and work uniforms (*zhifu*) were left. The 'outlandish outfits' included *qipao* or *cheungsam*, Western-style suits and any trousers found with a trouser-cuff width of less than 18 centimeters.... Pedestrians found wearing bourgeois clothes were waylaid on the street and had their clothes cut to shreds on the spot" (Sang Ye in Roberts, 1997: 43). It was simply safer to wear a Mao suit.

Skirts disappeared, as they were both impractical when doing manual work and ideologically inappropriate. The permanent wave was forbidden. Unmarried women wore pigtails. Others had their hair cropped short in the style of revolutionary women of the 1930s at Yan'an. The loose-fitting cotton Mao suit was a deliberately unflattering female mode of dress, especially in the 1970s when women stopped wearing belts to define their waists. But there were a number of variations in jacket styles, ranging from open or closed collars to simple checked and striped fabrics (Figs. 470, 472–476).

Riots occurred in 1966 in the British colony of Hong Kong, caused by a proposed fare increase on Star Ferry, and in the Portuguese territory of Macau between the Portuguese and pro-Beijing students over the site of a school. At that time, Communist sympathizers in Hong Kong and Macau wore white shirts over long trousers and black cloth slippers, a style adopted by office workers in China in the 1980s. The Little Red Book was carried both by the sympathizers and the general public in case of trouble.

Fig. 470 Students of the Jiangxi Communist Labor University talking to a veteran of the Red Army dressed in a blue Mao suit, 1976.

Fig. 471 Poster showing mass agricultural planning of the movement "Learn from Dazhai in agriculture," Shanghai, 1975.

Fig. 472 "Barefoot" doctor wearing a "spring and autumn shirt" made of patriotic wool, and pattern, in the catalogue of samples from the Fourth Tailoring Commune department, Tianjin, 1973.

Fig. 473 An election in the commune to select the head of the Brigade, the Little Red Book visible on the table, 1974.

Fig. 474 Children at their desks in a classroom reciting the works of Mao from the Little Red Book.

Fig. 473

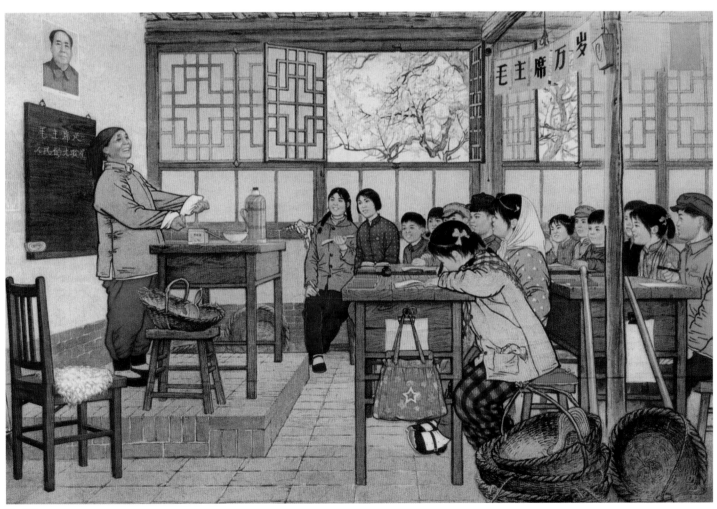

Fig. 474

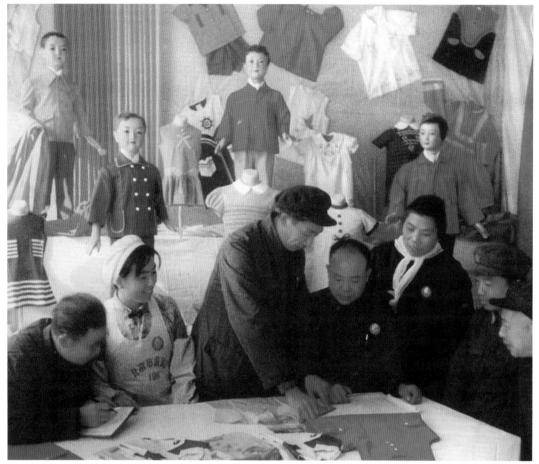

Fig. 475

Fig. 477

Fig. 476

Fig. 475 Showroom of the Beijing Garment Factory where children's clothes were produced.

Fig. 476 Group of older girls wearing patterned and plain jackets, the one in the center with a red armband.

Fig. 477 Above: Cover of clothing paper patterns printed with the slogan "Highest Direction: The core power that guides our career is the Chinese Communist Party. The theoretical basis that guides our thought is Marxist-Leninism," Guangzhou City Clothing Industry Company, Clothing Research Centre, Zhongshan Wulu, No. 7. Center and below: Paper patterns for a shirt and trousers worn by Communist sympathizers outside China in the 1960s and 1970s, and by office workers in China in the 1980s.

Slogans on Clothing

To show support for the movement, slogans were embroidered, painted, and printed on clothing and fabrics (Figs. 478–481, 483–486). Some civilian supporters, though often reluctant, wore red armbands with slogans avowing to fight capitalism and Western decadence (Figs. 476, 482).

Apart from the Han, there are fifty-five minority groups in China, which make up about 7 percent of the population. Many minorities were subjugated at this time and forbidden to use their own language and customs. The Manchu, in particular, were reviled for being the rulers of the last feudal dynasty. It has been reported that only about twenty people in China can still read the Manchu script and no more than a hundred can still speak Manchu, despite there being more than 10 million Manchu living in the country (*South China Morning Post*, September 1, 2004).

But one group at least was spared. During the Long March in December 1934, when the Red Army passed through Guizhou province in southwest China, the Miao, though poor farming folk, always made sure the recruits were fed and sheltered. In gratitude, Mao left them alone in the turbulent times after 1949. At a period when old ways were castigated and time-honored customs denounced, the Miao continued to decorate hard-wearing cotton collars, hats, and *dou dou* aprons with traditional Chinese motifs, such as the bat, butterflies, and the cat which can see evil approaching in the dark. Since the Miao were strong supporters of the Communists, slogans glorifying the Party were also embroidered on children's clothing (Figs. 487–489).

Fig. 478

Fig. 479

Fig. 480

Fig. 478 Tanka woman and child from Guangdong province, the baby carrier embroidered with the slogan "Red flower at sunrise," and underneath it, the red star, Sha Tau Kok, Hong Kong, 1979.

Fig. 479 Hoklo baby carrier cover made of cotton with a printed design of the rising sun, sunflowers – a symbol for Mao Zedong during the Cultural Revolution – and the characters for "Long life to Chairman Mao," Guangdong province, ca. 1967.

Fig. 480 Red printed cotton fabric with flowers, balloons, books, workers, and characters saying "Long Live the Great Proletariat Cultural Revolution," ca. 1969.

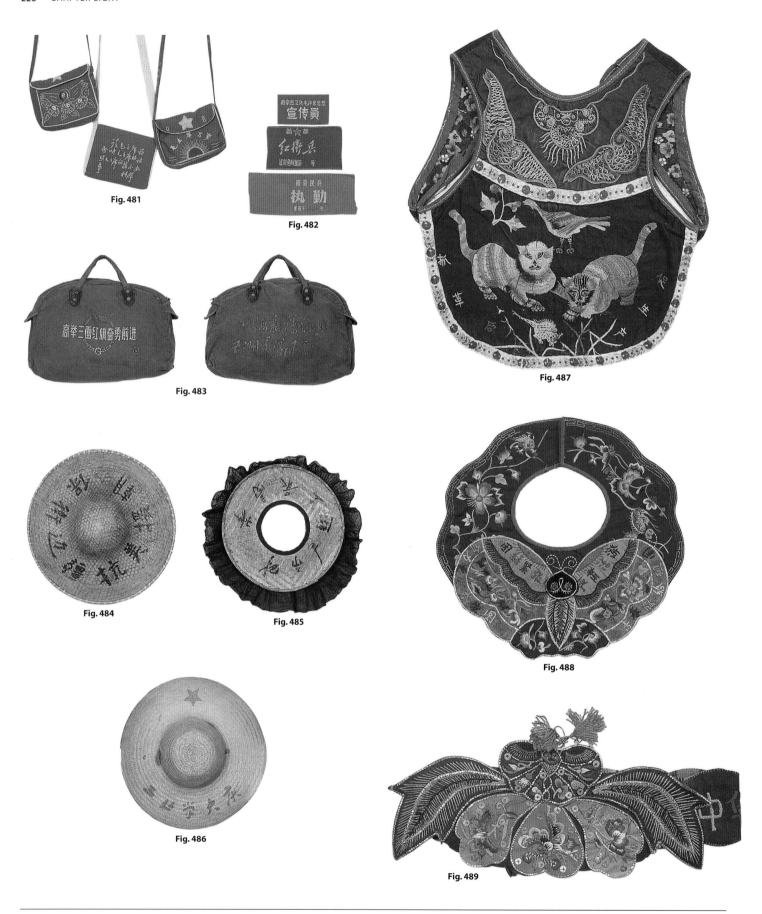

Fig. 481

Fig. 482

Fig. 483

Fig. 484

Fig. 485

Fig. 486

Fig. 487

Fig. 488

Fig. 489

Fig. 481 Red cotton bags for the hand-sized Little Red Book, of which more than 740 million were produced, with slogans embroidered on the front in yellow.

Fig. 482 Three red cotton armbands with slogans. From top: "Propaganda staff, Mao Zedong thought, Nanjing Red Guard"; "Capital (Beijing), Red Guard,

Yan'an Rebellion Brigade"; "On duty, Nanjing People's civilian soldier."

Fig. 483 Green cotton bag with characters. Front: "Uphold the Three Red Banners and go bravely forward," the three red banners being General Line, Great Leap Forward, People's Commune – the policy to build socialism by the Communist Party

in Spring 1958. Back: "The Four Seas are rising, clouds and water raging, The Five Continents are rocking, wind and thunder roaring," from a poem by Mao Zedong, "The East is Red Company," Xian.

Fig. 484 Revolutionary slogan on a Cantonese hat: "Protect the borders, resist the USA, and support Korea," ca. 1969.

Fig. 485 Revolutionary slogan on a Hakka hat: "Raise production to the highest level," ca. 1969.

Fig. 486 Straw hat with a red star and a popular slogan "Learn from Daqing," about the remarkable achievements in industry in Daqing, ca. 1969. Daqing was a model for the Chinese economy at this

The People's Liberation Army

The Communist Red Army, formed in 1927 of young peasants and workers from all over China, who became non-salaried commanders and fighters rather than officers and soldiers, was now renamed the People's Liberation Army (PLA). Relations between civilians and the PLA were supportive and mutually beneficial, since the population knew they needed a sympathetic army to protect their interests after recovering from threats from the Japanese and the Guomindang.

The PLA was an army of volunteers, so conscription was not a threat. Because it was a successful army, and represented the inspiring ideology of the Communist Party, families were proud to have a son or daughter enlist and fight for their future and their newly claimed land. The PLA refused to exploit the peasants, one of the army's historic rules being "Don't take a single needle or piece of thread from the people." Numbers of PLA members fluctuate: at the end of 1950, they stood at 5.5 million, but expanded to reach a peak of 6.11 million during the Korean War from 1950 to 1953. After this, numbers gradually reduced, and in recent years remain at about 2.5 million (*Time*, February 1, 1999).

When the Red Army was renamed the People's Liberation Army, the uniforms remained more or less unchanged, except that the color changed from the original blue-gray. They were now made in greenish-yellow cotton, a color originating from the dyeing facilities available at Yan'an in Shaanxi province where the Communists had their headquarters for many years.

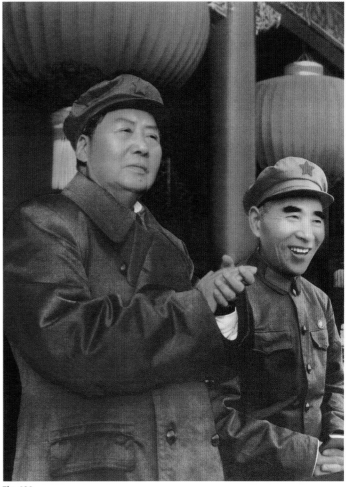

Fig. 490

Fig. 491

The Communists were proud of their egalitarian approach to rank and sex. All PLA troops wore an outfit that was mass-produced and thus inevitably often ill-fitting. Members of the army wore a jacket with a high, rounded collar and a center front opening closely buttoned to the neck, a brown leather belt worn tightly over the jacket, Western-style trousers, a soft peaked cap with a red star at the front, and cloth shoes or sandals. Until the mid-1980s, red flashes on the collar of the jacket bore no stars of rank or other identifying marks, thus deliberately hiding the identity of some individuals, though with mixed results. Rank was indicated merely by the number of pockets sewn on the jacket. Normally, there were two breast pockets, but more senior party members were allowed additional patch pockets below the belt (Figs. 491, 493, 495, 496). Children's versions of the PLA uniform were on sale in Beijing's Wangfujing Street in the 1980s (Fig. 500).

The air force uniform comprised a short leather jacket with a fur collar, blue trousers tucked into black leather boots, and close fitting helmet (Fig. 492). Naval attire was a white shirt with blue striped collar and insert, dark blue trousers, black leather shoes, and a flat white hat with a red star and black streamers (Fig. 494).

time, though the production figures were wildly distorted, giving a false picture to the detriment of the rest of the country.

Fig. 487 Miao child's *dou dou* apron decorated with cats, with the characters "Stick to the Revolution and production will increase" below them, Guizhou, 1950s–1960s.

Fig. 488 Miao child's collar in the form of a bat, traditionally an emblem for happiness, with the characters "Give your youth to the motherland; close ranks, be tough, work hard," Guizhou, 1950s–1960s.

Fig. 489 Miao child's hat in the form of a butterfly, symbolizing long life, with the characters "Young girls of New China

enjoy beauty and prosperity," Guizhou, 1950s–1960s.

Fig. 490 Chairman Mao, wearing a greenish-yellow People's Liberation Army overcoat and soft cap with a red star, with Vice-Chairman Lin Biao, in a five-button jacket with four patch pockets with flaps, and a cap, 1968.

Fig. 491 People's Liberation Army jacket in green cotton with two top pockets and a five-button fastening, date stamped 1966, worn with Western-style trousers.

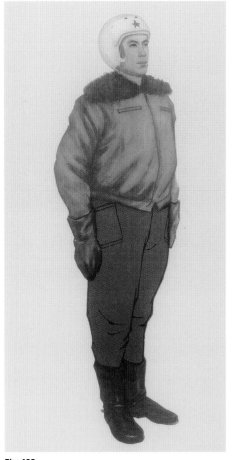

Fig. 492

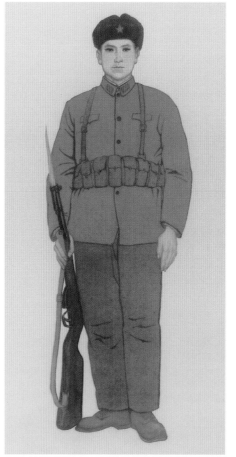

Fig. 493

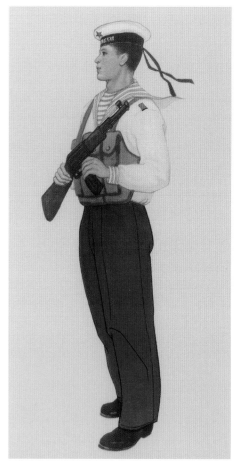

Fig. 494

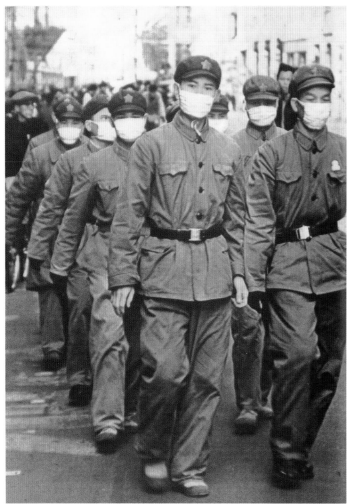

Fig. 495

Fig. 496

China Opens Its Doors

Mao Zedong's death in September 1976 brought an end to the Cultural Revolution. Later that year, the downfall of the Gang of Four, including Mao's widow Jiang Qing who had implemented the most extreme policies, led to a slow loosening of laws relating to dress and social constraints. In the late 1970s, a broad-scale reform was launched as land was returned to rural families and the commune system was finally abandoned, to be replaced by a new institutional arrangement called "household responsibility." This greatly improved the efficiency of rural resources and stimulated agricultural production, leading to wider reforms in China.

With improved living standards, in 1978 China imposed a "one child" policy on Han Chinese families to control the rate of population growth (Fig. 497). The policy continues to be strictly implemented and no family is meant to have more than one child. Women who are pregnant with a second (or subsequent) child are compelled to have an abortion or, if they refuse, may be forced into self-imposed exile. With the pressure to have boys, girl babies are aborted or abandoned, and the nation is now facing a worrying problem of having too many males who will never marry.

In 1984, under Deng Xiaoping's leadership and the Open-door Policy of reform, certain cities were designated "open" as part of a new strategy inviting foreign investment. Free trade regions called Special Economic Zones were formed in Xiamen in Fujian province, and Zhuhai and Shenzhen, across the border from Macau and Hong Kong respectively. Here, especially in Shenzhen, money began to flow in from Hong Kong Chinese, many originally from the surrounding Pearl River Delta, to form joint ventures. Multi-storied housing projects and modern government buildings were constructed on what had formerly been farmland. Within twenty years Shenzhen grew from a small market town to a city housing over 10 million people, many of them itinerant workers in the numerous factories producing goods for the West.

In the 1980s, Hu Yaobang, Chairman of the Chinese Communist Party, proposed that Party leaders wear Western suits in China, not only when traveling overseas, but the Mao suit continued to have strong connotations of authority. During the Tiananmen Square Incident of 1989, high-ranking officials wore the modified Sun Yatsen suit instead of a Western suit. Similarly, Jiang Zemin wore an olive green army Mao suit when he arrived in Hong Kong for the first anniversary of the handover to China in 1998, to reinforce Beijing's authority.

The blue cotton suits and caps worn by workers can still be seen in some parts of the country, although during the 1980s there were increasing signs in the major cities that greater variation in styles and colors were permitted (Figs. 498, 499). Men began to buy Western suits off the peg from department stores or from hawker stalls. Labels on the sleeves were deliberately left intact as a status symbol. Ties, shirts, and leather shoes completed the Western look.

Fig. 497

By the early 1980s, younger women in Beijing, Shanghai, and other major cities began to adopt Western dress, beginning with trousers, denim jeans, and T-shirts, and later dresses and skirts, while children continued to dress in Western styles. This trend gradually spread throughout China, the influence first coming from Hong Kong as families there sent cast-off clothing to help relatives in Guangdong province – an ironic reversal of the 1920s and 1930s era when Western fashion originated in Shanghai and filtered down, via Guangzhou, to Hong Kong. At first, fabric from the garments was recycled to make less fancy styles. Women continued to patronize tailors, but also purchased ready-made Western-style clothing from market stalls.

Hong Kong in the 1960s and early 1970s was something of a cultural and fashion backwater. Some department stores had no air-conditioning, unlike the mainland owned and run Chinese Products Emporium, and Western fashions were very much leftovers from past seasons. But with a rising economy at the end of the decade came an increasing adoption of Western styles, especially by

Figs. 492–494 Three posters of representatives from the three services of the People's Liberation Army, the Airforce, the Army, and the Navy, ca. 1960s.

Fig. 495 People's Liberation Army troops wearing face masks, Guangzhou, ca. 1967.

Fig. 496 Military outfit for everyday wear, and pattern, in the catalogue of samples from the Fourth Tailoring Commune department, Tianjin, 1973.

Fig. 497 Poster of a couple and one child, denoting the "one child" policy in force, Guangzhou, 1985.

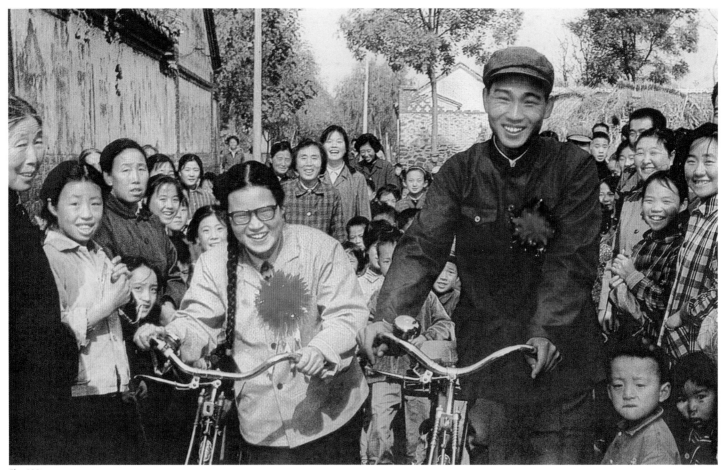

Fig. 498

Fig. 499

Fig. 500

Fig. 498 Country wedding, the bridegroom wearing a blue Mao jacket and green cap, the bride in a light pink jacket and dark trousers, with a red pompom in a buttonhole, 1980.

Fig. 499 Women in regulation jackets and Western trousers with a crease down the middle of the leg, 1980.

Fig. 501

the younger generation. Japan's influence and its passion for Italian and French styling was particularly strong with several Japanese department stores like Daimaru, and boutiques like Suzuya opening in the city. Knitted dresses and suits were popular with office girls and promoted by the Hong Kong Trade Development Council to their overseas buyers (Figs. 502, 503). Locally owned and run chains, with Italian and French sounding names like Bossini, Giordano and Michel Rene, began to sell inexpensive Western-inspired casual wear and became extremely popular.

The cheongsam continued to be worn but in many cases it became a hybrid Western style (Fig. 501). Gradually, it was worn less and less except by some older women, who teamed it with a matching jacket. Women in senior positions in the Hong Kong government and in the universities also wore it to affirm their Chinese identity, and students at a few privately run Protestant schools still wear the cotton cheongsam as uniform. However, tailors in Hong Kong continue to make them for locals and visitors for special occasions, while market stalls display cheaply produced rayon brocade cheongsam for the tourist market. For the most part, Hong Kong today is an international city and one of the main outlets in the world for high-end designer boutiques from Europe and the US.

Fig. 500 Boy's jacket, part of an army uniform including trousers and cap, purchased from a department store in the main street of Wangfujing, Beijing, 1986.

Fig. 501 Group of chic Hong Kong girls in cheongsams and modified cheongsams bordering on Western styles, taken at the graduating ceremony of the charm school opened the previous year by the owner, Vera Waters (third from right), 1966.

West Meets East Meets West

For over a century, Western fashion designers have looked to China for inspiration, from the time when chinoiserie was all the rage in the home and ladies donned Chinese embroidered robes for evening soirées. In the early years of the twentieth century, these robes, left over from the Qing dynasty, were easily obtainable in Beijing and other major cities. Westerners could purchase them from pawnshops where they lay unredeemed, often having been deposited for storage, a common custom.

In the 1970s, Yves Saint Laurent caused a sensation by naming a perfume Opium and fashioning a collection around it. During more recent times, designers such as John Galliano for Dior, Tom Ford with his collections for Gucci and YSL, Roberto Cavalli, and Dolce & Gabbana have all been inspired by oriental culture. The colors, designs, and details from Chinese opera, imperial dragon robes, and the Forbidden City, and the ever-popular cheongsam appear all the time.

On the other hand, many manufacturers producing for Western department stores and chain stores bring designs and ideas from the West and rely heavily on Chinese factories for their production. Where Hong Kong was once a leading garment supplier, factories on the mainland have now taken over. Many top-end European labels are manufactured in China, employing patterns and innovative fabrics from Europe. Chinese operators are quick to learn, the quality of the end product is high, and labor costs are low.

Despite this trend, no mainland fashion designers have so far achieved worldwide recognition, unlike, for instance, some Chinese painters who in recent years have produced works that are much sought after by wealthy overseas collectors. Design schools like

Fig. 502

Fig. 503

Beijing's Central Academy of Fine Arts, the Zhejiang Academy of Fine Art, and the Chinese Textile University of Shanghai teach fashion design and their graduates go on to work for some of the large garment manufacturing companies. Shanghai Garment Group Import and Export Co., established in 1980, is one such company which sells over US$20 million worth of exports annually, putting them among the top 500 import and export companies in China.

An increasing number of graduates establish their own labels, which are showcased at the China International Fashion Week in Beijing, sponsored by the China Fashion Designers Association. They are keen to produce new designs for the local Chinese market instead of just for overseas ones. However, like designers everywhere, there is always the difficulty in finding interesting fabrics in small quantities and, equally, small manufacturers who will make sample quantities prior to producing the line. Most will only manufacture thousands of pieces of one style. Thus, many designers rely on producing uniforms for hotels, banks, and other large companies to keep their companies afloat while they try to establish the ready-to-wear side.

Unlike Japanese designers, who challenged Western fashion in the 1990s with their innovative use of flat-plane clothes taking their form from the body, designers born and bred in China have yet to make their mark in overseas markets. The Chinese are masters of copying but can be short on originality, probably as a result of past history. Self-expression was discouraged in an examination system based on learning by rote. Regulations governed dress in feudal China, continuing in part during the Republican era, so traditional dress changed very little. There was not much freedom of expression for improvisation. Styles did not go out of fashion. Instead, they were handed down through the generations. In more recent times, the cult of the Mao suit stifled creativity. Yet, outside the system, among the lowest of the low, the fishing people, who were traditionally forbidden to live on land and to take the imperial examinations, inventiveness abounded, as can be seen in the baby carriers and festival clothing produced by the Hoklo and Tanka.

The lack of creativity among Chinese designers has been, however, offset by a particular skill – quality workmanship. Chinese painters traditionally copied the masters until they were finally deemed skilful enough to give vent to their own personal expression. In other fields, this has given rise to exquisite workmanship when the only way an artisan can stand out is through the quality of his or her work.

Though the garment industry in Hong Kong was the largest in the world in the 1970s, manufacturers there had little use for original design at that time and designers were seldom employed. Import/export companies acted as go-betweens for Western store buyers and local factories and relied upon sketches supplied by overseas designers. Although the Hong Kong Polytechnic University has given training in fashion design for over thirty years, Hong Kong designers have to go overseas to make a name for themselves.

Fig. 502 Cable knit hip-length woolen jackets, one with a deep fur collar and cuffs, worn with plain knitted skirts and pull-on hats, *Hong Kong Apparel*, Hong Kong Trade Development Council, 1975.

Fig. 503 Knitted suits with flared skirts, designed for export but also popular with local office girls, *Hong Kong Apparel*, Hong Kong Trade Development Council, 1975.

Fig. 504 Red and purple silk cocktail dresses, draped and tied at the upper hip, from the Judy Mann Collection, 1984.

Fig. 505 Innovative flat-plane long coat dress made from two patterns of straw matting, with a mandarin collar and slit openings for arms, from the Ragence Lam Collection, Spring/Summer 1985.

Fig. 506 Innovative flat-plane wrap-over jacket made from patterned straw matting, worn with a long straight skirt, from the Ragence Lam Collection, Spring/Summer 1985.

Fig. 504

Fig. 505

Hong Kong Fashion Week is a showcase for designers but attendance by overseas buyers fluctuates. Some local designers, like William Tang, Bernard Foong, Ragence Lam, Judy Mann, and LuLu Cheung (Figs. 504–506, 509, 510), have a loyal following among wealthy Hong Kong socialites, especially for one-off evening and bridal wear, but the small customer base in Hong Kong cannot support a full fashion house. American designer and long-time Hong Kong resident Diane Freis has made for the overseas market since the 1970s.

The Hong Kong Polytechnic University's most famous alumna is Vivienne Tam, now based in New York, who is one of the few Chinese designers who have a following overseas, and she has successfully built up a chain of over twenty boutiques in the USA, Japan, Hong Kong, and Shanghai. She constantly refers to her Chinese roots for inspiration, and her designs aim to meld the aesthetic and feminine mystique of Asia with the spirit of the modern world.

Vivienne first rose to prominence with her spring/summer 1995 "Mao" collection, which garnered headlines for its images of Mao Zedong (Figs. 507, 508). This was at a time when memories of the recent Cultural Revolution were still fresh and the man himself still controversial. Although some sections of the media and certain department stores refused to display the clothes, the collection was undoubtedly influential and is now in the permanent archives of major museums in London and New York (Fig. 444). Vivienne is best known in recent years for her successful blending of Chinese motifs and styles with Western styles, which are far removed from the costume-like designs produced by less skilful designers. As a result, her clothes are coveted by Westerners and Chinese alike.

Fig. 506

Fig. 507

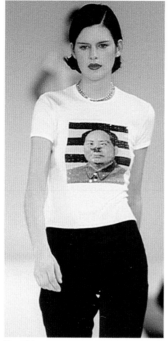

Fig. 508

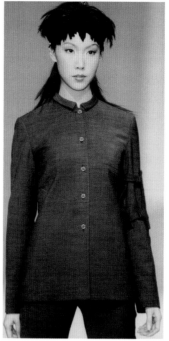

Fig. 509

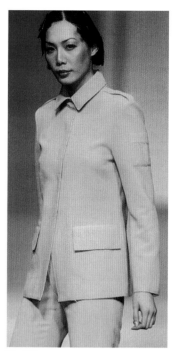

Fig. 510

Another design company with its roots in Hong Kong is Shanghai Tang. Founded by Hong Kong businessman David Tang in 1994, to introduce the fine quality of Chinese workmanship to the world, Shanghai Tang now has branches in Beijing and Shanghai as well as in the West. Initially garments and products were inspired by 1930s Shanghai fashions and updated with modern details and colors. The traditional jacket and loose *ku* trousers and the Mao suit were some of the original styles offered by this store in brightly colored silks and velvets, lined with neon colors, to make a fashion statement and to epitomize luxury.

Because these jackets and cheongsams have been copied by countless back-street tailors and traders, the company has now moved into collections, which take their inspiration from traditional Han Chinese clothes, minority dress, the cheongsam, and the Forbidden City (Figs. 511, 512). The clothes, originally labeled "Made by Chinese," now carry a "Made in China" label, reinforcing the idea that they are on a par with the best quality workmanship and design from Europe, despite negative connotations of cheap mass-production from the mainland. The styles, however, appeal mostly to Westerners rather than Chinese.

In China itself, consumers' tastes have changed. The opening up of the country in the 1990s to the world and the growing numbers of overseas visitors have resulted in a building boom, including numerous hotels, department stores, and stylish designer shops. The "Big Four" stores no longer have a presence, and there are no Western-run department stores, although Lane Crawford, an upscale store in Hong Kong since 1850, returned to Shanghai, and opened more stores in Harbin and Hangzhou.

There are shopping malls in many major cities, while Shanghai is once again fast becoming the fashion capital of mainland China. With a population of 14 million, there is a real consumer culture. Xintiandi, a trendy low-rise area of restaurants, clubs, and the Plaza 66 shopping mall developed by a Hong Kong businessman, is full of Western-brand boutiques. Pierre Cardin was the first to establish an outlet in 1979, but since then Louis Vuitton, Dior, Armani, Burberry, Prada, and Ferragamo have all opened stores in the main cities, including Beijing, Shanghai, and Shenzhen. These labels have had a major presence in Hong Kong for many years.

From among China's population of 1.3 billion, 200 million are considered middle class, with enough money to fulfill their aspirations. These wealthy Chinese are keen to buy European name brands. Successful businessmen, especially, purchase luxury Italian branded suits like Zegna and Brioni. However, many of the newly rich are fairly low-key in their dressing, loath to attract attention from the state or the criminal element, unlike in Hong Kong where there is much public display of wealth. The middle classes patronize tailors and have their clothes made to measure, often taking along their own designs or ideas. Lower down the scale, suits are bought off the peg and from market stalls.

Young Chinese women are up to date with fashion trends, and avidly devour the Western fashion magazines now available in China. *Elle* was the first international fashion magazine officially approved for publication in China, in 1988. Since then, Chinese editions of *Marie-Claire, Cosmopolitan,* and *Bazaar* have followed, with *Vogue* making its debut in 2005. Its US publisher, Conde Nast, collaborates with the long-established publication *China Pictorial,*

Fig. 507 Mao shirt dress printed with blocked images of Mao Zedong, Mao Collection, Vivienne Tam, 1995.

Fig. 508 Mao T-shirt featuring Mao with a bee on his nose, Mao Collection, Vivienne Tam, 1995.

Fig. 509 Light brown trouser suit with a small collar, five-button front fastening, and straps detail on sleeves, from the LuLu Cheung Collection, Fall/Winter 1999.

Fig. 510 Cream trouser suit with flap pockets, epaulettes, and pleated pocket detail on sleeves, from the LuLu Cheung Collection, Fall/Winter 1999.

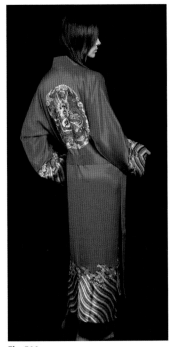
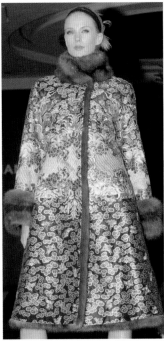

Fig. 511 **Fig. 512**

emphasis on Western fashion styles and pop culture, there are few indications that traditional dress like the cheongsam will make a comeback; at present only waitresses and others in the entertainment industry wear it, though popular movie stars like Gong Li and Zhang Ziyi wear it on and off the screen. Nostalgia is beginning its own revolution with products and styles from the early Communist era to the Cultural Revolution being highly fashionable for the younger generation.

Travel restrictions are gradually being lifted, allowing many Chinese to visit Hong Kong, and then overseas, initially in groups and then as individual travelers, exposing them further to Western fashions and culture. This is very evident now in Hong Kong where many of the big consumers who frequent upmarket department stores, jewelry shops, and designer boutiques are from the mainland, spending what would at one time be a lifetime's salary on a pair of shoes. This leads the stores to stock smaller sizes and the local expatriate population have difficulty in finding clothes to fit, except at the British chain store, Marks ansd Spencers. Tailors are still a popular option, both in the territory and across the border in Shenzhen.

Today, traditional dress and the Mao suit are worn only by some of the older generation and those living in remote areas of China. Western dress is worn throughout the country, and popular Western culture is fast replacing time-honored ways. Nevertheless, at the Lunar New Year festival in Hong Kong and Macau, as all over China, families look back to their roots and proudly dress their children in colorful replicas of traditional styles from the Qing dynasty (Figs. 513, 514).

which did much to spread the word on the Cultural Revolution in several languages. *Vogue* aims to celebrate Chinese culture and values, and sees their role as educating Chinese women. The magazine uses a mixture of Chinese and Western models and photographers.

As China's economy grows and living standards improve, it is highly likely that dress in China will continue to evolve. With the

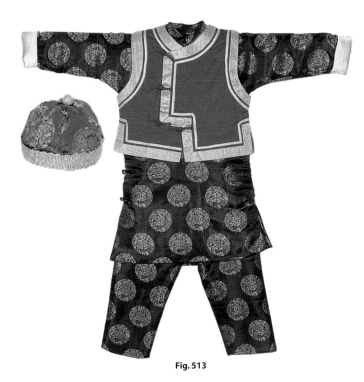

Fig. 513

Fig. 514

Fig. 511 Dressing gown in red satin, with a dragon roundel on the back and a *li shui* diagonal striped border at the hem and cuffs, Shui Collection, Shanghai Tang, 2004.

Fig. 512 Embroidered satin coat, fully lined with fur, in the style of a dragon robe, with fur collar and cuffs, Autumn Collection, Shanghai Tang, 2005.

Fig. 513 Boy's *chang shan*, trousers, and cap in blue rayon brocade, covered with a roundel design containing a long life character surrounded by dragons, and a matching red and gold rayon waistcoat, purchased from a market stall in Hong Kong before the Lunar New Year festival, January 2006.

Fig. 514 Girl in her best clothes at the Lunar New Year festival, Macau, January 2006.

BIBLIOGRAPHY

Alexander, William, "A Group of Chinese, Habited for Rainy Weather," *The Costume of China Illustrated in Forty-eight Coloured Engravings*, London: Miller, 1805.

Ball, J. Dyer, *Things Chinese: Being Notes on Various Things Connected with China*, London: Low, 1900; 5th edn published Shanghai: Kelly & Walsh, 1925; reprinted Hong Kong: Oxford University Press, 1982.

Berliner, Nancy Zeng, *Chinese Folk Art*, Boston: Little, Brown & Company, 1986.

Bird, Isabella L. [Mrs Bishop], *Korea and Her Neighbours: A Narrative of Travel &c.*, London: John Murray, 1898; reprinted Seoul: Yonsei University Press, 1970.

Bolton, Andrew, "The Mao Suit Unstitched," unpublished manuscript.

Breton de la Martiniere [Jean-Baptiste-Joseph], *China: Its Costume, Arts, Manufactures &c.*, 4 vols., London: J. J. Stockdale, 1812.

Burkhardt, V. R., *Chinese Creeds and Customs*, 3 vols., Hong Kong: South China Morning Post, 1955–9.

Cammann, Schuyler, *Catalogue of the Exhibition of Ch'ing Dynasty Costume Accessories*, Taipei: National Palace Museum, 1986.

_____, *China's Dragon Robes*, New York: Ronald Press, 1952.

_____, *Chinese Mandarin Squares: Brief Catalogue of the Letcher Collection*, Philadelphia: University of Pennsylvania, 1953.

_____, "The Development of the Mandarin Square," *Harvard Journal of Asiatic Studies*, Vol. 8, 1944–5, pp. 71–130.

Chiang Yee, *A Chinese Childhood*, London: Metheun & Co., 1940.

Cunningham, Alfred, *The Chinese Soldier and Other Sketches With a Description of the Capture of Manila,*, Hong Kong: Daily Press Office, 1902.

Da Ming Huidian, Collected Institute of the Great Ming, Vol. 2, post-war reprint.

Dickinson, G. and Wrigglesworth, L., *Imperial Wardrobe*, Hong Kong: Oxford University Press, 1990.

Doolittle, Revd Justus, *Social Life of the Chinese: A Daguerreotype of Daily Life in China*, 2 vols., London: Sampson Low, 1868.

Duda, Margaret, *Four Centuries of Silver: Personal Adornment in the Qing Dynasty and After*, Singapore: Times Editions, 2002.

Dudgeon, John, *Diet, Dress and Dwellings of the Chinese in Relation to Health*, published for the International Health Exhibition, 1884.

Garrett, Valery, *Chinese Clothing: An Illustrated Guide*, Hong Kong: Oxford University Press, 1994.

_____, *Chinese Dragon Robes*, Hong Kong: Oxford University Press, 1998.

_____, *A Collector's Guide to Chinese Dress Accessories*, Singapore: Times Editions, 1997.

_____, "From Court to Cradle: Jewelry of the Qing Dynasty," *Hong Kong Oriental Ceramics Society Bulletin*, No. 12, February 2002.

_____, "The Importance of Accessories in Qing Dynasty Dress Regulations," *Arts of Asia*, November/December 1997.

_____, *Mandarin Squares: Mandarins and Their Insignia*, Hong Kong: Oxford University Press, 1990.

_____, *Traditional Chinese Clothing in Hong Kong and South China, 1840–1980*, Hong Kong: Oxford University Press, 1987.

Goodall, John A., "Heaven and Earth," 120 album leaves from *San-ts'ai t'u-hui*, a Ming encyclopedia, 1610; reprinted London: Lund Humphries, 1979.

Graves, Revd R. H., *Forty Years in China, or China in Transition*, Baltimore: R. H. Woodward Co., 1895.

Hacker, Arthur, *China Illustrated: Western Views of the Middle Kingdom*, Rutland, Vermont: Tuttle Publishing, 2004.

Hayes, James, *South China Village Culture*, Hong Kong: Oxford University Press , 2001.

Holdsworth, May and Courtauld, C., *The Forbidden City: The Great Within*, Hong Kong: Odyssey Publications Ltd, 1995.

Hosie, Alexander, *Manchuria: Its People, Resources and Recent History*, London: Metheun & Co., 1904.

Jackson, Beverley, *Shanghai Girl Gets All Dressed Up*, Berkeley, Ca.: Ten Speed Press, 2005.

Jewelry and Accessories of the Royal Consorts of Ch'ing Dynasty, Peking: Forbidden City Publishing House and Hong Kong: Parco Publishing Company, 1992.

Jisi guanfu tu (Official Dress for Rites and Ceremonies Illustrated), 3rd year of the Republic, 1914.

Johnson, E. L., "'Patterned Bands' in the New Territories of Hong Kong," *Journal of the Hong Kong Branch of the Royal Asiatic Society*, Vol. 16, 1976.

Ko, Dorothy, *Every Step a Lotus: Shoes for Bound Feet*, Berkeley, California: University of California Press, 2001.

Levy, Howard S., *Chinese Footbinding: The History of a Curious Erotic Custom*, New York: Bell Publishing Company, 1967.

Little, Archibald (Mrs), *The Land of the Blue Gown*, London: T. Fisher Unwin, 1902.

Miyazaki, Ichisada (trans. Conrad Schirokauer), *China's Examination Hell: The Civil Service Examinations of Imperial China*, New Haven: Yale University Press, 1981.

Morse, Edward S., *Glimpses of China and Chinese Homes*, Boston: Little Brown, 1902.

Moule, The Venerable Arthur Evans, *The Chinese People: A Handbook on China*, London: Society for Promoting Christian Knowledge, 1914.

Roberts, Claire (ed.), *Evolution and Revolution: Chinese Dress 1700s–1990s*, Sydney: Powerhouse Publishing, 1997.

Scott, A. C., *Chinese Costume in Transition*, Singapore: Donald Moore, 1958.

Sirr, Henry Ch., *China and the Chinese: Their Religion, Character, Customs, and Manufactures &c.*, 2 vols., London: W. S. Orr & Co., 1849; reprinted San Francisco: Chinese Materials Center, Inc., 1979.

Smith, Arthur H., *Chinese Characteristics*, New York: Fleming H. Revell Company, 1894.

Steele, Valerie and Major, John S., *China Chic: East Meets West*, New Haven: Yale University Press, 1999.

Stuart, Jan and Rawski, Evelyn S., *Worshipping the Ancestors: Chinese Commemorative Portraits*, Washington, D.C.: Freer Gallery of Art and the Arthur M. Sackler Gallery, Smithsonian Institution, in association with Stanford University Press, Stanford, California, 2001.

Tam, Vivienne, *China Chic*, New York: Regan Books, 2000.

Vollmer, John E., *Decoding Dragons: Status Garments in Ch'ing Dynasty China*, Eugene: Museum of Art, University of Oregon, 1983.

_____, *Five Colours of the Universe: Symbolism in Clothes and Fabrics of the Ch'ing Dynasty (1644–1911)*, Edmonton: The Edmonton Art Gallery, 1980.

_____, *In the Presence of the Dragon Throne: Ch'ing Dynasty Costume (1644–1911) in the Royal Ontario Museum*, Toronto: Royal Ontario Museum, 1977.

_____, *Ruling from the Dragon Throne: Costume of the Qing Dynasty (1644–1911)*, Berkeley, California: Ten Speed Press, 2002.

Wade, Thomas, *The Army of the Chinese Empire*, Canton: The Chinese Repository, 1851, Vol. 10; reprinted Tokyo: Maruzen Co. Ltd, n.d.

Wang, Loretta H., *The Chinese Purse*, Taiwan: Hilit Publishing Co. Ltd, 1986.

Wang Yarong, *Chinese Folk Embroidery*, London: Thames & Hudson, 1987.

Welch, Patricia Bjaaland, *Chinese Art: A Visual Guide to Symbols and Motifs*, Rutland, Vermont: Tuttle Publishing, 2007.

Wells William, S., *The Middle Kingdom: A Survey of … the Chinese Empire and Its Inhabitants*, 2 vols., New York: Charles Scribner's Sons, 1883; reprinted New York: Paragon Book Reprint Corp., 1966.

Williams, C. A. S., *Outlines of Chinese Symbolism and Art Motives*, Peking: Customs College Press, 1931; reprinted as *Chinese Symbolism and Art Motifs*, 4th edn, Rutland, Vermont: Tuttle Publishing, 2006.

Wilson, Verity, *Chinese Dress*, London: Victoria and Albert Museum, 1986.

INDEX

Note: Numbers in *italic* refer to illustrations.

Accessories: Manchu women, 38, *38–9*, 40, *40–1*; mandarins, 70, 73–4, *73–4*; mandarins' wives, 113, *113–15*, 116
Alexander, William, *31*
All-China Federation of Democratic Youth, 217, *217*
Amulets, 188
Anklets, 113, *183*, 191, 205, *206*
Ao: girls, *82*, 195, *195–7*, 199; mandarins' wives, 106–7, *106–9*, *111*; 20th century, *134*, 135, 136, *136–9*; weddings, 120, *120*
Ao kun: girls, 199, 200; weddings, 152
Aprons: Cantonese women, 164, *165*, 166; *chao pao*, 12; children, 181, *182*; farming women, 164; Hakka women, 166, *166*, *167*; straw, 160, *161*

Ba Gua, 188, 190
Babies: clothes, *178*, 181, *181*; rituals, 181; shoes, 184–5, *185*
Baby carriers, 184, *185*, 203–4, *203–5*; covers, 204, *205*, 225
Bai shou yi, see Longevity jacket
Bai tong, 70, 113, 164, 181, *183*, 191, 205
Bamboo: belt, 98; hats, 164, *165*, 166, *166*, 168, *168*; jacket, 112, *112*; needles, 113; vest, 85
Banner gown, *see Qi pao*
Bannermen, *30*, 31, 34: armor, 27
Bao tou, 166, *166*, *167*
Bat motif, *18–19*, *20–1*, 22, 24, 41, 47, 50, 56, 57, 58, 72, 79, 80, 83, *101*, 103, *104*, *105*, *110*, *111*, *121*, *185*, *190*, *226*
Bei xin, *82*, *131*, *178*, 188, *189*
Beijing, 8, 10; map, *9*
Beijing Garment Factory, *224*
Bells, 191
Bird, Isabella, 82
Birthday badges, 103, *105*
Black gummed silk, 85, *87*, *159*, 160, 166, 168, 170, 172
Bondservants, 26, 34
Boot covers, 74
Boots: bound feet, *117*, 118, *119*; children, *195*; emperors, 15, *15*; mandarins, 70, 74, *74*; mandarins' children, *82*; military mandarins, *78*, 79; *see also* Shoes
Bound feet, 113, 116–18, *116*, *117*, *159*; boots, 117, 118, 119; children, *195*, 198; shoes, 118,

118–19, 198; socks, *119*; supports, *117*, 118
Bracelets, 113; children's, 205, *206*
Buddhist emblems, 17, *18–19*, 22, 24, 41, 46, 47, 50, 69, 72, 76, *101*, *110*, *111*
Bulaji, 213, *214*
Burial clothing: mandarins, 123–4, *125*; 20th century, 174, *175*, 176, *176–7*
Butterfly Wu, *152*

Calendaring, 158
Cantonese, 163–4, *163–5*; hat, *226*
Cape collar, 172, *173*
Capes, 52
Capital City Red Guard Rebels' Victory Exhibition, 222
Castiglione, Guiseppe, *28*
Central Academy of Fine Arts, 232
Ceremonial armor, 26, 27, *28*
Chang fu, 25
Chang shan: children, 55, 82, 178, *235*; Hong Kong, 213–14, *216*; merchants, 84, 85, *85*, 86
Chang shan ma gua: barber, *159*; burial clothing, 174; children, 188; New Republic, 131, *131*, 132, *132*; village elders, 163, *163*; weddings, 152, *153*
Changde Yee department store advertisement, *144*
Chao dai, see Girdles
Chao fu, 12
Chao gua, 34, *34*, 36, *36*, 37, 38, 53
Chao guan, 36, 38, *38*
Chao pao: Manchu men, 12, 14; Manchu women, *10*, 34, *35*, 36, *36*, 37, 44; mandarins, 68
Chao zhu: Manchu men, 14, 15; Manchu women, 36, 40; mandarins, 68, 70, 73, 74; mandarins' wives, 102
Charms, 113, 181, *183*, 188, 191, *192*, 205, *206*
Chatelaines, 113, *115*
Cheat's handkerchief, *64*
Cheongsam, *4*, 147, *147–51*, *221*; girls, *200*, 201, *201*, *235*; Hong Kong, 214, *216*, 231, *231*
Chest apron, *see Dou dou*
Cheung, LuLu, 233, *234*
Chiang Kaishek, *134*, 212
Chiang Yee, *186*
Chien Hsiang Yi Pao Chi advertisement, *143*
Children: education, 192; first birthday, 188
Children's clothes, *178*, 180, 188, *189*, 195, *195–7*, 198–201, *198–202*; Communist era, 217,

222, *224*; festivals, 207, *207*, 235, *235*; first birthday, 186, *186*, *187*; Manchu, 55, *55–9*, 60, *60–1*; mandarins, 82, *82*, *83*; protective motifs, 180, 181, 188; Western, *217*
Children's games, 192
Children's hats, 181, 184, *184*, 188, *189*, 193–4, *207*
Children's jewelry, 205, *206*
Children's shoes, *61*, 188, *192*, 194, *194*
China: expansion of, 7
China Ballet Troupe, *221*
China Fashion Designers Association, 232
China International Fashion Week, 232
Chinese homes: merchants, 84, *84*; 20th century, 136, *140*
Chinese Lu Ying, *see* Green Standard Army
Chinese Merchandise Emporium, 214; catalogue, *202*, 214, 218
Chinese Products Emporium, 229
Chinese Textile University, 232
Chinese women, *94–7*; education, 134; employment, 136; status, 94, 98
Chong Yang, 176
Chongzhen Emperor, 7
Chops, *see* Seals
Chun II, Prince, 59, *60*
Cixi, Empress Dowager, 34, 49, 52, 54; robe, *50*
Class structure, 142
Cloaks, 136, *141*
Clogs, 156, *161*, *162*
Clothing paper patterns, 152, *224*
Clothing production, 94
Clothing regulations: Manchu 10–11, *10*, 12, *35*, 37, 38, 40, 41; New Republic, 130–1, *130*
Collars, *see Ling tou*; *Pi ling*; *Yun jian*
Collars: children, 188, *190–1*, 207, *208*, *226*
Colors: auspicious, 181; dragon robes, 55; mandarins' wives, 98; marital status, 107; restrictions on use, 11, 16; symbolism, 11, 27; women, 54
Common people, *156*, 158, *158–61*
Commune election, *223*
Communist era, 212, *212*, 217, 220–1, 227; clothes, 213, 218–19, *218–19*, 222, *222–4*
Communist Party, *134*, 212, 217
Cool hat, *see Liang mao*
Coolies, *160*, *161*, 192
Coronet, 98, *98*, 100, *101*, 120,

120, *122*, 173
Cotton production, 158
Court hats: women, *see Chao guan*
Court necklace, *see Chao zhu*
Court robe, *see Chao pao*
Crow's tail quill, 73, *73*
Cultural Revolution, 220–2

Da lian purse, 15
Dalai Lama, 14
Daoist emblems, 17, *79*
Delivery chop, *19*, 23
Deng Xiaoping, 212, 229
Department stores, 142, 144, 146, 234; catalogues, 201, *214*
Der Ling, Princess, *52*
Diadem, *see Jin yue*
Dianzi, 46, *48*
Diao wei, 29
Divided trousers, 181, *181*, 186, *186*, 188
Dorgon, 7
Dou dou: babies, 181, *182*, 225, *226*; women, 112, *112*
Double happiness character, 51, *53*, 203, *203*
Dragon jackets, 46, *46*, 98, *98*, 99, 120
Dragon robes: cartoon, *16*; Dowager Duan Kang, *46*; Manchu, 11, 12, 14, 16–17, *16–21*, 22–3; Manchu children, 55, *55–9*; Manchu women, *32*, 34, 40–1; *43–5*, mandarins, 70, *70–2*; mandarins' children, *82*; *see also Long pao*; *Mang pao*
Dragon skirt, 98, *98*, 99, 100, 120
Drawstring purses, 15, *15*
Duan zhao, 75, *75*
Dyes, 158

Eagle hat, 193
Earmuffs, 195, *198*
Earrings, 113, *113*, *115*; Manchu women, 40
Eight Banners, 7, 26–7, 34
Eight Immortals, *86*, *104*, 193
Eight Trigrams, *see Ba Gua*
Embroidery, 92, 94, 97, 136; design books, 136, *140*, *141*; process, 22
Erh-shih, 40
Eunuchs, 10
Excellent Women, *see Xiu nu*

Fa lap, 164, *165*
Fans, *114*, 116, 164, *164*, 172; cases, 15, *89*, *90*, 91, *115*
Farming communities, 163–4, 166
Fashion designers: Chinese, 232,

233; Western, 231, 234
Fashion magazines, 152, 234–5
Festival of the Hungry Ghosts, *177*
Festive hat, *see Ji guan*
Fishing people, 168, 170
Five Blessings, 203
Five-clawed dragon robes, *see Long pao*
Five Evil Creatures, 180
Five Poisons, 180, *182*
Flaming pearl motif, *39, 40*, 41, *41, 190*
Foong, Bernard, 233
Foot binding, *see* Bound feet
Forbidden City, 8, 10, 34, 231
Four-clawed dragon robes, *see Mang pao*
Fourth Tailoring Commune department catalogue, *219, 222, 228*
Freis, Diane, 233
Fu emblem, 23, 180
Fu Xing Xiang Hat factory advertisement, *215*
Funeral offerings: children, 207, *209*
Funerals, 174, *175, 176, 177; see also* Burial clothing; Mourning clothes

Garment industry, 231, 232
Giquel, M., 28
Girdle plaques, 15, 73, *74*
Girdles: Manchu, 15, *15*; mandarins, 73; merchant class, 88
Girls: clothing, 195; education, 134, 195, 199, 201, 214; status, 94, 195
Gong Yixin, Prince, *26*
Gordon, General, 28
Graduates gowns, *65*, 66
Great Leap Forward, 212, 219
Great Wall, 8
Green Standard Army, 26, 28, 67, 78
Guan pimao, see Melon cap
Guangdong Mail and Telegraphic Service Co. propaganda poster, *213*
Guangxu Emperor, 22, 59
Gun, 107, 107, 109, 110
Gun fu, see Surcoats
Guomindang, 134, 212, 227

Hair ornaments, 164, 170, *170, 171*
Hairpins, 113, *114*, 174
Hakka, 166, *166–7*; hats, 166, *166, 170, 171, 226*
Hall & Holtz Ltd, 142, *144*
Hat box, *73*
Hat finials: Manchu men, 14, *14*, 25; Manchu women, *36*, 38, *38, 39*; mandarins, 66, 70, *73*
Hat stands, *73*
Hats: bamboo, 164, *165*, 166, *166*, 168, *168*; Cantonese, *226*; children, 181, 184, *184*, 188, *189*, 193, *207*; court dress, 14;

emperor, 14, *22*, 23, 25; Hakka, 166, *166, 170*, 171, *226*; Imperial family, 25; mandarins, 70, *70*, 73; noblemen, 25; officials, *13*, 25; prince, *13*; Republican dress, 130, *132*; straw, 160, *161, 226*; Tanka, 168, *168*; with slogans, *226*
Headbands: Cantonese, 164, *165*, 166; Hakka, 166, *166*; Manchu women, *39*, 40; mandarins' wives, *102*, 103, *104*
Headcloths, 166, *166, 167*
Headdress, *see Dianzi*; Wedding attire: Hong Kong
Headland, Mrs, 52
Headscarves, 168, *169*
Heavenly Twins, *189*
Hei jiao chou, see Black gummed silk
Hemp, 160
Hoklo, 170, *170*; baby carrier covers, *205, 225*; baby carriers, 204, *204*; charms, 205, *206*; children's clothes, 207, *207–9*; waistcoats, 207, *208, 209*; weddings, 172
Hong gua, 152, *154–5*, 172, *216*
Hong Kong: fashion, 229, 231, 235; garment industry, 232; riots, 222
Hong Kong Fashion Week, 233
Hong Kong Polytechnic University, 232, 233
Hong Kong Trade Development Council, 231
Hoods, 87, *88*
Hu Yaobang, 229
Hua dai, 166, *166, 167*
Hua yu, see Peacock feathers
Huang guifei, 34
Huang ma gua, 27, 28
Huangchao liqi tushi, 10
Hundred families: jacket, 181, *183*; tassel, 205

Illustrated Precedents for the Ritual Paraphernalia of the Imperial Court, *see Huangchao liqi tushi*; *see also* Clothing regulations: Manchu
Imperial City, *9*, 10
Imperial family: court necklace, 15; dragon robes, 16; hat insignia, 14, 25; hats, 25; insignia badges, 23, 25; robes, 11, 12, 17; roundels, 23
Imperial guardsmen: uniform, 27–8, *29*
Imperial Household, 22
Imperial Silkworks, 22–3; letter, *19*
Imperial Weaving and Dyeing Office, 22
Insignia squares, *see* Rank badges

Japanese department stores, 231
Jewelry: Cantonese women, 164; children, 181, *183*, 191, *206*; mandarins' wives, 113, *113, 115*
Ji fu, see Dragon robes

Ji guan: emperor, 23; women, 41, *41*
Jiang Qing, 134, 221, 229
Jiang Zemin, 229
Jiangxi Communist Labor University students, *222*
Jiao dai, 98, 120, *120*
Jin yue, 36, 39, 40
Junbian fu, see Zhifu

Kai mian, 103, 120
Kangxi Emperor, *11*, 16, 34, 55, 94
Kerchief, 15, *36*, 40, *41*; holder, 15
Kesi, 14, *20*, 22, *24*, 45, *46, 50, 55, 77, 80*, 99, 100, *104*
Key holders, 89, *91*
Kingfisher feather inlay, 46, *48*, 100, *100, 104*, 113, *114, 154*
Kneepads, *88*
Knitted dresses and suits, 231, *232*
Knitting patterns, 152; books, *152, 214*
Ku, 107, *111*, 160, 213, *216*

Lam, Ragence, 233, *233*
Lan yu, see Crow's tail quill
Lane Crawford, 142, 234
Lappets, 102, *102*
Leggings, 107, *111*, 118
Lenin outfit, *see Bulaji*
Li shi, 17, 34, 38, 46, 152, 154
Li shui motif, 17, *17, 20*, 34, 38, *44, 46, 47, 48*, 49, *50, 72, 76, 83, 104, 105, 129*, 152, *154–5*
Liang ba tou, 54, *54*
Liang mao, 166, *166*
Liening fu, see Bulaji
Ling tou, 25, *26*, 70, *70, 75*
Ling yue, 40, *40*
Lingzhi motif, *110, 182, 189*
Little, Mrs Archibald, 116, *117*
Little Red Book, *220*, 221, 222, *223*; bag, *226*
Liu Changyu, *68*
Long gua, see Surcoat
Long pao: Manchu men, 16–17; Manchu women, 40–1, *42–3, 44, 46*
Longevity: jacket, 124, *125*; skirt, 125
Lotus motif, 49, *111, 154–5, 185*, 203
Lu emblem, 180

Ma gua: children, 55, *60*, 178, *188*; mandarins, 134; merchant class, 79, *85, 85, 86*; military, 28
Macau: riots, 222
Manchu, 8
Manchu armies, 26–7
Manchu Ba Qi, see Eight Banners
Manchu children: clothing, 55, *55–9*, 60, *60–1*; education, 55
Manchu court, 8–10; attire, 12–15, *12–15*
Manchu emperors: boots, 15, *15*; ceremonial armor, 26–7; court attire, *11, 12, 12–13*, 14–15; court necklace, *14*, 15; dragon

robes, 11, 12, 14, 16–17, *16–21*, 22–3; drawstring purses, 15, *15*; hats, 14, *22*, 23, 25; helmet, *27*; imperial surcoats, *22*, 23, *23, 24*; informal robes, 25, *26*; roundels, 12, 25; Twelve Symbols of Imperial Authority, 22
Manchu noblemen: hats, 25; robes, *16, 18–19*
Manchu princes: hats, *13, 26*
Manchu princesses, *61*
Manchu women, 34, *53*, 61; accessories, 38, *38–9*, 40, *40–1*; court robes, 34, *34, 35*, 36, *36, 37*, 38; non-official attire, *48*, 49, *49–54*, 54; semiformal and informal attire, 40–1, *42–7*; shoes, 54, *54, 55*, status, 60
Mandarin buttons, 70
Mandarin duck motif, 62, *104, 154–5*, 203
Mandarin squares, 70; *see also* Rank badges
Mandarins, 64, 66, 67–8, *67*; accessories, 70, 73–4, *73–4*; court dress, 68, *68*, 69; domestic quarters, *67*; dragon robes, 70, *70–2*; examinations, 64–5, *64, 67, 67*; informal dress, 70; rank badges, 75, *76–7*, 78; surcoats, 75, *75*
Mandarins' wives, *2*, 94: formal dress, *100*, 102–3; funeral attire, 124; hairstyles, 113, *113, 114*; informal dress, 106, 107, *106–11*; semiofficial dress, 98, *98*
Mang ao, see Dragon jacket
Mang chu, see Dragon skirt
Mang pao, 16–17
Mann, Judy, 233, *233*
Mao Collection, *210*, 233, *234*
Mao suit, *133*, 134, 218–19, *218–20*, 222, *222*, 229, *230*, 235
Mao Zedong, *133*, 134, 212, 218, *218*, 220, 221, 225, 227, 229, 233
Mass-produced fabrics, 160
Melon cap, 85, *85*, 87, *159*, 160, *193, 194*
Merchant class, 84–5, *84–7*, 87–8
Merchants' wives: semiformal and informal dress, 106
Miao, 225; child's collar, *226*; child's *dou dou*, 225, *226*; child's hat, *226*
Military mandarins, 78–9, *78, 82*
Military uniforms: boys, 199, *200, 230*; Manchu, 26–9, *28–31*; 20th century, 132, 134
Ming dynasty, 7
Mitts, *161*
Money belt, 112, *112*
Mourning clothes, 125, 174, *174–5*

Nail: extenders, 113; guards, 54, *54*, 113, *115*
Nanjing, 132, 147
Nanjing Road, *142, 144, 146*
Nationalist government, 134
Natural Feet Society, 116

Navel cover, 181, *181*, *182*
Neck rings, *183*, *192*, 205, *206*
Needles, 113; cases, 113, *115*
Nei tao: children, *83*, 188; Manchu, 25, 70; military mandarins, *78*, 79
Neiwufu, *see* Imperial Household
New Republic, 128; official attire, 130–1
Nightwear, 85
Nurhachi, 8, 27; kinsmen, 26

Official Gazette, 11
Official Nine purses, 91
One-child policy, 195, 229; poster, *229*
One hundred longevity character garment, *see* Longevity jacket
Open-door Policy, 229
Opening the face, *see* Kai mian
Overskirt, 120, *121*

Padlocks, 181, *183*, 205, *206*
Paintbrush holders, *89*, 91
Palace of Heavenly Purity, *8*
Palm fiber clothes, 160
Pawning of clothing, 85, 229
Peach motif, *24*, *83*, 103, *105*, 124, *182*
Peacock feathers, *13*, 25, 73, *73*, *75*
Peacock motif, *76*, 108, *185*
Pedlars, 94, *97*, 142
People's Liberation Army, *220*, 227; uniform, 227, *227*, *228*
People's Republic: clothing, 213
Phoenix crown, *see* Coronet
Phoenix motif, 38, *38*, *39*, 40, *41*, 98, 103, *108*, *109*, *110*, *124*, 152, *154–5*, *182*, 184, *189*, *197*
Pi ling, 14, 34, *34*, *36*, *37*, 38, *38*, *68*, *69*, 70
Pigtails, *see* Queues
Porcupine quills, 113
Pu fu, 46, 75
Pujie, *60*
Purses, 15, *15*, 88, *89*, *90*, 91
Puttees, 88, *88*, *120*
Puyi, *59*, *60*, 128, 130, *132*, *201*

Qi pao, 60, *61*, 147
Qianlong Emperor, 10, 12, 23, 27, *28*, 94
Qianqinggong, *see* Palace of Heavenly Purity
Qilin motif, 79, 82, *110*, 188, *188*, *192*
Qing dynasty, 7, 10, 34, 128; reviews of troops, 27, *28*
Qing Ming, 176
Queues, 87, 131, *159*

Rank badges: Manchu men, *22*, 23, 25, *25*; Manchu children, 55, *59*; mandarins, *62*, 70, *70*, 75, *75–7*, 78, 79, *79–81*, 82; mandarins' children, 82, *82*, *83*; mandarins' wives, 98, *100*, 102, *102*, 103, *103*, *104*; village elder, *163*

Rationing, 212; coupons, 219, *220*
Red Army, 134, 227; veteran, *222*
Red Guards, 220–1
Regulations, *see* Clothing regulations
Reiss Brothers advertisement, *116*
Republican dress, 128, *128*, *129*, 130–2, *130–2*
Resist American, Aid Korea campaign demonstration, *212*
Revolutionary Alliance Party, 128
Riding jacket, *see* Ma gua
Ritual worship, 11
Romper suits, 201, *202*, 209
Rongchangxiang, 132
Roundels: child's surcoat, *83*; Manchu men, 12, 16, *22*, 23, *23*, *24*, 25, *59*; Manchu women, 34, 40, *44*, 46, *46*, *47*, 49, *49*; mandarins, 68, *69*; Republican dress, *128*, *129*, 130

Sable tail, *see* Diao wei
Sacrifice at the Temple of Heaven, 128, *128*, *129*–30
Sailor suits, 199, *200*, 201, *202*
San Kwong & Co. box, *140*
School uniforms, *133*, 199, 201
Seal box, *89*
Seals, 91
Seasonal change of clothes, 10–11
Sedan chair: bride, 120, *122*; Manchu emperor, *27*; mandarin, *67*
Servants, 159
Sewing machines, 94
Shan: girls, *199*; Hoklo, 170, *170*, *171*, 172
Shan ku: children, *193*, 219; Hakka, *167*; rural women, 213; Tanka, 168, *168*; weddings, 172; workers, *159*, 160, *161*
Shanghai, 142, *142*, 144, 146, 234
Shanghai Garment Group Import and Export Co., 232
Shanghai Tang, 234, *235*
Shanxi Governor, *82*
Shen yi, 124
Shengguan tu, 192
Shenzhen, 229
Shoemaker, *156*
Shoes: babies, 184–5, *185*; bound feet, 118, *118–19*; burial, *174*, *176*; children, *61*, 188, *192*, 194, *194*; Empress Dowager Cixi, *54*; Manchu women, 54, *54*, 55; merchant class, *85*, 88, *88*; New Republic, 132; peasants, 161; wedding, *155*; Western, 152; women, 152; *see also* Boots
Shopping malls, 234
Shou, 23, 25, 34, 46, *47*, *48*, 49, *50*, 52, *86*, *101*, 180, *185*, 188
Shou Xing, *185*, *187*, *192*
Shou yi, 124
Shunzhi Emperor, 7, *14*
Sincere department store, 144, 146; Ladies Dress Show Bulletin, *145*; staff, *131*, *144*; tailoring department, *146*

Sing-song girls, *135*, *136*
Sino-Japanese War, 132
Skirts: dragon, 98, *98*, *99*, 100; girls, *82*, 199, *199*; Manchu women, 34; mandarins' wives, 98, *98*, *99*, 100, *100*, 102–3, *102*; Republican dress, *128*, *129*, 130; 20th century, *134*, *135*, 136, *139*, *141*; wedding, *174*; *see also* Gun
Skullcaps: children, 55, *60*, *184*, 193; merchant class, 85, *85*, 87, 90; New Republic, 131, *131*, *132*; prince, *26*
Sleeveless vests, *see* Chao gua
Sleeveless waistcoat, *see* Bei xin
Slogans on clothing, 225, *225–6*
Snuff bottles, 91, *91*
Socks: bound feet, *119*; mandarins, 74, *74*
Special Economic Zones, 229
Spectacle cases, 15, *89*, 91, *115*
Sportswear, 152
Stole, *see* Xia pei
Straw: aprons, 160; hats, *161*, 166, *166*, *226*; raincoat, 160, *161*; shoes, 194, *194*; wrist covers, 160, *161*
Street of Tailors, Guangzhou, 96
Su, Prince, *24*
Su, Princess, *36*
Sun Company, 144, 146; wrapping paper, *146*
Sun (Daxin) Department store, 221
Sun Sun, 144, 146
Sun Yatsen, 128, 130, 132, *133*, *134*, 144
Sun Yatsen suit, *see* Zhongshan-style suit
Suo yi, *see* Straw raincoat
Surcoat: bridegroom, 120, *120*; children, 55, *59*, *83*, 188; imperial, *22*, 23, *23*, *24*; Manchu women, 45, 46, *46–8*, 49, *49*; mandarins, 70, *70*, 75, *75*; mandarins' wives, *100*, 102, *102*, 106

Tam, Vivienne, 233, *234*
Tang, David, 234, *235*
Tang, William, 233
Tang clan, 163
Tanka, 168, *168–9*; baby carriers, *203*, 204, *225*
Tartar City, *9*, 10
Ten nai, 29, *31*
Thumb ring and case, *89*, 91
Tiger men, *see* Ten nai
Tinqua, 65, 94, *100*, *123*
Tobacco pouches, 88, 91, *115*, 116
Torque, *see* Ling yue
Tou jin, 41, 106
Tung Men Hui, *see* Revolutionary Alliance Party, 128
Twelve Symbols of Imperial Authority, 12, *12*, *20–1*, 22, 23, *23*, 25, 41, *42–3*, 46, 55, *129*, 130

Under-*shan*, 161
Underwear, 85, 160–1, *162*

Village festivals: dress, 163
Visiting card cases, 91, *91*

Wah Lun Hip store dress box, *149*
Wai dao, 75
Waistcoats: Hoklo, 207, *208*, *209*
Wan emblem, 22, *24*
Wang Ao, *6*
Wanrong, *36*
Watch case, *90*, 91
Waters, Vera, *231*
Weaving, 22
Wedding attire: Hoklo, 172; Hong Kong, 172; Manchu, 49, *49*, *50*; mandarins, 98, *99*, 100, *100*, 120, *120–3*, 123; rural people, 172; 20th century, 152, *153–5*; Western, 152, *153*
Weddings: Cantonese, *172*; country, *230*; Hakka, *173*; Hoklo, 172, *173*; mandarins, 120, 123, *123*; rural people, 172
Western dress: children, 199, *200*, 201, *202*, 219; cities, 229; New Republic, 130, *130*, 132, *133*; People's Republic, 213; weddings, 152, *153*; women, 134–5, *135*, 152
Western fashion designers, 231
Western fashion magazines, 235
Whiteaway, Laidlaw & Co. Ltd, 142
Wing On, 144, 146
Wing On Cheung store dress box, *148*
Working clothes, 160
Wrist covers, *161*, 166
Wu fu, *see* Mourning clothes
Wu Sangui, 7

Xia pei, 98, *98*, 100, *100*, *101*, 102, 120
Xiang se, 34
Xiao mao, 85, *87*
Xiaogong, Empress, 34
Xiu nu, 34
Xuantong Emperor, *see* Puyi
Xuesheng fu, 199, *200*

Yi Huan, Prince, *61*
Yi Yu Dyeing Company advertisement, *201*
Yin Dan Shi Lin Company advertisement, *150*
Yongzheng Emperor, 25, 34, 70, 94
Young Pioneers, 217; scarf, 217, *217*
Yuan Shikai, 128, 130; robe, *130*
Yun jian, 100, *100*, *101*, 120, *121*

Zai shui, *see* Kerchief
Zaixun, Prince, *24*
Zhang Zuolin, *128*
Zhejiang Academy of Fine Art, 232
Zhifu, 218–19, *222*
Zhongshan-style suit, *126*, *133*, 134, 218, 229
Zhua zhou ceremony, *186*, 188

ACKNOWLEDGMENTS

Chinese dress has gone through many changes since my first small book was published in 1987. At that time, China was emerging from the tumultuous years of the Cultural Revolution (1966–76), controlled and driven by Mao Zedong. His eventual successor Deng Xiaoping's open-door policy allowed the country to open up again to the world, with, inevitably, Western influences filtering in via the media and foreign visitors. In Hong Kong, too, changes which began with the booming economy in the late 1970s saw long-established villages and market towns replaced by New Towns, each populated by more than half a million people.

When I arrived in Hong Kong in 1973, villagers in the New Territories were still dressed in the traditional *shan ku*, the ubiquitous black pajamas worn for centuries throughout China. In contrast, across the border, on my first visit to Guangzhou two years later, during the Cultural Revolution, I found everyone attired in blue or green Mao suits. It was impossible to imagine that only seventy years earlier, mandarins clad in sumptuous dragon robes were swept along in sedan chairs while their womenfolk, in richly embroidered gowns, tottered about on tiny bound feet.

Today, except in remote regions and areas populated by the minority groups, the dress of the vast majority of Chinese is indistinguishable from that of any other community around the world. Western dress has become the norm, ranging from top French and Italian designer labels purchased in up-market boutiques in Shanghai or Beijing to market stalls selling mass-produced goods, including designer imitations.

Although this book covers Chinese dress from the Qing dynasty (1644–1911) to the present day, with the exception of the many minority groups, the emphasis is on the dress of the twentieth century as reflected in the many wide-sweeping changes that occurred in Chinese society and culture. The dress of imperial China has already been well documented by costume historians like Schulyer Camman, John Vollmer, and Verity Wilson, and in my earlier work. I have always been more concerned about what ordinary people wore, stimulated initially by my interest in the farming and fishing groups of Hong Kong during the 1970s and 1980s where I was able to carry out fieldwork. At this time, life in China was too disruptive and the country off-limits to researchers.

So the start of a new millennium seemed a good a time to look back, over three centuries, and especially the past twenty years, to reflect on what has changed, and how much has stayed the same. Despite the universal influences of technology little dreamed of in the 1980s, I am glad to see that ancient customs which lay dormant during the turbulent times of the Cultural Revolution have been revived. Family connections are still important, and the lunar calendar continues to be observed with festivals carried out with fervour. Thousand of years of traditions survive and even thrive into the twenty-first century.

Many friends and collectors have helped in the gathering of information for this book. I have also found the work of Andrew Bolton and Sang Ye on the second half of the twentieth century in China most helpful. I would especially like to thank long-time friends and collectors Chris Hall, Teresa Coleman, and Judith and Ken Rutherford for their generous loan of items. Others who have assisted along the way are my husband Richard, Ian Dunn, Peter Gordon, Dr James Hayes, Dr Peggy Lu, Gail Taylor, John Vollmer, Vera Waters, Christina Wong Yan Chau, Linda Wrigglesworth, and not forgetting Holly. My editor, Noor Azlina Yunus, has been a constant source of support and encouragement. To all I give my sincere thanks.

Most of the photos and illustrations come from my collection, acquired over the past thirty years of living in Hong Kong, and from making very frequent visits to China. In Hong Kong, I was able to visit remote villages in the rural New Territories on a regular basis, where I photographed the villagers still wearing traditional dress and who generously donated or offered items for sale. A large proportion of these garments and accessories eventually formed the "Valery Garrett Study Collection" at the Victoria & Albert Museum in London, for the benefit of future researchers. In China, my visits to dealers, individuals, street markets, and curio stores proved fruitful and were a wonderful way of getting to know the country and its people. Three decades of collecting have brought untold pleasures and, most of all, treasured friends.

All photographs and illustrations are in the collection of the author, except where indicated below. Photographs in this book were provided by, or reproduced with the kind permission of the following individuals or organizations. Care has been taken to trace and acknowledge the source of illustrations, but in some instances this has not been possible. Where omissions have occurred, the publishers will be happy to correct them in future editions, provided they receive due notice.

Hugh D. R. Baker, London, UK: Fig. 364
Frances Bong, Hong Kong, SAR: Fig. 453
LuLu Cheung, Hong Kong, SAR: Figs. 509, 510
China Tourism Photo Library, Hong Kong, SAR: Fig. 384
Don Cohn, New York, USA: Fig. 172 (left)
Teresa Coleman Fine Art, Hong Kong, SAR: Figs. 20, 24, 81, 95–97, 191, 201, 203a, b, 218–221 (right), 234, 376 (top left, top right), 408, 409
T. R. Collard: Fig. 39
Niels Cross, UK: Fig. 429
The Field Museum, Chicago, USA: Fig. 9
Valery Garrett/Hong Kong Museum of Art, Hong Kong, SAR: Fig. 242
Valery Garrett/Hong Kong Museum of History, Hong Kong, SAR: Fig. 362
Chris Hall Collection Trust, Hong Kong, SAR: Figs. 17, 19, 21, 22, 28, 31, 50, 63, 70, 79, 80, 87, 92, 94, 118, 121, 123 (bottom right), 133, 136, 146, 147, 153, 154, 156, 169, 171 (left), 174 (right), 188, 192, 208, 243, 246, 247, 283, 285, 287–290, 299, 305, 374, 419, 421, 422, 449, 450, 452, 462, 463
James Hayes, Sydney, Australia: Fig. 253
Hong Kong Trade Development Council, Hong Kong, SAR: Figs. 502, 503
Ragence Lam/Hong Kong Arts Centre, Hong Kong SAR: Figs. 505, 506
Library of Congress, Washington, USA: Fig. 237
Keith Macgregor, UK: Fig. 341
Judy Mann, Hong Kong, SAR: Fig. 504
Nanjing Museum, Nanjing, PRC: Fig. 1
National Palace Museum, Taipei, Taiwan, Republic of China: Figs. 14, 59, 61
Palace Museum, Beijing, PRC: Figs. 5, 7, 15, 26, 41, 55, 75, 77
Public Records Office, Hong Kong, SAR: Figs. 254, 316, 333
Royal Ontario Museum ©ROM, Toronto, Canada: Fig. 16
Judith Rutherford, Sydney, Australia: Figs. 195, 477
Ken Rutherford, Sydney, Australia: Fig. 12
Sotheby's Picture Library, London, UK: Fig. 52
South China Morning Post, Hong Kong, SAR: Figs. 324, 388
Vivienne Tam, New York, USA: Figs. 444, 507, 508
Peter Tang Wing Tai, Macau, SAR; Fig. 129
Shanghai Tang, Hong Kong, SAR: Figs. 511, 512
Murray Warner Collection of Oriental Art, University of Oregon Museum of Art: Fig. 11
Vera Waters, Hong Kong, SAR: Fig. 501
Victoria & Albert Museum, London, UK: Figs. 6, 56
Linda Wrigglesworth, Ltd. London, UK: Figs. 49, 69, 187, 241